Arabs in Turkish Political Cartoons, 1876–1950

Contemporary Issues in the Middle East
Mehran Kamrava, *Series Editor*

Select Titles in Contemporary Issues in the Middle East

Being There, Being Here: Palestinian Writings in the World
Maurice Ebileeni

Kurds in Dark Times: New Perspectives on Violence and Resistance in Turkey
Ayça Alemdaroğlu and Fatma Müge Göçek, eds.

Life on Drugs in Iran: Between Prison and Rehab
Nahid Rahimipour Anaraki

The Lost Orchard: The Palestinian-Arab Citrus Industry, 1850–1950
Mustafa Kabha and Nahum Karlinsky

Readings in Syrian Prison Literature: The Poetics of Human Rights
R. Shareah Taleghani

Turkey's State Crisis: Institutions, Reform, and Conflict
Bülent Aras

Understanding Hezbollah: The Hegemony of Resistance
Abed T. Kanaaneh

*Victims of Commemoration: The Architecture
and Violence of Confronting the Past in Turkey*
Eray Çaylı

For a full list of titles in this series,
visit: https://press.syr.edu/supressbook-series
/contemporary-issues-in-the-middle-east/.

Arabs in Turkish Political Cartoons, 1876–1950

National Self and Non-National Other

Ilkim Büke Okyar

Syracuse University Press

∞ The paper used in this publication meets the minimum requirements
of the American National Standard for Information Sciences—Permanence
of Paper for Printed Library Materials, ANSI Z39.48-1992.

For a listing of books published and distributed by Syracuse University Press,
visit https://press.syr.edu.

ISBN: 978-0-8156-3804-9 (hardcover)
 978-0-8156-3797-4 (paperback)
 978-0-8156-5582-4 (e-book)

Library of Congress Cataloging-in-Publication Data

Names: Büke Okyar, İlkim, author.
Title: Arabs in Turkish political cartoons, 1876–1950 : national self
 and non-national other / İlkim Büke Okyar.
Description: First edition. | Syracuse : Syracuse University Press, 2023. |
 Series: Contemporary issues in the Middle East | Includes bibliographical
 references and index.
Identifiers: LCCN 2022045390 (print) | LCCN 2022045391 (ebook) |
 ISBN 9780815638049 (hardcover) | ISBN 9780815637974 (paperback) |
 ISBN 9780815655824 (ebook)
Subjects: LCSH: Arabs—Turkey—Ethnic identity. | Political cartoons—
 Turkey—History. | Turks—Ethnic identity—History—20th century. |
 National characteristics, Turkish. | Turkey—Politics and government—
 1909–1918. | Turkey—Politics and government—1918–1960.
Classification: LCC DR435.A66 B85 2023 (print) | LCC DR435.A66 (ebook) |
 DDC 305.892/705610207—dc23/eng/20221012
LC record available at https://lccn.loc.gov/2022045390
LC ebook record available at https://lccn.loc.gov/2022045391

To my children Buğda and Kerim

Contents

Illustrations

Notes on Transliteration

In the book, I have followed the system of transliteration adopted by the *International Journal of Middle East Studies*, which reduces diacritics to a minimum. In all the spellings for places' names and people, such as "İstanbul" and "Abdülhamid II," I have favored a modern Turkish transliteration. In references, I have retained the spelling of names used in the original documents, which may be crucial in locating the source in a file. Thus, whereas I refer to "Abdülhamid II" in the text, variations such as "Abdul Hamid II" might appear in the notes. For authors who published in Turkish and English, alternate spellings of their names may occur, but the standard Turkish transliteration of their names for their Turkish works has been retained in the bibliography to facilitate finding their works in catalogs.

It is also important to clarify the shifting use of "Turk" and "Ottoman" within the text. Early Europeans referred the Ottomans as "Turks." This terminology is not politically correct. For sure, the empire was a mixture of deeply rooted ethnic groups, Turks being the largest among all, but they were all Ottoman subjects and later Ottoman citizens living within the territories of the Ottoman Empire, subject to its laws and regulation. To remain loyal to the original text, I did not change the terminology in the quoted paragraphs. However, in the rest of the book, I will refer the Ottomans as "Ottomans."

Acknowledgments

This book is the culmination of a decade's worth of research and study. Throughout this long journey, I owe a debt of gratitude to so many people whom I encountered along the way. I was so lucky to be surrounded by this great gang of cicadas that enlightened the nights and cherished the days of my rather difficult path. A famous Victorian caricaturist, Max Beerbohm, says, "The most perfect caricature is that which, on a small surface, with the simplest means, most accurately exaggerates, to the highest point, the peculiarities of a human being, at his most characteristic moment in the most beautiful manner." My family, friends, and others that touched upon the making of this book worked as the perfect caricaturist in Beerbohm's description, trying to magnify the contours of my self-belief on every possible occasion, which seemed to be at the edge of extinction most of the time.

For that, I like to convey my thanks to my mentors and advisors, Dror Ze'evi and Avi Rubin from the Ben-Gurion University of the Negev, and Hasan Kayalı from the University of California, San Diego, whose encouragement and guidance were incomparable. I would like to convey my deepest gratitude to John Tallmadge for guiding me in the circuitous process of drafting the book proposal and obtaining a publisher.

The writing of this book most certainly required specialized knowledge on political cartoon production that was beyond my academic experience. For generously providing support in this area of expertise and sharing his private archives with me, I would like to express my sincere gratitude to Turgut Çeviker. For the great conversations we had on the final periods of the Ottoman Empire, I want to thank Feroz Ahmad. The exchanges we had were invaluable in the historical construction of this book.

I would also like to share my gratitude with my editors Margaret Solic, who bore my panic attacks patiently in times of a world-rocking pandemic; Kelly Balenske, who guided me to the end of this project; Emily Shelton, who edited my work; and, of course, the rest of the publishing team at Syracuse University Press.

A big share of my appreciation goes to my two best friends, Şebnem Gümüşcü and Meltem Ersoy, who have been my shining stars throughout this venture. I do not know if this book would ever have come to light without their support and long hours of personal therapy. Their sharp minds and dogged persistence assisted me in the most complex stylistic and technical matters in writing this book. My dear colleague and friend Minenur Küçük, she is one of the few people who helped me to stay focused amid loads of teaching work and desperation. Thank you for always keeping my spirits up.

My final but most personal gratitude is for my nucleolus and extended families. This book and, indeed, my life as a scholar would never have happened without their support, particularly my parents, and my beloved sister Aslı Büke, who provided essential help in supporting my writing. She is more than a sister can ever be. Then, of course, my pillar of strength, my husband, Ali Fethi Okyar, thank you for bearing my mood swings and tantrums and still loving me the same. I love you! I cannot express my appreciation to you for helping me stay in my cocoon when I needed substantial uninterrupted hours of concentration. I'm not sure if this book could ever come to an end without your care and support. And, last, my two brave children, there are not enough words to express my appreciation for your two strong hearts. My daughter, Buğda Giritlioğlu, and my son, Kerim Giritlioğlu, to whom I dedicate this book, thank you.

Arabs in Turkish Political Cartoons, 1876–1950

Introduction

What about the Buffalo!

The daily *Cumhuriyet* (Republic) has been one of Turkey's main sources of news since its establishment in May 1924, almost six months after the founding of the Turkish Republic. The newspaper, started with the support of Mustafa Kemal Atatürk, aimed at defending the enthusiastically established regime and creating public opinion concerning the changes made throughout the implementation of the new political system. Yunus Nadi, who supported the resistance with his articles in *Yeni Gün* (New Day) during the National Struggle, was appointed head of the newspaper. For the first half of the twentieth century, until other competitors increased their share in the market, *Cumhuriyet* had the widest distribution of any newspaper in Istanbul.[1] Its national and international distribution was mailed by subscription in weekly bundles.

Cumhuriyet quickly became popular reading among the Turkish urbanite class, entering into a new era of a nation-state governed under the founding Republican People's Party (RPP). During these formative

A small part of this chapter was published in an edited volume following the conference proceedings in Sofia, *International Conference of the Multimedial Representations of the Other and the Construction of Reality: East Central Europe, 1945–1980.* Ilkim Büke Okyar, "Arab Other in Turkish Political Cartoons, 1908–1939," in *Multimedial Representations of the Other and the Construction of Reality*, ed. Dagnosław Demski (Budapest: L'Harmattan, 2017), 104–27.

1. *Cumhuriyet* reached a circulation of seven thousand in a short time following its publication and gradually increased its sales. By the 1940s, its national distribution was sixty-two thousand (Konur Ertop 1973, 14; Ayşe Elif Emre Kaya 2010, 77).

years, the newspaper functioned as the government's unofficial organ, as its mouthpiece. While this did not mean that the newspaper fully intended to dictate the political agenda of one party, Yunus Nadi's political identity as an RPP member strongly influenced the newspaper's editorials, which were ministered to legitimize Turkey's domestic and international politics among its citizens.[2]

On an ordinary Thursday, November 18, 1943, *Cumhuriyet* published Cemal Nadir's political cartoon on the French Mandate's political aftermath in Lebanon amid the military and diplomatic watersheds caused by imperial formulations of the ex-Ottoman territories of Mesopotamia and the Levant. Nadir's colorful drawing on the last page of the paper, along with its title, *What about the Buffalo!* (*Mandanın başına gelenler!*), was a fictionalized representation of the current political situation in the ex-Ottoman provinces of Lebanon that had been colonized by France during the post–World War period and that were now moving toward independence. The colorful one-square illustration would be almost impossible for a daily reader to miss—not because of its context, but because of its colorful, grotesque representation of current political developments, echoing the nineteenth-century orientalist narratives that imagined the blue of the Mediterranean meeting the yellow of the Arabian desert.

In the cartoon, Nadir successfully grabs his readers' attention by two means: first, by his witty formulation of the title, which plays with the dual meanings of the Turkish word *manda*, which means both "mandate" and "buffalo"; second, by his bizarre hybrid visual composite of pragmatism, trumping all the mystique that brought the orientalism forth in the first place. Glancing at the colorful cartoon, three dominant themes catch the eye: a fully decorated Turkish Army officer who is clearly an icon of "modernity"; Middle Easterners in threatening poses brutally killing a gigantic buffalo; and, finally, the natural geographic boundaries imposed between them by the desert and the sea. Stripping this image further from

2. The paper's political position was further consolidated by its well-established cadre of writers, featuring the Republican era's most significant intellectual elite, including Ziya Gökalp, Ahmet Rasim, Peyami Safa, Ahmet Refik, Cenap Şahabettin, Halit Ziya, Fuad Köprülü, Zekeriya Sertel, and Yakup Kadri.

1. Cemal Nadir, *Cumhuriyet*, 18 November 1943, 4. *What about the Buffalo!*

its actual context brings me to the purpose of this book, in which I ask the following questions: How does one imagine other cultures and peoples in a way that separates oneself from the other? How can one draw such sharp borders, not only in physical terms—formed by simple brick walls or lines—but also in terms of perception, where beliefs and ideologies meet and ruthlessly clash? Whose reality is revealed in these representational forms, for whom, and on behalf of which causes?

Nadir's cartoon levies an imaginative geography that demonstrates the "ideological suppositions, fantasies, and images" about a currently important and politically volatile region of the world (Said 1994, 49). The Levant, as it was then called, encompassed ex-Ottoman territories in the eastern Mediterranean that were inhabited by different ethnic and religious groups generalized for centuries by the Turks in a single word: "Arab." The term "Arab" in the Turkish imagination connoted everything related to the cultural and social aspects of a large geography that stretched from Mesopotamia to North Africa and reached most of the lands of Islam,

providing its own orientalist gaze, as Edward Said would say, from the once imperial capital, Istanbul.

Nadir's emblematic colors of the desert and the sea—shades of ochre and yellow, and tones of navy blue—illuminate the imaginary geography of the Arab lands for the Turkish reader. It depicts the lush green area of Lebanon while the Arabian desert reflects most dauntingly the materiality of harsh but aesthetically appealing images of the colonial Orient. While Nadir never visited Lebanon or its neighboring geography, his depiction of the desert may have been more than a simple orientalist figment of his imagination. He might have sought to underline the particular clash between imagination and reality in the quest to define the Turkish national self: not because of the simple fact that much of the Levant is fertile, especially its Mediterranean shores, but because of its symbolic position in Turkish spectators' perception of the Arab-speaking Levant as its isolated, desert-like "other."

Meanwhile, Nadir's giant *manda*, tied down for the ritual of animal sacrifice, presents his Turkish audience with the bare realism of resistance to colonial occupation. The buffalo, with a French tricolor emblem on its forehead and blue eyes wide with horror, aware of its destiny, lies down on its side, huffing and puffing from its nostrils the contradictory words *tavzih* (evidence) and *tekzib* (denial) as it waits for its inevitable slaughter: the symbolic end of the French Mandate in North Africa and the Levant. The unavoidable end of the *manda* comes via its stabbing from all angles by the numerous Middle Easterners portrayed in the cartoon with similar yet differentiable physiognomies; they appear like a bunch of predators eager to butcher their prey. The ethnicities of the figures are marked by their outfits, particularly with their headgear: fezes for the Syrians and the Egyptian (the latter also wears a flag on his robe), and keffiyehs and turbans for the North Africans of Morocco and Tunisia and the Arabs of Iraq and Saudi Arabia.[3]

3. Between 1922 and 1953, the Egyptian flag was green, with a crescent moon and three stars, which symbolized the three component territories of the kingdom—namely, Egypt, Nubia, and Sudan—while the green signified the agricultural nature of the country; other sources claim that it symbolized the predominant religion of the country, Islam.

It is almost unavoidable to notice how Nadir's Arabs are fused into a single image representing savagery in the form of vicious barbarians running barefoot, ragefully swinging their swords to shred the flesh of their prey, their actions and appearance suggesting racial depravity and criminality (Sufian 2008, 24). With their fleshy red lips, radiant white teeth, thin black mustaches, shifty eyes, chunky bodies, and dark skin, Nadir's Arab figures resemble miniature ape-like monsters. They exist in binary opposition to the tall, "civilized" Turkish soldier standing proudly behind the boldly lined red border. There is almost no doubt that, for Nadir, depicting the Arabs' struggle was a way of recognizing their cause, an accreditation of their fight against their oppressors. Yet it is also clear that he has a "red line," both physically and perceptually, against the enemy—the French Mandate of southeastern Turkey—that it had fought some twenty years earlier. His bitterness is conveyed through his depiction of the Middle Easterners in their ultimate savagery while the Turkish soldier calmly observes the landscape from a secure distance, making sure to preserve the national self's profound estrangement from the Arab other.

Nadir's astonishing visual narrative contains not only stereotypes of "the Arab," as the various ethnicities of the Levant and North Africa, but also others. A Jew identified with Magen David on his black coat, an easily recognizable moneybag, and a hooked nose anxiously watches from the far corner of the desert, where Palestine is presumably located. From another corner, a British politician whose cunning character is projected through his gestures and facial expressions, keeps pulling on the buffalo's tail. A German wearing a *pickelhaube* helmet spies on the scene from behind the British and Turkish front, underlining his sneaky diplomacy. Nadir elegantly sets all of the intimidating actors of World War II against the well-built and protected Turkish boundaries.[4]

It has also been suggested that the three stars represented the three religious communities of the country: Muslims, Christians, and Jews.

4. The *Pickelhaube*, a general word for "headgear" in German, was a spiked helmet worn in the nineteenth and twentieth centuries by the German military. It became a symbol of militaristic Germans in nineteenth- and early to mid-twentieth-century political and war cartoons.

The red color of the sturdily built wall expresses its strength and inviolability as a physical national border, threatening any potential assailant. The undisputable frontier suggested by the cartoon, however, is not physical but, rather, cultural: it is demarcated by the very existence of the desert, which separates civilization from barbarity. As pointed out by Inge E. Boer (2006, 116–18), the desert is the essence of colonialist assumptions about the Orient. Here, of course, the Orient is an intellectual and political territory, a form of representation, and the desert is perhaps its most potent symbolic topographical form, a geographical stereotype, with its palm trees and oases.

Ever since Napoleon Bonaparte's incursion into Egypt in the late 1870s, the desert has stood out as one of the prevalent tropes in European literary and visual images of the Arab east. In her discussion of the desert as the oriental other, Boer elaborates further on Deleuze and Guattari, who argue that the desert became crucially connected to a perception of the Orient as the other. The desert is a barren "smooth space" made from rocks that crumbled into sand due to the heat of the strong sun and winds; it stands in opposition to the structured, "striated space," which was bounded and allocated to fixed intervals, providing an agricultural template for sedentary life (Boer 2006, 116–20). While smooth space symbolically connoted negativity and uncertainty, striated space ensured positivity and security.

For Boer, the binary opposition between "smooth" and "structured" is also manifested in symbolic boundaries of cultural formations between the West and the East. The uncivilized, barbaric people of the Orient wander around the desert, while the sedentary state apparatus of urban civilization organizes the striated space. Nadir's fully equipped—literally striated—Turkish soldier standing guard on the armed ramparts, guns pointed toward the Levant, is the perfect manifestation of the dichotomy between smooth and striated.

The construction of ethnic/national similarities and differences between nations has always been a significant part of their identity, and orientalism can be seen as one manifestation of this process in the colonial era. The emergence of nation-states on the eve of the Great War brought

these reciprocal comparisons even more sharply into focus. In their study of boundaries, Michèle Lamont and Virág Molnár (2002, 184) underline John Borneman's account of how national borders conveyed "a sense of inherent duality and promoted a process of mirror imaging where the construction of otherness constantly took place on both sides of the border." The important qualification they offer is that the production of otherness was never congruent with national territorial borders; instead, it became more pronounced in the politically active urban centers, where print capitalism flourished most fervently.

Print facilitated the production of national awareness and, eventually, its political instrumentalization. Cultural, literary, and popular representations of collective experiences through media frequently invoked "national character" as a seemingly self-evident explanation for differences in the minds of the metropolis's various inhabitants, who were endowed with membership in an "imagined nation" (Anderson 2006). This process also served to foster a sense of cultural, political, and moral superiority against the imagined other. Typically, ethnic or racial constructions of remote national characters—or so-called national stereotypes—functioned powerfully to define mutually agreed-upon national identification patterns. When Manfred Beller (2007, 13) quotes Lutz Rühling's description of stereotypes as "the smallest imagological unit of analysis," he is actually referring to the interpretation of this pattern in national identities.

While the reciprocal relationship between constructions of self and other has been widely acknowledged, what is often overlooked is the role played by various narrative forms—such as visual rhetoric—in mediating this relationship. In fact, national character is not only a set of attributes but also a formal and aesthetic construct. As Joep Leerssen (2007, 268) maintains, national stereotyping is best understood as a pragmatic and "audience-oriented practice." As borders solidify, so do national and nonnational others. Stereotyping the other and the self is an effort to construct a specific reality. Rather than describing a set of national characteristics, those engaged in the national project structure the collective worldview, norms, and values of their audience. Nadir's dramatic portrayal of the Lebanese struggle in a clear orientalist scene likely played to his readers'

self-image as dissimilar and superior to the Arabs. He knew perfectly well how to manipulate his audience and make them cherish the joy of not being one of the colonized others.

To be clear, I do not think Nadir based his cartoon on advanced intellectual formulations intended to somehow strengthen Turkish national sentiment. He was simply reflecting his own worldview, his political position, and his imagined reality concerning Lebanon's independence finally granted from France. Certainly, in the process of such perceptional fabrications, his stereotypes and symbolism were drawn from a myriad of images and memories accumulated over the years. As I will show, such fantasies reflect Nadir's social and cultural formation as well as that of his generation, producing an enduring synthesis that is partly revealed in the relationship of representation and reality in *What about the Buffalo!*

Imagining National and Non-National:
Arabs in Turkish Cultural Memory

Theories of the modern nation-state have proliferated since the second half of the nineteenth century, opening an immense field for scholars interested in how nations emerge from their imperial pasts. Pioneers of the modernist school asserted that both the formation of nations and nationalism as an ideology arose from the rationality and liberalism of the nineteenth century. As Anthony D. Smith indicates (2009, 18) in his latest book, *Ethno-Symbolism and Nationalism: A Cultural Approach*, scholars such as Karl Deutsch saw the formation of nations as a linear movement of societies toward the state of modernity that became available as a result of urbanization, communication technologies, social mobility, rising education levels, and, most importantly, the liberal practices of Western democracies. The institutionalization of these developments, especially the securitization of national territories, was made possible only by the presence of a legitimate state structure, giving the term "nation-state" its meaning.

This modernist perspective treats "nations" as an almost natural homogeneous group and as the reason for the rise of states within the capitalist world system. Anthony Giddens's (1984, 185) characterization

was more accurate in that respect, in referring to the "nation" as "collectivity existing with clearly demarcated territory, which is subject to unitary administration, reflexively monitored both by the internal state apparatus and those of other states." Yet the latter definition required the modern state not only to raise armies and develop institutions but also to demand loyalty from its citizens. This loyalty is probably the most fundamental requirement for the state's existence and durability. States need culturally grounded and homogeneous social systems to sustain their legitimacy and power.

As both Anderson (2006, 7) and Ernest Gellner (2006, 5) assert, one of the main ingredients to provide the social and cultural scheme that would pave the way for a consolidated nation-state system is the intelligentsia, whose role is to present the cultural codes significant for uniting the society around a single image of a limited, sovereign community—namely, a nation. As a class of well-educated, articulate persons constituting a distinct, recognized, and self-conscious social stratum within a nation, an intelligentsia claims for itself the guiding role of an intellectual, social, or political vanguard. With the invention of print and the spread of print capitalism, this role was bestowed mostly on printmen as the articulators of ideas and ideologies. Daily newspapers, illustrated gazettes, and weekly cultural and social journals were all part of this vivid world of creation. The printmen—publishers, editors, writers, and artists—became a crucial part of this venture. Alongside the intellectuals as scriptwriters of the nationalist discourse, the printmen played their role as broadcasters in urban centers, creating a sovereign sphere of culture to mobilize the imagining of a national identity.

This book is not another study of nation-building or state formation. Neither is it a political or economic history of the transition from a premodern empire to a modern nation-state. Despite the fact that each of these aspects of history played a significant role in contextualizing the way we see our others, my purpose here is mainly to document the impact of visual colloquial Turkish mass culture on the historiography of Arab stereotypes, and hence on its own definition of self. The story I cover is the story of the Arabs in Turkish colloquial culture: how they were shown, and how they were made visible to the national knowledge. By shifting the

focus of inquiry from the abstract discourses of elite intellectuals to the visual rhetoric of popular culture, this book brings the everyday production of nationalist discourse into the mainstream historical narrative of modern Turkey.

Images of Arabs have a long history in Turkish cultural memory. They developed over centuries of interaction between peoples and cultures as a necessary outcome of daily life in multiethnic spaces, particularly in the Ottoman capital, Istanbul. We can trace the first typologies of the Arab as an imperial stereotype back to Karagöz, the famous Ottoman shadow theater. Here, in describing an "imperial stereotype," I am emphasizing Arabs' political status as one of the ethnic subjects of the empire.

In old Ottoman Turkish, the word "Arap," like Shakespeare's "Moor," referred to an indistinct group of "southern" Muslims from the Middle East and Africa. In classic Karagöz plays, there were two types of Arab characters with their ingrained mannerisms and attributes, racially distinguished from each other: Ak (white) Arab and Kara (Black) Arab. The first chapter of this book traces the emergence of these two characters as the oldest representation of Arabs in Turkish colloquial culture. The "white" and "Black" Arab puppets from Karagöz established the blueprints of Arab stereotypes alongside other imperial stereotypes for centuries to come. These stereotypes played their part in Turks' definition of the national self once they claimed their own nation-state. Nadir's readers were familiar with these stereotypes not only because they were part of a vast post–World War I narrative that depicted the Arab as a dishonest, back-stabbing savage but also because they had been part of Turkish traditional culture since the sixteenth century.

Arabs, in their various manifestations, were among the oldest characters of the Karagöz plays that entertained urbanites of the empire. All the ethnic and religious characters in Karagöz were ridiculed: Kurds, Armenians, Greeks, Jews, and even Turks themselves. Among these numerous types, Arabs were among those often portraying distrusted passersby. However, as history turned toward homogeneity both socially and culturally, this image of the Arabs as ridiculous and harmlessly cunning transformed into a vulgar persona. As nationalist endeavors became the dominant force of political mobilization in the final years of the empire,

Arabs were pushed to the margins, conclusively becoming one of the new republic's non-national others.

Ottoman expansionism had already begun to alter the socially created typology of the Arab in the late nineteenth and early twentieth centuries. Still, the critical turning point occurred during World War I, when the empire lost its territories in North Africa and the Middle East. The final era of Ottoman history brought the irrevocable collapse of the multiethnic empire, but this was not a simple linear development. For example, the Libyan struggle against Italy, supported by the Ottoman army in North Africa, raised some sympathy for heroic resistance to colonial powers and created a sense of shared destiny in the first decade of the twentieth century. However, the Arab rebellion in the Levant diminished that moment of compassion. Now Arabs were not only one of the main obstacles against the Empire's quest for modernity; they were also one of the causes of its dissolution. This was especially evident following the 1916 Arab revolt of Sharif Hussein, an event that strengthened the negative image of Arabs in the postwar narrative that began to be heavily employed in the early 1920s. The new territorially delimited nation-state was defined around Turkishness, and the Turkish elite's ambivalent feelings toward Arabs were molded by bitter feelings of betrayal. The conflicting prescriptions of Arabness (which Arab?) intertwined both with pity for their subjugation by the imperial powers and grievance for their backstabbing, which pierced the Turkish collective memory and manifested in every possible discourse, including the political cartoon space, placing the Arab stereotype in continuous limbo.

The Arab's centuries-long representational transformation, first through the puppet masters and later through printmen, played a crucial role in answering the question "Who is like me, and who is different?" In this context, the "Arab," in its simplest sense, served as the mirror reflection of "us," the worthy national self. This imaginary of the Arab inevitably resulted from accumulated experiences and *longue-durée* perceptions formed by a complex flow of ideas from above and from below. The perception of the Arab was registered through various pictorial presentations, constructing symbolic boundaries between these two culturally competing groups. I consider it crucial to trace the latter flow with

specific reference to the domain of political cartoons, where the fantasies and topoi regarding Arabs were expressed in the daily news through graphic grotesques.

Needless to say, there were other constructed "others" against which the Turks defined themselves; here, "Kurds," "Jews," and "Armenians" hold pride of place. In the following chapters, they will play occasional roles, but, as I will argue, the stereotype of the Arab, sometimes with its exclusive Arabness—overemphasized geographical relation as decedents of the Prophet, and sometimes as an umbrella concept for the diversity of the region—will carve out an essential space in the hall of ethnicities, welding Arabs to a collective and timeless group identity.

Constructing Visual Meaning: Building Boundaries, Making Nations

The relation between images and stereotypes needs clarification for their potential interpretation as symbolic boundaries. For Michel Lamont and Molnár Virág (2002), stereotypes consist of perceived lines, which include and define people, groups, and things while excluding others. In 1922, Walter Lippmann (1998, 79–94), in his book *Public Opinion*, defined the term "stereotype" using the abstract idea of "pictures in our heads." According to Lipmann, stereotypes are accepted as generalized perceptions of the other that often carry negative connotations and seldom recognize individual variations. Stereotypes prevail because, once adopted, they are very difficult to change based on new information, and they are carried from generation to generation through cultural codes. Homi Bhabha (Barker and Bhabha 2003, 162) similarly points to the generalized simplicity of the stereotype as its defining element, residing not in its false representation but more in its "arrested, fixated form of representation."

In colonial discourse, these ethnically and racially signifying forms become the enduring signs of a negative difference. Referring to Frantz Fanon's *Black Skin, White Masks*, Bhabha (1994, 75) reminds us that Blackness becomes a symbol for a set of constructed knowledges that traps one's identity, as in "wherever he goes, the negro remains a negro." For the stereotype, Bhabha adds, "impedes the circulation and articulation of

a signifier of race as anything other than its fixity as racism. We always already know that blacks are licentious, Asiatics duplicitous" (75). No different than Fanon's observation on racial stereotypes of Blacks, for the Turks, it was the Arab who stood as one of the most despised ethnic stereotypes of all, and that stereotype remains relevant even today.

Stereotypes serve as a conceptual metaphor for other cases where classifications yield to negotiations, such as in Nadir's cartoon, between smooth and structured spaces or between civilized and uncivilized identities. These discussions of stereotypes that Joep Leerssen terms "imagology" have taken a turn in the last century that has made them more central to national identity studies (Beller and Leerson 2007). Increasingly, the attitudes, stereotypes, and prejudices of "us" versus "them," and their nature as textual and visual constructs, have become a fundamental component of discursive historical analysis, introducing a new layer for representing the mutual construction of different cultures and societies.

I find Ruth Brynth's (2007, 3) description insightful for offering perspective on how imagining enables people to create a "counterfactual alternative to reality by mentally altering or undoing some aspects of the facts in their mental representation of reality." Brynth certainly sheds light on the works of scholars such as Ernst Gellner, Eric Hobsbawm, and Benedict Anderson, who understood national identities as constructed forms: reflections of a state of mind rather than a rational set of conditions and facts.

Images are not transparent. As Réné Magritte showed in his famous painting *Ceci n'est pas une pipe*, they are not the thing in itself but a specific representation of it by someone with a specific history, bias, and artistic tradition. Images can either create sharp divisions when they contradict a worldview, or enlighten their audience when they are appropriately acknowledged. It is important to note this fact, especially while discussing the ways that nationalist discourse and its imagined content are represented visually. Images are forms of negotiation between the intelligentsia and the public, of which printmen are the medium. This negotiation becomes especially significant within the contexts of imagery and imagination.

For Cicero, the act of imagination meant seeing through the mind's eye. More up-to-date definitions of imagery define it as the ability to

produce and simulate novel objects, peoples, and ideas in the mind without any immediate sensory input (Byrne 2007). It is also described as forming experiences in one's mind, which can re-create past experiences, such as vivid memories with imagined changes, or entirely invented exotic scenes. Tim Inglot (Janowski and Ingold 2016) describes imagination as synonymous with perception because the world that is perceived is continually brought forth in the very act of imagination.

Deconstructing the term "imagination" requires a prior terminological definition: "the image." "Image" belongs to the same semantic field as multiple similar terms such as "emblem," "picture," "semblance," "incarnation," "apparition," "impression," and "idea." Joep Leerssen (Beller and Leerson 2007, 13) defines the image as a mental or discursive representation or reputation attached to a person, group, ethnicity, or nation. As such, images are often configured through various forms of communication, such as literary or pictorial/visual depictions, folk songs, or national myths. They become intangible in the sense that they vary according to perceptions in the service of creating stereotypes. Following Inglot's and Leersen's observations indicating that there is no real boundary between perception and imagination, in my discussion I prefer to interpret the term as a mental picture, a memory of perception that contains both intellectual and emotional elements. This mental image is elicited by the reorganization in the mind of a received cultural schema that continuously reproduces these cultural codes. In most cases, especially within the larger discussions of nations and national identities, these images supply the symbolic boundaries created around the national and non-national characters.

Since the Age of Enlightenment, the modern state's imposition of "being civilized" created an increasing awareness of the nation that served to politicize stereotypes for defining who is "us" and who is "them." Such a twofold definition of the nation yielded, on the one hand, affiliations to sentiments like patriotism, loyalty, history, religion, language, and shared ideas. On the other hand, it fostered antagonism and competition toward different interests and views on the part of other nations. The modern history of nation-states is, in a broader sense, based on these identities and differences. Most certainly, the Ottoman Empire, first, and, later,

the Turkish Republic, actively represented their imperial and national selves through the stereotyped mental images of their others—sometimes through laughter, sometimes through vulgarity.

An Ecology of Reproduction: The Satirical Press, Political Cartoons, and Cartoonists from Empire to Nation-State

If one imagines themselves as part of a cultural community, one also needs to imagine the counterself that defines the boundaries of that community. This dual process of imagination takes place in various conceptual genres of popular culture, from literature to the visual arts. The nineteenth century was a crucible for the production of literature and art, feeding Western fantasies about the exotic cultures of the colonial world that would later become the subject of orientalist studies. Among the various categories of cultural production focusing on the Orient, lithography offered the simplest form of delivering news. The invention of copperplate engraving facilitated the mass production of more detailed images, sometimes in their perfect and sometimes in their grotesque forms, to provide humor or satire. Thereby, lithography encouraged the emergence of the political cartoon as a popular art form in the course of print history.

The term "cartoon" was first used in its current meaning in the midnineteenth century, when the British satirical monthly *Punch* used it as a title for a series of humorous illustrations attacking the government's plans for a new Parliament building and contrasting its lavishness with the extreme poverty of many ordinary people (Refaie 2009). At a time when the newspaper was still a predominantly verbal medium, cartoons created a visual sensation that is hard to imagine today. Many cartoonists of the late nineteenth and early twentieth centuries came to be regarded as influential and highly respected political commentators.

Political cartoons were distinctive because they were explicit and offered a precision of meaning found in few other visual genres of the time. The cartoon's message was able to serve and facilitate the imagination of self and other unambiguously. Three aspects played an important role on the rising popularity of the political cartoons: first, the printing conventions that allowed for labeling; second, the abilities of cartoonists

to capture the distinctive visual traits of well-known public figures; and, finally, the opportunity that caricature, as a technique, provided for exaggeration.

The metaphorical combination of the real and the imaginary was one of the features of cartoons that distinguished them from other newspaper images, such as press photographs and illustrative drawings. This capability gave the cartoons significant power because they provided the image directly while depending on the reader's ability to forecast and manipulate its possibilities to create meaning. European publications in particular, from the Victorian *Punch* to the French *Charivarie*, offered fine examples of political cartoons. These papers, designed by publishers and the intelligentsia, quickly became instruments of political publicity in the nineteenth century. The attribution of characteristics, convictions, and ideas expressed through illustrations offered explicit statements about the exotic unknown within colonial discourse while creating possibilities for the construction of stereotypes of national and non-national others for decades to come.

Political cartoons became "unavoidably co-determined, subjective, historical, and cultural factors," which made them essential as historical "evidence" embedded in a strategy of power (Rajchman 1988, 94). John Rajchman, in his analysis of Foucault's conceptualization of the "art of seeing," claims that visual representation of a historical moment in time contains not only the evidence itself but also the knowledge that might easily become instrumentalized in manipulating the public's mind. The representations in political cartoons similarly picture "not simply what things looked like, but how things were made visible, how things were given to be seen to knowledge or power" (93).

Returning to Nadir's cartoon, the Foucauldian visibility of his illustration of Lebanon's independence from France did not provide a simple theme in the manner of a motif but served as a reference point for other topics, such as the conflicting identities of Arabs and Turks. Modern scholarship now understands that visual images offer insight into the creation of identity that other types of text do not. Nadir's cartoon is a significant example for demonstrating political cartoons' capacity to

reproduce various power positions of the liked and disliked, or national or non-national: in our case, the non-national disliked Arabs.

The already familiar figures of the Arab in their conventional forms were etched in people's minds, attracting public laughter in traditional Ramadan-night Karagöz shadow theater. From the sixteenth century onward, Karagöz plays enacted a splendid variety of stereotypes of the capital's multicultural residents. Arabs with their keffiyeh (headwear) and djellabas (robes) were among the oldest figures in these colorful spectacles as the empire embraced print capitalism toward the end of the nineteenth century. As history took its turn, these stereotypes slowly altered as part of a broader agenda. Within postcolonial discourse, these traditional characters turned into mere illustrations of the nation's other.

When print capitalism emerged in the Ottoman Empire, publishers were eager to attract readers by all possible means (Göçek 1987; Brummett 2000). It was not long before political lithography—that effective agent of political and social criticism—found its way to the daily news press. Almost right away, the shadow puppet stereotypes of the Karagöz plays found their way to the space of political cartoons, communicating with their audience through the pens of their creators, the cartoonists.

Nineteenth-century Ottoman political cartoonists were highly influenced by European imperialism's colonial zeitgeist, which, in a way, served to legitimize the culturally and socially constructed relationship between the powerful metropole and its powerless periphery. Within the constitutional era's political realm, Arabs became the Ottomans' uncivilized counterimage, just as the Ottomans themselves had been perceived as the exotic other by Europeans (Deringil 1999).

Despite the clarity of a political cartoonist's job description, the central questions for scholars of nationalism who were taken by the visual rhetoric of the political cartoons revolved around how much power cartoonists had to make radical changes in the social structure, or to what degree they could use their power within political systems, especially in times of social and cultural change. It would be an exaggeration to say that they were primary actors, but their position as part of the intelligentsia should not be underestimated. The power of their cartoons and their

contribution to the visualization of the current political discourses certainly amplified their significance as builders of public opinion.

Ottoman publishers of the nineteenth century acknowledged the capacity of political cartoons as a tool of political protest and social engineering in the quest for modernization and Westernization. Of course, with broader access to Europe, the influence of non-Muslim minorities in transmitting this new medium to the Ottoman public is undeniable. Political cartoons became a daily occurrence in the imperial capital of Istanbul, but their bite was soon tempered by the palace. Indeed, during the reign of Sultan Abdülhamid II, censorship was pervasive, and newspapers became little more than official organs of the state, acting as the sultan's image-builders (Brummett 2000). Illustrated satirical gazettes had to find their way around state censorship to convey their anti-government critiques. The 1908 Revolution put a temporary halt to Abdülhamid II's thirty years of repressing the press, opening room to expand print media. Publishers, who were also among the intelligentsia of the regime, embraced political cartoons as part of a communication system that was already familiar to the public. They used it to pitch the components of constitutionalism and freedom against the old regime's tyranny, constantly comparing one to the other.

The years following the 1908 Revolution up until the proclamation of the Turkish Republic in 1923 proved to be an overwhelming challenge for its rulers. It was a period of constant flux that required a total reformulation of sociopolitical and intellectual life around the concept of national citizenship with a shared identity (Karpat 2004, 421–22).[5] Formulation of a shared identity relied on a preexisting texture of myths, memories, values, and, finally, symbols that accumulated in the collective memory. This foundation of collective memory was what gave people the power to imagine ethnic and national identity.

5. Kemal Karpat collocated the major events paving the way for this immense transformation that hewed the empire into a series of monarchies and republics in six phases: the shift of the ruling elite from the sultan to a newly formed nationalist military; the loss of territory and influence in the Balkans, North Africa, and the Arab regions; the defeat in World War I; the occupation of the empire by the allied powers; the success of the War of Independence in 1922; and, finally, the abolition of the sultanate and caliphate.

The reformulation of a Turkish identity around a collective memory required the full engagement not only of the republic's political elite but also its intelligentsia. The intellectuals' role was essential as creators, inventors, producers, and analysts of the competing ideas of the nationalist paradigm (Conversi 1995, 74). The republican press, unlike its Western counterparts, was rooted in both the worlds of politics and literature, creating a close relationship between the two. However, the power of visual rhetoric to pursue the state's ideals consolidated a place for political cartoonists as the third party in a republican team of broadcasters.

In surveying almost all the papers with visual representations published since the introduction of lithography to Ottoman society, I encountered a complex and symbolically laden image of the Arab. The Great War, followed by the anti-Arab spirit of the new Turkish nationalism catalyzed by the mythical Arab betrayal, hitched the process of creating a new, "civilized" Turkish identity to the vulgar perception of the Arab, which expressed itself openly and violently in the cartoons of the early republican period. In the perception of the new republic's intellectuals, Arab ex-subjects of the empire were caught up in the web of orientalist discourse as the colonized or antagonized local actors in a more intricate form.

The Alphabet Reform of 1928

During this relatively brief period of political and cultural transformation, a robust social engineering project of modernization took place in which the republican state's nature, and its specific pattern of state-society relations, were set in motion. As nationalist agendas grew, governments sought to promote state ideology and legitimization through educational means. The alphabet reform of 1928 was among these transformative projects and had a major impact on the development of political cartoon press.

The Arabic alphabet was the official script of Ottoman Turkish. Changing to Latin script was the culmination of a long process that had dominated the agenda of nineteenth-century Ottoman intellectuals as part of modernization efforts under the Tanzimat (Yılmaz 2011). As underlined by Benjamin Fortna (2011, 21), reading was key to Ottoman and republican approaches to political, cultural, social, and economic

mobilization, given the possibilities that literacy offered in terms of both mass communication and commodification, two hallmarks of modernity (Baron 2005, 61). However, the alphabet reform only succeeded under nationalist leadership. Studies of the period between the 1870s and early 1900s show that the percentage of the population who could read was not more than 10 percent and was limited to the urban centers, where one could have access to education (Yılmaz 2011, 681).

The republican "revolution" under Mustafa Kemal had to adapt to the nation's popular base, revealing the limits of top-down cultural change to rally people to the nationalist cause. However, in the short term, the alphabet reform seems to have facilitated literacy much less than might be expected, especially among the literate middle class, who had been educated with the old alphabet. In fact, as Fortna (2011, 20–21) claims, it may well have "retarded reading efforts in the short term and certainly imposed a rupture that broke up textual and generational continuity." Some of those who were already literate had difficulties adjusting to the new script, while others occasionally found that neither the language nor the format resonated with them. This of course did not mean that the masses were made illiterate overnight and so disregarded the contemporary intellectuals' iconic writings, especially in a population where the majority did not know how to read and often attended public readings. But, as one of the results of adapting to the new script, the satirical press rose as the principal and most effective mediator of this transformational period. It became the primary vehicle for transferring contemporary cultural ideologies, including the idea of a collective Turkish identity, while, more broadly, it contributed to the building of a secular national symbolic language and culture.

The satirical press did not offer intellectual insight into Turkish identity in its cocoon. The seemingly shallow and simplistic nationalist themes of political cartoons between 1923 and 1949 did not require their audience to be highly literate either. Instead, the easily memorizable content aided the mass distribution of nationalist ideas across class and literacy lines. Ayhan Akman (1998, 85–86) argues that the alphabet reform of 1928 is one of the reasons for the significant increase in political cartoon production in early republican Turkey. The instant transformation of the Arabic

script of Ottoman Turkish to the Latin alphabet created a strong glitch in the cultural sphere. The necessary but severe consequences of the alphabet reform caused irreversible damage to print media for a time, leaving newspaper editors no choice but to rely on graphic material. Most magazines and dailies that adopted visual means folded their circulations, while others lost their market share.

The consequences of the alphabet reform were felt deeply through the social and cultural transformations of the early republican era. In the words of Hale Yılmaz (2013, 159), the language reform "initiated a process of cultural transformations whose terms were not entirely determined by the state, but shaped in part by the perceptions, decisions, and actions of Turkish citizens as well as the structural conditions of the times and of the consolidation of the Kemalist nation-state in that process."

For all of these reasons, the alphabet reform of 1928 provided one of the most significant boosts in the cartoon press since the 1908 revolution. For example, Cemal Nadir's cartoon *Exodus!* (*Hicret!*), which appeared a day after the alphabet reform, was probably one of the best representations of this fundamental cultural transformation. Nadir's stylistically exceptional personification of each Arabic character in the word *hicret* as swinging up their stuff to leave the scene was the dramatic implication of the cultural displacement that was undertaken by the new republic.

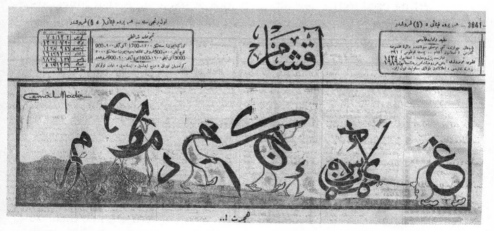

2. Cemal Nadir, *Akşam*, 1 December 1928, 1. *Exodus!*

After the committee to Latinize the alphabet was set up in June 1928, both of the leading satirical periodicals of the period, *Karagöz* and *Akbaba*, along with the rest of the print media, started using the new alphabet. Only *Karagöz* (the paper of political satire) exceptionally followed a gradual transformation. For the next six months, its issues came out in both Arabic and Latin scripts. Starting in January 1929, the magazine was released exclusively in Latin characters, thereby joining the others.

From the start, cartoons and light vernacular dialogues were more popular and influential than the dense intellectual works of Ottoman Turkish intellectuals. This newly formed mass medium was especially effective in mediating between the written discourses of "bourgeois nationalists" and the Turkish urban masses' everyday expressions. This was by no means a top-down enterprise, because both producers and consumers were engaged in an ongoing dialogue.

Most producers, especially the publishers and the political cartoonists, were part of a growing Ottoman—later Turkish—middle class. This social connection greatly enhanced their mediation and authentication engagements with the Ottoman Turkish general public. Indeed, the form, content, and colloquial languages of these vernacular modes were stimulated by and principally echoed in everyday life's interests and social diversities in Turkey. The demand from below was mostly for entertaining, culturally relevant, and linguistically comprehensible media.

Getting used to the new alphabet took years, and, by that time, cartoons had already become a crucial part of newspapers. Print capitalism and the resulting commercialization of Turkish popular culture, centered in Istanbul, exposed more and more Turks to mass culture in the republican state's quest for homogenization. These predominantly colloquial cartoons popularized Turks' collective identification as an imagined political community with "deep, horizontal comradeship" (Anderson 2006, 7).

Some Notes on Method and Sources

Since I am looking at national and non-national stereotypes and their representations as a form of discourse, my primary concern is not to theorize cultural or national identity but to survey how visual representations of the

non-national other continuously reproduce national stereotypes, and vice versa. When we look at them in actual use, the meanings situated in the images of the other not only carry specific purposes in different contexts but are also integrally linked to various stereotypes of social and cultural groups that passed down over a longue durée. Therefore, a comprehensive discourse analysis of images representing the Arab as the non-national other would require asking questions about what their significance was in relation to politics and power at given moments in time and space, and how they intertwined with their stereotyped personas.

It is humbling as well as exciting to realize how little work has been done on political cartoons as historical "evidence" within the fields of imagology and boundary studies that aim to engage the role of symbolic resources in "creating, maintaining, contesting, or even dissolving" institutionalized political and social differences embedded in ethnic and racial inequalities (Lamont and Molnár 2002, 167). Certainly, working with political cartoons is not an easy task. Since they are subjective in nature, one has to undertake analysis not only of the cartoon itself, where the process of otherization takes place, but also of the cartoonist and the publisher, who were part of its creation. The relationship between text and image and the relations between the artist and publisher emerge as the most intriguing aspects of interpreting political cartoons. The artist must know and utilize the audience's beliefs, values, and attitudes if they are to be an effective persuader, and the publisher must consider how the individual artistic contribution can be integrated into a coherent, collaborative journal while taking into account the restrictions imposed by press laws and censors.

Political cartoons tend to reflect the perspective of adjacent texts. Their accompanying articles in the journal, where the stereotyped character and its immediate environment are categorized in national terms, reflect empirical real-world identities, our perceptions of which comprise the totality of our cumulated social and cultural experiences. When the time comes, they surface to consciousness from the darkness of our unconscious. This was perhaps best described by Franz K. Stanzel (in Beller 2007, 11), when he similarly pointed to how political conflicts and even wars sink into oblivion more easily than the images of others, "which

are obviously locked up in a deeper stratum of consciousness. In times of political tension, conflicts, or war [or where power is negotiated], these images rise up or are called up from an unconscious inventory of images and generalize prejudices about the other."

Working with political cartoons is not devoid of challenges. Most of the previous scholarship that have used political cartoons as historical evidence swung between nationalist/ideological approaches and a modernist/developmentalist approach. However, the last couple of decades has witnessed the emergence of a more innovative body of research on literary and visual representations and the occasional personification of the nation in authentic national archetypes. Müge Göçek's (1998) edited volume on the *Political Cartoons in the Middle East* focuses on the political cartoon space of the ex-Ottoman territories in the Middle East, covering issues from gender and nationalism to the question of modernity in the sociocultural construction of Middle Eastern societies. Tobias Heinzelmann's (2004) *The Balkan Question in Ottoman Caricatures, 1908–1914*, on the other hand, examines Ottoman cartoons mainly from the perspective of political relations between the Ottoman government and the newly liberated regimes in the Balkans. Although his work presents narratives and images concerning Ottoman-European relations as reflected in political cartoons, it does not offer the reader a comprehensive discussion of imperial identities and their stereotypes. The most pertinent study for our purposes is likely Palmira Brumett's (2000) impressive *Image and Imperialism in the Ottoman Revolutionary Press, 1908–1911*, which has played an important role in the materialization of this book. Her comprehensive analysis of Ottoman cartoons published during the constitutional revolution in 1908 demonstrates a wider social perspective on the political, economic, and cultural transformation of the Ottoman population, which was struggling to redefine its identity against an encroaching Europe. Finally, Turgut Çeviker's three-volume work on the Turkish cartoon press from 1876 to the foundation of the Turkish Republic in 1923 takes a holistic approach in its exploration of the cartoon industry, offering a valuable source for scholars interested in the artistic development of political satire press from empire to republic.

However, very little academic research has undertaken the study of political cartoons from an imagological perspective. The neglect of political cartoons as a source for ethnic and racial studies concerning stereotypical images has come to the attention of scholars only in recent years. One of the aims of this book is to contribute to this literature and set forth political cartoons as a not-to-miss discourse in the larger discussions of ethnicity, in which, as in the case of this book, Arab stereotypes have a place of their own. That being said, I have decided to take Joep Leerssen's methodological advice on deconstructing how the national and non-national stereotypes of Arabs are formulated, preserved, and circulated first in Ottoman and later in Turkish political cartoons.

The first task in pursuing this aim was to establish an intertext of the Arab as a set of figurative or metaphorical expressions and clichés where fluctuations of appreciation and depreciation take place (Chatterjee 1993). This required a thorough examination of literary and visual sources, including the traditional and colloquial texts in Turkish where the Arab has been discussed. Calling an unresolvable situation "Arab's hair" (*Arap saçı*), for example, implies a contextual tradition that is passively or actively echoed, varied, negated, or mocked by the individual instance in question (Leerssen 2007, 28)—or, as the common expression "Neither the sweets of Damascus, nor the face of the Arab" (*Ne Şam'in sekeri, ne Arabın yüzü*) expresses something like "Neither the best nor the worst," the worst being represented by the face or presence of the Arab, which still escapes the frank coarseness of some other sayings, using the Arab to imply the repulsiveness of a situation.

In the next phase, I contextualized these metaphors or clichés within the texts where they occurred, mainly in political satire gazettes. Among various forms of satire, political cartoons have a unique capacity to combine visual symbolism with a given text of its genre. They tie down and specify the contexts' narratives and situate the national metaphor's status within the given setting. Symbols, like visual images or forms, refer to something essential; therefore, they tend to carry their own significance as major components of creating a pictorial metaphor—they substitute for the signified. The compression and graphic disposition of symbols play a

significant role in how they are interpreted and evaluated. The cartoon-ist's challenge is to employ the proper techniques and symbols to create the intended effect.

The emerging nationalist current in the nineteenth century was most certainly the channel for popular culture to invent and generate myriad of symbols in encapsulating abstract contexts of nations, national identity, or ethnosymbolic boundaries. Symbols point to something essential, some-thing more concrete, within national identities, evoking something absent or subtle, thus empowering their meanings. For example, the feelings that a flag stimulates for a patriot are, of course, beyond its simple meaning as a piece of cloth. Suzanne Langer (1953, xi) defines a symbol as "any device whereby we are enabled to make an abstraction" and suggests that the symbolic function includes more than language alone, although language stands out as the major discursive field of symbolic production; symbol-ism, she points out, takes into account a different sort of semantic. Among others, art forms are probably the most capable of types of articulation not governed by the laws of language but instead by the "articulation of concepts" (26).

Such symbolism, which cannot be translated, does not have defini-tions and cannot communicate generalities directly is "peculiarly well suited to the expression of ideas that defy linguistics" (Langer 1953, 26). Yet artistic forms communicate complex combinations in a single glance. Such things as qualities, lines, rhythms, and other elements may occur in numerous presentations; they can be related, combined, and abstracted in creative means. From miniatures of the thirteenth century to drawings of the Renaissance, as with the figures of traditional spectacles and per-formances: all these forms of visual art present the invaluable capacity of symbolic images in transposing perceptions. The meanings of these sym-bolic elements should be understood through the whole—that is, through their relationships within a total structure and not as isolated sounds, col-ors, or lines. Langer calls this kind of semantic "presentational symbol-ism" to characterize its essential distinction from discursive symbolism, or "language" (Langer 1953, 45; Reichling 1993, 4). This presentational symbolism constitutes one of the essential links that this book intends to

uncover in tracing how the Arab stereotype was formulated in Ottoman and Turkish popular culture.

Similar to their European colleagues, the Ottoman cartoonists conveyed their messages in a single glance and in a single frame often by incorporating a binary opposition of the given political, social, or cultural states: for example, the juxtaposition of civilized and uncivilized, or the contrast between modern and traditional. The technique of comparing and contrasting was reflected in visual rhetoric where images and their captions, molded with the cartoonist's perception, delivered the message. These visual forms combined with the text would invest in the consolidation of symbols that helped in constructing an imaginary world of perceptions and ideas.

Of course, symbols and their meanings tend to be modified as social values and experiences change, particularly when it comes to stereotypes. Cultural features or social behaviors may lose power or significance and can be discarded, modified, or replaced by new ones. Thus, classic symbols used for the national and non-national were redefined during the empire's political transition from autocracy to constitutionalism, and, later, to republic. A new set of symbols in line with Europe's "civilized" political, social, and cultural notions was adopted. Obviously, one cannot leave out the historical context of these symbolic formulations. Political cartoons cannot be interpreted timelessly, despite their reproduction of seemingly timeless stereotypes; their power lies in deciphering and transforming historical codes into new ones through symbolic references intended for the eyes of a targeted audience while maintaining the reproduction of visual knowledge.

Finally, based on these methodological provisions, I demonstrate how the othering of the Arab works alongside the Ottoman—and, later, Turkishself as Leerseen (Beller and Leerssen 2007, 29) in what would call an "identitarian process of maintaining a sense of selfhood across time." Thus, this examination emphasizes the global diversity of cartoon press. Colonial representation of the other in its orientalist sense, followed by twentieth-century nationalisms, have worked on the assumption that stereotypes, whether geographic, ethnic, or national representations, are the

basic taxonomic unit of reference (Medhurst and DeSousa 1981, 198). This classification of the other leads to a realization that any nationality is, to a large extent, an Andersonian condition. With symbolic rather than concrete borders, they create a world map where national perceptions of the other set imaginary boundaries.

Regarding the Content

This book is the story of the white Arab's journey in Turkish collective memory. The Arab has appeared, disappeared, and reappeared throughout its visual history in Turkish colloquial culture. The first chapter presents the traditional sources of images of Arabs in Ottoman Turkish lore that would later become blueprints in the service of political cartoonists.

The second chapter explores how the technique of lithography emerged as a powerful medium in the nineteenth-century Ottoman press; it discusses how this medium facilitated the transformation of illustrative art as an agent, altering political cartoons as a system of thought, knowledge, and communication that constructs our experience of the world. The chapter also summarizes the historical development of the political cartoon press, emphasizing prominent political satire papers and the artists that contributed to the continuity of Arab stereotype as the non-national other.

From European cultural centers to the Ottoman Empire's imperial capital, these representations of the other came, by and large, to be accepted, turning them into a universal language among the civilized colonizers. Therefore, the third chapter describes this cultural interaction that united the Ottoman and European cartoonists in terms of their stylistic rapprochement. It defines the political and cultural habitat in which the ethnic stereotyping of the Turkish nationalist cartoons found its symbolic roots before flourishing within its own cultural habitat. Of course, engaging with the constructional relationship of this complex artistic web is rather limited. It involves a longue-durée perspective where chronological restriction and a sociological evaluation of modernity intersects with political iconography as a new genre of communication and powerful component of mass education. Therefore, the chapter works to exhibit

the link between Ottoman and European cartoonists' technical and representational similarities in the imagining of the Ottoman Empire's own Orient, while also disclosing the layered, ambivalent, and occasionally sympathetic coding of these images.

The next series of chapters contain the various thematic occasions in which colonizer and colonized, ethnicity and nation, elites and masses interact. The chapters build on various cases where the Arab appears in its most excluded form. The first of the series, chapter 4, starts with the nineteenth century's twofold envisioning of the Arab and Arabness in Ottoman political cartoons. The first part of the chapter demonstrates the changing political discourse introduced by the Eastern Question as the central diplomatic affair between the leading imperial powers. Second part is about the Ottoman sultan Abdülhamid II's response to this increasingly demeaning reputation of his sultanate fused by European popular culture. The chapter traces a myriad of European and Ottoman lithographs that construct the Ottoman imagination of its own Orient, offering a complementary tribute to the works of Selim Deringil and Ussama Makdisi by introducing the visual aspects of Ottoman orientalism and the Ottoman *mission civilisatrice*.

Chapter 5 turns its gaze from the faraway borders of the empire to its capital and takes as its central subject not the Bedouins of the Arabian desert, but the bureaucratic elite of the Ottoman court. It offers a visual account of the high-ranking Arab bureaucrats of Abdülhamid II's court and their contested positions in the government with the constitutional revolution of 1908.

The Arab's journey continues in chapter 6, as the Great War breaks out. Throughout World War I, the Arab appeared either within discussions of the Yemenite rebellion against the Ottoman Empire or North Africa's Sanusiya resistance to Italy's colonial ambitions. While the first manifested the traitorous character of the Arabs in Ottoman political cartoons, the other glorified the North African Arabs' defense against the Italians.

Chapter 6 also examines the specific junction where the strands of history, which the nineteenth and early twentieth centuries pulled apart, intersects with the Turkish Republic's ex-Ottoman Arab provinces. As the

war came to an end along with the empire, so did Arabs as its disputed subjects. Out of a collapsed empire, a Turkish government emerged in Ankara, paving the way for the Turkish nation-state. Betrayal of the Ottoman Turkish troops in the Levant during World War I was the dominant theme of republican Turkey's nationalist narrative during the 1920s. Turkey's early republican cartoonists made a strong effort to alienate the Arab from the Turkish collective memory. The chapter exhibits this process of marginalization through sets of cartoons where the Turks encounter their Arab others in the consolidation of the republic's eastern borders.

The final chapter attempts to unlock what happened to the Arab stereotype throughout the Turkish nationalism's political, social, and cultural transition in the 1930s and 1940s. Heavily inspired by the works of Franz Fanon and Homi Bhabha, the chapter demonstrates how the Arab stereotype was caught in the web of racial fascism, similar to equivalent experiences imposed by the Western world.

1

Ethnic and Cultural Boundaries in Early Ottoman Entertainment

Staging Otherness

The nineteenth century witnessed a dramatic increase in the proliferation of stereotypical portrayals of racial, social, and cultural others. Certainly, this increased interest in classification was stimulated in part by the spread of Social Darwinism. The cultural phenomenon of exhibiting non-European people in front of European audiences as colonialism prevailed occurred mainly in the metropoles of the western part of the continent. World Fairs like the French Industrial Exposition of 1844 held in Paris or the Great Exhibition of the Works of Industry of All Nations of 1851 in London provided the most accepted platforms for staging the unfamiliar colonial other, where an excess of exhibits in which a wide variety of non-Western societies and cultures were represented. Inspired by colonial power relations, but despite the lack of colonial tradition, stereotypes of other lands have been an integral part of Western public culture establishing the core of orientalism in the sense of confirming national and racial superiority. Long before the colonial exhibitions of the unfamiliar took place in European metropoles, they were already being staged in Ottoman coffeehouses through the famous Karagöz shadow theater.

The ethnic and racial boundaries that separate the national from the non-national mostly reside in the minds of a nation's subjects rather than in written form. The notion of the other has been an integral part of nationalist doctrine, where the existence of the self presupposes the existence of the other. The discourse of nationalism and national identity

is, in its most simplistic and biased definition, the distinction between the in-group and those belonging to other communities—the "others." Within the public sphere's self-aggrandizing visualization of the nation, there has always been a need for a mirror image. For example, the Greeks used the term "barbarian" for all non-Greek-speaking peoples, including the Egyptians, Persians, Medes, and Phoenicians, thereby emphasizing their otherness. Similarly, Arabs used *ajam* to refer to anyone who was not part of the linguistically defined Arab geography. The term, adopted from Arabic, connoted so strongly in Ottoman vernacular language that it became the widely accepted expression for the Persians that spoke Farsi (Pakalın 1993, 7–8).

Over centuries, in the quest for regional and cultural domination, these adjectives for national otherness mingled in multicultural empires to represent the disliked or the overpowered. In such contexts, traditional art forms including miniatures, puppet shows, and theater performances served their function by providing publicly familiar images as an integral part of the sociocultural formulation of the other. And, when the nineteenth century's contested nationalisms came to the doorstep of the Ottoman Empire, Arab stereotypes from traditional shadow theater snatched the leading role in the emerging sphere of political cartoons.

On the eve of the new Republic, Arabs were not new to the Turks' gaze. They existed in the cultural and social mix of the Ottoman Empire long before the winds of nationalism changed the world known to them as subjects of the sultan. This chapter explores the first recorded appearances where the Arab's journey began for the Ottoman public and the division of its imagined persona in terms of racial definitions.

Karagöz Shadow Theater

For more than two thousand years, the Anatolian peninsula stood as one of the main paths for travelers between Asia and Europe. It has been touched by numerous civilizations, whose social and cultural traces were assimilated by the generations that came after. It might be difficult to follow the trail of these layers to the point of distinguishing the exact cultural tones; however, their collective blueprints survived in early Anatolian

peasant festivals, sometimes as folk dances, and sometimes as timeless dramas (And 1963, 9–10).

The urge to imitate human actions as an intrinsic character of entertainment was developed as part of these peasant festivities. These occasions of performing actually formed the first practices of what we today call "theaters" (And 1963, 33). Among various theatrical illustrations in Anatolia, shadow theater stood out as one of the enduring forms of amusement in Turkish folk culture from the day it entered the gates of the empire.

In its currently recognized form, shadow theater became popular in the Ottoman capital of Istanbul in the sixteenth century, after Sultan Selim I conquered Egypt in 1516 and brought a group of shadow puppeteers with him to the palace.[1] From then on, the spectacle of shadows had a considerable presence in Ottoman entertainment, enriching the empire's cultural life through laughter. The earliest images of the Arabs, with their customary mannerisms and attributes, can be traced back to the scripts of the famous Karagöz (Dark-Eye) shadow theater.

Both in the palace and in the conventional wisdom of Anatolian Sufism, shadow theater was considered a form of *hâyâl* (imagination, shadow, or mirror), where, in Eastern mysticism, its origins rested. The spectacle would be referred to in the palace as *lu'ub al-hâyâl* (a display composed of images or shadows) or *zıll-i hâyâl* (the shadow of the image), which resonated with a deeper understanding of life itself. The performance of two-dimensional leather-cut puppets mirrored on a flat cotton paper screen was nothing but the simple reflection of existence, a photographic print of the universe that, in fact, was nothing more than an illusion; all of the characters that come and go are mere impressions on the human stage that one calls life.

It did not take long for the shadow theater to be embraced by the common public outside the gates of the palace, where it would be linked inseparably to the name *Karagöz*, or "Dark-Eye." The name referred to the

1. According to the memories of an Egyptian historian and an eyewitness, upon conquering Egypt, Selim I came across a shadow theater performance by the Nile River. Extremely impressed by it, he awarded the performers and decided to take them to Istanbul for his son, Süleyman I (And 1975, 25–33).

scripts that made light of subject matter generally considered taboo, particularly subjects that were normally considered too serious or painful to discuss within the social and political structures of the empire.

Just as in the other geographies it intersected with, the shadow theater held an important place throughout the larger areas of the Ottoman Empire and became extremely fashionable during the sixteenth century. It became so popular, in fact, that both civil and religious authorities began to fear the prestige it enjoyed among the public. The reasons behind its attractiveness, as opposed to other forms of entertainment, are open to discussion. But, for one thing, its performers provided both mirth and critique to their spectators from various segments of the cultural and social hierarchy, creating an alternative space—a bubble—isolated from the verdicts of the official and religious orders. Framed within that small piece of cotton cloth were moments of freedom to mock the unmockable, ridicule the self-important, and critique the divine.

Karagöz's significance in Ottoman cultural and social life was not only established by its recognition as the main source of entertainment for the general public during communal gatherings like Ramazan evenings.[2] It was also acknowledged for its links to particular institutions, like the guilds, that fit into an entire network of social, religious and economic affiliations within which individual and group identity was continually affirmed and reinforced. The kind of crosscutting social, cultural, and economic popularity that Karagöz carried among these groups had an influential capacity that none of the other entertainment forms enjoyed.

In Hobbesian fashion, where human nature sought laughter in one person ridiculing another's defect, Karagöz's punch line was its powerful formulations of *taklit* (imitation). These imitations impersonated particular dialects or peculiar behaviors and distorted facial expressions for entertainment: all forms of imitation that would revolve around certain characters recognizable to audiences through their symbolically significant features. In some cases, these stock characters would be differentiated by their costumes, skin colors, or unique behaviors.

2. Muslim sacred month when a strict fasting is practiced from dawn to sunset.

The laughter that these plays provoked also commonly elicited a sudden sense of superiority, sometimes of self, but most of the time of the other. "Laughter is a song of triumph," says Marcel Pagnol in his *Notes Sur Le Rire*; "it expresses the laugher's sudden discovery of his momentary superiority over the person he laughs at and this explains all bursts of laughter in all times and all countries" (in Langer 1953, 339). The Karagöz characters were there to entertain and, in some cases, inform or even educate the crowd while providing that brief, abrupt sense of power and supremacy over the imitated.

In its technicalities, the Karagöz stage—a precursor to modern cinema—was separated from the audience by a frame holding a white translucent sheet, preferably made of fine Egyptian muslin. The canvas was stretched firmly on the frame, which was usually two to two-and-a-half meters. The operator (*hâyâli*) stood behind the screen, holding the leather figures against the canvas, lit from behind by a flickering oil lamp. As a light source, the lamp would be held just below the screen, giving the figures a more lifelike appearance.

Karagöz figures were called *tasvir* (portrayals). They were made of very finely processed leather (preferably camel hide) using a special technique aimed at producing transparent figures, and they were painted with Indian ink or root dyes in vivid colors. When the screen diffused the light, which shone through the transparent multicolored material, the *tasvir*s reflected onto the canvas like colorful silhouettes. The *hâyâli* controlled the puppets by holding them against the screen with horizontal rods, allowing for the correct reflections of the shadows onto the stage canvas. According to Metin And (1975, 44–46), the *hâyâli*'s mastery lay in the ability to hold and move the figures while narrating the plays orally, adjusting his voice for the linguistic and dialectic differences among the characters (Kudret 2005, 33–34).

Although the shadow theater became a significant public spectacle in the sixteenth-century Ottoman capital, the first vivid descriptions of it were recorded in the seventh century by the famous Ottoman Turkish traveler Evliya Çelebi, whose *Seyâhatnâme* (Book of Travels) provides picturesque details regarding the famous performers of his day, the subjects of the most popular plays, and the screen personalities. While he fails to

explain the satirical significance of the performances and the details of less famous artists who performed in the local coffeehouses, Evliya Çelebi shows how Karagöz became the most popular form of entertainment not only in the capital but also in the empire's distant periphery. This spectacle, which earlier could only be exhibited at rare public or private gatherings, attained unheard-of popularity as coffeehouses became widespread along the borders of the empire.

The Karagöz plays were part of an oral tradition where the puppeteer (*Hayali*) as the narrator played a significant role in the success of the performance. A good puppeteer should not only be able to recite the stories, but also to sing well. Here, singing well does not mean singing like a singer; for a good performance it is necessary to caricaturize the song by staying within a special tone or method (*usûl*), which is much more difficult than singing normally. The tone is the essence of the performance, which brought forth the performer's reputation, based on his capacity to imitate the accent and dialect of the types performed.

The recording of the Karagöz plays in written form began as late as the nineteenth century. As the scripts of the plays were altered according to the political and social atmosphere of the day, their content tends to reflect the contemporary matters of that given time and place. The transformation from the Ottoman Empire to the Turkish Republic did not change that. The stock characters and essentials of the plays would remain intact as they formed the outlines of the nation's stereotypes both during and after the fall of the empire. However, one thing that did not stay intact was the way this major theatrical genre and tradition became the object of popular social engineering within the formulations of a nation-state.

The Imperial Capital and Its Stereotypes

Karagöz played an important role in Ottoman public life. It removed the social and economic barriers among the hierarchies of the population, as well as between the diverse ethnic and religious groups of the empire, by holding up to society its self-reflection, with a core of laughter. It brought people together through humor, ridicule, and criticism—both of the state and of the peculiarities among its diverse citizens.

From the imperial point of view, Karagöz plays provided a naive form of entertainment that worked as a security valve to relieve public discontent. The palace perceived it as simply the common people's means of entertainment. This elite disdain helped Karagöz plays evade censorship while continuing to offer poignant political and social satire.

Employing a wide range of characters, Karagöz was an artistic space in which contradictions, differences, and relations typical of an extremely diverse society found vivid expression (And 1975, 51). Although this tradition was originally imported to the empire, most of the characters were created, and later assimilated, in Ottoman contexts, bearing the imprint of imperial social and cultural experiences spanning three continents: Europe, Asia, and Africa. Interestingly, such a colorful scheme of characters has never captured the attention of scholars of orientalism. It would be interesting to ask what kind of reality and fictitious concepts Karagöz represents, especially considering the symbolically rich stereotypes it produced over centuries.

The Karagöz screen with its script and characters was closely related to symbolism strongly influenced by Sufi mysticism. As discussed in great detail by Siyavuşgil (1941), the stage itself exemplified a *mahalle* (quarter/ neighborhood) of the capital Dersaadet (Istanbul). In Ottoman culture, the centers of social and economic life were the *mahalle*s, which were separated from each other based on ethnic boundaries. Each *mahalle*, to a certain extent, had independent control over everyday occurrences as well as community solidarity and many informal means of regulating and directing public morality (Duben and Behar 2002). Siyavusgil's observation makes sense, considering that the *mahalle*, as the smallest cohesive unit of the city, contained the heterogeneous texture of society and provided a framework for communal solidarity. With its symbolic realism, the Karagöz stage embraced the similarities and differences among people living together in these units. The plots reflected daily encounters decorated with the political and social headlines of the times where each stereotype participated through its performance.

Historians have long recognized Karagöz plays as important material for studying the religious, ethnic, and linguistic diversity of the Ottoman Empire while emphasizing the satirical dimension of this art. From the

late nineteenth to the early twentieth century, foreign travelers who visited Ottoman lands managed to collect an impressive number of traditional shadow theater plays that would later serve as valuable resources for scholars of the field. Pioneering studies of Karagöz tradition began to appear in early twentieth-century European literature. Hungarian Turkologist and folklorist Ignac Kunos (1886) explored Karagöz as part of Ottoman folklore culture. Georg Jacob (1900) wrote about the Karagöz tradition in his book *Turkische Schattentheatre*, later translated into Turkish by Orhan Şahin Gökyay (1938). Helmut Ritter compiled the largest collection of Karagöz plays—recorded originally from oral narrations of the nineteenth-century Ottoman palace's Karagöz performer Nazif Bey along with other performers and puppet-masters like Memduh, Sefer Mehmet, and Küçük Ali—in his famous *Karagöz: Türkische Schattenspiele* in 1920. Andreas Tietze (1977) cataloged a collection of Karagöz puppet illustrations and published what are probably the best transliterations of the plays to date.

While European scholars mainly focused on dialectical classification of the Karagöz characters, Siyavuşgil proposed a more sociocultural approach. He collected the cast under two major clusters: locals of the *mahalle*, and outsiders who pass through it (Siyavuşgil 1941, 143; Kudret 2005, 24–25). These outsiders are also divided into two demographic subclusters: Turks from the empire's various provinces (Rumelili, Kastamonulu, Bolulu, and Tatar), and other, non-Turkish inhabitants of the empire with various ethnic or religious origins, such as Persian, Arab, Albanian, Jewish, Armenian, Greek, and Frank (Siyavuşgil 1941, 144–45).[3] His cataloging was significant for most to reflect the underlying different ethnic and regional loyalties as perceived by the empire.

In all these various classifications done by European and Turkish Turkologists, one commonality was that the cast of the Karagöz plays reflected a complex and diverse social stratum. The culture of the *mahalle*

3. Metin And's breakdown of the characters is similar to Siyavuşgil's, yet he offers an extra layer of subgroups based on the inhabitants' dialects, gender, clothing, behavioral tendencies, ethnicities, religion, and the question of whether they are earthly or unearthly.

was conceived as a microcosm representing both the empire's capital and the entirety of the empire at the same time. Whether they resided in or passed through the *mahalle*, the *tasvirs* of the Karagöz plots were part of the Ottoman cultural heritage rooted in the sociocultural life of the capital itself, and the characters were the two-dimensional representations of the mere demographics of the city.

Another significant feature of Karagöz characters that remained intact in the making of vernacular stereotypes was their impersonated cognomens. None of the characters except the main protagonists, Karagöz and Hacıvat, had an individual appellation; rather, they had nicknames that represented their social and ethnic personas. The characters were designed in a way to ensure that their facial features, hairstyles, outfits, dialects, communication skills, behavioral patterns, and other visual and oral details, from head to toe, would be embodied within these nicknames.

The main plot of most plays was constructed around ridiculing and making humorous the linguistic, communicative, or behavioral differences among these various ethnic, religious, and social stereotypes that formed an integral part of Ottoman society (Siyavuşgil 1941, 138–41). The two friends, Karagöz and Hacıvat, like the flip sides of a coin, would serve to reveal the public opinion on any given plot, echoing the differences of social groups living in proximity to one another, trapped within the same environment.

Karagöz represented the ordinary man in an Ottoman context. The man uses common spoken language, often amusingly vulgar; is ignorant and occasionally devious; likes to tease the strangers he encounters and make fun of their deficiencies; and is usually unemployed and always preoccupied with making a living for his family, although his attempts to find a job are fruitless. Many of the plays are tailored around Karagöz getting a new job opportunity, but he always ends up disappointing the people who provided this opportunity by misbehaving and eventually getting fired. When he feels trapped, he normally resorts to violence, beating up Hacıvat or whoever else is in front of him. Due to his crudeness and sarcasm, he is disregarded and not well respected in the neighborhood.

Hacıvat, on the other hand, one of the two protagonists, who appears as Karagöz's best friend, is distinguished as a slightly more educated

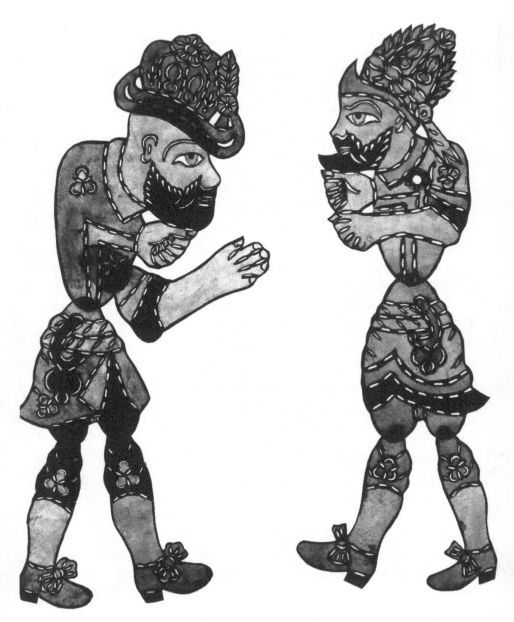

3. Karagöz and Hacıvat. With the permission of Yapı Kredi Museum Karagöz Collection.

figure compared to Karagöz. His language is richer and more articulate compared to Karagöz's street talk; he has a good knowledge of poetry and music, yet he seems superficial, snobbish, and even opportunistic. Despite his relatively higher social rank, Hacıvat is unemployed as well. The narrative of the plays emerges around the dialogues of these two out-of-work friends. The added humor in their conversations occurs when Hacıvat's arrogance is defeated by Karagöz's naive benevolence and expressive power in his common language. Karagöz easily fools Hacıvat, despite the latter's pragmatism. Unlike Karagöz's impulsive behavior, Hacıvat's actions are well calculated. He usually offers advice and aid to the residents of his neighborhood, which assures his position there as a highly respected character.

The contrasts and tensions between the two protagonists and their relations with the others provided endless comical entertainment for the Karagöz audience while revealing clues about the personalities of the other characters. Stereotypical features were accentuated in both the plays and *tasvirs* through the repetition of moral attributes and physical characteristics such as facial traits (skin tone; the size and the shape of the eyes, lips, and nose; and hair, including mustache and beard).

The costumes were important as well. The hat was probably the most determinant part of the attire in pinpointing a character's ethnic or religious background (reflecting the importance of headgear as a social signifier in Ottoman society). Accessorizing the costumes with items significant to their ethnic or religious background also helped bring the personalities into focus. For example, the *shtreimel* of the Jewish rabbi, or the *kalimavkion* of the Greek Orthodox priest, were used to identify the religious social positions of these characters.

Ethnically differentiating traits would be used repetitively to create a pattern recognizable to the audience. For example, Turks from the Anatolian provinces were criticized by the locals of the capital for their rudeness and improper manners and were held in contempt for their naivete. These details of the two-dimensional figures would remain consistent with their original representations over generations, sealing these stock types in the Turkish public unconscious.

The Karagöz characters—those who were ridiculed and those who were praised—were chosen among the inhabitants of the city that commonly interacted with the locals. Yet, unlike provincial Turks, the "imperial outsiders" (those coming from the outlying provinces) displayed more problematic behaviors in their relations with the inhabitants of the *mahalle*. In the satirical spirit of the Karagöz plays, the criticisms of the outsiders by the capital's natives can easily be traced to their silliness, with untrustworthiness as their common feature. The Persian or Ajam, for example, appeared as a rich carpet dealer from Tehran who would constantly recite poetry in order to sweet-talk women who appreciated his artistic taste. The Albanian, on the other hand, with his *qeleshe* as his headgear,[4] would be depicted as a tempered *boza* seller in the narrow streets of the *mahalle*.[5] In other cases, he would appear as a gardener who would try to act like one of the locals by overemphasizing polite speech. The mockery in the plays was usually built around his inability to hide either his temper or his Albanian accent, which would reveal itself as he sang inane songs about vegetables.

The Arabs in the Karagöz plays, on the other hand, were tricky figures. The characters' common portrait was more complex and elaborate than that of the other characters, such as the Arnavut (Albanian), Ajam (Persian), or Rum (Greek). They did not have one specific mode of depiction. After all, in the seventeenth and eighteenth centuries, Arabs were as much part of the Ottoman world as Kurds, Turks, or Armenians. Although the word "Arab" (*Arap*) itself was mainly used to signify sub-Saharan Africans in Ottoman and, later, in Turkish colloquial culture, the Karagöz figures were portrayed according to two different sets of images and two different typologies. Emphasizing this difference, the characters are separated based on their skin tone: on the one hand, the white (*Ak*) Arab, a provincial figure who visited the *mahalle*, and, on the other, the unqualified term "Arab," which referred to a *zenci*, an African "Arab" slave appointed as servants to the household.

4. Traditional Albanian headgear: a white cone-shaped skullcap with a tassel hanging from the top.
5. Boza is a special wintertime drink made out of fermented millet.

Among the thirty-nine plays compiled by Cevdet Kudret, Arab characters appeared in fifteen of the plots. Within these fifteen, the *Ak* Arab and *Arab/Zenci* never appear in the same drama. They both display very different personalities—almost in total contrast to each other—yet they both have the faces of that noble but unintellectual East familiar to travelers in the Orient.

(*Ak*) "White" Arab of Mashrek

While empires may differ quite substantially—and, while early modern empires such as the Ottoman and the Austro-Hungarian empires differed from British or French ones diachronically and synchronically—all empires, and especially their metropoles, tend to produce a body of knowledge about their others, living in or beyond the empire's peripheries. This perceptional otherization requires a geographical projection. For the Ottomans of the imperial capital, the vague landscape to the east of Istanbul that began somewhere south of the Taurus Mountains that separate the Anatolian plateau from the steppe and that in turn quickly fade into the Syrian desert, were territories that belonged to Arabs. These lands came under Ottoman rule following Selim I's campaigns in the Middle East and North Africa at the beginning of the sixteenth century. For a time, Ottoman authors employed the term *Arabistan* as the geographical designation of where the Arab lived, yet this term itself was not easily understood in their mental geography, leaving the ethnic makeup often unclear in the Ottoman imperial imagination.

In its most generous application, *Arabistan* encompassed the Arabic-speaking regions of Arabia and the western Fertile Crescent, including today's Syria, Lebanon, Israel, the Palestinian territories, and Jordan, with the occasional addition of the province of Mosul in northern Iraq (partly because some territories were under Persian rule). Yemen, Egypt, and the various provinces of Libya had their distinct topographical designation that did not carry any association with ethnicity.

Despite the vague ethnic connotations of the term "Arab," there were certain distinguishing factors for the capital's residents. For example, while the inhabitants of Yemen were referred to as "Arab" in the Ottoman

construction of their identity, those of Egypt were more often simply labeled *fellahin* (peasants), using the colloquial Arabic plural for the agricultural class.[6] Again, as pointed out by Bruce Masters (2013), the Ottomans posted in Cairo were aware of the fact that Egyptians spoke Arabic, but, as was the case with the Arabic-speaking Christians whom Evliya Çelebi encountered in Beirut in the seventeenth century, that fact did not necessarily make them Arabs.

A question that one should probably ask while exploring the stereotypes of the famous Karagöz plays is, what would "Arab" mean to the man on the street in the sixteenth-century Ottoman imperial capital? Where would the points of encounter be for the capital's residents and the empire's newly incorporated Arab subjects? It is, of course, not easy to tease out answers, given the ambiguity and complexity of the period. Nevertheless, one thing that is certain is that if the Arab succeeded in becoming part of the cast in the Karagöz shadow theater, he must have been encountered daily in the capital's crowd. After all, the most important quality of Karagöz shadow theater was its capacity to draw its subjects and characters from the everyday life of the metropole.

The white *"ak"* Arab is one of the earliest puppet figures in Karagöz plays. Besides the original texts of Karagöz themselves, there are limited primary sources that reveal the kind of observations that one might expect to find in the memoirs of a traveler. Evliya Çelebi's seventeenth-century *Seyahatname* (Travel Book) is one of those sources containing an early mention of the white Arab (Siyavuşgil 1941, 180). Çelebi's writings occupy a unique place for being probably the longest and most ambitious travel account by any writer in any language, and a key text for all aspects of the Ottoman Empire at the time of its greatest expansion in the seventeenth century. In his *Seyahatname*, Çelebi opens his first chapter with a tribute to the capital, offering a panoramic depiction of the city, from the buildings to the occupations of its residents and various social groups, with reference to white Arabs among them (Dankoff and Kim 2010, 377).

6. Both Hathaway (2018, 23–24) and Masters (2013, 14–15) present a detailed explanation of the conceptual geography of the Arab territories for the Ottoman self.

More comprehensive information on the presence of Arabs in the capital can also be found in Ahmet Refik's work on Ottoman social life, where he cites İbrahim Peçevi's writings from the sixteenth century (Altınay 1931). On various occasions Refik includes references to the Arabs in Istanbul. Among these accounts, the city's security seems to be the most concerning. One of the spillover effects of Sultan Selim's 1516 Middle East campaign was a wave of migration to the capital from the Arab regions. While some of these newcomers incorporated themselves into the capital's economic system, some remained outside and posed a threat to public safety. For example, Refik (1932, 54) mentions that Arabs were both among the merchants selling coffee from Yemen or sweets from Damascus while others would form gangs for burgling or begging and sometimes for harassing passers-by for money.

In Karagöz plays, the white Arab of the capital was designated by various nicknames. Most frequently used was Hacı Kandil (Haji Oil Lamp). There are times where he would also be called Hacı Fitil (Haji Candlewick) or Hacı Şamandıra (Haji Pontoon), which are all complementary parts of an oil lamp.[7] The name *Hacı Kandil* was a double form of mockery. First was the appellation *hacı*, which signified the character's religious association as a Muslim who had completed the pilgrimage to Mecca. In folk language, going on the pilgrimage was also associated with one's social status and indicated a person of advanced age (to have the time and money needed to travel to Mecca, a person needed to be financially established and secure). But since, in the minds of the capital's audience, the Arab was already part of that religiously sacred geographic imagination, he didn't need to make the pilgrimage; thus he did not truly earn the title *hacı* and all the affiliations that came with it. The mockery of calling him *hacı* essentially underlined his character as opportunistic and hypocritical.

7. In Kudret's classification of Karagöz, the plays including these Arab characters are: "Ağalık" (Being Agha), "Abdal Bekçi" (The Foolish Night Watchman), "Çeşme" or "Kütahya" (The Fountain or Kütahya), "Hamam" (The Turkish Bath), "Kayık" (The Boat), "Orman" (The Forest), "Sahte Esirci" (The Fake Slave Trader), "Şairlik" (Poetry), and "Tahmis" (Coffee Grinding). Siyavuşgil (1941, 127–28).

Kandil, on the other hand, signified another layer of the ridicule embedded within the dual meaning of the cognomen itself. The dictionary translation of *Kandil* is "an oil lamp, usually composed of two parts: the pontoon (body, oil float) and candlewick" (Pakalın 1993, 158–59). However, in colloquial Turkish, it also indicates a "sharp, pointy nose" (*Türkiye* 1975, 2621). This kind of linguistic diversion was very common in Karagöz plays and is part of what makes them so hard to translate. It is within these jokes that the amusement, critique, and potential for laughter lie.

The white Arab would frequently be portrayed as a beggar. If he was not featured as a bum that fed off the *mahalle*'s residents, then he would either be a sweets or baklava merchant, or a coffee grinder, a type one would often encounter on the streets of the capital. His light-colored skin earned him the label "white" Arab, simultaneously making one think of the rest of Arabs as dark. His facial features would be highlighted with a smoothly formed black mustache and a pointed beard. His nose would be sharp and bony and his almond-shaped eyes sheltered under thick black eyebrows. These features were accompanied with a keffiyeh that would be rolled like a turban in the traditional twelve-band style. The rest of his costume, however, was colorfully fashioned by shades of red and brown instead of the commonly observed white garb.

In the plays, this intriguing character with his exotic touch would usually travel to Istanbul from Egypt, Beirut, or Damascus. His route was often revealed to curious spectators through the shadow puppets of camels, constantly constructing the symbolic relationship between the Arab stereotype and geographical features of the Levant. As a common practice, the *hayali* would add a layer of dialectic variance with an Arabian accent both in writing and citing the text to further distinguish the white Arab from the other stereotypes.

Typical of traditional Karagöz plays, each stereotype had a specific jingle they would sing when entering the scene. This technique, unique to Karagöz, functioned to announce the upcoming persona on the stage. Similar to other stereotypes, whose main target was to entertain the crowd, the white Arab also entered the scene with a cheerful *gazel* deeply laced

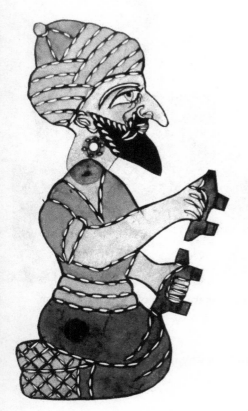
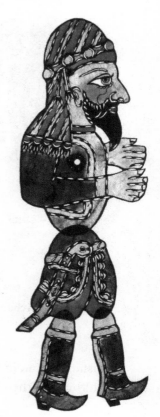

4. White Arab characters [from left to right]: Arab beggar and Arab merchant. With the permission of Yapı Kredi Museum Karagöz Collection.

with Arabic words in an exaggerated poetic style.[8] This jingle would be preserved in Ottoman/Turkish slang for years to come as *maval okumak*, to refer to telling lies. *Maval* is translated into English as an Arab ballad, a lie (in slang) (Pakalın 1993, 422; Moran 1985, 600). The *gazel* he sings is about the promises of exclusive gifts he had brought for women from

8. A *gazel* is a classic poetic genre typical of Karagöz shadow theater's traditional construction.

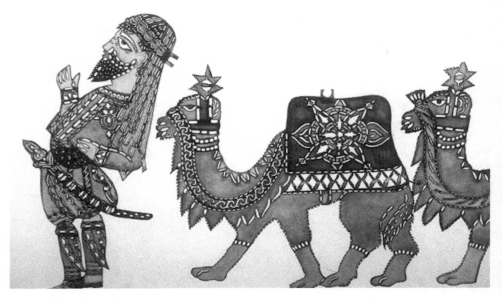

5. White Arab merchant with camels. With the permission of Karagöz Museum, Bursa.

Arabistan so that, in return, he can find his way into the women's homes and, ultimately, their beds.

> Hey, girls! I bring wool fabrics and silk drapes for you! Open the door for me and let me in tonight. Believe that when eyes fall asleep, the lover will fall asleep, as well. A lover, my children, is piteous, do not hurt him. Open the door for me, and say: "The light of my eye, welcome!" Furnished with peacock-feather pillows and velvet quilts, let me go out onto the balcony, and light the candles for me. (Kudret 2005, 63)

In the texts of the Karagöz shadow theater, the general attitude toward the white Arab was a skeptical one, prompted, it can be argued, more by his mincing arrogance than by his role as an outsider—at least at the beginning of the sixteenth century, when the Arab first started to appear on the cotton curtain.

The Muslim identity of the Arab, as revealed in his title, *hacı*, seems to work as a shield for him in the multicultural metropole. In dialogues,

the white Arab always praises himself with his religious connection to the prophet Mohammed's tribe, playing off the tradition of sympathy among the Muslims of the empire, offering his prayers in return for favors. In the nine plays where the Arab Hacı Kandil is the main character, the story revolves around his efforts to avoid paying his debts or to get out of an uncomfortable situation while Karagöz discovers his true intentions.

The conversations between Karagöz and Arab usually consist of repetitive questions like: Who? Whom? When? Where? or What? This is caused not only by the Arab's stupidity but also by misunderstandings stemming from his Egyptian or Damascene accent. Karagöz constantly misinterprets the Arab, and the dialogue repeats over and over again, leading to increasingly ridiculous discussions while slowly revealing the true character of the Arab to the suspicious audience.

For example, in the play *Kayık* (The Boat), both Karagöz and Hacıvat are working on Hacıvat's boat to ferry customers from one side of the Bosphorus to the other. One of their first customers turns out to be Hacı Kandil, who approaches the boat and yells out to ask about the boat's route. Karagöz replies by calling him "Bonehead" for yelling instead of asking politely, referring to his facial structure. This time, the Arab, as an eager merchant, asks the price of the trip. Karagöz replies, yet as soon as the Arab learns the fare his arrogance is replaced by a poverty-stricken attitude, and he reminds the two oarsmen—Karagöz and Hacıvat—his distinguished religious identity as a pilgrim, hoping to get a discount. Karagöz and Hacıvat, convinced by the Arab's claim, reduce the fare to half-price in return for prayer. But, instead of praying, Hacı starts singing a *gazel*. As the singing goes on, the distracted oarsmen crash into another boat. Once the song ends, so does their trip, and they dock the boat. The Arab pays the promised half-price and leaves the boat without saying any prayers; the two foolish protagonists, on the other hand, end up with no profit but a loss.

In one of the oldest plays, *Ağalık* (Being an Agha), Hacı Kandil appears as a crippled beggar instead of a stingy merchant. The play opens with him as a mendicant with no arms or legs approaching and greeting Karagöz. After a series of interchanges based on dialect misunderstandings (which, again, is part of the humor), the beggar finally succeeds in persuading

Karagöz to spare some money in return for prayers. He adds that since he has no arms and legs to grasp the money, Karagöz should stuff it into his mouth. Karagöz, convinced, does as he wishes and puts the coins into the mendicant's mouth, asking Hacı Kandil to make good wishes and prayers for him in return. Instead, Hacı Kandil, with a full mouth, starts mumbling and asks Karagöz to confirm with an "amen" at the end of each articulation as an act of religiously sealing the prayers (Kudret 2005, 97–99; Siyavuşgil 1941, 180–81).

The careful listener can tell that these prayers, uttered in a guttural and incomprehensible language, are actually composed of camouflaged curses. At first, fooled by his title, Karagöz follows the instructions of the Arab beggar and ends up agreeing with all the curses with an enthusiastic amen. However, after a couple of hearty approvals, Karagöz discovers Hacı Kandil's intentions and headbutts him (a characteristic act of Karagöz in the plays) and sends him away. Similarly, in *Sahte Esirci* (The Fake Slave Merchant), the Arab is typecast as a slave merchant disguised as a burglar named Hacı Fitil (Haji Candlewick). When Karagöz asks who's at the door, Hacı Fitil answers, "Open the door, I'm a poor man," revealing another version of the Arab's stereotypical cunning persona (Kudret 2005, 853).

The plots of "Abdal Bekçi" (The Foolish Night Watchman), on the other hand, presents a white Arab as a libidinous character. In the play he craves the secret password to the house of a woman who recently moved into the neighborhood. The only way to obtain it is by answering her questions correctly. The Arab is so anxious for a sexually appealing invitation that he responds before she can even ask the question (Kudret 2005, 63). Meanwhile, Karagöz secretly watches the dialogue between the two and makes fun of the Arab by repeating and distorting his words and commenting on the weakness of his sexual appetite (Kudret 2005, 63–65).

In all of the plays where he is present, the white Arab is characterized by his calculating, unreliable personality. Yet the latter is not necessarily related to his intelligence; on the contrary, it is mainly constructed around his weakness—sexual or financial—that would unconsciously invest in the Arab's disloyal image. The fact that the humor is always tailored around Karagöz's process of exposing the Arab's plots is significant in terms of demonstrating to the audience how the "we," whether ethnic or

national, is always superior to the "other"—that is, to "outsiders" not from the capital, and, in this case, the white Arab.

"Black" (*Kara*) Arabs of Karagöz

Foreign lands and cultures may inspire incomprehension, apprehension, fear, or loathing, but in some cases they can also elicit curiosity and delight. This positive appreciation is in some respects the very opposite of what one might consider a prejudice. For the subjects of the Ottoman Empire, the term "Arab" signified two groups who were as opposed in racial, ethnic, and geographic terms as the two sides of a coin, yet were personified under the same linguistic reference.

Since their conquest by the Ottomans in 1516, white Arabs were seen as members of *Qavm Najib* (noble Arab tribe) by the palace, holding a special status in the empire's social hierarchy. The restrictions on the enslavement of Muslims and "People of the Book" (Jews and Christians) who were subjects of the empire shifted the attention of slave traders toward the pagan areas of Africa. These societies, known as the Zanj in Arabic and Zenci (the Black Arab) in Ottoman Turkish, were an integral part of the slavery system that flourished following the empire's expansion across the North African and sub-Saharan territories in the sixteenth century.

Like its parallel American system, the structure of Ottoman slavery depended on the continuous importation of captives into the empire. Karagöz's famous *zenci* characters found their way to the urban centers of the empire through slave routes from Central Africa and Sudan via the Ethiopian plateau, Egypt, and the pilgrimage routes to and from Arabia (Toledano 1998, 8–9). It was not unusual to return to the capital from a pilgrimage with an African slave. *Zenci*s were employed in households, on plantations, and in the army as slave-soldiers. Some could ascend to high official rank, but in general were considered inferior to European and Caucasian slaves.

However, the more intriguing aspect of slavery evolved around the position of the male African slaves appointed as eunuchs to the Ottoman harem. As pointed out by Ehud Toledano (1984), eunuchs were an important part of harem slavery. Castration made them reliable servants of the

Ottoman court, where physical access to the ruler could wield great influence. Until the nineteenth century, the Ottoman harem in Istanbul was under their administration, providing them access to power. The eunuchs were responsible for supervising and guarding the women and maintaining contact between them and the outside "male world" (381). However, following the abolition of slavery at the beginning of the twentieth century, their position of servitude shifted from royal slaves to servants in the Ottoman household, making the *zenci* Arabs among the commoners in Ottoman social life.

In classical Karagöz shadow theater, much as in Shakespeare's *Othello*, where the eponymous character is described neither as an Arab nor a Black African but rather as a "Moor," a category that obfuscates these definitions, the *zenci* figure emerged as a distinct character through being the only personality who was both indigenous and an outsider to the *mahalle* (Faroqhi, McGowan, and Pamuk 1997, 597–98). In the capital, Black Arabs were visually familiar to residents, not in the sense of the familiarity felt toward an often encountered outsider but more as a distant neighbor.

In the plots, the Black Arab with all his or her geographical ambiguity appears in two gender significant roles: *lâla* (a eunuch or manservant),[9] and *dadı* (female servant usually responsible for caring a child).[10] On rare occasions, Black Arabs are identified with musicians such as the *kabakcı* (gourd player) or *tefci* (tambourine player). Their actions in the plays are of minor significance.[11] However, that does not change the fact that

9. See Kudret's (2005) Karagöz for the plays *Balık* (The Fish), 191–98; *Çeşme* (The Fountain), 334–37; and *Kanlı Nigar* (Bloody Nigar), 576–82, which includes the Arap Lâla.

10. See Kudret's (2005) Karagöz for the plays *Leyla ile Mecnun*, *Tahir ile Zühre*, and *Yazıcı*, which are the only three scripts with the female Arab character. The great majority of the slaves imported to the empire were African women, while the African men were smaller in number. The women would either be employed to do domestic work in the palace or in elite Ottoman households.

11. Kudret, "Şairlik-Aşıklık," in Karagöz (2005, 983–84). Kabakcı Arap is both a musician and a foolish poet. He plays his *kabak* (musical instrument), but he mixes up the lyrics to his songs almost all the time.

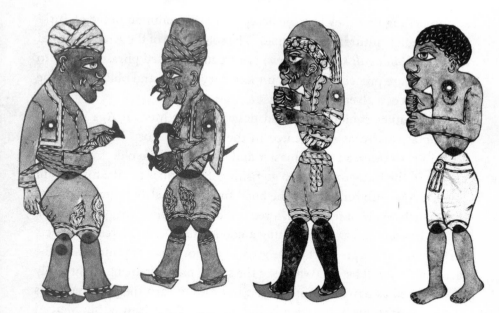

6. Black Arab slaves. With the permission of Yapı Kredi Museum Karagöz Collection.

these portrayals fixed the association of a certain set of physical attributes assigned to the Black Arab for the Ottoman audience.

Lâla—or, as he is commonly known, Mercan Ağa—is one of the most colorful characters on the Karagöz screen, not only because of the features of his character, but also for his centuries-old depiction with a touch of red as part of his pictorial presentation. The implication of the color red and its connection to the Black Arab is not clear, but we see traces of the color on almost every possible verbal and visual occasion: his fleshy lips; his flashy fez; his penchant for red attire; and his surname, *Mercan* (red coral).

The Ottoman Black Arab's special love for red must have been very noticeable in daily life, as it is so clearly featured in Karagöz plays. In one of the most popular, *Balık* (The Fish), the relations between the Black Arab's lack of instruction, perception, and learning and devotion to red are established. This constructed relation is embodied in the Mercan Ağa character and his dialogue with his master, Çelebi. These dialogues were

so compelling that they became accepted in the common usage of Turkish colloquial culture. For example, "The sole worry of the Arab is the red shoe" (*Arabın derdi kırmızı pabuç*) is a frequently used phrase to refer to those who are preoccupied with unnecessary details and oblivious to the seriousness of a given situation.

This rather symbolically bald description of Mercan Ağa is worth looking at closely, as represented in the play. The story is built around Çelebi's plan (Mercan Ağa's master and also one of the oldest characters known in the Karagöz plays) to go fishing. He decides to take his servant Mercan Ağa with him to row the boat. In return, Çelebi promises to buy the eunuch a pair of red shoes, a red fez, and red *şalvar* (baggy trousers). But he has one condition: catching a good haul of fish. Mercan Ağa gets very excited at the prospect of the gifts, and, more than anything, with the fact that they will be red. Watching the scene, his excitement might easily be perceived as naive, effeminate joy. In order to earn the gifts, he needs to row the boat slowly and silently and not scare the fish away. But Mercan Ağa, overwhelmed by happiness, cannot contain his enthusiasm, and so, each time a fish approaches the hook, he loudly repeats his master's promise in his funny accent. After the third fish flees, an empty-handed Çelebi gets annoyed and decides to head back home. Unaware of his master's displeasure with him, Mercan Ağa feels disappointed at not getting the shoes he had dreamed of earning.

In the colorful puppets of Karagöz, Mercan Ağa's joyful and showy character is embodied in a strong, manly physical figure. However, his soft, effeminate accent magnified in the plays' dialogues reveals at once his status as a eunuch, enhancing his social and even his sexual status as a male servant. With his funny, exaggerated pronunciation, idiocy, and waggish compassion, he contradicts the reality of the chief eunuch as one of the most powerful figures in the Ottoman court. I will be offering a more extended account of the chief eunuch's image in the following chapters, but, for now, I shall continue with Karagöz's warm-hearted Black Arab, who was the subject of the ridicule and laughter built around these contrasts and contradictions between fiction and reality.

Unlike the white Arab with his keffiyeh, Mercan Ağa is always depicted with the Ottoman traditional hat, *tarboosh*, fez, which he especially loved

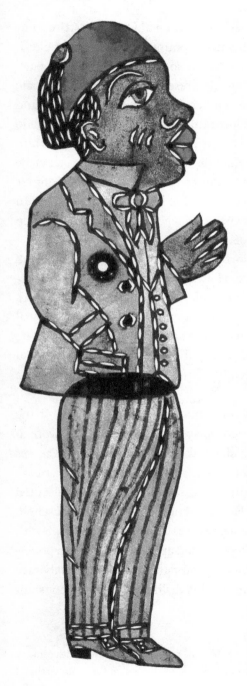

7. Lâla (Black Arab eunuch–male servant). With the permission of Yapı Kredi Museum Karagöz Collection.

wearing.[12] Presumably, his attachment to traditional Ottoman attire symbolizes his deeper connection to his host community and household; it demonstrates an effort to be accepted by the society of which he is a part. This is not unexpected, considering his presence in the most intimate spaces of the household, serving as eunuch and slave to concubines and officials in the harem together with low-ranking chambermaids (Tolenado 1993; Muhtar 1932). His loyal, trustworthy presence in the house gives him a sense of self-esteem and, on the Karagöz stage, an air of nouveau-riche importance. Mercan Ağa's status as a newcomer to economic freedom is subject to even greater scrutiny because of his lack of social prestige. In both plays he is described as an unwise character. He often gets beaten up or mocked by Karagöz (Kudret 2005, 192–212, 334–35).

Mercan Ağa represents the colorful character of the Black male Arab stereotype of the Ottoman *mahalle*. However, Karagöz plays have transformed sets of balance in presenting gender concepts (Ze'evi 2006, 141). They are biased in their designs, placing less emphasis on women's social position. The personified female characters are limited to Karagöz's wife and daughter, while the rest are generalized as unidentified Zenne. And when it comes to ethnically and racially distinctive female characters, the list gets even shorter.

The Arab *dadı*—or, as she is sometimes called, the *halayık* of the house—is singled out as the Karagöz plays' racially identified woman stereotype. In most plays in which she makes an appearance, she serves as a messenger between her *hanım* (female mistress) and the mistress's male companions. Within this defined role, she is perceived as a devoted and trusted servant of the house. Her affiliation with a noble household gives her a snobbish attitude that emerges especially in her dialogue with Karagöz. Somehow, she is always skeptical and approaches him as a potential liar, and she protects her mistress's good name by trying to sabotage any event that would involve Karagöz. This dislike turns into a constant

12. The fez is a type of headgear that only became popular in the nineteenth century and that, when it was first introduced, was opposed by the ulama on the grounds that it was an irreligious innovation.

struggle between the Arab *halayık* and Karagöz, which produces the humor of these plots.

With her unseemly arrogance and an accent similar to that of her male counterpart, the Arab *halayık* is presented as similar to her real-life version, with only a slight exaggeration, which rests in her mimicking her mistress in enjoying the privileges of a higher-class household. In her *tasvirs*, she is usually accessorized with a fan and parasol to partially cover her face, especially when talking to strangers, just like the noble women of the imperial household. It is she who maintains the moral equilibrium between Karagöz's deviousness and the household's reputation. This naturally emerging reaction in her character suggests that this might be the habit of such women in reality, since she is used to keeping her native cultural and social background and her current status in balance (Kudret 2005, 997–1037). For example, in the play *Yazıcı* (The Scribe), she is presented with the name "Zarafet," which means "elegance," causing the meaning of her name to contradict (in viewers' minds) her comparatively large figure, which was thought to demonstrate a certain level of clumsiness. Typical of Karagöz plays, her name signifies her social profile as the "wannabe" of the *mahalle*. She is, in a way, more perceptive and quick witted than the *lâla*. The fact that she is a trustworthy housekeeper who dispenses advice whenever needed produces in the audience a sense of sympathy and familiarity.

Much like the general characterization of the other female types in the plays, the female Black Arab is portrayed as relatively independent, enjoying a certain level of authority over her master. Compared to Mercan Ağa, the Arab *halayık* is more clever and conscientious. She is practical when it comes to solving problems and is not as easily deceived by Karagöz's pranks. Yet the one feature of her personality that she shares with her male counterpart is their mutual affection for shades of red.

Karagöz plays provide a resource for a prereading of the Arab as one of the featured non-national characters that will come to dominate modern Turkey's definition of self versus other in emerging nationalist discourse. Karagöz shadow theater was the metaphorical "kitchen" in which the most striking and lasting stereotypes of the Ottoman Empire—and, later, the Republic—were produced, along the lines of ethnic and racial boundaries.

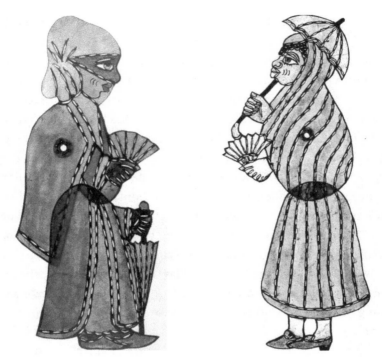

8. *Dadı* (Black Arab female servant). With the permission of Yapı Kredi Museum Karagöz Collection.

Examining the interrelations of the Karagöz plays contributes greatly to our understanding of any specific, contemporary instances of Arab stereotyping that was continually reproduced in the Ottoman colloquial culture. Therefore, this chapter scanned the Karagöz shadow theater where the public, in Dror Ze'evi's words, "presented itself to itself" (Ze'evi 2006, 125).

The representation of others in the sixteenth- and seventeenth-century Ottoman Empire was not merely characterized in power relations, as one would understand them in their colonial context; it was more so about being a loyal subject of the empire and being accepted as a subgroup by the imperial society. The staging of these characters correlated to form normative narratives of racial and ethnic otherness to essentialize or even orientalize the sociocultural structures within the multicultural empire. For

Ottoman society, with its limited public literacy, these staged scripts consolidated a relationship between performances and reality, the experience of which the stage purports to offer an image. Moreover, Karagöz shadow theater supplied this discourse of otherness through its full recital.

It is important to keep in mind that these texts produced in earlier centuries bore the imprint of those times while reflecting for a modern audience the complexities of a period marked by unprecedented change. We can safely assume that common images of Arabs did not remain static in the centuries following the conquest of Arabia, and that they probably changed, depending on the nature of local encounters.

As with many other Karagöz figures, the common characteristics associated with ethnic and religious features were portrayed and even caricatured on the curtain of the shadow theater. The white Arab, like many other strangers either living in or visiting the capital, represented a frequently encountered social stereotype that was at the same time recognized as different, thus creating a sense of "us" and "them." The archetype of Hacı Kandil, as the Arab subject of the empire, was widely imagined not only through his pictorial existence but also through the proverbs and idioms derived from these illustrated types, as represented and portrayed in the Karagöz scripts. Phrases like *Kırk Arabın aklı bir incir çekirdeğini doldurmaz* (The minds of forty Arabs are not enough to fill up one fig's core) or *Ne Şam'ın şekeri, ne Arabın yüzü* (Neither Damascus's candy, nor the Arab's face), or expressions such as *Medine dilencisi* (Medina's beggar—an idiom meaning a poorly dressed, down-at-the-heels person), or *maval okuma* (a reference to someone who lies to get out of an unpleasant situation) contributed to the construction of these stereotypes, which would stick in the Turkish cultural imagination.

2

Publishing and Censoring

Political Cartoon Press from Empire to Republic

> Engravings or lithographs act immediately upon the imagination
> of the people, like a book which is read with the speed of light;
> if it wounds modesty or public decency, the damage is rapid and
> irremediable.
>
> —French Interior Minister, François Regis de
> la Bourdonnaye, Compte de la Bretéche, 8
> September 1829

Caricature—or, in its more simplified sense, the cartoon—is one of the privileged genres for the dissemination of stereotypes because it elicits both suspension of disbelief and appreciative recognition on the part of an audience. The study of any group of political cartoons poses a set of intriguing questions about the relationships between text, image, artist, and publisher. Individual artistic contributions must be made in collaboration with a journal and observe the restrictions imposed by press laws. These technical and historical considerations emerge not as determining factors in the creation of art, but rather as essential circumstances that affect the process of conception and execution of images that, in our case, contribute to a sense of national and non-national character. Therefore, before pursuing further analysis of the Arab stereotype and its consolidation in the late Ottoman and early republican imagination, it is of the utmost importance to depict the editorial kitchen in which this entire production was made.

A political cartoon in a satirical journal is part of a larger system of communication containing a contextual relationship to the current events

represented sometimes as a text in the same journal or as articles in conventional newspapers. Its interpretation requires a closer examination not only in the context of associated events but also the related commentary on the political and social position of its artist, publisher, journalist, and editor. Determining the role of each within such a complex web of activity is hardly simple. This chapter examines this collective effort in which the Arab stereotype flourished, concentrating on the way images depended upon a particular context of production while at the same time their meanings arose from unconscious inspiration, vision, expression, and repression.

Ottoman Political Cartoons as a Discursive Field

The history of collaborations between the satirical press and political cartoons is a fairly recent one, compared with the history of literature. Political caricatures appeared in the media only after the invention of lithography, around 1800, in Germany, which made it possible for the first time to produce an extraordinarily large number of prints from a single drawing executed on a block of stone (Pennel 1915, 9). Roughly seventy years later, the art of lithography became a popular tool in the Ottoman daily press industry, muscling text with illustrations. This new technique sometimes helped publishers bypass the censorship policies of the state, and sometimes it brought on their wrath.

The strength of visual images in the cultural and communicative field derives from their intertextuality. Images project a synthesis of all instances and figures of speech that have accumulated into stereotypes by dint of repetition and mutual resemblance. For example, any case of national characterization is not primarily based on empirical reality, but on an accumulation of a convoluted set of related visual instances gathered over a longue durée. As a form of narration, political cartoons embody this repertoire in flesh and bone and provide readers with tools to serve their collective imagination.

The experience of viewing cartoons in a daily newspaper is structured temporally and cannot be looked at without considering the effects of serialization on the emergence of particular contexts focused on particular

social, political, or moral themes. For the nineteenth-century Ottoman reader, the case was the same. The prints appeared not only as individual images but also in relation to articles and other adjoining pictures as well as similar prints appearing at other times or in other venues. A satirical discourse, generated around the ideas proposed by the journal's editors, would evolve over weeks or months through this fashioned serialization. The cartoons contributed to, but did not monopolize, that discourse, which in turn became embedded in the meaning of the individual prints.

To elaborate further, an example would be a series of prints that appeared in the famous paper *Karagöz* satirizing Italy's imperial ambitions in North Africa in 1911. A short summary of the events surrounding the diplomatic aggression between two powers is necessary to demonstrate how the series in *Karagöz* unfolded while empowering a particular image or symbol for the collective memory of the receiving group.

For Italy, a precondition for the achievement of high-power status against its European rivals included completing its colonial expansion in Africa and the eastern Mediterranean. On 28 September 1911, Italy presented the Ottoman government with an ultimatum, demanding Ottoman consent to the occupation of Tripolitania on the pretext that Italian citizens there were being threatened by Muslim fanatics (Zürcher 1993, 105). Although the Ottoman province of Tripolitania (modern-day Libya) would have been economically and strategically insignificant at the time to a commoner in the capital, it held significance as the last remaining Ottoman territory in Africa that had not been occupied by other imperial powers. Thus, despite the Ottomans' offer to resolve the matter peacefully, Italy declared war the next day.

Holding Tripolitania was essential to the Ottoman government, not so much because of its underlying territorial value but because the loss of the province would seriously affect the credibility of the sultan's government in the eyes of its Arab subjects further east. Lacking sufficient military power to defend North Africa, the Ottoman officers within the government decided to carry out a guerilla war by galvanizing the Arab resistance, which had already begun under the leadership of the militant Sanusiya religious order. For an entire year, Bedouin troops led by these officers successfully harassed the Italians and prevented them from

making significant headway inland. The war lasted until the Ottomans agreed to conclude peace on 17 October 1912, leaving Tripolitania in Italian hands.

Both Ottoman political and military activities to contain Tripolitania provided the subject matter for many political cartoons through the year. From 13 September 1911 to 23 August 1912, *Karagöz* ran about one hundred issues, of which thirty-five contained cartoons about the Italian invasion of Tripolitania. In intervening issues of the journal, the reader saw prints about diverse political topics, from Italy's cunning deals with the other imperial powers to local Sanusiya tribesmen's acts of resistance with the support of Ottoman officers. Besides *Karagöz*, other satirical papers claimed the same subject, resulting in a much larger number of commentaries and cartoons. Thus, in a one-year period, these printed materials gradually established a satirical discourse about the Ottoman response to the Italian occupation of Tripolitania. Yet this discourse was embedded in a matrix of competition among forms of satires about other topics and was itself fractured by the various voices outside of *Karagöz*'s cartoonists. The heterogeneous and yet interdependent nature of these voices, which were bound thematically in a satirical discourse, created the necessary foundation for rhetorical discussion.

As in the above case, each voice that contributes to the political cartoon discourse is slightly altered or intensified by its relation to the surrounding perspectives, far and beyond the arena of the specific paper in which they appear. There can be no meaningful depiction of a personal fantasy, because satirical meanings derive from the relation of the imagery to some public issue. Cartoons themselves are a dialogized form of expression. Similar to an interpretation that interacts with its previous linguistic meanings, cartoons generate sense only concerning their preexisting subject.

Early Imperial Media and the Political Cartoon Press: A Brief Overview

Ottoman Muslims' historiography of the press was a latecomer compared to non-Muslim communities of the empire and the rest of Europe. In the 1480s, the sultan Bayezid II strongly opposed the introduction of the press

among the empire's Muslim subjects and released decrees opposing its practice (Göçek 1987, 112). According to Müge Göçek, the social disturbances generated by print technology in Europe, especially in religious matters, caused Beyazıt II's refusal to adopt the latest innovation due to its possible subversive effects on the public. Besides, the regeneration of holy texts and the Quran was only acceptable if they were calligraphed by a certain script (*hüsn-i hat*) preserved under professional guilds. The reproduction of these religious texts by the press was considered disrespectful and was controlled by the sultan's verdicts. For example, the sultan issued a law in 1485 (several decades after the appearance of Gütenberg's first book published in Germany, around 1439) banning the printing of all forms of script in Ottoman Turkish in order to maintain full control over any possible flows.

From Beyazıt II's verdict in the fifteenth century to Mahmut II's in the nineteenth, the presence of the print industry was intermittent. Only in the second half of the century did the Ottoman press make a significant leap forward, when the first Ottoman Turkish newspaper, *Takvim-i Vekâyi* (The Calendar of Events), appeared in November 1831 at the initiative of Mahmut II himself (Akçura 2012, 48).[1] The sultan's paper was followed by *Cerîde-i Havâdis* (Register of News) in 1840, published by an English resident of the empire, William Churchill. This newspaper, which was subsidized by the state, eventually turned into a semiofficial broadsheet. Until the publication of the first private daily in Ottoman Turkish in 1860, these two papers constituted the rather meager inventory of the Ottoman press.

In the western hemisphere, the introduction of illustrations to newspapers originated in the nineteenth century as Europe underwent the massive transformations of the industrial revolution. Changes in urban life brought with them a cultural shift. The spread of mass education meant the potential of mass readership. In such an atmosphere, visual media, and especially caricatures, thrived in a beneficial partnership with

1. The name of the first newspaper in Arabic script was given by Sultan Mahmut II himself. After its first year, the two different locations where the newspaper was prepared for print and actually printed were merged, and the name was changed to *Takvim-i Vekâyihâne-i Âmire*.

publishers and their audiences. As well as facilitating huge print runs from a single plate, lithography allowed graphic art to be situated alongside the text, thereby initiating a new epoch in conventional publishing. Publishers hoped to capitalize on lithography's attractiveness and popularity to increase revenues and circulation. At the same time, audiences shared a medium that expressed a joint stand on the issues of the day and questioned the hegemony of the state, undermining the legitimacy of authority by shaping public perceptions.

It was in 1829 that Charles Philipon presented the first illustrated satirical journal, *La Silhouette*, and distributed it on an industrial scale in the streets of Paris, Europe's cultural capital. *La Silhouette* was the prototype for the highly successful *Le Caricature* (1830) and, later, the daily *Le Charivari* (1832), which nurtured the most prominent caricaturists of the time, such as Grandville, Cham, Aubert, Gustave Doré, Emmanuel Poiré, and Honoré Daumier (Grove 2012, 97). Following these French successes, *Punch Magazine* (1841), established in London by Henry Mayhew and Ebenezer Landells, pursued a similar format but increased the volume of political cartoons in comparison to text. Over the course of the century, lithographic caricatures became an indispensable component of daily commentaries. As Laurence Grove (2012, 104) puts it, "Their capacity to grab attention immediately meant that the journals could not have survived on text alone."

The Ottomans entered the publication scene rather late. There was no significant daily press presence until the early 1830s. However, they were quick to identify the persuasive effects of lithographs, not only as a form of political protest but also as a social-engineering tool for modernization and Westernization. The influence of non-Muslim editors like Teodor Kasap, Agop Baronyan, and Zakariya Beykozluyan, who had broader access to European publications, was, of course, undeniable in facilitating this new medium among the rest of the capital's eager publishers (Çeviker 1991, 21–31).[2]

2. Non-Muslim minorities' long-standing dominance in the printing industry, due to their special status within the empire, gave them easier access to closely follow developments in Europe. Besides having their own print shops, non-Muslim communities of

The changing social life of the public throughout the Tanzimat period dominated both the literary and visual content of these new periodicals. Very similar to the Karagöz shadow plays, which poignantly satirized current social and political conditions, the illustrated satirical press also created a platform for daily critiques on diverse subjects, from gender relations to the economy, and, to a certain extent, the politics of the sultanate.

Ottoman publishing houses adopted the lithographic press soon after its introduction in Germany. The palace's official *Takvimhane-i Vekai* was the first to offer illustrated commentary, in 1831.[3] The adoption of this advanced technique by the imperial press announced a new age of newspapers in the empire. In the words of Benedict Anderson (2006, 35–36), these "one-day best-sellers" quickly became popular. The twin influences of literary and visual communication combined to shape an alternative Ottoman popular culture space under the rubric of political satire. As the imperial capital and center of political and social life, Istanbul became a source of inspiration for satirists and publishers alike.

From empire to republic, the evolution of Istanbul's satirical press can be parsed into four periods: the pre-Hamidian (1860–76), Hamidian (1876–1908), postrevolutionary (1908–18), and, finally, the republican one-party era (1918–50s). These periods are significant in terms of elucidating the dynamics of the satirical press with regard to political, economic, and social changes. These transformations provided vivid material for the reproduction of stereotypes within the changing political order.

The pre-Hamidian period stands as the era when the printing, publishing, and distribution culture of the periodicals developed and began to

the empire were supplied with foreign publications. For example, most of the religious books for Armenians, Greeks, Jews, or Arab Christians were printed in Europe. Rome and Paris especially played a significant role in this respect, sustaining a literary non-Muslim public in the Ottoman capital.

3. Following the imperial newspaper *Takvimhane-I Vekai*, the first private paper, *Ayine-i Vatan*, was published by Mehmet Akif in Matbaa-yı Amire in 1867. It held one of the first examples of picture illustrations as an integral part of the bulletin. The newspaper was closed the same year, after its tenth issue, due to financial problems.

circulate in the capital's literary crowds. However, at the time, lithography was still not a popular technique. Even the first known satirical journal of the non-Muslim Ottoman press was distant from the idea of lithography.

Following *Diyojen*, in October 1870, Ali Raşid and Filip Efendiler published a supplement to *Terakki* (Progress), which had been in distribution since 1868 (Topuz 2003, 30; Çeviker 1991, 21). The supplement was entirely dedicated to ridiculing the Ottoman public through visual and literary commentaries as the initial satirical newspaper (Topuz 2003, 30; Çeviker 1991, 21). At the beginning of its weekly publication as an add-on, *Terraki* was four pages long, just like its predecessor, *Diyojen*, and it featured literary satire only. However, a few months after its first appearance, its name was changed to *Terakki Eğlencesi* (Joy of Progress), and its editor added two more pages, reserving one full page for political cartoons.

Terakki targeted a broader public than its opponents, including both middle and upper middle classes consisting of various social and ethnic groups reflecting the viewpoints of an emerging critical block. The illustration of the journal's assorted spectators from different ethnic, religious, and age groups, as part of its emblem underlined the journal's diversity while affirming the homogeneity of modernity by the fact that they were all reading the same journal. This also reflected the journal's commercial positioning within the wider audience.

Nearly a decade later, in the early 1880s, the satirical press strengthened its position as a political force under Abdülhamid II rule but against his despotism. The press quickly became the medium for opinion-making, political indoctrination, and the dissemination of news. The strength of this medium created concern in the upper echelons of the palace, and the satirical bite was soon dulled by the adoption of strict censorship regulations (Karpat 2001, 195–97). Indeed, during the reign of Abdülhamid II, newspapers became little more than official organs of the state, devoted to creating a counterposition as the sultan's image-builders. In this regard, the illustrated satirical gazettes had to find their way around state censorship to convey their anti-government critiques. *Terakki* and *Diyojen* had already been forced to close in 1874. Once Abdülhamid II's reign started to solidify its iron rule with new regulations governing the

newspaper press, many artists and intellectuals critical of the palace were forced to flee the empire or risk being exiled. Among others, the satirical publications were perceived as no less than a potential threat to the sultan's image.

The publishing history of the illustrated satirical press at the end of the nineteenth century did not follow a linear path. Due to the challenges imposed by state censorship, it did not achieve a sustainable form of survival until the middle of the twentieth century. The constitutional revolution of 1908, which ended Abdülhamid II's thirty-year despotism, temporarily put an end to the repression of the press, opening room for an expansion in print media. Artists and publishers embraced the constitutional revolution and the resulting production boom. Cartoonists were finally free to use their art to support constitutionalism and freedom against the old regime's tyranny, constantly comparing one with the other. In that sense, the 1908 Revolution unlocked the door to a new era for Ottoman illustrated satire both artistically and contextually (Öngören 1983, 75–78).

The Postrevolutionary Satirical Press: 1908–1918

Political cartoons tend to make contemporary issues visible through the critique of authority. However, the revolutionary cartoon press of 1908 evolved mainly around the critique of the old Hamidian regime—namely, the elite, the sultan Abdülhamid II, and the palace's power brokers, rather than the new government, political parties, parliament, and new Europeanized bourgeoisie (Brummett 2000, 133). Thus, in the empire's struggle for survival, satire shaped the field of politics through two means: first, by giving voice to the overwhelming majority of people disenfranchised by the old regime and by claiming the right of the people to use ridicule to redefine themselves as active citizens; and, second (and more important), by playing a vital role in spreading news of current political debates and educating the public on ideas about advancement, civilization, and liberty.

During the second constitutional era (1908–20), Ottoman satire in general, and political cartoon production in particular, were shaped

around these two ideological approaches while employing both modern and traditional techniques. This outburst of freedom also generated the first groups of republican cartoonists to employ new artistic formulations imported from the West (Çeviker 1991, 20–39).

Abdülhamid II's despotism repressed both content and production in the print industry. The regime shut down most of the satirical press, whose publishers and artists, as part of the intellectual opposition, sought refuge in Europe. Disconnected from their fellow countrymen and facing financial challenges in exile, the oppositional press could hardly be called lively during the last decade of the nineteenth century. However, it would be wrong to say that those years were a total loss for the key figures of the Ottoman revolutionary press.

If we look back at this history, we can recognize this awkward stage as a transformational period for these artists, whose acquaintance with European colleagues familiarized them with the styles and techniques of symbolically expressing the fundamental values of Western liberalism. During the postconstitutional era, this new line introduced an alternative style to the existing traditional descriptive caricature (*Geleneksel tasvirci karikatür*), which Turgut Çeviker (1991, 17–39) categorizes as Westernized modern caricature (*Batılı modern karikatür*). However, to avoid the old modernization narrative with its usual reifications, I instead call these categories "contemporary" and "classical" (figs. 9–10).

The contemporary satirical publications were presented to the Ottoman public by prominent cartoonists such as Cemil Cem, Sedat Nuri Ileri, and Damat Ferit Bey, who published alternately in Salah Cimcoz and Celal Esat (Arseven)'s *Kalem* (1908–11), followed by Hasan Vasaf's *Davul* (1908–9), and Cemil Cem's *Djem* (1910–12), all published bilingually in French and Ottoman Turkish. Besides the Turkish artists, *Kalem* and *Djem* also presented the work of European cartoonists, including Ion, A. Scarcelli, A. Rigopulos, L. Andres, N. Fléchs, and Pahatrekas (Çeviker 1991, 101–8).

Kalem was the most noteworthy among the contemporary satire journals, followed by *Djem* (fig. 9). Some idea of their impact can be gleaned from Halit Ziya Uşaklıgil's description of *Kalem* as "the gift of Thursday mornings" that provided the best kind of humor for its readers (Uşaklıgil

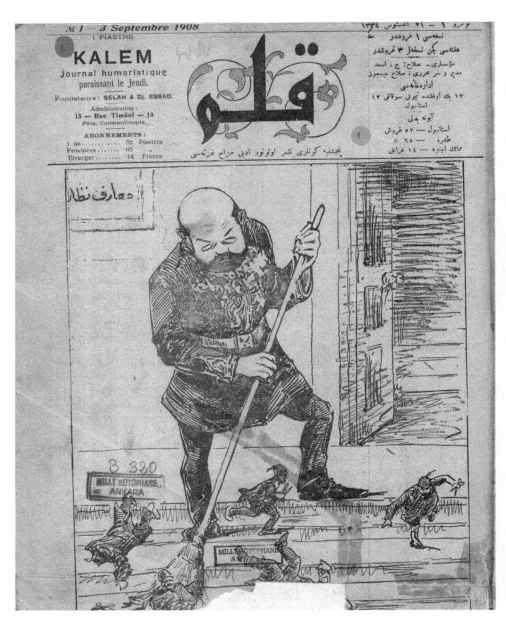

9. The cover of *Kalem*, 3 September 1908.

10. The cover of *Karagöz*, 10 September 1908.

1908).[4] *Kalem* was sixteen pages long and published bilingually every week. The first and last page printed cartoons with subtitles in both Ottoman Turkish and French. The following ten pages would contain political essays by one of the editors, as well as reporting and commentaries on weekly events. Only four pages would be reserved for reviews and articles published in French.

Djem, on the other hand, would come out weekly in twenty-two pages divided evenly into Ottoman and French. The journal would have two illustrated covers, on the front and the back, one in Ottoman and the other in French. The second page for each side would contain political cartoons. The interior pages would be evenly distributed between political essays, commentaries, and advertisements, again in both Ottoman Turkish and French.

Forerunners of the contemporary cartoon sphere showed significant artistic flair in using "modern" lines that were much less ornate than those of nineteenth-century cartoons and more persuasive and refined in their critiques of political and social issues. For Ottoman cartoonists, the formation was shaped around their longtime exposure to Western art, strengthened by teaching Western-style design and technique at the Sanayi-i Nefise (Fine Arts) Academy.[5]

The Western artistic tradition positioned the subject in a perspectival view so that readers would feel as if they were looking through or beyond the object (Shaw 2007). This feeling of depth within simplicity can easily be distinguished in the drawings of the modernist cartoonists, who tended to focus on human figures whose total forms were distorted and obscured while including minimum details of their surroundings.

Cemil Cem was one of the leading names in this genre. A lawyer by training, he spent the early years of his career in France as an official in

4. Halit Ziya was one of the most prominent intellectuals of the time. His writings were published in various newspapers. This paragraph, which I have translated, is from his column in *Sabah* newspaper, published on 19 September 1908, under the title "Mizahta Hikmet" (Philosophy in Satire).

5. The Sanayi-i Nefise (Imperial Academy of Fine Arts), Istanbul's first art school, was opened in 1883 by Abdul Hamid II. Osman Hamdi Bey was appointed president of the academy.

foreign affairs. During his stay in Paris, Cem's pursuit of a diplomatic career led him to attend lectures at the School of Political Science. While in France, drawing was little more than a hobby for him. Yet he began sending his cartoons to *Kalem*, which was published in Istanbul in 1908.

Upon his return to Istanbul in 1910, he took a steep turn in his career and started publishing the famous humor magazine *Djem* that same year. He drew portrait caricatures, in which he skillfully reflected the most prominent aspects of the personality and appearances of the statesmen. His exhibition of his subjects carried an understanding that conveys humor through writing. He criticized the statesmen and the administration without hesitation. He later influenced many cartoonists both with his realism and the subtle sense of humor in his captions (Çapanoğlu 1970, 31–33).

As is also the case with Cem's *Djem*, in the best cartoons, the meaning embedded in the images transcends the related circumstantial details and carries multiple levels of meaning. Both cartoons published in *Kalem* (released on 18 May 1911, and later in *Djem* on 16 December 1910) by A. Rigopulos and N. Fléchs are good examples of such techniques.[6] They dispense with lengthy, detailed captions to convey the intended messages; instead, the targeted subject is referred to either within the lines of dialogue or in a simple sentence, and sometimes a single word. The effectiveness of the cartoon depends on the reader's comprehension and participation as much as it does on the cartoonist's creativity and talent. The reader must extract the message, which requires knowledge of its political context. Such work, however, sophisticated in both style and meaning, limits the audience to the social and cultural elite.

On the contrary, followers of the classical line (*gelenekci-tasvirci*) were not so integrated into the new artistic currents. Still, as political cartoonists, they were just as effective in transmitting the revolution's spirit, both for criticizing the old and honoring the new regime (fig. 10). Artistically, they positioned themselves as disciples of the traditional line of the Tanzimat period led by political humorists as in Theodor Kasap's *Diyojen* (1870)

6. In both cartoons, the cartoonists illustrated various critiques of İbrahim Hakkı Pasha, who served as the empire's grand vizier from January 1910 to September 1911.

and *Hayal* (1873). The most prominent names of this school following the 1908 constitutional revolution were probably Halit Naci, the chief cartoonist of Sedat Simavi and Ali Fuat's satirical newspaper *Karagöz* (1908–50) and Mehmet Rauf's *Hayal-i Cedid* (1910), followed by Mehmet Baha and Münir Osman, all of whom alternated between the two journals.

Their work combined the old-style descriptive technique with extensive use of symbolism and text. According to Turgut Çeviker (1991), classical cartoonists had limited knowledge of Western culture compared to their contemporary counterparts.[7] Their exposure was limited to local sources and illegally smuggled European publications. After the revolution, they aimed to produce cartoons not only for the intellectual elite but also for the broader public to boost awareness of current political and social events. In their visual rhetoric, they relied to a high degree on unspoken premises, which invited the reader to respond from within their traditional values and beliefs.

These developments in the political cartoon domain defined a new relationship to Europe, creating a bifurcation in the artistic and contextual discourse between the existing forms and the new approaches. In this sense, the classicalists did not make a significant contribution to the artistic development of modern Turkish cartooning (Çeviker 1991, 20–39). However, their art enjoyed populist success because they knew how to manipulate the beliefs and values of their readers, thereby successfully managing to serve as the voice of the majority.

In this regard, Ahmet Fuat's *Karagöz* was the most influential and longest-lasting satirical newspaper. *Karagöz* played a vital role in communicating political debates and shaping the public's imagination. In doing so, it carried the old shadow theater's famous penchant for criticism and its fictional characters into the realm of satire and led the way for fellow journals

7. As Çeviker notes, we have few resources on the lives of the period's cartoonists, but one exception is Halit Naci. Various sources remark that he was a military officer and, later, a student at the Sanayi-i Nefise. We do not know much about Mehmet Baha besides his military background and his talent in imagining and depicting people's daily lives. Çeviker managed to collect the extremely limited information on Münir Osman from various newspaper articles of the time, but little is known about his personal background.

that would mimic its style. *Hayal-i Cedid, Baba Himmet,* and *Yeni Geveze* are among the successors that adopted the characters of Karagöz plays as their protagonists, but none survived as long as the satire paper *Karagöz*.[8]

Karagöz's success and continuous publication for almost half a century are noteworthy. The paper managed to deliver political and cultural critiques throughout a traumatic period of war and change, amalgamating traditional and imported symbols to become the voice of the everyman. Its well-established distribution was limited to Istanbul, like the rest of the empire's print media. It addressed the middle-class readership and claimed an unbiased (or, to be more precise, uncritical) account of current affairs, sometimes applauding and sometimes criticizing the government.

The journal was published in four pages, with the cartoons always on the first and last pages. Occasionally there would be a third cartoon, similar in format, on the inner two pages that contained mainly essays and commentaries. While the format gave readers the same sense of the puppet show curtain's visual parade, the *muhavveres* (dialogues) between Karagöz and Hacıvat appeared in form of the textual commentaries. With its arrangement, coverage, and language, *Karagöz* managed to keep its readers' interest for over two decades, throughout the most turbulent years of the empire and, later, of the nascent republic.[9]

Early Republican Satirical Press: 1918–1950

The war years were disastrous for the Ottoman Empire. The loss of territory was enormous, and the human loss was even more painful, with Ottoman Muslim casualties only one part of the story. The space for satire

8. Among the successors of Karagöz (1908–50), Çeviker includes *Nekregû* (1908); *Zuhurî* (1908); *Tasvir-i Hayal* (1908), whose title refers to shadow theater; *Hacıvat* (1908), named after one of the main characters in Karagöz shadow theater; *İbiş* (1908); *Nekregû ve Pişekâr* (1909); *Eşref* (1909); *Hayal-i Cedid* (1910); *Yeni Geveze* (1910–12); *Cadaloz* (Old Nag, 1911); *Baba Himmet,* named after a famous folk figure (1911); and *Köylü* (Villager, (1913).

9. *Karagöz* published a total of 2,803 issues between 10 August 1908 and 26 January 1935. The publication restarted on 14 February 1935, resumed with its original numbering, and lasted until its closure in 1950.

was devastated as well. Most of the journals closed, leaving *Karagöz* as the sole survivor. This latency period in the cartoon industry ended with the publishing of *Diken* (as the successor to the long-closed *Djem* and *Kalem*) in 1918, saving *Karagöz* from its loneliness. *Diken* followed a style partly similar to that of Karagöz, and partly to a contemporary line of art. The reason for the hybridity was not because of the paper's publishing strategy, but because of the limited number of cartoonists, who often had to work for more than one journal, compromising their artistic techniques in the process (Karay 1940, 12).

The entrance of *Diken* into the political cartoon industry reintroduced a platform for contemporary cartoonists after a short pause, securing the continuity of their artistic approach. Hence, in the complex transition to a nation-state, the two main currents of political satire preserved their artistic spheres. *Karagöz* continued its populist, traditionalist, and largely pro-government rhetoric until the early 1950s with almost the same group of cartoonists, whereas the line that connected first *Djem* to *Diken*, and to *Güleryüz*, later to *Aydede*, and, finally, to *Akbaba* followed a more hybrid trajectory.

Nevertheless, except for *Karagöz*, the designs and themes of all of the satirical magazines published during the republican period were similar.[10] If not for their titles, it would be difficult to distinguish them by their covers. They concerned themselves more with political and social motivation than with artistic quality, leaving the reader with somewhat lowbrow humor.

The body of each magazine was based around three main types of content: short articles, poems, and black-cut illustrations—small prints that accompanied puns either in the text or underneath. *Karagöz*, unlike the others, used a particular accent, a kind of text-over, using old Karagöz and Hacıvat as voices of the Ottoman (and later Turkish) public, and as detached watchers of the development of history, hoping that the government in Ankara would fulfill the promises of an imagined nation.

10. From the 1918s to 1930s, around twenty-two satirical journals were published. The most prominent were *Karagöz* (1908–50), *Diken* (1918–19), *Güleryüz* (1921–23), *Aydede* (1922), *Âyine* (1921–23), *Akbaba* (1922–77), *Zümrüdüanka* (1923–25), *Kelebek* (1923–24), and *Karikatür* (1936–48).

After 1935, *Karagöz* changed its publication to once a week. Style-wise, it abandoned the descriptive illustrated form of commentary that had dominated its content for decades, but remained loyal to its original roster of cartoonists, led by Halit Naci, Mehmet Baha, and Ratip Tahir. Starting in the early 1920s, it embraced a more substantive style in its political cartoons that would help the journal to maintain its reputation as one of the most recognized satirical periodicals not only during the Otto-man Empire but also under the republic.[11]

This did not mean that *Karagöz* was free from competition, or that it dominated the political cartoon discourse. Against the strong position of *Karagöz*, as the representative of tradition, Refik Halit's *Aydede* (The Man in the Moon) made its appearance on 22 January 1922. *Aydede* positioned itself against *Karagöz* both stylistically and politically. Although its life as *Aydede* lasted only for a year, amid the economic challenges of the War of Independence, prior to its closure it managed to publish ninety issues.

What separated *Aydede* from its contemporaries was its unique design. *Aydede* is considered the last complementary link in the chain from *Djem* and *Kalem*. All of the satirical journals that were published later in the republican period, except *Karagöz*, followed its stylistic and thematic path (Çeviker 1991, 176–78). *Aydede* featured a prominent roster of satirists and cartoonists who would form the building blocks of early republican cartoon production. Its artistic contributors were primarily educated or trained in Europe and carried over Western techniques in producing their own textual and illustrated satire.[12]

11. In a shift from earlier policy, following the War of Independence, the cartoons of these artists were published unsigned. Turgut Çeviker believes that the unsigned car-toons between 1918 and 1923 were mainly the work of Mehmet Baha (1991, 140–41). After the magazine's original owner, Ali Fuat Bey stepped down, the journal was owned and run by various other prominent intellectuals of the time such as Burhan Cahid, (1927–30), Orhan Seyfi Orhon (1928–32), and Sedat Simavi (1932–35).

12. The list of contributors includes eminent intellectuals such as Yusuf Ziya Ortaç, Orhan Seyfi Orhon, and Reşat Nuri Güntekin, and cartoonists such as Ahmet Rıfkı, Ahmet Münif Fehim, Ramiz Gökçe, Ratip Tahir Burak, Hasan Fahrettin, and Cemil Cem.

During the War of Independence, unlike *Karagöz, Aydede*'s political loyalty was to the government in Istanbul. From the beginning, Refik Halit stood in opposition to the government in Ankara, while Sedat Simavi's *Güleryüz* remained its main competitor with *Karagöz* in supporting Mustafa Kemal and his brothers in arms. With the backing of the Istanbul government, *Aydede* had the financial means to maintain a large staff of writers and cartoonists to conduct its propaganda against Ankara. The team included Yusuf Ziya Ortaç as editorial adviser and Ahmet Rıfkı, Münif Fehmi, and Ramiz Gökçe as its topmost cartoonists (Apaydın 2007).

Aydede's promising adventure was short lived. When the government in Istanbul collapsed in 1922, it did, too. Refik Halit, along with Ahmet Rıfkı and Münif Fehmi, fled the country; the latter found refuge in Beirut, while others escaped to San Remo, Italy. Their names appeared on a list of 150 personae non gratae in Turkey, also known as the *yüzellilikler* (the hundred and fifty).

Nevertheless, almost overnight, *Aydede* restructured its entire operation under a new name, *Akbaba* (Vulture), with Yusuf Ziya Ortaç as its new publisher and editor. *Akbaba* had the exact same structure and format as *Aydede*, but this time professed loyalty to the newly established Turkish government in Ankara. No doubt the cartoonists of *Aydede* did not change their political views from one night to the next as they started illustrating for *Akbaba*; however, their pragmatic maneuver likely shows that they were quick to accept the new reality.[13] With its talent roster inherited from *Aydede, Akbaba* continued its publication consecutively for fifty-five years from its first issue. Ramiz Gökce endured as the magazine's leading political cartoonist, contributing to the building of visual discourse around the dazzling political circumstances of early republican Turkey (Çeviker 1991a, 185–92).

13. In 1918–23, twenty-one satirical journals were published. Most of these lasted no more than a few issues. In the early Republican period, from 1923 to 1939, this number shrank to less than ten magazines; *Akbaba* and, later, in 1936, *Karikatür* led the market. Another line of journals including *Zümrüdü Anka* (1923), *Kelebek* (1923), *Papağan* (1924), *Guguk* (1924), and *Cem* (1927) tried to survive the competition. All of these journals were published in Istanbul (Öngören 1983, 89–95).

Until 1936, *Akbaba* remained the only satirical journal alongside *Karagöz*. The latter, after the demise of its leading cartoonists, Halit Naci in 1927 and Mehmet Baha in 1928, gradually lost its influence. Although Sedat Simavi bought the rights to the magazine, he could not prevent its closure, and in 1936 he launched another satirical journal, *Karikatür*, which largely adopted the same format as *Akbaba* while completely abandoning the traditional style of *Karagöz*. *Karikatür* continued to be distributed until 1948, once a week, alongside *Akbaba*, even sharing the same cartoonist, Ramiz Gökçe, as its primary political illustrator. However, both magazines lacked critical commentary as the real essence of their satire/humor because they operated in a period when such criticism was widely seen as an impediment to national interests (Öngören 1983, 89–95).

Political Cartoonists and Their Audience

Communication is, in essence, an act of conveying meanings from one party or group to another through the use of mutually understood signs, symbols, and semiotic rules. Among other forms of communication, political cartoons exchange information through visual rhetoric. The cartoonists and the readers are the two ends of this communication line. Here, the cartoonist's goal is to influence or manipulate as many clients as possible.

In the case of Ottoman political cartoon production, this relationship was established between the cartoonists as part of the intelligentsia in particular, and the capital's public in general, bypassing the degrees of cultural refinement or literacy among the targeted audience. Most certainly the power of mockery through visualization is difficult to suppress. Victor Alba's quotation of the infamous Boss Tweed's public statement after being needled by the celebrated American cartoonist Thomas Nast best explains the impact political cartoons may have on a larger public, crosscutting social classes: "Even if his supporters could not read, they could all look at damn pictures."[14]

14. William Magear Tweed, widely known as "Boss" Tweed, was an American politician most notable for being the "boss" of Tammany Hall, the Democratic Party's political machine, which played a major role in the politics of nineteenth-century New York City

Does this mean that level of education is directly related to the popularity of political cartoon magazines? For the period before the inclusion of satire by newspapers, historians had already emphasized the importance of any particular piece of graphic art based on the number of adaptations and editions they went through. It is difficult to directly connect this fact to the level of education in a given society, and it is very hard to know how many people looked at the political cartoons included in the package deal of a newspaper. But, undoubtedly, the pictures relieved the monotony of the text while providing additional information and opinions. And, much like modern-day advertising, they aimed at retaining existing loyalties rather than gaining new ones.

On the other hand, understanding cartoonists as the product of an intelligentsia in the service of their audience (as in the case of the Ottomans) requires a general overview of the social and cultural spaces that worked as a cradle for the intellectual development of their members. This synopsis also sheds light on why the publishing and distribution of periodicals were limited to large urban centers, especially the capitals.

In the case of the Ottoman Empire, the structural reforms that were undertaken throughout the "long nineteenth century" contributed to state centralization, exhibiting a radical deviation from the earlier Ottoman instinct of reinforcing traditional institutions, as was the practice in initial reform efforts (Fortna 2002; Somel 2001; Shaw and Shaw 2002, 55). The reformers intended to extend the scope of reforms into all aspects of life, including education, economy, and citizenship. Among others, the effects of educational reform had a significant impact on printing and publishing by providing the necessary audience for an expanded press and contributing to the growth of a reading public. These multifaceted transformations of the nineteenth century contributed to the emergence of a new middle class that gained access to Western ideologies and literature as a substitute for traditional Ottoman teachings that was standardized strictly in terms

and State. Thomas Nast, on the other hand, was a German-born American caricaturist and editorial cartoonist often considered to be the "Father of the American Cartoon." He was a critic of Democratic Representative Tweed and the Tammany Hall Democratic Party political machine (Coupe 1969, 83–84).

of curriculum, with a predictable emphasis on religious sciences such as *tafsir* (scriptural exegesis), *kalam* (theology), and *fiqh* (law).

At the turn of the century, however, much more energy was expended in establishing a uniform, empire-wide system of schools and maintaining it from the imperial center in Istanbul. One thing that facilitated this process was the introduction of a European education system where teachings in French, in particular, attained a privileged status. French was considered a semiofficial language and "one of communication between the educated speakers of different linguistic communities" (Strauss 2003, 40–44). The sultanate viewed the teaching of French as an essential means for attaining a "civilized" empire. By his account, the Ottoman Empire proved itself to be an "educator state" through following a highly systematic education or even an "indoctrination" program for molding a generation that would be loyal to the values of the center. This was a strategy, as defined by Eric Hobsbawm, to create "a captive audience available for indoctrination in the education system" within a "citizen mobilizing and citizen influencing state" (in Deringil 2011, 93–94).

As Selim Deringil (2011, 93–94) elaborates, mass education played a highly important role in the Hamidian era as part of a mission of civilization. To pose the challenge as raised by its Western opponents, in this sense, the Hamidian education system adopted the road taken by its ideological enemy, the French Revolution, and believed that teaching the people French was an important way of civilizing them.

From the perspective of Stanford J. Shaw and Ezel Kural Shaw (2002, 106), the new education system was designed to include the teaching of Western languages, especially French, as well as the humanities and social sciences, as a form of "liberation for the hearts and minds from the restrictions imposed by the old order." During this period of intense educational reform that aimed to regain the competitive strength of the state, the schooling system expanded rapidly, while keeping the traditional Muslim schools as an alternative.

Between 1867 and 1895, the number of state schools more than doubled. Primary schooling became compulsory in Istanbul, middle and high schools were improved, and schools for girls were founded. Linguists worked to clarify, systematize, and "liberate" the vocabulary and

grammar of the Ottoman Turkish language from its Arabic and Farsi origins (Shaw and Shaw 2002, 112–13).[15] The new primary education system achieved partial success in reaching its goals. Higher education institutions, such as military, engineering, and medical schools, were included and promoted through the establishment of universities. The formation of higher education facilitated the configuration of an audience profile that was eager to read in foreign languages, study abroad, follow developments in Europe, and, more importantly, have access to different ideas (Berkes 1999, 173–88).[16]

The outburst of printed political satire at the beginning of the twentieth century should be understood against this backdrop of an incubation stage during the Hamidian era. The hub of this spike in political cartoons was the imperial capital, Istanbul. Alan Duben and Cem Behar (2002, 25–26) argue that "Istanbul was the major political, administrative, economic, and cultural center of the Empire." It was also the focal point for the processes of development, functioning as a microcosm of the Ottoman Empire in general. The imperial capital's capacity in state-of-the-art printing press and techniques capable of producing political cartoons on paper made it even more attractive for the intelligentsia, who wanted to convey their political, social, and cultural critique of emerging political developments.

The abolition of the Meclis-i Mebusan (Ottoman Parliament) in 1877 was the opening shot in Abdülhamid II's increasingly autocratic rule. Most of the intellectuals who advocated readopting the constitution and reopening parliament were either banished from or fled the empire, mainly to Western urban centers like Paris, London, and Geneva, and, after the British occupation, to Cairo. These liberal intellectuals who gradually came together in a loosely formed coalition throughout Europe were none other than the "Young Turks" who would be the forerunners of the 1908 constitutional revolution.

15. During the Tanzimat period, the number of schools in secular education rose significantly, covering 90 percent of school-age boys, and over one-third of school-age girls.

16. The opening of Dar-ul-funûn (the first modern university) was agreed upon during the reign of Abdul Aziz in 1845, and the first class was taught in 1863.

The members of the Young Turk movement had different backgrounds and expressed their opposition in different ways. Most were educated at the imperial Lycée de Galata Saray, the Imperial War Academy, the Civil Service Academy, or the Army Medical School, all with excellent command of French as their primary foreign language (Shaw and Shaw 2002, 255–56). Carrying on their activities outside the empire, these liberal intellectuals were strongly opinionated and had been influenced by a mixture of secularist, Westernized, and anti-imperialistic ideas. They also had in common a disdain for Abdülhamid II's pan-Islamic policies.

It would be appropriate to say that intellectuals of the postrevolutionary period had their roots in one of three main official institutions: the military, the ulema (religious scholars), and the bureaucracy. The educational opportunities of the Ottoman modernization reforms resulted in the emergence of middle-class intellectuals ("the enlightened," or *münevver*) who rejected the indiscriminate borrowing of European institutions. Instead, they advocated a profound change based on a real understanding of Western values and beliefs (Zürcher 2010, 68). This was a generation that was able to obtain a mostly secular education and that eventually formed a class of modern professionals from which many early Ottoman intellectuals were recruited (Özdalga 2013). For many of these new professionals, the press was the primary medium of opposition, and, for those who engaged with political cartooning as a hobby, it offered a great venue.

Kalem's publisher, Selah Cimcoz (1887–1950), for example, came from a politically active family, and his grandfather had served as vizier in the Ottoman court. He studied law before entering politics, and, following the 1908 Revolution, he served in the Committee of Union and Progress, most of the time as part of the opposition to its censorship policies. During the capital's occupation, he served in parliament as a representative from Istanbul. From 1918 to 1923, he was a political prisoner under the British in Malta. After the republic, his political life continued with his former position, this time in the Turkish parliament, serving for four administrative periods.

Cemil Cem (1882–1950), the chief political cartoonist of *Kalem* and, later, *Djem*, was in Europe throughout the War of Independence. After the emergence of the new state, he came back to Istanbul and served for a

period as president of the School of Fine Arts. He retired to reopen *Djem* in 1927, but, because he had criticized some members of the government, his paper was closed in 1928. He was prosecuted and sentenced to a year in prison.

Ali Fuat Bey (?–1919), the publisher and political cartoonist of *Karagöz*, fled the country to join the Young Turk movement in Europe during Abdülhamid II's period of despotism. Throughout his exile in London, he published a paper called *Abdülhamid II* that severely criticized the sultan's policies. He came back to the capital following the 1908 Revolution, at which time he initiated the famous *Karagöz*. Former military officers Halit Naci (1875–1927) and Mehmet Baha (?–1928) became part of Ali Fuat's *Karagöz* as its key political cartoonists.

It goes without saying that, as part of a Muslim-dominated professional middle class that was dependent on the state for its social status, material existence, and moral strength, these intellectuals would become advocates for the nation during the demise of the empire. This time, however, the publishers and political cartoonists would use their full powers in order to build a nation-state that relied on modern secular norms. In the republican period, there was almost complete cooperation between the state and satirical press. Exceptions would be eliminated rapidly, without making much of a fuss, like the shuttering of *Djem* in 1928.

A Brief History of Censorship from Empire to Republic

Laughter proved itself to be one of the most powerful vehicles in demonstrating the superiority of a discontented population. And what could be a more suitable means for that task, among genres, than political cartoons? In almost all times, whether under the harsh regimes of sultanates or other political regimes, political cartoons appear as a powerful armory against the government's suppression and control, which can hang like the sword of Damocles over the heads of publishers.

Unlike the general concept of censorship as a ban on publication, its broadest definition refers to inspection and examination in order to enforce restrictions aimed at the control of newspapers and books, allowing only articles that are in line with the government's policies. Other

forms of censorship can be seen in government inspection of, for example, plays before they are performed or of letters and telegrams before they are mailed. In other words, censorship is a watchdog of which artists must be constantly wary. One learns to avoid sensitive matters; one develops a way to second-guess the subjective fine line between lampoons and defamation—the link where satire can easily cross into treason.

In the Ottoman Empire, censorship of the satirical press spanned decades of fluctuating climates, and most production took place under a dark cloud. After newspapers first began publishing in the 1860s, a period of tolerance gave way to increasing repression toward under Abdülhamid II's rule. With the increasing number of vernacular newspapers, the Matbuaat Müdürlüğü (Administration of Press Affairs) was established in 1862. The main task of this new institution was to keep closer tabs on the two privately owned newspapers *Tercümân-ı Ahvâl* and *Tasvîr-i Efkâr*, which emerged as the leading critics of the palace. In 1864, a new press regulation increased the power of the ministry by adopting the 1852 press law of Louis Napoléon Bonaparte of France. Prefects throughout the country were given authority to suppress unfavorable comments and silence all political critique by seizing the offices of leading newspapers. An additional government decree was issued on 17 April 1876 to include smuggled publications. A certificate of approval became mandatory for every book and paper, requiring also the checking and examination of all releases coming from abroad.

This ingeniously punitive era of government censorship paused with the declaration of the constitutional monarchy in December 1876. The period known as the first constitutional era of the Ottoman Empire was the period from the promulgation of the Kanun-i Esasi (Basic Law), on 23 December 1876, to its suspension by Abdülhamid II on 14 February 1878. However, the short-lived constitutional law had allowed a certain level of press freedom in 1877, when the law was amended by the government to enable the state to completely shut down newspapers that engaged in satire. Lawyers representing prominent caricaturists of the period condemned the officials who had described satire as buffoonery and approved its prohibition. For example, in his defense of the satirical papers, Manok Efendi, one of the lawyers of a closed journal, characterized visual and

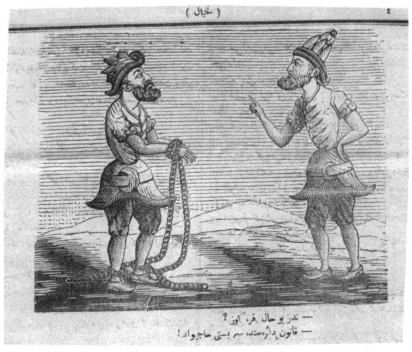

11. *Hayal*, 21 February 1877, 3. [Critique of the censorship law] "What is it with you Karagöz?—Freedom within the limits of law!"

literary satire as an art form. He claimed that if buffoonery was a sufficient reason to ban an art form, the traditional Karagöz shadow theater should be outlawed as well (Çeviker 1991b, 79–86).[17] What likely influenced Monok Efendi's defense was an anonymous cartoon published in an earlier edition of *Hayal* that presented Karagöz, the famous protagonist of the traditional shadow theater, his hands and feet chained, confused by his bondage and trying to make sense of it (fig. 11).

Between 1878 and 1908, the empire experienced a period of extreme repression of the press, which is remembered in history as the *istibdat*

17. See the full text for the parliamentary meeting, session 25, 8 May 1877.

dönemi (period of despotism). Amid diplomatic and homegrown pressures, the Young Turk revolution of 1908 forced Sultan Abdülhamid II to finally restore the constitutional monarchy with the revival of the Ottoman parliament, the general assembly of the Ottoman Empire, and the restoration of the constitution of 1876. During this second constitutional experience, the law to strengthen the popularly elected chamber of deputies was revised by the new parliament led by the revolutionary Committee of Union and Progress (CUP) at the expense of the unelected senate and the sultan's powers. The brief feeling of optimism sparked by the change formed and fused together many political parties and groups for the first time in the empire's history. The new constitution offered hope. However, even though censorship checks were abolished both officially and in practice, the Ottoman intelligentsia was still cautious, expecting that this state of affairs would only be temporary.

Within the intricate patterns of shifting policies of censorship, the satirical press in the first decade of the twentieth century had to act with great care, not trusting the influx of so-called freedom of the press under the CUP. Selah Cimcoz, the publisher and the head editor of the post-revolution's famous literary humor magazine *Kalem*, commented on this largely shared concern in "Freedom of the Press," a skillfully schemed text that was published in his journal's second issue, on 10 September 1908, both in Ottoman Turkish and French, warning its audience that censorship is an inevitable part of governments, because all start with giving the freedoms at first and banning them later (fig. 12).

However, confirming the concerns of many publishers, the major setback under the CUP occurred when censorship regulations were reimposed after a countercoup against the 1908 constitution under the auspices of the sultan launched a reactionary movement in 1909. The latter ultimately resulted in the constitutionalists gaining back control of the Ottoman government from the reactionaries and immediately stripping the sultan of his powers, both from the constitution and from the throne.

The CUP leaders set out to replace the ideal of a "loyal subject" with another ideal, of a "loyal citizen," whereby loyalty would be paid to the

قره‌كوز — صاووشك آرقداشلر ، صاووشك .. بوهجوم يمان هجوم .. صيجان دلكي بر يارده ...

12. *Karagöz*, 18 January 1911, 1. "Run, my friends, run! This attack is a grave attack! There is nowhere to hide!" [Flag held by the horsemen on the right reads "Committee of Union and Progress"; flag on the left reads "Press."]

system rather than to the person of the sultan (Yosmaoğlu 2003). To normalize the process of social and political control required the centralization of control over the press, which was reassigned by the CUP to the Ministry of the Interior. Following the counterrevolution, the CUP altered the press regulation that had been reestablished in 1908. The earlier decree had stated that the "press is free within the limits of the law, and by no means can it be subject to prior inspection and examination" (Baykal 2019, 118). What the CUP did, however, was to define those limits in a more circumscribed way, imposing censorship sometimes openly, sometimes covertly.

Karagöz, as the admiral ship of the political cartoon press, was one of the main opponents of the newly imposed press laws. In a series published over a six-month period, the paper attacked the government for its constant pressure on the media. One of the cartoons in this series depicted the reemerging control over the press through the metaphor of a hunt where a crowd representing the press with a donkey at the back line—the donkey referred to the satirical magazine *Eşek* (Donkey) that was closed by the CUP after the publication of its second issue—is chased by a mounted troop composed of government members: the prime minister İbrahim Hakkı Pasha, chief mufti Şeyhülislam Musa Kazım, finance minister Cavid Bey, and Istanbul's parliamentary representative Hallaçyan Efendi.

In just a few months, another cartoon series by *Karagöz* brought the aggravation in censorship policies to the public eye. In two sequential cartoons printed within a few weeks of each other, Karagöz, the protagonist, expressed his critiques through his position of being symbolically tied to a chair with a piece of metal nailed to his mouth. A couple of weeks later, the same illustration would be reissued, this time with the same clenched Karagöz, who, no longer able to stand the pressure, spits out his critiques despite the metal covering over his mouth (figs. 13–14).

With the start of World War I and the later occupation of Istanbul by the British in 1918, the Ottoman press found itself wedged between the censorship regulations of a small Ottoman government limited to Istanbul and those of the occupying forces. From the beginning of the war, Istanbul had adopted a more invasive form of censorship, suppressing rather than reacting to the publication of "undesirable" materials.

Following the armistice of Mondros in 1918, Mustafa Kemal and his comrades initiated a nationalist movement that would soon morph into the War for Independence. The Nationalists formed a government in Ankara, where they would organize the struggle against the victorious imperial forces of Britain, France, and Italy. The combination of allied and Ottoman censorship left no room for the Nationalists to publicly defend themselves against the accusations directed at them. As a result, the Ankara government had to create an alternative press infrastructure to spread its messages concerning the struggle against the imperial powers. The period

— آمان حاجیواد .. ابی پرچین ایت . بشقه چاره یوق . اورتهلق بو حالده آیکن قابل دکل طورهمام سویلرم ...حالبوکه جزا قانونی چیقیور ...
پتدیکم کوندر ...

13. *Karagöz*, 31 May 1911, 1. [On the left] "Oh, Hacıvat! Make sure you clench it well . . . There is no other solution . . . It is impossible for me to be quiet when there is so much trouble around. It would be the day I finish since the punitive law is on its way!"

from 1919 to 1923 can be characterized as a press battle between Istanbul and Ankara, and between pro-nationalist papers and those arrayed against them.

After the emergence of the Turkish Republic in 1923 under a single-party government, the press went through another phase of tranquility. The regulations governing the media since the constitutional revolution were still intact. However, following the abolition of the Caliphate in 1924, multifaceted ethnic and religious conflicts broke out over the creation of a secular Turkish national identity. The uprisings were brutally crushed. Especially following the Kurdish rebellion under Sheik Said, which quickly spread across southeastern Anatolia, the Turkish

14. *Karagöz*, 10 June 1911, N308, 3. [On the right] "Ah, Karagöz, ah! . . . I told you to clench it well! If you jam it so tight, it is sure that it will burst out . . . It is not my fault . . . Neither nail nor lock holds it. I was going to blow up if I did not inhale."

government imposed martial law effective on 25 February 1925. Under the ruling Cumhuriyet Halk Fırkası (Republican People's Party), the law on the maintenance of order (*Takrir-i Sükun Kanunu*) was put in process on 4 March 1925, to grant the government unchecked powers, especially over the press. The latter move had several consequences, including the closure of all newspapers except for *Cumhuriyet* and *Hakimiyet-i Milliye* (both of which were official or semiofficial state publications). The goal was to censor any criticism of the ruling party's actions dealing with its ethnic groups that would discredit the government policies regarding the reformation of the country.

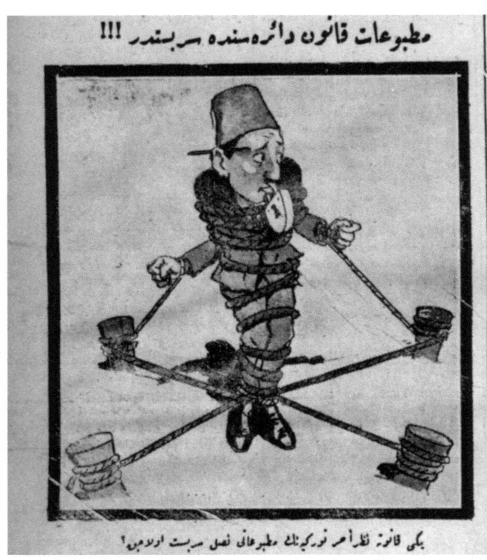

15. *Tevhid-i Efkar*, 6 December 1924, 1. *Press Is Free at the Law Office!!!* [Caption]
"How will Turkey's press be free according to the new law?"

Censorship in the form of suspending or banning newspapers, satirical journals, or, more boldly, in the form of violence against journalists and artists, had been in use from the early days of the Ottoman press, and it was undoubtedly applied after the emergence of the republic. Clearly, not every offender could be caught, not every clever manipulation of the censorship process foreseen. From the nineteenth century to the early 1950s, the satirical press published under substantial government surveillance. During this period, only a very few publications managed to survive.

3

Young Turkish Diaspora in Europe

Learning to Illustrate the Orient

In the context of nineteenth-century expansionism, Europe's willingness to engage in conflict over the Mediterranean edged its imperial powers ever closer to the heart of the Ottoman Empire. Military encounters between the two became more aggressive while cultural interactions became even more penetrating. During this period, the attraction of the Orient as an exotic alternative universe fired up the European imagination through paintings, pictures, and travel writing of artists and intellectuals. In Edward Said's (1974) formulation, the Orient became the imagined other.[1]

Cultural or ethnic stereotypes tend to be viewed as symbolic notions, constructed through an external as well as an internal process of reality performed by the individual, thus explaining the personal evaluations of images in visual illustrations. They can, consequently, be apprehended as explanations of reality connected to emotional, social, or political factors and perceptive structures in our innermost world of experience. Nineteenth-century orientalism was no different in that sense. The symbolical creation of the other at the hands of European artists and novelists actualized the unfamiliar and made it familiar for their audience. In this regard, ethnic stereotypes, to some extent, can be understood as expressions of

1. In its broader geographical imagining, within the scope of this book, the Orient included North Africa and the Middle East.

a symbolic approach to reality, one that is perceived as meaningful. The stereotyped images presented by political cartoonists about people from other cultures were no different in that context than the paintings or verses of the orientalists. With their unique symbolism, political cartoons were similarly effective in consolidating the image of the other.

Nineteenth-century Europe was a hotbed of visual symbolism for the flourishing cartoon press. The recurrence of creatively designed and formulated illustrations of signs, forms, and figures in cartoons empowered their artists with an alternative set of cultural and political weapons while attracting more readers to the newspapers they appeared in. For Victor Navasky (2013, 41), for example, satirical portraits of an era—cartoons in particular, and images in general—tell the story better than the written word because written styles are ever-evolving, whereas symbols are more durable.

The romantic symbols assigned to the Europe's Orient supported hegemonic claims over these lands and its people. When the political cartoon as a medium was introduced to the public eye, it abandoned the ethnographic expeditions into the unknown in favor of formal experience shaped around political and military contacts. The civilized world's burden to deliver modernization to the "uncivilized" and "barbaric" inhabitants of North Africa and the Middle East was perhaps the central cliché of orientalist discourse, yet, through its representation to ordinary people, it was instilled with a sense of correctness. After all, the symbols that defined the Orient were predominantly developed based on these binary oppositions. Cruelty, despotism, intoxicated indolence, and sexual fantasy were reiterated as the dominant motifs of the Middle East and North Africa, which provided a negative mirror image of Europe's political, economic, cultural, and social norms of modernity, as well as the ethical norms of Christianity.

The Arab stereotype in the Ottoman public consciousness grew out of a symbolic world of infinite complexity that found its roots in the nineteenth century's traditional and colonial European imagery. As Ussama Makdisi (2002) has argued, in an age of Western-dominated modernity every nation created its own Orient, and the nineteenth-century Ottoman Empire was no different. Especially under Abdülhamid II's despotic

rule, a group of young, educated Ottoman intellectuals found their way to Europe, forming a small but influential diaspora. Most of the cartoonists critiquing the regime were among them. As an enthusiastic, vulnerable, and open diaspora, these young cartoonists learned and imitated from their European counterparts how to praise the liked and reproach the disliked.

Starting from the late nineteenth century, Ottoman lithographic cartoons engaged in creating a sense of Ottoman modernity by depicting the Orient in a manner similar to their European contemporaries. Using the same symbols and visual contexts, Ottoman cartoonists transposed Europe's colonial formulations of difference into Ottoman with an urge to assert the modern status of the latter both against European imperialism and emerging Arab nationalism. They created, subjugated, and drew their own Orient just as their European colleagues did.

The formulation of the non-national Arab stereotype in Ottoman political cartoons that constitutes the core discussion of this book is the amalgamation of, first, traditional themes in Ottoman political cartoons; and, second, the colonial influence from Europe against the empire's despised stereotypes, particularly the Arab, during a period of increasing nationalist sentiment. However, it is important to take a look at the European political cartoon sphere, where orientalist symbols and images emerged in their most overt colonial tones. The latter served as an educational platform for Ottoman cartoonists once they had the opportunity to claim their position as members of a civilized and modern empire.

Images and Stereotypes in Orientalist Production

Orientalism, in the sense of constructing cultural, spatial, and visual mythologies and stereotypes that are often connected to geopolitical ideologies, flourished in the nineteenth century, when steam navigation and railroads made travel more accessible and facilitated contact with other landscapes and peoples. This expansion took place via diplomatic, military, scholar, and cultural channels. Although Europe seemed united by several fundamental cultural trends—including political liberalization, new literary styles, and scientific innovations—it was also deeply divided.

Within their industrial and colonial rivalries, European states found themselves increasingly locked in diplomatic interactions that, by 1871, had resulted in continent-wide alliance systems. Collectively, all of these developments led to a century of growing nationalism. Individual states jealously protected and highlighted their identities and indeed established more ambitious territorial aims than ever before. Orientalism, as a collective attitude, a culture-specific discourse, and, more importantly, a political template (in the Saidian sense) was shaped by these influences.

In the production of this cultural discourse, the role played by artists and writers must also be viewed in a political-geographical context. As the Western world became entangled in the web of expansion—amid the colonial ambitions of England and France in particular—the European public was introduced to North Africa and the Levant under Ottoman domination through the works of these artists and writers.

In its system of knowledge, the Orient is less a place than a topos, a set of references, a congeries of characteristics, that seems to have its origin in a quotation, a fragment of a text, a citation, a product of the imagination, or an amalgam of all of these. Direct observation or circumstantial descriptions of the Orient are fictions presented by writing, yet invariably these are secondary to systematic tasks of another sort (Said 1979, 177).

Over a century of cultural production, oriental stereotypes, as abstract forms of the imagined unfamiliar, were illustrated in terms of perceived cultural and physical attributes. In the context of political cartoons, these characteristics were the necessary ingredients for humor (Said 1979, 177). For French cartoonists like Daumier, for example, the physical features that separated their foreign subjects from Europeans were quite clear. In highlighting the essential contrasts between a Frenchman and a non-French European, or a civilized European and a barbaric non-European, the distinctions artists made aimed not to simply present reality but to describe the familiar against the backdrop of the unfamiliar other (Said 1979, 59).

By the early nineteenth century, fantasies of the Orient dominated the European imaginary. The popularity of the *One Thousand and One Nights* (or *Arabian Nights*) exemplified this increasing political and cultural interest. The tales of Sinbad, Aladdin, and Ali Baba and the Forty Thieves offered genies, talking serpents, moving mountains and trees,

and mystic tools including magic carpets, embedded in a range of fantasy and crime narratives that crossed the boundaries between imagination and reality. These tales fueled the escapist creativity of artists and novelists while stimulating the interest of scholars and inspiring the geographical ambitions of politicians.

European orientalism also owed a great deal to colonial expeditions. Most noteworthy of those was Napoleon's historical campaign in Egypt under Ottoman rule, which unleashed a new wave of orientalist scholarship depicting the Orient and Occident as opposing poles, one of which signified the limits of civilization while the other stood for everything savage and brutal. The French invasion of Algeria was the second phase of this campaign; it gave another level of impetus to France's documentation of Muslim cultures since, as colonizers, they now had crucial access to their exotic subjects.

In a short while, the East became an open theater for the living spectacle of oriental culture. The precise documentation and empirical evidence of the traveling novelists and artists during this time were perceived by European audiences as evidence for ethnographic and geographic reality, reducing a diverse and multilayered culture to a one-dimensional image.

In 1841, Edgar Quinet, a French poet, historian, and political philosopher who made a significant contribution to the developing tradition of liberalism in France, described the nineteenth century as the "reawakening of the Oriental": in other words, a cultural and artistic recovery of colonial romanticism. This approach was even more evident in the writings of famous authors like Victor Hugo, Robert Louis Stevenson, Rudyard Kipling, Herman Melville, and Lawrence Durrell. The flamboyant travel journals of Gustave Flaubert, whose travels to Egypt with his journalist friend Maxime Du Camp contributed extensively to the visualization of the Orient. Of particular importance are paintings of North Africa, by such artists as Eugène Delacroix, Jean-Léon Gérôme, and Jean-August-Dominique Ingres. In his art Henri Rousseau created an exotic world, unconstrained by geographical and historical references. Being ethnographically desituated, Rousseau's paintings are a perfect laboratory for a study of European notions of the exotic. In all of these art forms, the cultural filtering worked mutually with the original hosts'

impressions and sensations. After all, the nineteenth century's cultural production hearkened back to the early works of late seventeenth- and early eighteenth-century novelists like Montesquieu, dramatists like Racine, and memoirists like Lady Montague.

In the cultural sphere, such reductive accounts of firsthand experiences motivated those who had never personally traveled to the Orient to view these geographies. Jean-Auguste-Dominique Ingres had never seen a slave woman when he painted his *Odalisque* (1812), which depicted a nude white harem slave in a way that echoed Théophile Gautier's La Nue in his *Emaux et Camée*. Similarly, Ingres had never visited the Ottoman harem as depicted in *Le Bain Turc* (1862), where he presented a group of naked women, based on the letters of Lady Montague, wife of the British ambassador to the Ottomans in 1764 (Gautier 1872, 199–201; Lagarde and Laurent 1985, 263–70). Ingres's presentation of the Turkish harem in a highly erotic style associated with its mythological subject matter created an enchanted world of sensual delight where orientals appeared "as they really are."

The encounter with the cultural alterity of the Orient has also been linked to the hegemonic expansion that would lay a natural claim to the interpretation and conquest of unfamiliar cultures. Orientalism developed an ethnocentric, supremacist attitude that fostered a Foucauldian sense of the power-knowledge relationship that would prove fatal for indigenous people. As Homi K. Bhabha (Barker and Bhabha 2003, 159–60) has noted, the strategic articulations of the racial and sexual knowledge about the Orient and the "inscription in the play of colonial power as modes of differentiation, defense, fixation, and hierarchization" were ways of constructing a colonial discourse that would add new stereotypes to traditional ones, representing the Orient and its Islamic cultures as fundamentally inferior. Moreover, functional justifications for these oriental stereotypes were established in every sphere of the European cultural domain, from literature to painting.

With the advent of print capitalism and the invention of lithography—both of which facilitated the replication of graphic art—political cartoons became just as significant as other forms of imagery in the realm of orientalist production. Daily illustrated papers started to function as

a second generation of producers of the structural links between the oriental other and the European self. Portrayals of stereotyped exotic traits and primitive landscapes projected colonial discourse in its most vivid and contemporary forms, inserting it into daily accounts of political and cultural events and creating a sphere of comparison. Prominent political cartoonists like France's Charles Philipon and Honoré Daumier or Britain's John Leech and Sir John Tenniel stood out among those who contributed to constructing this colonialist image of the Orient. Their art relied less on direct experience than on available domestic resources of previous mentors, or on their own received ideas. Like Ingres, Daumier had never left Paris. Still, his depiction of the Ottoman ruler in his cartoons was clearly inspired by the sultan's portrayal by the French lithographer August Forbin (1819) or the French painter Auguste Couder (1840).

Ottomans as Orientals and Orientalizers

As Selim Deringil (1999, 165) put it in his *Well-Protected Domains*, "In a strange paradox, the Ottomans were viewing their Arab subjects through the very same prism, through which the Europeans viewed them." Inadvertently, the Ottoman self-image adopted much of the same value system as that of the West, and political cartoons reflected this paradoxical view. The Ottomans were not avid travelers. In his essay on Ottoman travel in the late nineteenth century, Ottoman *münevver* (intellectual) Ahmet Midhat Efendi claimed that there were no travelogues composed in the Ottoman Empire except for one or two in the form of diplomatic reports (Herzog and Motika 2000). Although the volume of travel literature grew over time with the blooming of the Ottoman press and publications, Ahmet Mithat Efendi's critical observations remained mostly relevant for travel writing.

Similarly, within the realms of the empire, apart from abstract arabesque forms and miniatures in books, certain aspects of the visual arts were latecomers. For example, painting only began to be taught as an academic discipline with the opening of the school of fine arts Mekteb-i Sanayi-i Nefise-i Şahane in 1883, more than two hundred years after the establishment of the French Académie des Beaux-Arts (1648). And, when it came to imagining the other, Ottoman cartoonists' own Orient

was often fictionalized not through the narratives, letters, or memoirs of Ottoman travelers, but through their observations of Europeans.

In terms of experiencing the Orient secondhand, the Ottoman intellectuals and urban audience of Istanbul were, in some ways, no different from the readers of *Le Charivari* in Paris or *Punch* in London. As Elizabeth Childs (2004, 61) notes, these European readers were ordinary people with neither the desire nor the means for foreign travel. In satirical publishing, the grotesque images of the Orient were mostly produced by nontraveling artists for a domestic audience with only vicarious knowledge of the larger world. In a way, their art aimed to produce a perceptual domination of the West by summoning oriental stereotypes around specific behavioral characteristics that, as Childs explains, included religious fanaticism amalgamated with violence and cruelty, a fixation on despotic leaders, physical sloth and passivity caused by a lazy nature or overindulgence of drugs (hashish), and, finally, the sexual availability and heightened sensuality of oriental women, particularly in the thematic environment of the Ottoman harem.

One fundamental difference between the Ottomans' orientalizing of the Middle East and North Africa and European orientalism was that, for the Ottoman audience, Arabs were not unfamiliar images, as they were for readers in Paris or London. The white Arabs of the Levant or Black Arabs of Africa were already a familiar presence in the Ottoman capital, having moved in and out of the confines of the empire since the sixteenth century. A regular Ottoman from Istanbul would encounter these types regularly either in Karagöz plays during Ramadan or on daily visits to the Grand Bazaar or a coffee shop. What was missing for these spectators, however, were geographical references that would place Arab types on the world atlas. As Europe's exotic stereotypes of the Orient were placed in Algiers, Tunisia, Egypt, Levant, India or Far East, Arabistan (as the lands containing anything at the east of capital Istanbul) served as an umbrella for an imagined geography.

In fact, geographically, the Orient was, for both Europeans and Ottomans, the same imagined—not to say "imaginary"—space. Daily papers and weekly journals in the mid-nineteenth-century Ottoman capital evoked for their readers the exotic and unknown geographies of both East

and West through the gaze of European orientalizers. Lithographs offered imagery based not on the people themselves but on stereotypes of oriental landscapes and historical events supplied by colonial discourse.

In Istanbul, where the dual power of the press had recently been discovered and brought under the control of the palace, information about the other offered a vivid and alternative way to introduce European art and culture to the Ottoman spectator. *Istanbul*, one of the first private newspapers of the capital, began to regularly publish lithographic illustrations of newly discovered geographies on other continents. These images, marked by their European sense of colonial superiority, were inspired by

16. *Istanbul*, 28 September 1868, 5. A picture of a boa snake living in tropical America jumping from the top of a tree.

حبش حکمدارینک رسمیدر

17. *Istanbul*, 11 November 1867, 5. A picture of Habesh's ruler.

ديت الشام وطرابلس غرب چولرنده، يولنان هجين دوه سى ديكله معروف جملك رسميدر

18. *Istanbul*, 23 May 1869, 5. A picture of the Arab pilgrim that travels with his camel in the deserts of Damascus and Tripolitania.

the exotic paintings of famous Western artists like Henri Rousseau or Jean-Léon Gérôme. They created a feast for the eyes while nourishing the imagination and sparking curiosity about these unknown places.

The text of these lithographs in *Istanbul* carried short, guiding descriptions of their content, each referring to the place and event portrayed. The illustrations provided local audiences with romantic stories of the unknown, including images of rice fields in India, exotic animals in newfound lands, the struggles of adventurous "Turks" with giant snakes in the mysterious forests of America, and colonial assaults on Black aboriginal tribes in Africa (figs. 16–17).

However, among these daily illustrated scenes, only a few drawings depict the Middle East. In its weekly issue in May 1869 (fig. 18), *Istanbul* printed European lithographer Whitney Dol's portrayal of an Arab haji traveling on his camel in the deserts of Damascus (Bilad-al Şam) and Tripolitania (Trablusgarb). This depiction was probably one of the very few representations of the Arab stereotype in the mid-nineteenth-century Ottoman press. The picture in its oriental sense successfully demonstrated in a single image both the people and the landscape of the Muslim Middle East, where the Arab haji wandered in a vast desert on his way from the Middle East to North Africa. The link between the stereotype of the haji and the famous French painter Leon Belly's portrait of *Pilgrims Going to Mecca* (1861) is undeniable. Both created a unified perception of the Orient for the urban societies of major imperial capitals.

From Exotic to Barbaric: Changing Images of the Ottoman Turk

The cartoonists of *Le Charivari*, including Charles Philippon and Honoré Daumier, created the most impressive examples of French humor in general and colonial humor in particular. Their works targeted the theater of international politics while drawing on a broad range of physical stereotypes supported by contemporary ideas about race and cultural difference. These images provided the man on the street with daily formulations of world diplomacy in a constant relationship of power. For example, an early Daumier cartoon from 1853 clearly demonstrates how the French

19. *Le Charivari*, 22 June 1853, 12. *La Fludomanie*. [Caption] "This is what the different peoples of the world are busy doing." Source: Bibilioteque Nationale de France.

understood the colonial world around them. The caption of the cartoon, titled *La Fluidomanie*, read: "This is what the different peoples of the world are busy doing" (fig. 19).[2]

The cartoon illustrates a twofold power relations in the same framework. The first one is relieved by the four continents' representation in the cartoon's setting, where they are aligned based on their political significance to France, on a two-dimensional illustrated map of the globe. This means that, while Asia and America stand equally distant but closer

2. *Fluidomanie* referred to the spiritual séance-like table games popular in Europe at the time.

to Europe in the foreground of the composition, Africa is ranged further away from Europe, toward the back of the frame. The second regards the power relationship within the given continents: for each one, Daumier portrays the ruler on the right and the stereotyped ruled on the left sitting across a round table, obsessively playing *fluidomanie*. From the fixed racial and geographical features along with the details of their costumes, the cartoon simply let the audience identify the ethnicity of the rulers and the ruled, along with their perceived level of civilization. The lower quadrant—that is, Europe—seats Britain versus India; to their right, in Asia, Russian Cossacks versus the Chinese; to their left, America with Americans of European descent versus Native Americans; and, finally, above Europe, in Africa, the Ottomans versus the Arabs. The colonized nations in America and Asia wear a savage facial expression, whereas the Arabs of Africa and the Indians of Europe appear to have more docile features, as their colonial rulers seem ambitious and eager. Daumier depicts the Ottomans as part of the colonizing world, just like the British and the French. Entering the twentieth century, the Ottomans themselves shared this same view.

Notwithstanding Daumier's depiction, the European press typically characterized the Ottoman Empire as a savage place. The Ottoman-Russian challenge in the East gave the European media an ideal opportunity to "pontificate on the two 'barbaric' empires" (Deringil 199, 144–46). The Ottoman's image gradually shifted in the European mind to align with Muslim North Africans in a single perception of dark-skinned indigenous people in exotic attire (fig. 20). For a common European, any nuance between white Arabs of the Middle East with their keffiyeh, Black Arabs of North Africa with their turban, and Ottoman Turks with their fez seemed nonexistent.

Despite its gradual disintegration, for nineteenth-century Europeans the stereotype of the Orient was still defined by the geographical limits of the Ottoman Empire. The French novelist Alphonse Daudet reinforced this notion in his *Aventures prodigieuses du Tartarin de Tarascon* (1872), where his protagonist notes that the Tarascons, the people of a southern French town, designate all orientals as "Turks":

20. D'Ostoya, *Le Rire*, 19 September 1908, 16. *Court Singers*. [Caption] "The revolts are easy, the crowns are fragile, like the cheerful little children, one should not look inside!" Source: Biblioteque Nationale de France.

All this crowd pressed, jostled in front of the door of Tartarin, this good Mr. Tartarin, who was going to kill lions among the Teurs [Turks].

For Tarascon, Algeria, Africa, Greece, Turkey, all this forms a large, very vague country, almost mythological and it is called the Teurs (the Turks). (Daudet 1872, 80; my translation)

This unified image became bolder as the power balance in Europe shifted with the emerging threat from Russia. Starting with the Russo-Ottoman War of 1768–74, Europe became the epicenter of serious political tension centered around the question of what should come of the Ottoman Empire. This fundamental question shaping the relations of Great Powers was known as the "Eastern Question." As the world entered the nineteenth century amid competing ideologies of imperialism and nationalism, many newly emerging nations were eager to display their military strength. European states, especially Britain and France, had surpassed the Ottoman Empire economically, technologically, and militarily. Meanwhile, Russia consistently tried to control and later incorporate the northern shores of the Black Sea to further its ultimate dream of reaching the warm waters of the Mediterranean. A clash with the Ottomans, who regarded those areas as strategically valuable, was inevitable. These diplomatic reformulations among the great powers prevailed in the European cartoon press, providing a space for exhibiting the extent of political manipulation through stereotyping. For example, Comte de Noé Amédée Charles Henri (CHAM) compares the complex politics of the Eastern Question to the seasonally shifting faces of the wax figures behind hairdressers' display windows. The faces slide from "war" to "peace" in Le Charivarie's January issue of 1854, in which he identified "war" with the stereotype of the Ottoman sultan (fig. 21).

As in the first half of the nineteenth century, the Ottoman Empire was stuck between pressure from Europe in the west and Russia in the northeast. And, as if this wasn't enough, the political and economic strength of the empire was severely challenged by a series of wars like the Greek War of Independence (1825–28); the Turco-Russo Wars (1828–29, 1877–78); and the Crimean War (1853–56), nearly all of which ended in serious defeat and loss of territory.

21. Cham, *Orient Question*, *Le Charivari*, 25 January 1854, 6. Source: Biblioteque Nationale de France.

22. William Heath, *Mrs. Greece and Her Rough Lovers*, in *Thomas McClean*, 1828. © The Trustees of the British Museum.

The Crimean War was particularly significant for the affirmation of the empire's weakened political and military position in world politics. Russian agitation in Ottoman provinces arose over whether the Catholic or the Orthodox Church should control the holy places in Palestine, especially the Church of the Nativity in Bethlehem. France, threatened by the possibility of Russia's presence in the Mediterranean, interceded on behalf of the Catholics while Russia defended the rights of the Orthodox. Afraid that another Ottoman defeat would allow a Russian expansion, France allied with Britain in support of the Ottoman Army. For three years, the war raged inconclusively in and around Crimea.

The Russo-Ottoman wars provided the European satirical press with its most extreme stereotypes of the Ottomans as uncivilized, barbaric, and incapable of conducting robust diplomacy in a global political environment. French and British political cartoons recurrently portrayed the empire in binary opposition to their own position of power, which

23. Honoré Daumier, *Le Charivari*, 12 October 1849, 6. *In the Orient*. Source: Biblioteque Nationale de France.

created a perception of it as the illegitimate ruler of subjugated nations (fig. 22). Illustrative techniques to overpower the other and legitimize the discourse of European states were frequently employed as part of orientalist discourse. Demagnifying the figure of the Turk against the British or French (fig. 23), referring to biblical or mythological narratives such as the story of David and Goliath or the Giant and the Dwarf (figs. 24–25), or anthropomorphizing nations based on their dominance—Russia as a bear, Britain as a lion, and the Ottoman Empire as a turkey—were just a few of these techniques (fig. 26), accompanied by such physiognomic details as vicious expressions in the eyes or vulgar mouths with exaggerated teeth (fig. 27).[3] The occasional depiction of the Ottoman in scruffy

3. William Heath (1794–1840) was a British cartoonist best known for his published engravings, which included caricatures, political cartoons, and commentary on contemporary life. He published his work in *McLean's Monthly*. Thomas McLean was a

A GOOD JOKE.

Russia, "OH, IT'S MY FUN! I ONLY WANT TO FRIGHTEN THE LITTLE FELLOW."

24. Sir John Tenniel, *Punch*, 23 July 1853, n.p. *A Good Joke*. A heavily armed Russian Cossack soldier threateningly mocks a diminutive Turk, with French and British sailors standing in support behind him.

clothes reinforced the impression of a feeble and uncivilized empire while creating a perceptual linkage between the Muslim populations of the European colonies in North Africa.

Amid contesting stereotypes of leading world powers, a series of so-called comic war maps became highly popular among European urban society (Barron 2008). These emerged between 1848 and 1870, years

print publisher of a wide range of genres in London. The prints published were signed as "Repository of Wit & Humour." The *Monthly Sheet of Caricatures* had begun publication in London in 1830, lithographed like Philipon's journals. In these and other ventures, the publisher McLean issued hundreds of political caricatures during a formative period for modern legislation.

25. *Punch*, 5 August 1854, n.p. *The Giant and the Dwarf. Punch* Cartoon Library / TopFoto. Le Honoré Daumier, *Le Charivari*, 5 July 1854, 6. *David et Goliath*. Source: Biblioteque Nationale de France.

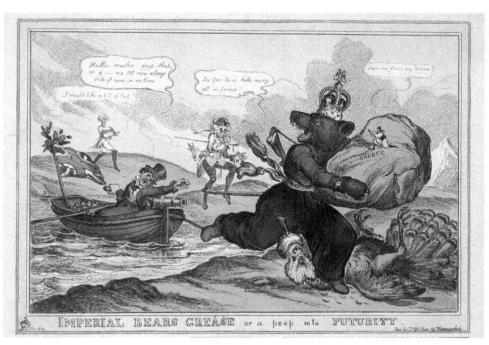

26. William Heath, *Imperial Bears Grease, or a Peep into Futurity*, in *Thomas McClean*, 1828. © The Trustees of the British Museum.

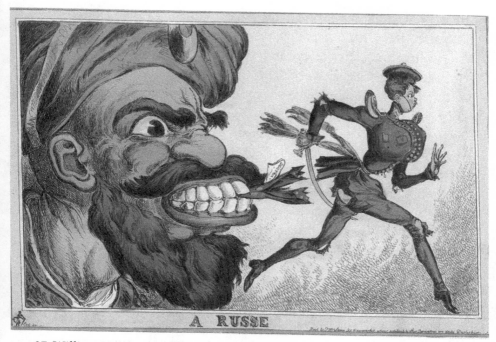

A RUSSE

27. William Heath, *A Russe*, in *Thomas McClean*, 1828. Source: © The Trustees of the British Museum.

punctuated by the 1848 Revolution, the 1859 Franco-Austrian War, the Crimean War of 1853–56, and the Franco-Prussian War of 1870–71. The maps displayed for "geographical fun" presented the acquaintance and encounters with foreign lands in a humorous way and invested a great deal in national stereotypes, not least for those of the French and English imaginaries. In the period of the emerging ideologies of nation-states, new representations of national identities became symbolically evident in various forms, not just human but animal, historical, and mythical. European nations and their respective national traits, customs, and characteristics in opposition to their others were defined with symbolism and the biting satirical humor of this figurative current within the descriptions given around the periphery of the map, providing the public with visual formulations of imperial power struggles around consolidated national stereotypes. Frederick W. Ross in London was among the pioneers of satirical

map production; his Serio-Comic political cartoon maps, a series published between 1877 and 1900, were considered masterpieces of visual storytelling and national personification.

The first in the series, *A Serio-Comic War Map*, visually illustrates each country with a national stereotype, with the borders used to give form to a series of interwoven narratives. Russia, for example, is depicted as an octopus that looms over the scene, its wild, erratic tentacles extending eagerly and causing chaos and conflict all over Europe. In Ross's eyes, reflecting the dominant British view, Russia has already forgotten about the wounds it received in previous encounters with the Ottoman Empire, slowly wrapping its tentacles around the personified Ottoman "Turk" who holds only a small pistol to defend himself. The binary opposition between the magnitude of the danger and the tiny weapon emphasizes the empire's weakness set against its regional competitors. In the next two maps in the series, *Angling in Troubled Waters* (1899) and *John Bull and His Friends* (1900), Russia continues to dominate the scene and threaten British interests while the Ottoman Empire, portrayed in the grumpy face of the sultan, has to raise itself up on the shoulders of its European neighbors. In *Angling in Troubled Waters* (fig. 28), Ross tells the story of the Ottoman Empire:

> Turkey, who has lost so much weight as to be scarcely recognizable, is holding his hand to his ear. Would that he might hear the howl of indignation which rises against him for the terrible stain upon his clothes. His look is still fixed in the nose of Crete, but it looks as if it might easily be torn out. Russia treats heavily upon him, and he no longer knows the repose of by-gone days. Even the present for a "good boy" [European support against the Greeks], which lies in his pocket, may not bring him much satisfaction.[4]

4. The passage is copied from the legend of Frederick William Rose's map *Angling in Troubled Waters*, where he explains his characterizations for each national figure. For the maps, please see the Illustration Chronicles at https://illustrationchronicles.com/Mapping-Chaos-Fred-W-Rose-s-Serio-Comic-War-Map (accessed September 16, 2022).

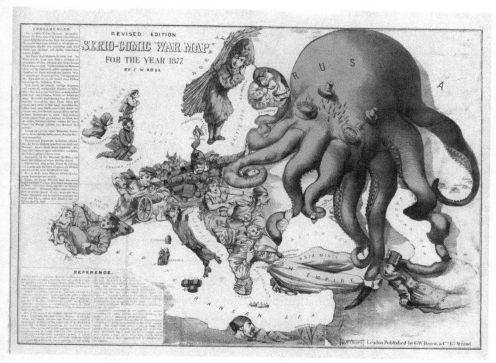

28. Serio-Comic War Map, 1877, by Frederic Rose Comic Maps. Courtesy of P. J. Mode Collection of Persuasive Cartography, Cornell University.

The narrative behind Ross's illustration represented the supposed superiority of Europe in the "angling waters" of war diplomacy, while exposing the weak and consumed nature of the Ottoman Empire that had lost its place among the great empires of the modern world. Starting from the early nineteenth century, the numerous symbolic depictions of the Ottomans as the other emerged around the mirror image of the Ottoman Empire as an out-of-date empire, resting on the barbaric values of the uncivilized. The latter was provided through the mobilization of double-edged concepts like West versus East, civilized versus barbaric, and even Christian versus Muslim.

From the European perspective, despotism, radicalism, and underdevelopment quickly became the defining elements of the Ottoman Empire.

Except for the sexual appeal of the harem, all remaining connotations coalesced into a pejorative image of the Ottomans. The abolition of the *Meclis-i Mebusan* (Ottoman Parliament) in 1877 aggravated censorship of the press, and the establishment of espionage networks against the opposition all signaled Sultan Abdülhamid II's increasingly autocratic rule, which was drifting even further away from Western ideals. *Punch's* depiction of the sultan's new regime drew upon scenery from the International Conference held in Constantinople where all the imperial powers (Britain, Russia, France, Germany, Austria-Hungary, and Italy) met in the wake of the 1897 Balkan crisis.

The cartoon's orientalist portrayal of the sultan (fig. 29) shows him sitting cross-legged on a carpeted floor wearing a fez and Ottoman sandals, his big belly under his kaftan a symbol of laziness, his eyes focused on his nargile (hookah, or water pipe) as he childishly blows bubbles containing many of the unfulfilled promises in the charter: "Constitution, 1877" (referring to the 1876 Constitution that would be formally promulgated by the sultan only a year later); "Hatt-ı Hümâyûn, 1856" (the imperial reform edict of 1856, which reinforced the Tanzimat reforms promising equality in education, government appointments, and administration of justice to all); "Hatt-ı Sherif, 1839" (the imperial edict for the restructuring of the empire, also known as Tanzimat Fermanı); and, finally, "Iradé" (which can refer either to a personal decision to resist or to the "imperial script" of the previous reform acts).[5]

Scholars of Ottoman history have suggested that Abdülhamid II blamed the parliamentary system (and the representative system in general) for the fundamental failures of the Ottoman-Russian War of 1877. Yet the aftershocks of parliament's closure only began to be felt in the 1880s, when significant territorial losses threw the political system into turmoil. In North Africa, the French occupied Tunisia in 1881, the British

5. Charles Philippon, in France's *La Caricature*, used the same graphic depiction to denounce Louis-Philippe's false promises on 4 November 1830 as Sir John Tenniel used Abdülhamid II to show that copying popular patterns was common between the European cartoonists, a pattern that was also adopted by the Ottoman cartoonists.

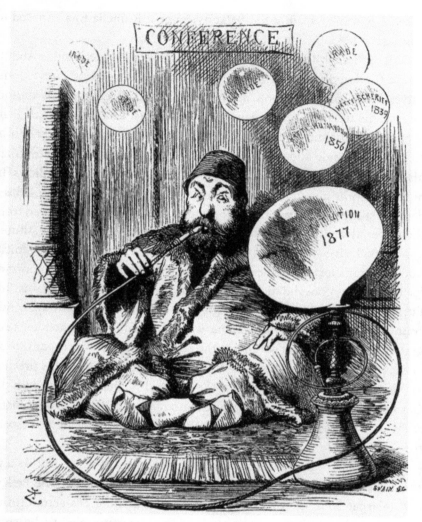

29. Sir John Tenniel, *One Bubble More!* In *Punch*, 1877. Bubbles read [from left to right]: "Iradé"; "Iradé"; "Iradé"; "Iradé": "Hatt-ı Sheriff 1839"; "Hatt-ı Humayoun 1856"; "Constitution 1877." Source: Punch Magazine Ltd. *Punch* Cartoon Library / TopFoto.

seized Egypt in 1882, and the Balkans' Eastern Rumelia was annexed to Bulgaria in 1885.

All of these military and political failures served to legitimize Abdül-hamid II's despotic rule, which led to interrogations, arrests, convictions, and exile for critics or opponents of the regime. To strengthen his author-ity over his territories, especially the Middle East and the Arabian Pen-insula, Abdülhamid II claimed his position as the recognized caliph of all Muslims inside and outside the empire. He did not hesitate to utilize his influence over the Islamic world to bolster his centralizing policies. In his book *Arabs and Young Turks*, Hasan Kayalı (1997, 32–33) provides a detailed study of Arab politics in the late Ottoman Empire as viewed from the imperial capital in Istanbul and notes that Abdülhamid II instituted a more inclusive strategy concerning Arabia by expanding communica-tion and transportation lines. Railway projects were the most important for the sultan's consolidation of his status in the Middle East against his European aggressors. The building of the famous Hejaz railway, which connected the holy city of Medina with Damascus and extended tele-graphic communication parallel to the railway, ensured "the organization of the pilgrimage under his close supervision, thus adding to his prestige as the leader of Islam." Contracting the Istanbul-Baghdad railway with the Germans, on the other hand, allowed the sultan to expand his diplomatic relations with Germany to counterbalance British and French interests in the region.

Appeals were made in Indonesia, China, Africa, and central Asia in the name of Abdülhamid II, the "Caliph and Commander of the Believ-ers" (Karpat 2001, 83–88). The extent of Abdülhamid II's actual influ-ence over Muslim populations worldwide is questionable. To be sure, Hamidian pan-Islamism turned out to be a failure, yielding no significant political action. However, the sultan's pan-Islamic approach was meant to obstruct British power in the Muslim world, and the British did perceive it as a threat to their interests, especially in India, their primary source of raw materials (83–88). Also, there was considerable discontent in Brit-ish public opinion toward the sultan following his rapprochement with the Germans. The following Greco-Ottoman War of 1897 and Christian massacres in Anatolia and the Balkans further distanced the British and

French from the Ottoman Empire. Of course, Ottoman public opinion in the early 1900s was mostly shaped by the press, which functioned as the state's broadcaster. Any perceived threat received the utmost negative coverage.

The conflict between the Greeks and Ottomans caused the first cracks in the polished image that the Ottomans had presented to European audiences. The clashes were primarily caused by the political and diplomatic proceedings that surrounded the Greek occupation of Crete. Despite the hands-off approach of Britain and France in efforts to prevent territorial disputes, the irredentist policies of Greece over Crete resulted in confrontation. The Greeks were overwhelmed by the Ottoman army, which had recently been reorganized under German supervision, but the Ottomans eventually yielded to pressure from the European powers and withdrew their troops under a truce signed in May 1897. This peace treaty compelled Greece to pay the Ottomans an indemnity, submit to an international commission that would control their finances, and yield some territory to the empire.

The developments in the Balkans provided the British with abundant material to draw upon when satirizing the empire. In the spring of 1897, images of war started to crop up in starkly dramatic (and thus overtly theatrical) terms that showed the democratic underdog (Greece) opposing the unambiguously black and alien force of oppression of the Ottoman sultan. At the speed of light, the conflict turned into a European propaganda campaign against Abdülhamid II, tarnishing his public image through published documents and illustrated newspapers.[6] *Punch* printed a series of pointed cartoons of the sultan and his officers by Sir John Tenniel between 1896 and 1898 that mocked his government for its diplomatic impotence.

In the following months, anti-Ottoman propaganda in both Europe and Britain correspondingly grew. Abdülhamid II's image quickly solidified into that of an oppressor, tyrant, and dictator, while his subjects were

6. British formal hostility toward Abdülhamid II was not only a matter of realpolitik but also an outcome of widespread discontent in British public opinion following the Batak massacre in Bulgaria.

depicted as oppressed, backward, and primitive (fig. 30). Almost every other issue of *Punch* would feature a cartoon reinforcing a passive, weak, and even feminine Ottoman stereotype in a patronizing manner (fig. 31). This burgeoning negative image of the empire abroad embodied in the sultan's persona became central to his domestic and foreign policies in the years that followed.

One of the main reasons that the Hamidian regime intensified pressure over its "enlightened" intellectuals who had strong intellectual interaction with Europe was to buttress the sultan's image. Restoring this image became the priority of Ottoman politicians, who tried desperately to make the case that "they were a Great Power recognized by the Treaty of Paris of 1856" (Deringil 1999, 139–40). The sultan's persona was essential in the legitimization of his power, not only within the borders of the empire but also, most notably, in the West and in the fringe territories of Muslim communities. The Western representation of the sultan's territories as the "bastion of bloodthirsty tyrants, at worst, or, a decadent fleshpot of Oriental vice, at best" was a theme frequently used in European media, especially in France and Britain (140). Yet the efforts to contain the damage done by incessant pejorative publications in international print media while suppressing what was printed inside the empire were not so effective in the Western public imagination.

By the beginning of the twentieth century, the Ottoman Empire's image in the eye of the European reader had become that of a clumsy and diminished figure hiding behind his barbaric and uncivilized nature while enjoying the sexual domination of his harem. Although this orientalist fantasy had captivated popular readers during the nineteenth century, its dualistic imperialist allegory also served European political ambitions. Nothing was left from the naive romanticism of the previous century. There is no question that these political cartoons were part of a larger cultural and imperial tendency that preoccupied Europe at the turn of the century. At the same time, they presented a subtle irony that simultaneously mocked the imperialist and racist xenophobia that characterized much of the discourse produced in response to the destabilized Ottoman Empire.

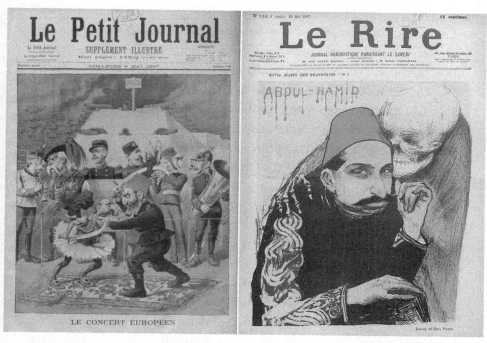

30. French press criticizing Abdülhamid's despotism. Source: Biblioteque Nationale de France.

31. British Press mocking Abdülhamid II. Source: Punch Magazine Ltd. Center image: *Punch* Cartoon Library / TopFoto.

By the end of the nineteenth century, the legacy of the Orient was well known, and the stereotypes were tenacious. In their depictions, Western cartoonists invoked received ideas about oriental physiognomy, appearance, behavior, and language. Many of the same perceptions of oriental others easily survived into the new century, expanding into the empire's capital. Young Ottoman intellectuals mesmerized by nationalist endeavors and eager to impose their own orientalist notions on their Arab provinces took account of the European stereotypes that were equally present in Ottoman cartoon images of the Orient in general and the Arab other in particular. For the Young Turks, the struggle for civilization began with the empire's provinces. As Birgit Schaebler (Schaebler and Stenberg 2004, 19–20) observes about the Ottoman discourse on civilization, "It was the inner boundaries that the Ottomans found wanting in civilization, and toward whom they developed a sense of their own mission civilisatrice. For them, the Arabs, Turkmen, and Kurds were rather ignoble savages."

Europe's exhibition of Abdülhamid II as the *grand saigneur d'Orient*, the despotic ruler of the Islamic East, blood dripping from his mouth, decapitating his subjects, and ruthlessly strangling his opponents, was identified with Muslim Ottoman society in general. Picturesque battle scenes legitimized gratuitous violence and cruel repression as the particular domain of the Ottoman East's barbarism. These depictions offered a single conceptual stereotype of the Ottoman Turk that referred to early paintings of Horace Vernet (1819), Benjamin Constant, and Eugene Delacroix, or the stories of the *Arabian Nights* (fig. 32).

Although the romanticism of the oriental other was long gone by the beginning of the twentieth century after the constitutional revolution of 1908 and nationalist endeavors, the forerunners of the revolution, who were back in the imperial capital, turned their gaze toward the east, this time from Istanbul instead of the culture capitals of the West. They were now themselves the orientalizers, with the quest of redefining Ottoman nationalism against the despised other. To proceed with their new role, they used equivalent techniques and symbolic patterns to illustrate the empire's uncivilized ethnicities as their identified others. The East, beyond the borders of the capital, lacked progress and modernity to the extent that even Abdülhamid II himself described his own backyard as

32. *L'Assiette au Beurre*, 29 August 1908, n.p. *Turkey Regenerated*. A series by D'Ostoya concerning the massacre of the Christians in Bulgaria by Abdülhamid. Source: Biblioteque Nationale de France.

primitive (Schaebler and Stenberg 2004, 41–43). The situation in the Arab provinces, which resisted the centralization policies of the Young Turks, was even more problematic. These uncivilized provinces and their people were seen as obstacles to the reform and modernization that was deeply desired by the new political elite.

Of course, the civilization mission that was undertaken during Abdülhamid II was not entirely different from what the CUP was aiming to achieve in the empire's eastern regions in terms of a centralized order and a sense of modernity. Yet the way they pursued these aspirations was cruel. In Ussama Makdisi's words (2002, 790), multifaceted Ottoman positions had been constructed by the nineteenth-century reforms to implicitly and explicitly acknowledge the West as the home of progress and the East as a "theatre of backwardness." The Crimean War and the subsequent military and political humiliation created dual pressures on the sultan from inside and outside. As Makdisi argues, the Ottomans were not late to recognize and respond to the power of Western orientalism, which held up a mirror to their military and economic decline. To deal with it, they preferred to embrace its underlying logic of time and progress, while resisting its political and colonialist implications. This is one

reason why the Arab-inhabited regions became a pervasive and defining facet of Ottoman modernity.

Another reason, according to Makdisi (2002, 769), lay in Ottoman efforts to study, discipline, and improve their imperial subjects, especially in the Arab provinces. These transformations created a notion of a pre-modern space within the empire in a manner akin to the way European administrators represented their colonial subjects. This process culminated in the sense of a Turkish national mission to lead the empire's conventional stagnant ethnic and national groups into Ottoman modernity.

European Symbolism in Ottoman Political Cartoons: Flirting with Modernity

While the Ottoman Empire, unlike India and Africa, had never been subjected to colonial rule, it was captivated by European culture, and by the French in particular (Brummett 1995, 434). Indeed, Paris became a sort of intellectual Mecca for Ottoman cartoonists.[7] The selective adaptation of styles from various Eurasian cultures had been part of Ottoman elite culture long before the nineteenth century. However, in the case of political cartoons, the cultural and symbolic domination of French graphic art was undeniable.

Of course, Karagöz shadow theater, with its long-established roots in Ottoman culture, provided cartoonists with a great resource of homegrown symbols. The traditional characters and mascots delivered familiar faces and trustworthy voices, but they were inadequate for transferring contemporary liberal ideas. In an age of emerging ideological currents like liberalism and nationalism, a new set of symbols was needed. Through persistent visual repetition, symbols of freedom, liberty, constitution, and civilization, and their contrasting concepts, such as slavery,

7. According to Ceviker's (1991) comprehensive work on Ottoman and Turkish cartoon history, prominent cartoonists of the Second Constitutional Era such as Cemil Cem, Sedat Simavi, Halit Naci, Damat Fahir, Sedat Nuri, Ali Dino, and Ali Sami Boyar were trained and published in major European cultural centers, particularly Paris and Brussels.

oppression, and barbarism, dominated the European cultural domain. This same set of symbols, which reduced these contemporary nationalist concepts to a "good us" versus an "evil them," seemed to be the missing piece for Young Turk cartoonists, who were ambitious about reshaping their society and transforming the sultan's autocracy into a modern and civilized government. In an unsigned cartoon from *Kalem*, for example, this stark opposition was metaphorically represented through an ugly, slow-witted troll standing beside Marianne, who allegorically personified liberty, reason, and the nation, the principles of the French Revolution (fig. 33). Especially after the 1908 Revolution, feminine allegory became a common means of symbolizing the break with the old patrimonial monarchical system headed by the sultan and promoting modern republican ideology in Ottoman popular culture. These forms of symbolic representation offered strong-willed Ottoman intellectuals with a range of visible signs that would both help them bypass the severe censorship of the ruling government and promote their vision of a better future through humor.

For one thing, Ottoman political cartoonists were not innovators. Within the spirit of the time, both European and Ottoman cartoonists exchanged techniques and practices in their illustrations. In a twisted way, this exchange provided a sense of continuity, of connection, among intellectuals and artists with similar ideologies. For example, in its June 1911 issue, *Kalem* published three cartoons representing interior minister Halil Menteşe.[8] On the first page, a cartoon by Rigopulos portrayed him standing on a scale, trying to calculate how much weight he had gained over the months he served as interior minister, indulging his corrupt nature, his face and belly grotesquely magnified. On the fifth page, the story line continued in Menteşe's depiction as a gradually maturing pear in four successive frames (fig. 34). This was not an original idea, however, but an imitation: what Rigopulos had done was to transpose the famous French

8. Halil Menteşe was one of the leading members of the Committee of Union and Progress. He served as interior and justice minister during the final years of the Ottoman Empire. After the signing of the Armistice of Monduros in 1918, and with the occupation of Istanbul, he was captured and exiled to Malta by the British.

La Liberté et le Despotisme.

33. *Kalem*, 5 November 1910, 1. *Liberty and Despotism.*

caricaturist Charles Philipon's depiction of Louis Philippe, published in *Le Charivari* in 1835, into the Ottoman context.[9]

The contextual relation between Philipon and Louis Philippe is noteworthy. Philipon, who had been charged for his mockery of the French king under censorship laws, argued in his defense that, actually, the king's physiognomy could easily be found anywhere. To demonstrate, he drew four sequential portraits of the king that began with his recognizable likeness and ended with a pear. Philipon added captions to his illustrations of Louis Philippe's embryonic facial features from the statements he had made in court to evade possible censorship and punishment. He argued that he just drew four different sketches where each resembled the previous one, and it was the viewer who perceived and transformed these sketches (fig. 35) "for a pear, for a brioche, and for all grotesque heads in which chance or malice might find some resemblance" (Mainardi 2017, 44–46).

Ottoman publishers were also strong supporters of this kind of work. Especially contemporary satire papers like *Kalem*, *Djem*, and *Hayal-i Cedid* were eager to adopt a common symbolic language with Europe, particularly France. Mainly in the first decade of the twentieth century, resemblances between European and Ottoman political cartoons were undeniably close. As part of asserting a similarity to—or even as a fluent way of declaring their intellectual competency alongside—their European counterparts, these magazines were published in both Turkish and French. Additionally, they included sections from the European papers as part of their printed issues. For example, *Hayal-i Cedid* published illustrations from the weekly Italian humor magazine *Il Papagallo* on its last page. This interaction between the artists and publishers was mutual, of course—not to the extent that the French papers had a section in Ottoman Turkish, but to the extent that they printed cartoons from the revolutionary Ottoman papers in their "foreign caricatures" sections.

9. There is little information available on A. Rigopulos. It is known that he was a foreigner living in Istanbul who worked with Cemil Cem, and his cartoons appeared mainly in *Cem* and *Latife*.

34. A. Rigopulos, *Kalem*, 19 May 1911, 1, 5. [French] *Pear*; [Ottoman] *Product of Internal Affairs*. Portrait of the internal affairs minister Halil Menteşe.

At the beginning of the twentieth century, in the culturally colonized world of the Ottoman Empire, urban intellectuals and politicians blamed the empire's political and economic dependency not merely on the backwardness of the ex-sultan's policies but also on the savage populations inhabiting the borders of the empire for resisting modernity. As for the newly established CUP government, the first decade of the century was mostly about recovering from Abdülhamid II's despotism, liberating the empire from European political domination while remaining loyal to its ideologies, and transforming the state into a socially and politically civilized empire. Modernization was at the center of the social agenda while a critique of Western colonialism dominated the political one. For the Ottoman cartoonists who claimed their respective roles in this modernization process, European symbolism seemed like a perfect medium for conveying the contradictory contexts of Western ideologies. The recurring symbolic references accumulated into an extended discourse that

35. Honoré Daumier, *Le Charivari*, 17 January 1834, 1. [French] *Pears*. Portrait of Louis Philip. Source: Biblioteque Nationale de France.

contributed to the development of a common visual language enriched by European motives that aligned European and Ottoman readers around a new "imagined community."

Young Turks learned from their European counterparts. They adopted the European imagery of the Orient and applied it to their venture. The notion of the "premodern" or "backward" was mostly used in relation to the Arab provinces of the empire during this time. Yet, until the Italian-Ottoman War in Tripolitania, representations of Arabs did not occupy a significant portion of the Ottoman cartoon sphere. It is safe to say that the Hamidian period served as an incubation stage for the Arab stereotype as the Ottomans' other. As we shall see in the next chapter, it was only during and after the trauma of, first, the Balkan War and then the Great War that a more complex and symbolically laden image of the Arab emerged in Ottoman and early republican cartoons.

4

"No Wooden Tongs, No Arab Pashas"

The Imperial Capital and Its Arab Residences in the Revolutionary Press

The nature of the political cartoon and its strength as a medium for creating a broader social construction of reality enabled Ottoman readers to walk around in an imagined world where the unfamiliar became familiar. Such a process required attributing specific and easily recognizable characteristics to different groups within an ethnically diverse society. The pattern of political and social behaviors through which this society articulated its collective experiences created and defined the characteristics of groups. In other words, "received knowledge" and common consensus formed a set of recognizable stereotypes that made not only the international political arena but also the Ottoman Empire's various ethnic groups intelligible to the Ottoman mind (Leerssen 2007, 17–32).

The Ottomans themselves were not exempt from this kind of stereotyping on the part of their European adversaries. While an uncivilized, backward image was attributed to the Ottoman Middle East in the colonial context, Europe was visualized and represented in the Ottoman Empire with a dual nature, as both a beacon of progress and as a political and military rival.

A series of political cartoons that targeted the Arab bureaucrats under the Abdülhamid II government dominated the first year of the 1908 constitutional revolution. These cartoons carry significance in terms of reflecting how the Arab stereotype began to transform from its well-known

romantic representation in Karagöz plots to gradually become the non-national other in an ethnically diversified Ottoman empire. Therefore, this chapter explores the internal aggression toward Arabs living in the capital, Istanbul, at the core of the imperial order. It demonstrates that Ottoman orientalism, in a manner similar to that of Europe, carried—in the words of Rudyard Kipling—the "white man's burden" in favor of a mission civilisatrice, and, later, a nationalist campaign of exclusion. The capital and its Arab society provided a firsthand experience for Ottoman urban intellectuals seeking to manufacture narratives that would consolidate the image of Arab as a non-national scapegoat for the empire's doomed future.

Daily Encounters and Clashing Identities:
Arab Students in Istanbul

During the Hamidian era, the Ottomans' image was established in Europe as the "unspeakable Turk," a way of discrediting Abdülhamid II's rule while isolating the Ottomans from the international political board game. Selim Deringil (1999) describes how Ottoman statesmen tried desperately to prove their position among the great powers by attempting to control both the empire's and the sultan's image. These efforts aimed to contain the damage done by negative representations of the Ottomans as bloodthirsty tyrants by replacing them with positive images on both the external and internal fronts.

External damage control involved a two-step recipe. The sultan's aides covered the first step by offering coverage while reporting to the international press regarding the sultan's position as a legitimate leader similar to those of other empires like Russia and Germany. The second step, which required building a positive image, was delegated to Ottoman representatives abroad. Their task was, on the one hand, to control the critiques against Abdülhamid II by exiled Ottoman intellectuals and, on the other, to monitor and, where possible, manage public events that dealt with the Ottoman image in Europe.

Internal damage control, however, required a more challenging process, where the role of Arabs seemed critical. For one thing, Abdülhamid II was convinced of the necessity of a mission civilisatrice that involved

educational tools within the realm of his empire. *Arabistan* (or "Arabia") emerged as a trope in the Ottoman discourse on civilization and progress. Ottoman reformers, including the sultan himself, viewed the Arab lands as ignorant, socially backward, and economically undeveloped. However, the outcome of the Russian war, the British position protectorate in Egypt, and France's increased influence in the Levant, especially in Beirut, forced the sultan to reinforce the security of his provinces. Such a mission required him to rely on an increasingly professional bureaucracy and a disciplined officer class that would involve Arabs as key players. Nevertheless, the problem was that the Arabs were significantly underrepresented in traditional government and administrative circles.

An additional objective of educating Arabs for the civil service was to invest in a new generation that would remain obedient by embracing the imperial center's values as its own. This would help create a sense of national unity ideologically dependent on Ottomanism and devoted to the sultan. Education stood as an integral apparatus for achieving such a result across the empire's culturally diverse territory. From Selim Deringil (1999, 93) to Akşin Somel (2001, 169–73), scholars of the Ottoman reforms of the late nineteenth and early twentieth centuries have presented a detailed picture of the educational policies restructured under Abdülhamid II that were meant to provide a captive audience available for indoctrination.

As education was undertaken as one of the main apparatuses for sultan's internal image control, two essential educational policies were proposed by the prominent statesman and reformer and modernizer Ahmet Şakir Pasha. He argued that mixed schooling of Muslim and non-Muslim children and exclusive use of the Turkish language would facilitate a loyal and competent state elite (Somel 2001, 169–73; Deringil 1999, 94). His proposals served the palace's goal of impressing European observers with deliberate steps toward modernity, especially in the empire's supposedly uncivilized Arab regions.

Another proposal made by Ahmet Şakir concerned the education of key actors in the distant Arab territories by providing an imperial experience right at the center. Through this mission, he aimed to create ties between the peripheral Arab provinces and Istanbul. He believed this would offer these notables-to-be an opportunity to breed a new generation

of Arab leaders with a sense of Ottoman unity organized around loyalty to the sultan.

Ahmet Şakir's efforts paid off in 1892 when the sultan agreed to issue an imperial decree for the opening of Mekteb-i Aşiret-i Hümayun (Royal Tribal School) in the center of Istanbul. The school was initially planned for training only the siblings and sons of the Arab elite in order to strengthen their allegiance to the central authority. Such loyalty was crucial for the Ottoman palace while contesting the British and French presence that was emerging as a counterinfluence in the Arab provinces (Deringil 1999, 101; Kayalı 1997, 26–30). Eventually, the school's opening was met with enthusiasm by the Arab tribes and other ethnically different traditional Muslim societies of the empire, like Kurds and Albanians.

The impact of Mekteb-i Aşiret-i Hümayun was noteworthy. Soon after its opening, due to high demand, the school expanded its terms of acceptance to include the sons of Kurdish sheiks, especially those who held commanding positions in the irregular Hamidiye cavalry (Deringil 1999, 101).[1] Upon graduation, the education program tended to steer Kurdish boys into Ottoman cavalry units, while Arabs were often trained as civil servants (104). Admission was widened even further to include Albanian pupils. Interest in the school was mostly related to the expectation that its graduates would attend the imperial school, Mekteb-i Sultani, upon successfully completing their coursework. After that, they could choose to continue to the faculty of political science (Mekteb-i Mülkiye) and eventually return to their home provinces as teachers and officials with a certain level of influence in the palace's chain of power. If they were part of the right networks, they could even stay and find a position in the Ottoman court.

As Selim Deringil (1999) and Hasan Kayalı (1997) put it, Mekteb-i Aşiret-i Hümayun was probably the most crucial part of the mission civilisatrice of Hamidian policies that attempted to modernize the uncivilized

1. Based on data from Deringil, we can see that the students were accepted from the *vilayet*s of Aleppo, Syria, Baghdad, Basra, Mosul, Diyarbekir, and Tripoli (four students per vilayet), Yemen and the Hijaz (five students per *vilayet*); and from the *sanjak*s of Bingazi, Jerusalem, and Zor (four students per *sanjak*).

nomadic populations of the empire. However, the cultural colonialism of the palace was directly manifested in the school's management and faculty. Their disdain of their ethnically diverse students, however, served in the long run to widen the gap instead of narrowing it. Deringil's example of the education minister Zühdü Pasha's comments on these students' conduct is noteworthy for demonstrating the ethnic prejudices among the Ottoman educators toward Arab and Kurdish students; in Zühdü Pasha's words, "Many of the students [were] still in their state of nomadism and savagery, they have yet to understand the blessings of civilization" (Deringil 1999, 103). For Zühdü Pasha part of this "savage" behavior consisted of "jumping over the school wall in an attempt to escape" (103). He would emphasize the significance of Friday prayers at the great mosque of the city as an occasion for socialization, which he thought they would appreciate, "as they are people of the desert and have not had much contact with civilized folk" (103).

This perceptual hostility toward the school's ethnically diverse students was not limited to the educational board. Despite the palace's educational efforts, general aggression persisted in the capital toward those from the eastern peripheries of the empire, including these youngsters. Perhaps the long-lasting reproduction of stereotypes, as in the case of white Arabs who were represented in the Karagöz plays as unpleasant and bitter characters, had some part to play. Whatever the cause, the gossip that circulated around the streets of the capital looked down upon these Arab and Kurdish students as "savages"—a source of discomfort, and an obstacle to modern life in the capital.

Interestingly, a similar tension existed between the students from competing Arab and Kurdish tribes. Resistance to the cultural and political assimilation promoted by the curriculum manifested itself through regular conflicts that emerged from both inside and outside of school. In one such incident, Arab and Kurdish students had been "involved in a fight using stones, shoes, and fists, resulting in light injuries to four Kurds and six Arabs" (Deringil 1999, 103). The extent of the violence required Zühdü Pasha, the minister of education, to intervene with a military escort.

In a short while, as a strategy to boost the sultan's centralization efforts in the sphere of education, through the Mekteb-i Aşiret-i Hümayun,

backfired. Instead, it marginalized these young students, especially the Arabs, whose social isolation caused them to stick together instead of adapting to urban life in the capital. Inevitably, these students met within their own fraternities and sometimes introduced each other to circles that instilled an ethnic consciousness into an Arab identity that contributed to the ethnic tension in the capital's cultural centers (Kayalı 1997, 48–49).

The school's fifteen-year existence came to an end in 1907. The closure was due to the outcome of a food riot that went out of control. However, the rumors were that the school's shuttering might perhaps have been a rush to suppress nascent Arab nationalism, or the spread of Young Turk propaganda, since tensions were rising in the capital among the intellectual circles to which these students were drawn.

There is likely a great deal of truth to these rumors. Even after its closure, the school's legacy of students' involvement in nationalistic endeavors persisted. The efforts of former students in the Arab nationalist revival continued under the palace's massive surveillance. They would hold meetings in various venues suited for crowded gatherings; on many occasions coffeehouses owned by Arabs supporting their cause would serve this purpose. The need for such organized activity of Arab students became even more evident after the declaration of the second constitution in 1908.

Following the Young Turk revolution, the Arab functionaries who had served in the Hamidian regime became public targets. Although they and their houses would be attacked anonymously, such attacks were not carried out against Ottoman Turks who had served the old regime. The apparent discontent among the public against the Arab residents of the capital carried qualities of ethnic discrimination very much based in the Hamidian policies toward Arab rapprochement.

Postrevolutionary developments mobilized the deposed Arab bureaucrats and students to start an organization to defend Arab interests within the empire. The Arab-Ottoman Brotherhood (al-Ikha' al-Arabic al-Uthmani) was the first Arab society established in Istanbul after the Young Turk revolution (Kayalı 1997, 68–69; Tauber 1993, 61–62). Though the club welcomed a large number of Arab students as members, it was short lived. Following the 1909 countercoup organized by Abdülhamid II,

the society's activities came under even greater scrutiny. The CUP government knew that most of the society's branches in the major Arab vilayets had supported the counterrevolution and the restoration of Abdülhamid II's position.

Consequently, the Arab-Ottoman Brotherhood became one of the main targets of activities disavowing Arabs under the parliamentary regime of the CUP. The society was dissolved directly after the issuance of a "law of associations" on 16 August 1909 that forbade people from setting up "political societies on the basis of nationalism or incorporating the names of races" (Kayalı 1997, 76; Tauber 1993, 65). Of course, similar to the Young Turks' experience under Abdülhamid II's despotic rule, such restrictions ended up marginalizing underprivileged ethnic groups and creating venues for underground activities. The case of the Arabs was no different. Under pressure from the government and, at the same time, moved by nationalist ideas, they did not hesitate to integrate their secret associations in the capital's political, cultural, and social circles. One of these societies was the Literary Club (1910), an open association for Arab students in Istanbul to discuss their culture and heritage rather than "wandering around idly in Istanbul's streets trying to be like the Turks" (Tauber 1993, 101). The club was established by an Arab student from Damascus, Abd al-Karim Qasim al-Khalil, who later became a prominent Arab nationalist.

Although when these societies first formed they saw themselves as part of an Ottoman unity, CUP policies polarized relations between the two ethnic groups, resulting in Arabs developing separatist tendencies under the auspices of nationalism. As Eliezer Tauber (1993, 105) highlights, by the 1910s the idea of Arab independence became so overwhelming that the students designed an Arab flag to display on their club's wall during their meetings: four horizontal stripes, the top one white, followed by black, green, and red.

Another account of events that demonstrates the tensions between Arab students and the capital's residents took place when, in March 1910, the Ottoman newspaper *Iqdam* published a highly critical article on Yemen that insulted Arabs in general, describing them as camel drivers

who lacked any notion of honor or loyalty. It referred to Yemeni Arabs in particular as money-lovers who would "sacrifice anything for money, even the honor of women" (Tauber 1993, 105). The article created great anger among Istanbul's young Arab population, which held a fiery demonstration against the newspaper's owner and the article's author. One of many of such events, the demonstration added more fuel to the fire in the capital, where residents and the press worked together to try and detach Arab society from the its center.

Arab Bureaucrats in the Ottoman Court

Glass walls between Ottoman Turks and Arabs were erected in the government and military spheres as well. Throughout Ottoman history, Arabs had been absent from top government and military positions. Their gradual involvement in the government's political hierarchy began only in the late nineteenth century under the First Constitutional Monarchy, when they were inaugurated as members of parliament to represent the Arab provinces of the empire. During the two terms of the first parliament, only 12 percent of the incumbencies belonged to Arabs. The atmosphere in the parliamentary meetings was rather different than on the streets, especially when it came to expressing ethnic or national positions. At the time, there was no demonstration of a common interest in building a collective Arab idea (Kayalı 1997, 26–30).

The limited involvement of the Arab political elite in the Ottoman bureaucracy changed under Abdülhamid II's rule. After he dissolved the parliamentary system in 1878, he placed new emphasis on Islam, as one of the fundamental ingredients of Ottomanism, and his role as the caliph. This new religious emphasis magnified the diplomatically biased position of Arabistan and its people toward the sultan. Unlike previous configurations of the empire's political and military echelons, the new Ottoman governmental structure now assigned prominent roles to Arabs. Among them was Ahmad İzzet al-Abid Pasha, an influential Arab from Damascus who held a position as Abdülhamid II's close adviser, in charge of all Arabic correspondences; he later became the head of the sultan's personal intelligence organization at Yıldız Palace. Necib Melhame Pasha, a

Maronite from Lebanon, had been the official head of the sultan's secret police in charge of his personal safety, and his brother Selim Melhame Pasha was appointed minister of agriculture, mining, and forestry (Seal 2010, 55–56). Similar appointments were given to other Arab bureaucrats who preserved close ties to their families in the Arab provinces.

This network was significant to the sultan for two reasons. First, he wanted to directly control the commercial and political centers of the Levant like Damascus and Beirut. Second, the Arabs' integration into the Ottoman political system would help him to maintain Arab public support for his claim as the rightful caliph. This rather challenging position of the "caliph of all Muslims" was found exceptionable at the time, especially among the *Salafi* circles led by prominent Islamic thinkers such as Muhammad Abduh and Rashid Rida. For the palace generally, and the sultan specifically, consolidating his religious position played a critical domestic role while serving as a point of leverage against his European rivals. Any attacks from the Arabs in general would jeopardize the sultan's image even further.

Inside the empire, especially in Istanbul, the political arena was contested by the supporters of the sultan and the Young Turk opposition. At the same time, the intellectual arena was shaped by debates among Islamists, Westernists, Ottomanists, Arabists, and Turkists. As C. Ernest Dawn (1991) has pointed out, the latter was still limited to a decided minority, and, prior to 1908, their ideology was mainly centered around Ottomanism without any Turkish bias. Indeed, these competing ideologies occupied only a minority of the total population, mostly limited to middle-class professionals who had access to printed media. However, on the street, or in the close circles of the Young Turks, the unspoken tension between Arabs and Turks was expressed through vernacular means.

On the part of the Ottoman administration, there was general discontent with the Arab bureaucrats. Şükrü Hanioğlu (1991, 31–32) notes the tendency among the higher ranks of the CUP to disparage Arabs as an inferior ethnic group despite their claim for all ethnic groups of the Ottoman Empire being equal, with no difference between Arabs and Turks; thus, they considered it normal for all groups to want to develop their ethnic cultures. On the other hand, in the private correspondence of two

prominent members of the party, Nazım Bey, who helped to reorganize the CUP in 1906, and İshak Sükuti, one of its five founding members, this hostility was expressed through belittling phrases like "the dogs of the Turkish nation."

This antagonism toward Arabs, fused with Abdülhamid II's opposition in diaspora and among the public, was becoming more apparent in the streets of the Ottoman capital, where it made itself palpably evident in various popular forms. Expressions like *Tahtadan masa Arapdan paşa olmaz* (No wooden tongs, no Arab pashas) started to circulate among the public, conveying discontent with the regime and the Arabs occupying its various administrative ranks.

Following the revolution and the new CUP government's relaxation of the heavy restrictions on the press, it did not take long for these expressions to find their way into the political cartoon space. Fervent propaganda against the bureaucrats who were part of Abdülhamid II's absolutist rule now appeared in all kinds of media, with Arab administrators being the most actively targeted. The illustrated papers and posters magnified the negative image of Arabs by featuring cartoon narratives of these bureaucrats like Arab İzzet, Selim and Nejib Melhame pashas and their cunning, selfish acts.[2] As the CUP removed the sultan from his position as the head of the government, these bureaucrats were all accused by the Young Turk officers of high treason and corruption (Haydaroğlu 1997, 121–26). For example, a treatise written on Abdülhamid II's espionage network in 1909 demonstrated in detail the criminal acts of these Arab pashas. An account of İzzet Pasha described how he had tortured a group of Young Turks prisoners held at Yıdız Palace in 1896 without any specific charges and similarly destroyed many other families along the way (121).

2. Turgut Çeviker's ([1908] 1991c) *İbret Albümü* (Exemplary Album) offers a collection of these posters printed under the new Young Turk government that aimed at denouncing Abdülhamid II's corrupt pashas to an awakening public. The collection is significant for its categorizations of these propaganda posters by each individual targeted, which gives the reader a chance to grasp the entirety of whatever had been released on that specific person.

Public Disowning of the Arab Pashas

Targeting of the Arab bureaucrats dominated the central message of the many cartoons that followed the revolution. One might not be surprised by the grievances that the Young Turk officers held against these Arab administrators; after all, they were the ones who had acted on behalf of the sultan to eliminate the Young Turk opposition, both inside and outside the empire. For example, one cartoon demonstrated how Arab İzzet Pasha had expanded his network of spies to control every institution that might provide support to the Young Turk opposition including the school of medicine, the school of engineering, and the polytechnic school. The tentacles of a personified octopus with an outsized facial portrait of İzzet Pasha holding each one of these institutions tightly along with other non-Muslim opponents (Armenians and liberal intellectuals) communicated the deeds of the doomed sultan and his entourage to the larger public (fig. 36).

The hatred and humiliation of the Arab bureaucrats in these cartoons were ruthless and severe. Of course, the escape of these Arab pashas to Europe right before the 1908 Revolution prevented the CUP government from putting them on trial for the crimes of which they were accused. Moreover, in the cartoons, it seemed like their punishment was left to the public through imaginary means. They were sentenced to be held in the memories of many as corrupt, vampiric creatures, judged and condemned by public opinion and executed by cartoonists' brushes.[3] These visual illustrations were published bilingually in Ottoman Turkish and French, but, in some cases, a note in Russian or Armenian was added. Such propaganda aimed to reach all the Muslim and non-Muslim ethnic communities of the capital. Amid the emotional upheaval of revolution, the Young Turks' prejudice against Arabs revealed itself within such demonized portrayals that set the Arab stereotype in stone (fig. 37).

3. These images were almost inescapably similar to what was assigned to Abdülhamid II in the Western cartoon press.

36. *Arab Izzet's Deception.* Card postal, Ottoman Revolutionary Press, 1908. Istanbul Metropolitan Taksim Atatürk Library Collection, *İbret Albümü*, 61. With the courtesy of Turgut Çeviker.

While these cartoon illustrations mainly appeared as independent publications containing a single narrative, some were distributed as part of a series called *Les Vampires* that featured Arab İzzet, as İzzet Pasha was called, and Selim Melhame Pasha (figs. 38–40), thus indicating the Young Turks' particular dislike for these two Arab bureaucrats. The cartoons were designed in two parts, divided vertically. The section on the left included an illustration of the pashas getting caught committing their crime. For example, Arab İzzet was shown bending over two skeletons that symbolized the lives he had taken during his term in office; Selim, for his part, was displayed with the moneybags he had stolen. The section on the right contained verses in French condemning all their misdeeds, as though publicly sentencing them for their crimes.

Political cartoons in newspapers were no less effective than printed posters in ensuring the visual executions of the Arabs. From *Karagöz*

37. "Let's see if the vicious Izzet will be able to con the death itself?"
Card postal, Ottoman Revolutionary Press, 1908. Istanbul Metropolitan
Taksim Atatürk Library Collection, *İbret Albümü*, 72. With courtesy of
Turgut Çeviker.

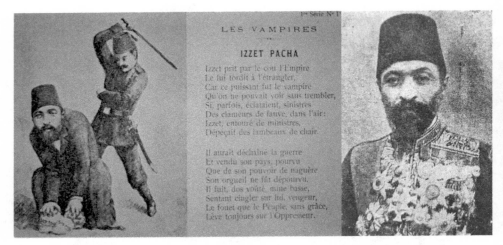

38. *Vampires: Izzet Pasha.* Card postal series no. 1, Ottoman Revolutionary Press, 1908. Istanbul Metropolitan Taksim Atatürk Library Collection, *İbret Albümü*, 60. With courtesy of Turgut Çeviker.

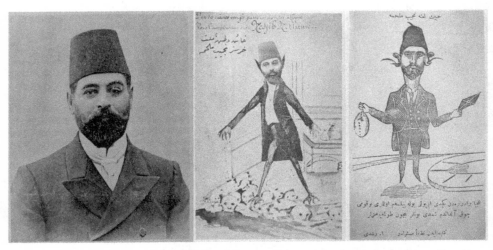

39. *A Traitor and a Thief, Necib Melhame.* [The original word used is *millet-i hırsız*, which translates as "the people of the thieves," referring to the Arabs in general.] Card postal series, Ottoman Revolutionary Press, 1908. Istanbul Metropolitan Taksim Atatürk Library Collection, *İbret Albümü*, 98–99. With courtesy of Turgut Çeviker.

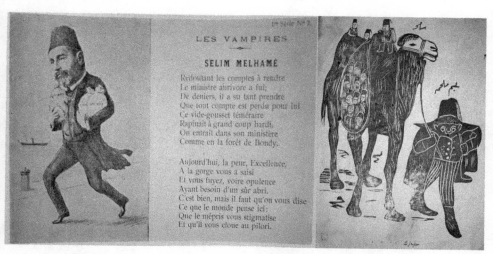

40. *Vampires: Selim Melhame.* Card postal series no. 2, Ottoman Revolutionary Press, 1908. Istanbul Metropolitan Taksim Atatürk Library Collection, *İbret Albümü*, 94. With courtesy of Turgut Çeviker.

to *Kalem*, all the papers used similar themes and imagery in their condemnation of these once-popular bureaucrats of Abdülhamid II. *Kalem's* first issue, in August 1908, a month after the revolution, opened with two sequential and complementary cartoons. The first featured Rıza Tevfik, an Ottoman and later Turkish philosopher, poet, a politician of liberal persuasion and an opinion leader in the Young Turk movement. In the issue, he was depicted in a museum-like setting, showing several young Ottoman students the mummified pashas of the Hamidian era in a glass display (including Arab İzzet). The cartoon's bilingual commentary conveyed these pashas' corrupt nature by comparing their craving for wealth to the hunger of an elephant. A second cartoon on the following page carried the reader into the fictional narrative behind the mummified pashas. The caption read "Caravane des voleurs—une surprise épouvantable!" (Caravan of thieves—a dreadful surprise!). In an elegantly designed single frame, the anonymous artist depicted the same administrators being caught by a lion (representing CUP) in a landscape where a palm tree, a caravan of camels, and bare rocky ground fixes the scene geographically as somewhere in the Arab provinces (figs. 41–42).

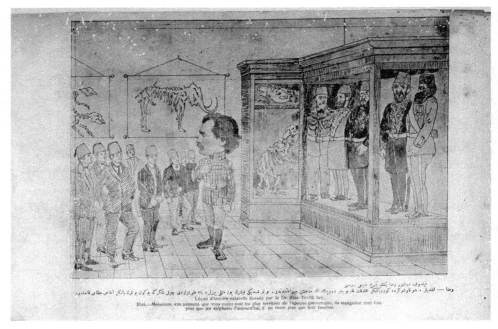

41. *Kalem*, 21 August 1908, 6. [Ottoman] Natural science history lessons given by Rıza Tevfik Bey.

The dominant current of nationalism, which aimed to create a sense of homogeneity within the empire, empowered the CUP's assimilationist policies in a colonial sense that can be summarized as "The Turks have conquered Arab lands with their swords and they—the Arabs—must all know that they are Turks." This psychological boundary in the Ottomans' mind functioned as a barrier against the supposedly wild nature of the Arabs, for, as Edward Said writes in *Culture and Imperialism* (1994, 52), "no identity can ever exist by itself and without an array of opposites, negatives, oppositions: Greeks always require barbarians, and Europeans Africans, Orientals." The increased presence of Arabs in the political, cultural, and social circles of Istanbul was perceived as a violation of these boundaries, which had been tacitly negotiated between the state and Ottoman society. However, as Inge E. Boer (2006, 10) argues, boundaries are "negotiated in a process that does not end with the provisional designation of a boundary." The boundary is arbitrary in character, temporary and

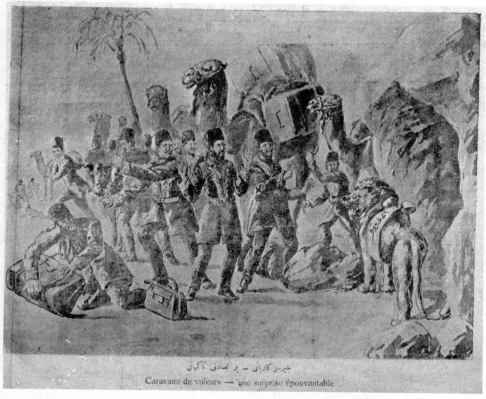

خبر کاروانی — بر تصادف آگمان

Caravane de voleurs — une surprise épouvantable

42. *Kalem*, 21 August 1908, 5. [Ottoman] *Caravans of Thieves*.

changeable. And when it is crossed or challenged in a society with rigid perceptional lines, as was the case with Arabs in the Ottoman capital, it gives rise to complications.

These negotiations were made manifest in the cartoons aiming at those who were undermined: the Arabs of the capital and the periphery. The cartoons targeting the Arab functionaries of the Ottoman court carried the harshest propaganda, using visual metaphors to manipulate public opinion and deflate the pomposity of Abdülhamid II's bureaucracy. Cartoons that symbolically linked Arabs to corruption exemplified with hallucinatory flair how the social hierarchies of everyday life were being profaned and overturned. The Arab pashas were turned into a group of fools existing in a chaotic world, portrayed in binary oppositions of good

and evil, loyal and disloyal, honest and corrupt. In an effort to undercut Abdülhamid II's policies, the cartoons skillfully emphasized the absence of Ottoman values and traits among the Arab subjects of the empire, whose Arabness was associated with the characteristics of snakes, sea monsters, vampires, devil-fish, and wild beasts, thus combining prejudices that were widely shared at the time among the Ottoman Turkish citizens of the capital.

Administering the Empire: The Committee of Union and Progress (CUP)

During his reign, Abdülhamid II personally managed intelligence affairs. But, as with the Melhame brothers and Arab İzzet Pasha, he appointed Arab functionaries to key positions in his spy network. This body of informants, also known as the Yıldız Intelligence Organization, was an obstacle to the organizing efforts of the Young Turks during the prerevolutionary period. After the revolution, this network became one of their prime targets and, like many others, was dissolved after the proclamation of the Second Constitutional Monarchy.

Despite the changes that the CUP promised, it did not take long to replace Abdülhamid II's spy network with their own. The network's main aim was to track the activities of minority groups in the empire with nationalist intentions. In the following years, this intelligence network would grow into the famous Teşkilat-i Mahsusa (Ottoman Special Organization), nominally affiliated with the Grand Vizier but acting more or less independently.

The Ottoman Special Organization's activities were not welcomed by either the empire's Arab circles or the Ottoman intellectuals, and the new government was criticized for behaving too much like its predecessor. Meanwhile, the inner political struggles in Istanbul were aggravated by policy failures in Fezzan, Trablusgarb, and Benghazi (today's Libya). The CUP government's intolerance of any extra conflict within its jurisdiction meant increased spying activity over the minorities of the empire who were involved in separatist movements. At the time, almost all minority associations came under the surveillance of CUP spies.

43. *Kalem*, 11 May 1911, 8. *Monkey!! Tell Me Who Am I?*

The political cartoon press raised a red flag, critiquing the new CUP government by making persistent comparisons between the CUP and the Hamidian regimes. In May 1911, *Kalem* published a cartoon (fig. 43) by Scarcelli titled *Maymunun muhtelif çehreleri* (The Monkey's Various Faces). The monkey soon emerged as the favored symbolic representation

44. Youssouf Franco Bey, *Consultative Menagerie*, January 1885. *Youssouf Bey: The Charged Portraits of Fin de Siècle*, Ömer M. Koç Collection.

of Abdülhamid II's spies, especially the Arab ones (figs. 44–45). Scarelli wanted to emphasize that the CUP's failing policies produced outcomes similar to those of the Hamidian era, and he did so by drawing various ethnic and European stereotypes of the empire that worked once for Abdülhamid II's and now for CUP's intelligence organization. The cartoon demonstrates the shifting images of the ex-Hamidian government's spy network from different ethnic backgrounds, such as the Arab, puzzling the reader by stating: "Monkey!! That I was!!" ("Monkey" holds a special meaning here). He reveals his contemporary identity by graphically stating who he is today ("Who I am!"), as a CUP bureaucrat. What was significant about the cartoon was the representation of the Arab, whether with his keffiyeh or his fez, as a central figure of the Hamidian

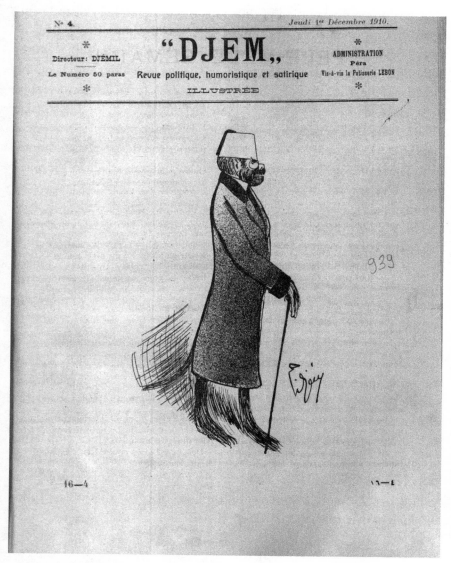

45. Cemil Cem, *Djem*, 1 December 1910, 1.

spy network. The stereotyping of the Arabs centered on the uncertainty of whether or not their interests lay with the empire, and it was this, in a certain sense, that made them potential allies of the empire's European rivals, who were firmly positioned against Ottoman interests.

The Ottoman revolution of 1908 was inspired mainly by liberal prin-
ciples of a representative government that would undermine the legiti-
macy of dynastic absolutism. Yet nationalism and nation-building, which,
under the CUP had become the main survival strategy for the old empire,
threatened the delicate configuration among its polyglot and diverse sub-
jects. The exiled young officers and intellectuals that sought to challenge
Abdülhamid II's absolutism were driven by liberal concepts such as *millet*
(nation) and *hürriyet* (freedom) in envisioning the future of their home-
land. Those who challenged the sultan's authority were driven by the ques-
tions "Who are we?" and "Where is the nation?" Unlike the traditional
Ottoman ruling class, who would use the term *Türk* to describe the peas-
ants of Anatolia, these new professional bureaucrats defined themselves as
the Young Turks, a name imposed on them by their European hosts while
in exile. Their goal was to transform the crumbling empire into a modern
state based on a shared sense of commitment among its citizens and suffi-
cient military and political strength to halt the encroachment of European
powers. 1908 saw these ideas come to power.

Although the Young Turks brought back the constitution and the par-
liament in 1908, they were divided within their constitutional visions. A lib-
eral wing, *Teşebbüs-i Şahsi ve Adem-i Merkeziyet Cemiyeti*, was established
among the Young Turks by Abdülhamid II's nephew Prince Sabahattin,
who became one of the most vital members of the Young Turk movement.
As a liberal himself, his debates highlighted the need for decentralization
and autonomy for non-Turkish ethnic minorities, including the Arab prov-
inces (Berkes 1999, 310–12).[4] However, the CUP's dominant tendency was
seeking unity around a more centralized authority with Ottoman Turks'
domination over the national sphere (Lewis 2001, 214).

4. According to Sabahaddin, the Abdülhamid II tyranny was not the cause of Turk-
ish grievances but the product of certain features in society; the real need was to change
society itself. He formulated an ideology around the teachings of Demonins, who argued
that societies belong to two major social types: one founded on *formation communitaire*,
and the other on *formation particulariste*. Based on this, Sabahaddin proposed the forma-
tion of a decentralized government and administration with local governments extend-
ing to the villages, along with a new education system.

This struggle among different political tendencies was expressed in a political cartoon by L'Andres in the weekly *Alem* (1909), once more investing in the reproduction of Arab stereotype. The cartoon demonstrated a brawl between two rival parties, *Fırka-ı Ahrar* (The Liberal Union) and the CUP (fig. 46). The cartoon's narrative was designed around two Young Turk figures placed in a medallion labeled bilingually as Istanbul (Ottoman reference) and Constantinople (European reference), implying the East versus West binary. The fighting figures were simply the two political parties, Union Liberale (The Liberal Union) and Union et Progres (CUP), struggling to push each other out of the political frame. The Turkish caption of the cartoon summarized the narrative as "The last portrait of the revolution," intended as a critique of both parties for being more concerned with their own political positions than with the conflicts surrounding the empire.

The French caption satirized the CUP in a commentary text: "Unissons-nous! Unisson-nous!" (Let's unite! Let's unite!), ironizing the Young Turks' initial manifesto, which called for a parliament equally

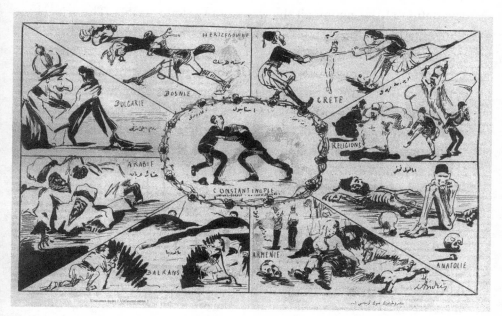

46. *Alem*, 16 March 1909, 9. [Ottoman] "The last portrait of the revolution."

representative of the empire's various ethnic and religious groups. The cartoon revealed an alternative story, depicting the various challenges raised in the Ottoman territories as threats to the CUP's initial declaration for integration. The artist encircled the central medallion with a chaotic atmosphere, keenly suggesting the capital's unawareness of how the Ottoman Empire was being shattered by the nationalist or religious tendencies fueled by liberal ideas symbolically represented in the puppet "Liberty" held by Prince Ferdinand. The same ideas that once empowered CUP members to organize the Young Turk revolution were now the ideas most resisted.

Essentially, the cartoon mocked the two political parties for fighting to pursue a centralized versus a decentralized administration while ignoring the fact that all territories of the empire were being torn apart for various reasons. The borders of the homeland seem to have been fuzzy for the artist, as they were for the Young Turks. Neither the idea of *vatan* (homeland) nor an actually existing *vatan*—where a nation could emerge—clearly existed. The cartoon depicted each of the regions under Ottoman rule as they confronted their ends, revealing the tribulations and devastation of the empire all the way from Crete to Arabia. The critical representation of the empires' stereotypes of the non-Turkish and non-Muslim populations was positioned in relation to these external and internal conflicts. The representations of Arabs in the two different sections of the cartoon's frame associate them with uncivilized manners. In their plain white garb, they either massacre the members of different religions with the symbolic "sword of Islam" or else kill each other with stones in tribal conflicts. The artist presented his imagined reality as composed of Islamism and cynicism, likely related to CUP intellectuals' criticisms of the *ümmet*, (the nation of Islam) and the Islamic *din-u-devlet*, which they challenged with the concept of Ottomanism centered on Turkishness (Lewis 2001, 318; Zeine 1973, 75–76).

A similar representation of the stereotypically vicious Arab appeared in an earlier cartoon, published in *Boşboğaz ve Güllabi* on 19 October 1908. The similarities with the cartoon in *Alem* are so obvious that one might easily think one was copied from the other. However, the context in *Boşboğaz* differed slightly. *Alem*'s positioning of the Arabs was part of an

inner conflict reflecting the disputed regions circling the central government; *Boşboğaz*'s portrayal of the Arab stereotype, however, was built in relation to an external conflict with Europe. The scene is set against an orientalist landscape decorated with distant palm trees. In a caption, a young woman labeled as *Avrupa* (Europe, text next to the figure and on the keffiyeh) stands under the arches of an oriental building reading a book on *al-jazirat*. The term *al-jazirat* (in Arabic al-Jazira, meaning "the

47. *Boşboğaz*, 6 August 1908, 3. [Ottoman] "Morocco . . . !?"

island") is the common abbreviation for "al-jazira al-'arabiyya," or the Arab peninsula (Ochsenwald 1991, 203; Ahmed 1986, 188). Contradicting the book's title, the text attached to the illustration (fig. 47) declares the scene's geographic location as "*Fas . . . !*" (Morocco).

The sloppy manner in which the woman wears the traditional Arabic headgear, the keffiyeh, reveals her gratuitous effort to romanticize the oriental East. In a binary opposition, the real nature of the Orient is revealed in the background, where the two Arabs are struggling to kill each other, denoted by the Arab's symbolic curvy sword. Standing from where the cartoon was produced—namely, an artist's house in Istanbul—the drawing reflects the postrevolutionary perception of the Ottoman Arab lands in North Africa. It criticizes both the Europeans and the Arabs, putting the Ottoman Turks in a defensive position against the imperialist propaganda that emerged mainly in France and Britain. The cartoon works as a manifesto against those imagining the Orient as an umbrella geography with a single community composed of Arabs, symbolically arguing against Europe's conceptual fuzziness regarding the location of the Near East and the true nature of its people.

Under the CUP, ethnic prejudice against the Arabs living in the periphery of the empire took a different direction. Revolving around political matters and the imperial balance of power, Arabs in their traditional outfits became the symbol of barbarism, as typically portrayed through their willingness to cut one another's throats. This image reflected the Young Turks' ethnocentrism in blaming the out-group and vindicating the in-group, according to the postrevolutionary point of view. It aimed to tear back the oriental curtain the West employed to culturally subjugate the Ottoman East by framing the Arabs as the epitome of the uncivilized.

5

From Ottoman Center
to Arab Periphery

The Arabs of Yemen, Tripolitania, and Egypt

The pan-Islamic policies of Sultan Abdülhamid II between 1878 and 1908, and, later, of the CUP between 1908 and 1918, attempted to formulate bonds between the empire's ethnically diverse Muslims (Turks, Arabs, Albanians, and Kurds). After the success of the Young Turk revolution, Europe expected that a revolutionary regime wedded to liberal constitutionalism and progress would not seek to profit from the revivalist pan-Islamic movement. However, the CUP's efforts on behalf of reform and centralization in 1912–13 did not produce the expected outcome, and it was not long before the CUP began to reveal tendencies toward pan-Islamism; as the war years (1914–18) brought the empire to an end, the CUP proved to be as fervent advocates of pan-Islamism as Abdülhamid II had been.

During this period, significant political and military encounters took place between the Ottoman empire and their imperial rivals over the empire's Arab territories. Among those, three events received substantial attention in the daily news and political cartoon press: the revolt in Yemen in 1911, resistance against the Italians in North Africa (1910–12), and the confrontation with the British in Egypt (1915–18). The content of this coverage varied from criticizing the empire's extensive borders to applauding its interwar policies with the singular aim of making the nation memorable. In these cartoons, Arabs' identification as part of the national type was often indistinct, even obscure, bringing to mind the question of where their (Arab) loyalty resided—in a religious unity with their fellow Muslims, or in an ethnic unity according to their Arabness?

159

To convince audiences of the former, the cartoons concerning the border Arab provinces attempted to secure the empire's continuity by undermining the violent postrevolutionary communication between Turks and Arabs. Instead, they tended to delineate the Arabs in their remoteness to modernity, but as still part of a pan-Islamic unity, their ethnically assigned features of remoteness and distance most often suggested by their outfits and their physical appearance (facial hair being the significant element). However, in cases where the cartoonist made the Arab the focus of the composition, he might prefer to satirize him through the use of landscape and animal symbolisms, locking in his association with them forever. The latter technique was widely adopted, especially during this period of highly complicated military and diplomatic campaigns.

Landscape and Animal Symbolism
in Ottoman Political Cartoons

To understand any specific genre of representation, we must address how its producers formulate their images, particularly the kinds of information they rely upon to create their abbreviated, encoded language of symbols. In the case of political cartoons, symbols are especially essential. Political cartoonists generally select, manipulate, and emphasize physical features to distinguish their subjects or their narratives. This act of distillation separates the foreign subject from the original, the barbaric from the civilized—or, in the specific context of this book, the Arab from the Ottoman Turk. Stereotypes are one way of establishing these recognizable contrasting features, codes of behavior, common attributes, and, in fact, the entire complex of received ideas about the other.

With the 1908 Revolution, the physiognomic and racial features of Arab identity had become ingrained in the political cartoon press as part of Young Turk propaganda. After all, the humor not only functions to express aggression but also to strengthen the morale of those who use it and undermine the morale of those against whom it is aimed. This power was employed to reinforce an ideology that revolved around a concept of the nation that identified itself with Turkism, defining the empire as the government of Turks and excluding the Arabs from the political center.

The political cartoons created by Young Turk artists utilized the distinguishing physical features of Arabs as part of the process of alterity. With this artistic license came the challenge of establishing a visual code for the representation of the Arab that would be immediately identifiable to the Ottoman public. In a fashion reminiscent of the physiognomics of Aristotle, the cartoonists draw their figures from "movements, shapes, and colors, and from habits as appearing in the face, from the growth of hair, from the smoothness of the skin, from [dialect], from the condition of flesh, from parts and general character of the body" (Hett 1955, 93). For example, the Karagöz plays' white Arab character, with his pointy nose and goatee under his keffiyeh, succeed in part because of physiognomic and stylistic resemblances—details that, in cartoons, may assume almost metonymic significance. Yet, for such an image to work as humor, there must be sufficient knowledge of both the subject's physiognomy and the visual codes established through repetition. For example, among the number of political cartoons concerning Arab stereotypes, only about half of them are identifiable with historical figures. The rest are anonymous, fictional types, common men identified as members of a particular group by their appearance, actions, attitudes, and speech.

However, what strengthened the relationship of these personae with the suggested geographies of the Levant and North Africa is the simultaneous employment of landscape symbolism. Landscapes work as anchors that connect the communities to a certain geography. Gary Backhause (2009, 7) claims that landscapes carry significant symbolic meanings from one medium into another. For example, a desert refers to an entity that one can experience, remember, or imagine. Such apprehension of a material entity is a way of embodying the given landscape's symbolic meaning within its situational relevance. Most of the revolutionary cartoonists had never been in the geographies that they were portraying in their compositions, yet they knew how perceptions allowed one to take a symbol from its origins as a concept all the way to its fulfillment as something vividly imagined.

If the orientalism of Delacroix and Deschamps found its power in the vivid representations of human figures, landscape symbolism loomed even larger in the second half of the nineteenth century. The panoramas and site scenes in the artists' travels set the groundwork for oriental

landscape symbolism for most of the cartoonists from the urban centers of Europe to Istanbul. Distinct features of landscape, such as desert and palm trees, lent themselves perfectly for expressing symbolic contextual meanings that transcended their empirical definitions. Similarly, a symbolic landscape embraces the object of reference—for instance, a palm tree as a medium of cultural imagination, or a pyramid for historical imagination—and thereby integrates it into the act of symbolic reflection.

This process also makes it possible for various animal figures to similarly embody popular national stereotypes. For example, a camel evokes in one's mind the deserts of the Arabian Peninsula or Sinai, just as the crocodile could be associated with the Nile river in Egypt; both could serve perfectly in the creative metaphorical capacity of the human mind as a physical manifestation of ideas, or even phenomena. Of course, such productions would gain traction during extended periods of literary and visual displays, such as the images of a palm tree and a camel that shared the stage with the white Arab character in Karagöz performances. Similar to the theatrical representation of Karagöz plays, the same landscape collages were depicted alongside the corrupt Arab pashas in revolutionary political cartoons to expose their ethnic backgrounds and bind them to the cultural values presented by these landscapes.

Since Claude Lévi-Strauss made his classic observation in *The Savage Mind* (1966) on the homology between animal categories and social classification, a large body of research on animals as social metaphors has accumulated. Following the line of research developed by Mary Douglas (1999) and Edmund Leach (1964), a considerable part of the debate has focused on the fact that some animals, because of their strong symbolic and metaphoric connotations, are used more than others. This metaphorism became very common in the political cartoon production, especially, of the Victorian period, that used them as proxies for human races. In British political cartoons, animal symbolism emerged as part of a relational construction of Britain's diplomatic dealings. For example, the lion, known as the king of the animal world, with its strength, masculinity, and grandeur, symbolized British collective identity built around the monarchy. On the other hand, the Russians, one of Britain's main rivals concerning the Eastern Question, were represented as bears, with

reference to their untamed and wild nature in an enormous body (i.e., its geographical size).

The symbolic significance of animals is sometimes obvious and primal, such as those associated with characteristics like warfare, wisdom, or specific behaviors, while in other cases animals are used as symbols for complex or abstract ideas and beliefs. Sometimes these animal characteristics will be projected onto other groups in a colonial spirit as a way of discrediting them, as with the Britain portrayal of the Irish as vicious gorillas, or the Ottoman Empire as the animal Turkey.

These artistic techniques of landscape and animal symbolism generated among the British cartoonists were adopted in no time by the Ottoman cartoonists as well. Providing them with a short-cut stereotyping of various ethnic and national identities amid complex diplomatic pre–world war developments. Both as creators and publishers, they subscribed to this production model as the interaction of a vast array of categories of human types in which they commonly classified and reduced social and cultural groups for the representation of national others, presenting the average Ottoman reader with an imagined reality of those being represented.

The Empire's Arab Provinces in Its Final Epoch

After the nineteenth century, the European powers' ambition for regional expansion, especially in the lands under Ottoman rule, grew into a raison d'être with ever-greater audacity (Ross 1922, 307–19; Zeevi 2004, 73–94; Lewis 2002, 324). The 1877 Ottoman defeat by Russia triggered a change in the balance of powers that now favored British, French, and Russian interests in North Africa and the Levant and left the Ottomans bitter and disgraced. Britain, especially, turned the Eastern question into a referendum against the Ottomans and supported campaigns with a media onslaught that highlighted uprisings in the Balkans and the preceding war with Russia (Auchterlonie 2001, 10).[1] Public opinion in England no longer

1. Propaganda in Europe, specifically by Britain, followed the harsh measures taken by the Ottoman government to crush the uprisings.

held that the integrity of the Ottoman Empire served British interests. A storm of moral anger descended upon the European public when the press described the Ottomans as the "most cruel and mischievous despotism on Earth" (Auchterlonie 2001, 11). The conquest of Algeria by France (1830s) and Egypt by Britain (1880s) clearly manifested these trends.

The 1908 Revolution reverberated in foreign relations with European powers. The British and French, who favored the Young Turks in their struggle against Abdülhamid II, took a short break from their quest to protect their Muslim subjects in the colonies from the sultan's call for Islamic unity. The CUP's initial policies were pro-British and undermined relations with Germany, which had been strengthened during Abdülhamid II's reign. There were only a few officers, notably Enver Pasha, who favored a German alliance. The Austro-German-Ottoman rapprochement orchestrated by Abdülhamid II had endangered Britain's interests in the Suez Canal and the Persian Gulf while threatening French trade routes in Syrian ports. On the eastern front, it had enraged the Russians, who feared they would lose direct access to the Mediterranean (Ross 1922, 310). The CUP rise to power seemed to allay those fears, but soon the trend began to shift.

The influence of the 1908 Revolution's success (and of its constitutional, pluralistic, and democratic slogans) on public opinion in British-controlled Egypt, and potentially on freedom of movement in India, created a substantial menace for the British (Ahmad 2008, 141–55; Brummett 2000, 154–55). Now the Ottoman threat had transformed from religious to ideological in the British colonies.

Meanwhile, governmental jurisdictions were changing in the Balkan provinces. Austria-Hungary annexed Bosnia and Herzegovina, Bulgaria declared independence, and the Cretan deputies unilaterally declared a union with Greece. The CUP government took over an empire burdened with unsettled diplomatic matters and nationalist uprisings from Albania's rocky hills (1910) to Yemen's sandy shores (1911). These external and internal challenges resulted in a party dictatorship of the centralist CUP. The ideal for common citizenship was soon undermined as the party attempted to conflate the ideology of Ottomanism with Turkish

nationalism—a move that would serve only to reinforce the secessionist leanings of non-Turkish groups such as Arab nationalists.

The Islamization policies of Abdülhamid II before 1908 privileging the Arab provinces had been designed to extend to eastern Arabia, Yemen, and the Arab peninsula, as he wanted to create a web of religious loyalty against the European colonialist threat (Burke 1972, 98). The sultan believed that "the idea of an ethnic nation and race was being preached by the British to divide the Turks and Arabs and incite uprisings in Arabia, Albania, and possibly Syria" (Karpat 2004, 177). Thus, to counter this threat, he had applied policies to strengthen the Arab presence at the governmental level. The region was already integrated with the center through the building of a direct line of communication to the capital via the Berlin-Baghdad and the Hejaz railways, which, along with a parallel telegraph line, connected the holy city of Medina with Damascus and ensured the organization of the pilgrimage to Mecca under the sultan's close supervision (Kayalı 1997, 27). The Islamic unity promoted by Abdülhamid II best served the interests of an emerging pan-Arab movement, for the sultan feared that, without the Ottoman military and political shield, the Arabs would be fragmented into various groups and their lands occupied by foreign powers.

After the 1908 Revolution, Arab-Ottoman alienation was not immediately apparent. On the contrary, the subsequent months witnessed euphoric demonstrations of unity. The CUP had little opportunity to develop a robust legislative, given its external and internal challenges. With the outbreak of the Albanian revolt in 1911, followed by the Italian-Ottoman War in Tripolitania, CUP leaders were spending most of their time on political and military maneuvering against the insurgencies in the Balkans and European claims in North Africa, mainly in Fezzan, Trablusgarb and Benghazi (today's Libya). Meanwhile, to keep the empire intact, the CUP's domestic policies were intensified with the popular current of nationalism mainly directed around linguistic matters in favor of centralization, which, in a short while, further distanced the Arabs from the capital. The gradual ideological detachment of Arab subjects was reinforced by increased European influence in the Arab provinces, where Ottoman rule was becoming

destabilized. This ideological estrangement, which overlapped with the CUP's reflexive policies of Turkification and centralization that alienated its ethnically diverse communities to protect the empire's integrity, created among the Ottoman public a vague sense of distrust, especially against the Arabs. They were gradually excluded not only from the political but also from the Ottoman social body, despite their territorial unity until the end of the Great War. Perhaps due to the unclear status of the Arabs either as friends or foes, throughout this period (from Balkan wars to the end of World War I), cartoonists tended to shelve the ethnic rifts and preserved the Arab stereotype in favor of assumed cooperation necessitated by the upcoming war. The revolutionary cartoonists took a break from their vigorous representation of the Arab stereotype until the next time the Arab became an actor in the imperial power struggle.

Imagining an Empire: Where Is the Homeland? Where Is the Nation?

Stereotypes are narratives. They inhere in the stories that we tell each other about our national selves or our ethnic qualities as we continually reproduce our boundaries. These stories change over time, but they are always contested, often violently. For the postrevolutionary Ottoman political elite, the narrative of the national self started as a fuzzy concept. The answers to the reasonable questions "Where is the homeland?" and "Who are we?" were constantly shifting as imagined political borders were negotiated to match ethnic boundaries. For example, on 8 October 1908, the contested concepts of "homeland" and "freedom" were brought into public discussion by contemporary political satirical gazette *Boş Boğaz ve Güllabi* in a dialogue titled "Between Two Children":

> What is a homeland?—A play, with reference to Namık Kemal's play "Vatan or Silistria";
>
> What is freedom?—The name of a newspaper that was published by the Young Turks in London during the Hamidian period from 1893 to 1896;

What is brotherhood?—I can't say since I haven't seen it . . . ;—Justice?—The name of my aunt's daughter.[2]

This short literary sketch was descriptive in essence and was characterized by delicacy, wit, and subtlety in delivering the Western principles of the French Revolution to the capital's readers. The dialogue was a conversation between two children trying to make sense of the symbolic vocabularies of Western liberalism such as "homeland," "freedom," "brotherhood," and "justice." Understandably naive in the face of social and political changes, the children bandied about the meanings of these new terms as they related to their daily reality. Their conceptual confusion, which symbolized that of the Ottoman public in general, provoked the laughter.

The word *vatan* originated from the Arabic and meant "place of birth" (Gökalp 1959, 76–78; Lewis 2002, 334), but by the nineteenth century it had been redefined to reflect the French word *patrie*, suggesting a purely European influence. Similarly, *millet*, from the Arabic word *milla*, was used to identify a religious community before taking on the modern sense of a "nation." Throughout its political history, the Ottomans had used it to designate the religious communities within the empire, such as Greeks, Jews, Armenians, or, in a broader sense, the non-Muslims of the empire. Still, they did not use it with ethnic references, as with the Turkish or Kurdish *millet* (Lewis 2002, 334–36; Karpat 2004, 328–36). This reassignment of terminology, which kept the old meanings beside the new ones, gave birth to a confused sense of identity. The sentiments for *vatan* as birthplace and as national homeland coexisted and built upon each other, yet it was not clearly defined in people's minds.[3] It seemed that,

2. *Boş Boğaz ve Güllabi* was one of the first satirical gazettes to be published biweekly right after the 1908 Revolution. It was published by Hüseyin Rahmi Gürpınar, one of the most prominent intellectuals of the late Ottoman and early republican periods. "Iki Çocuk Arasında," 8 October 1908, 3.

3. Najmabadi (2005, 97–131) offers a brilliant discussion on the changing meanings of "vatan."

for Ottoman Turkish Muslims, *vatan* and *millet* could be an empire that would embrace most of Islam's heartlands, including the Levant, Mesopotamia and the Arabian Peninsula.

In the general consciousness of the Ottomans, Namık Kemal was the first intellectual to popularize the terms *vatan* (homeland) and *millet* (nation) along with *hürriyet* (liberty) with meanings close to their European ones (Uzer 2016, 21). Yet none of these terms were internalized in their full European sense. Instead, they were pursued as aspects of a romantic conception, a "sacred idea that sprung from the union of many lofty sentiments such as nation, freedom, welfare, brotherhood, property, sovereignty, respect for ancestors, love of family, memory of youth" (Lewis 2002, 337).[4] But, for a soldier, the word *vatan* was no more than his village square: a nucleus of sentiment, affection, and nostalgia, not of loyalty, and only to a limited degree of identity.[5] The word had more religious than ethnic references than and was never territorial (Lewis 1991, 531; Karpat 2004, 329–35, Uzer 2016, 21–22).

The boundaries of *vatan*, in its old, deep-rooted Ottoman sense, and the idea of an ethnic nation with its imported concept defined by language, culture, and imagined origin, were in a state of flux among the political and intellectual circles of the society in general, as much as they were for the members of CUP. However, here the question was how the political elite defined the empire's territory: What was expendable, and what was not?

The Ottoman Empire's quest to define a nation in its European context shifted first from Ottomanism to Islamism, then to Turanism, before finally settling on Turkism. These concepts were fiercely debated in literary circles among intellectuals including Namık Kemal, Yusuf Akçura, and, finally, Ziya Gökalp, who sought a common denominator, an amalgam, to

4. From Namık Kemal's article in *İbret*, March 22, 1873, quoted in Lewis (2002, 337).

5. From Ahmet Cevdet Pasha's deposition to a special commission, quoted by Lewis (2002, 338). "If we were to adapt the word homeland now, and if, in the course of time, it was to establish itself in men's minds and acquire the power that it has in Europe, even then it would not be as potent as religious zeal, nor could it take its place. Even then it would take a long time, and in the meantime our armies would be left without spirit."

keep the empire united. Ottomanism, which was promoted in the writings of Namık Kemal, was challenged by competing arguments of Islamism and Turkism of Ottoman ideologues such as Yusuf Akçura. In his 1912 article "Üç Tarzı Siyaset" (Three Styles of Politics), Akçura proposed an Ottoman nationalism defined around the components of Islamism, which, he believed, was fundamental for the integration of the multiethnic empire. His approach to Islamic nationalist unity gained popularity as an alternative to Ottomanism after the failure of the First Constitutional Era and was highly praised by Abdülhamid II. Pan-Islamism aimed to unify the Muslim world and promote Muslims' welfare without abolishing citizenship for all. As Bernard Lewis (2002, 216–17) puts it, "In [Arab lands] lived a population of many millions, speaking a different language, and feeling themselves to belong to a separate race. But the Arabs were bound to the empire by Islamic brotherhood and allegiance to the caliphate." Their separation was not to be feared. This spiritual bond gave a temporary sense of security to the CUP even as it lost territories in the Balkans and North Africa.

However, the notion of togetherness through Islam did not constitute a sustainable ground, as these groups demanded rights and freedoms that were limited under a centralized government. For Akçura, such unification would alienate the non-Muslim populations within the empire. A Turkish national policy based on the Turkish race was another prospect suggested by Akçura's article as an alternative to Ottomanism, which was, in his opinion, doomed to fail. Islamism had already its share of complications (Akçura 1976).[6] On the other hand, Turkism, as Akçura called it, offered an alternative prospect for unification. The idea of a Turkish nation based on

6. Regarding Ottomanism, Lewis (2001, 219) refers to British ambassador Sir Gerald Lowther's remarks after participating in Talat Pasha's speech to the Thessaloniki branch of the CUP as follows: "That the CUP have given up any idea of Ottomanizing all the non-Turkish elements by sympathetic and constitutional ways has long been manifest. To them, 'Ottoman' evidently means 'Turk,' and their present policy of 'Ottomanization' is one of pounding the non-Turkish elements in a Turkish mortar." In addition, and most importantly, neither Turks nor Muslims, non-Muslim or Turkish communities, were willing to be incorporated under an Ottoman nation.

the Turks' political and economic interests quickly became popular. The contemporary intellectuals devoted to the CUP saw an alternative option in risking the alienation of non-Turkish parts of the empire, the mostly "backward and uncivilized" Arab provinces that needed to be enlightened with the "Ottoman light" (Lewis 2002, 341; Deringil 2011, 147–48).

Anthony Smith (1991, 99) has defined nationalism as "a doctrine of culture and symbolic language and consciousness, aiming to create a world of collective cultural identities or cultural nations." He explains how the process of nationalism was more or less an unintended consequence for Europe, while, for non-Western entities, it was the result of nationalist movements created by design (100). For the Young Turks, who had been part of a large empire and lacked any set, clear idea of a nation, it was a process of trial and error.

Between 1910 and 1918, the Ottomans lost their territories in the Balkans, North Africa, the Aegean Sea, and, finally, the Levant. The Albanian revolt of 1910 convinced the CUP that it would be difficult to serve extensive supranational interests while trying to keep the empire unified. They were left with nothing but Anatolia as the only piece of territory that could be bordered as homeland (*vatan*) and secured at all costs. Ziya Gökalp, a prominent sociologist, writer, poet, and political activist of the time and the leading defender of Turkism, was among the few who sponsored Anatolia as the geographic hearth of the Turkish people. It was Anatolia that represented the "true" culture and values of the Turks, rather than the "Byzantine and Arab high cultures of the Ottoman" (Zürcher 2010, 120). These nationalist ideals were fundamental in the deidentification of Ottoman Turkey from its Arab components.[7]

This contentious relationship between the CUP government and its policies over the Arab provinces was evident among the Turkish intelligentsia

7. As Kayalı (1997, 32–33) underlines, until the beginning of the twentieth century, Arab opinion continued to favor unity under the Islamic Ottoman Empire and was averse to centrifugal influences in the direction of autonomy or separatism. However, toward the end of 1909, an adversarial relationship began to take shape between the Unionists and those Arab leaders who had failed to find immediate rewards under the increasingly CUP-dominated constitutional regime.

48. A. Scarcelli, *Kalem*, 6 April 1911, 1. [Ottoman] *Interior Minister's Interior.*

and found expression in political cartoons as well as other literary forms. For example, *Kalem* published a cartoon titled *The Interior Minister's Interior!* (*Le ministre de son Intérieur!* in French, and *Dahiliyenin dahili!* in Ottoman) on 6 April 1911 that criticized the empire's vast imperial body as a source of conflict and chaos. In the cartoon, Ottoman *vatan* was depicted as an anatomical map of the interior minister Halil Mentese Pasha. The corpulent Pasha, naked except for striped socks and a fez (representing the empire under the CUP government), stands holding the skin of his torso wide open on both sides, laying bare his inner organs for examination (fig. 48). Each of his dying vital organs is numbered according to its importance, starting from 1) the heart, labeled Albania; 2) the lungs, Baghdad; 3)

the liver, Yemen; and 4) the intestines, Syria. The numbering in the cartoon is an explicit demonstration of how the Levant, Mesopotamia, and the Arabian Peninsula were part of a highly delicate interior matter.

Demonstration of Albania as the empire's only Balkan province was critical in terms of its long historical closeness to the imperial elite (the guards of the sultan were chosen from the Albanians). Before the 1908 Revolution, Albania was one of the important centers for the Young Turk movement. Along with Young Turk revolutionaries, the Albanians were strongly influenced by European nationalism, and they desired the individual freedoms and privileges that could only be provided through constitutionalism. However, after the revolution, the policies the CUP adopted aimed at cooperation in a united empire and stood opposed to Albanian demands for autonomy, development of the Albanian language, and the appointment of Albanians to important government positions. Albanian demands for autonomy were similar in many ways to those of the Arab nationalists, for whom one of the main points of resentment was the CUP's intense Turkification effort through education and language (Kayalı 1997, 79–80; Tamari 2015). Arab nationalist circles, in line with the Albanians, were convinced that the CUP's Turkification policies were seeking to assimilate them. The fundamental argument both for Arab and Albanian loyalty to the empire had been around religious unity built on Islam (Seale 2010, 61–62). But, for the leaders of CUP, the Ottoman Empire was a Turkish empire; all other nationalities had to be assimilated in order to consolidate a strong empire along the lines of Britain and France, starting with a common language.

The popular newspaper *Tanin* referred to the CUP's language policies by criticizing the Arabs' resistance to them, as if they were not under Turkish rule, leaving the government no choice but to force Arabs to forget their language and learn the language of the nation ruling them (Tauber 1993, 56–57). While competing for and legitimizing political power through ethnic assimilation might seem retrogressive—especially in light of the CUP's emphasis on constitutional progress and modernization—it remained a stubborn reality for the government. In April 1911, Muslim and Catholic Albanians joined forces to begin their rebellion for "liberty, justice, and autonomy" (Shaw and Shaw 2002, 288–89).

Returning to *Kalem's* cartoon of Halil Menteşe, his "heart," the most vital organ of the imperial "body," represented Albania, which was already claiming its independence. No doubt the Albanian revolt would ignite other nationalist movements, including that of Arabs, who were next in the series, depicted as the lungs: the Ottoman administrative center in Mesopotamia, Baghdad. The artist magnified Baghdad's privileged position in the empire by portraying it as an essential organ that adjusts the body's relationship to its outer environmental conditions. Inhaling and exhaling its oxygen, Baghdad held strategic significance to the empire by providing free access to the Port of Basra on the Persian Gulf through the Baghdad Railway (and in that period perhaps also in terms of access to newly discovered oil resources). About the same time as Albania, Baghdad squirmed with unrest, provoked by local notables aiming to establish an independent Arab political structure (Kayalı 1997, 47).

Halil Menteşe's third most important organ in the illustration is the liver, labeled as Yemen, also vital for his body's survival. Yemen's depiction was related to its importance as a link to the Arabian Sea and a symbolic Ottoman dominance in the further end of the Arabian Peninsula. Like the other two regions of the series, the province was afflicted with local insurgencies between the tribes of the highlands and the Ottomans over securing and controlling the portal zone. Although the Ottomans managed to bring the insurgencies under control, they had to cede the north of the province to the local Zaydi leader in return for his loyalty and alliance to the Ottoman sultan.

Among the last of the interior minister's failing organs is his intestines: Syria. For some time, Syria had acted as one of the centers of Arab nationalism. Damascus and Beirut of the Syria *vilayet* emerged as alternative centers to Cairo under the British protectorate that provided a safe haven for the Arab nationalists from the 1880s onward. A functional and well-organized Arab movement already existed in both cities. After all, there, the 1908 Revolution created great joy among the Arabs and Turks, who, for a brief moment in time, stood shoulder to shoulder singing songs of equality and brotherhood. However, it was not long before expectations for equal governance between the empire's diverse communities melted away. The CUP's centralization policies inflamed the grievances of two

ethnically different Muslim groups. Arab revivalist circles began to seek the "equal" representation promised by the revolution by advocating for a decentralized government structure, leading to significant protests in Damascus and Beirut (Zeine 1973; Tauber 1993; Kayalı 1997; Ahmad 2014). As Benedict Anderson (2006, 85) notes, the CUP came to be hated by non-Turkish speakers as Turkifiers.

Of course, *Kalem*'s cartoon did not have all of this detailed historical, sociological, and political analysis in mind when depicting the interior minister's interior. It simply reflected an elitist consensus on the CUP government's existing challenges, especially those facing the interior minister himself. His grand torso suggested a territorial expansiveness, and, likewise, his attempts to soothe and contain his failing organs. Was *Kalem* announcing, in a critical manner, the approaching end of the sick man? That question, of course, was left to the audience to answer.

Yemen and Yemeni Arabs in Political Cartoons

The revolts in Yemen by the Zaydi tribes in 1904–11 were particularly damaging to the CUP government that had recently been established in Istanbul and simultaneously had to deal with nationalist movements in Macedonia and Albania, all requiring military inventions. Yemen carried strategic importance against the British expansion from India to the Red Sea and Arabia. The opening of the Suez Canal in 1869 strengthened the Ottoman decision to hold on to Yemen to counter a possible intervention from Egypt, which was under heavy British influence.

Representations of the Yemeni Arabs in Ottoman political cartoons were fused in 1909 with news of the emerging rebellions in Yemen. Such coverage in political cartoon papers, each serving the other in a complementary way, used two stylistic techniques that unified the entire region and its people under two modes of symbolic rhetoric: first, through the physiognomic illustration of the identifiable historical character of Zaidi Imam al-Yahya, with his magnified savagery; and, second, geographic symbolism of the desert. One of the most impressive examples of the months-long series appeared on the cover of a short-lived political satire journal, *Alem* (fig. 49). Printed in both Ottoman Turkish and French,

— Allez dire au Grand Vézir que je ne veux pas me soumettre car je suis ici le maître.

امام يحيى بن محمد حميدالدين — تبليغ ايديكز .. اميرمكنك نوذيله.
زيديارك بولندقلرى برلرى ايتم .

49. *Alem*, 3 April 1909, 1. [Ottoman] *Inside of the Internal Affairs Ministry.*

Alem's caption opened a series that targeted a rebellious Yemeni imam for claiming the Ottoman territories in Yemen.

An informed reader who followed the daily newspapers would easily recognize Muhammad bin al-Yahya Hamid ad-Din, the Zaydi imam of Yemen, as he was depicted on the cover of *Alem*. The CUP's centralized pressure and maladministration resulted in the increased regional

power of Zaydi Imam and facilitated his expansion of influence among the other neighboring Arab tribes with similar attitudes toward CUP. The imam's challenge provoked severe criticism among the capital's intelligentsia. Quickly, the political cartoon industry started their campaign to undermine his political ambition and assign him a position of inferiority in the mind of the public. *Alem*'s cartoon attacked the imam by representing the binary opposition between his identity as the religious leader of his community, and a poor, uncivilized Bedouin who lacked the qualities of a true, strong leader. Despite his title and significant regional influence, the imam's crudely depicted nature belittles him and his position against the Ottoman government and public.

The emphasis on backwardness combined with poverty is reinforced in the artist's choice to illustrate the imam's servants barefoot and dressed in worn-out clothes, similar to their master. The characters are set against a patched tent with a ripped flag pitched in the middle of a desert. The overall impression of destitution underlines the cultural and economic deprivation of these territories, raising the question of just how harmful such a remote and insignificant threat to the mighty Ottoman Empire could possibly be.

For the capital's audience, Yemen was a distant, unfamiliar, and wild territory, at the farthest eastern border of the empire, but it was still part of the imperial body. Istanbul's cartoon press treated the unrest in a critical fashion and often in comparative relation to the insurgencies in Albania. The series' cartoonists exposed both stereotypes, Yemeni and Albanian, through almost constant comparison. These two different geographies and characters revolting against the empire became paired during the short period of the rebellions, thereby setting the visual boundaries of the empire's territorial struggle.

Over the course of three months, from February to April 1911, *Kalem*, among other papers, depicted the empire's predicament in trying to control the disorder in these provinces. For example, in one cartoon, two figures—Isa Boletin, the Albanian revolutionary commander and Yemen's Imam Zaidi— functioned as national stereotypes recognized by their ethnic outfits as an Albanian and an Arab (fig. 50). They are positioned on either side of famous Turkish army commander Mahmut Şevket Pasha,

io—ii2 ————————————— KALEM ————————————— ١٠—١١٢

Un ministre qui sera bientôt affecté de strabisme double divergent à force de regarder de deux côtés à la fois.

حم صاحبه ٥٥ صوك پاثه پاثه حول مياعد اوغرايدیق اولان پر تیهلار .

50. A. Rigopoulos, *Kalem*, 9 February 1911, 1. [Ottoman] "The commander who will go farther apart to keep looking left and right all the time."

who is identified with an exaggerated moustache that dominates the center of the composition. In the cartoon's alignment, the Albanian Isa Boletin faces front, with Yemeni Imam al-Yahya of Zaydis facing back. Yet both characters are looking away from Mahmut Şevket Pasha, who stands between them. By looking at the strange expression on his face, one realizes that his eyes are not correctly aligned, with one looking left and the other right. The Albanian commander in his traditional military uniform

gazes at Mahmut Şevket Pasha, signaling to the audience a possible ground for dialogue between the two. The Arab, on the other hand, stands barefoot in his keffiyeh and robe, his back turned to Mahmut Şevket Pasha and the Ottoman audience, not making eye contact with any of them. The Arab's disconnectedness from the rest of the characters signals the cartoonist's position, placing Yemeni Arabs further away from a possible Ottoman unity. The position of the two rebels also demonstrates the symbolic boundaries regarding the two non-Turkish communities. While one seems reasonably open to mending fences (Albanians), the other is closed to rapprochement (Yemenis).

Similarly, in another cartoon in the series, the cartoonist (Rigopoulos) depicts Mahmut Sevket Pasha once again, this time with a facial expression of resignation in trying to suppress rebels in two far-flung corners of the empire (fig. 51). The artist represents the distance between the two provinces with a miniature map laid under the feet of the exaggerated figure of Mahmut Şevket. The legend bilingually expresses the vagueness of the empire's borders' as "from Albania's rocks to Yemen's deserts," drawing attention to the extraordinary effort the army commander must deploy in order to crush the conflicts.

In April 1911, *Djem* depicted two Ottoman officers talking to each other, dressed in their Ottoman uniforms but wearing the traditional Arab headgear the keffiyeh instead of the actual Ottoman helmet to complement their uniform, adapting to the geographic conditions of the region. The officers' national loyalty is identifiable by the tents of the Ottoman military in the background (fig. 52). The scene is configured to portray a small Ottoman troop's journey to Sana to surveil the upcoming parliamentary elections in the far corner of the empire. The CUP government was presumably concerned about a possible disruption of the elections by the Zaydi community leader al-Yahya under Ottoman sovereignty. The dialogue between the officers raises the question of Ottoman-Turkish-Muslim identity once again in a very subtle way; it adds an economic aspect to Yemen's geographic position as a place of deprivation by highlighting the officers' low compensation compared to the extreme challenges of their mission (fig. 52). Perhaps one of the questions that the artist intended to raise in the public's mind was "Do they need to be there?" By this time,

9—120

— Quel est donc ce sort que traine tou-
jours mes semelles sur les rochers de l'Albanie
et sur le sable de l'Yémen ?

— ڤوف ! آراڤى چوق اولوور ، بر صاغه صوله . . .

51. A. Rigopoulos, *Kalem*, 6 April 1911, 5. [Ottoman] "It is being too much, one to the right, one to the left!"

Yemen had already gained a reputation in Ottoman folk songs as a place where heroism and patriotism would lack any meaning. This was partly due to the two decades of fierce confrontation between the imam and his predecessors, on one side, and the imperial government in Istanbul, on the other. The Ottoman elite was accustomed to imagining Yemen as a site of barbarism, more so than any other place in the region (Kühn 2007, 315–31). Yemen meant exile, a place of hopelessness and doom (Zürcher 2010, 187). A feeling of resentment was not restricted to Yemen, as Eric J. Zürcher notes, but a notion shared by all of the Ottoman troops serving in Syria, Palestine, and wider Mesopotamia.

52. Cemil Cem, *Djem*, 8 April 1911, 5 [Ottoman] *On the Road to Sanâa!* [Due to a new election]

The challenges the Albanian and Yemeni revolts posed to the CUP, and their critical consequences in terms of the growing necessity for a more precise definition of the *vatan*, were themes fervently taken up by modernist cartoonists. On the other hand, traditionalists, who sided more closely with the government and its territorial borders, offered a promising visualization of the empire's presence in these distant territories. For example, a cartoon by Halit Naci published in *Karagöz* in August 1911 confirmed the popular view that the unrests in Albania and Yemen were temporary and would be solved in due time by a victorious Ottoman army (fig. 53).

53. *Karagöz*, 9 August 1911, 1. [Ottoman] *For the Revolts of Malisor and Yemen.* [Caption] Karagöz: "Look, Hacıvat! They will start quarreling with each other as soon as they realize we are taking them safely to the shore."

The insurgencies in these two Muslim regions were exposed as incitement by European powers against the empire, which reflexively rejected their bid for self-determination. In his cartoon, Naci stylishly illustrates the response of the CUP to these rebellions: three passengers in a boat branded by their ethnic outfits as an Albanian (Isa Boletini), a Yemeni (Imam Zayid), and a third person of unclear descent being dragged back to Ottoman territories by Karagöz (the boat Karagöz rows is named *CUP*). In the background are three figures, recognizable as the Greek King Georgios, Nikola of Montenegro, and an Austrian official, anxiously watching the boat pass by. The imperial reply to the rebellions of Albanians and Yemenis is articulated to the public in the cartoon's caption, which indicates the success of the Ottoman government in outsmarting its rivals in the Balkans, who will no doubt start fighting each other as soon as they realize they have been left without pawns to play—one of these pawns being Arabs.

North Africa: Tripolitanians in Ottoman Political Cartoons

Obviously, the years between the Young Turk Revolution and World War I posed a great challenge to the CUP government. Ottoman provinces in North Africa were in a state of tremendous political turbulence as the imperial governments pursued their colonial ambitions. Within the complex political environment of states competing for resources and territorial expansion, the Kingdom of Italy saw an opportunity to pursue its goal of extending influence over the Ottomans' last territories in North Africa, particularly the Trablusgarb *vilayet* (Tripolitania, in today's Libya), of which the main subprovinces were Fezzan, Cyrenaica, and Tripoli itself.

The Italians wanted to secure a position in the Mediterranean balance of power by controlling a coastal portion of North Africa (Micheletta and Ungari 2013, 17). With both France in Morocco and Britain in Egypt, Italy adjusted its economically limited policy toward Tripolitania. The new strategy was to detach Tripolitania from the Ottoman Empire in order to preserve Italian leverage against the other imperial states; if they did not claim the province, they assumed, another great power would. The Italian Foreign Ministry had adopted its policy concerning Ottoman

territories in North Africa as early as 1905, yet pursued its agenda prudently, relying more on economic advances than overt aggression. The lack of necessary political and military supplies in the area made the Ottoman position in Tripolitania more vulnerable. The distance of the CUP government from these territories caused stress in the region, creating a sense of abandonment.

In November 1910, discussions around the political developments concerning Italy's interest in Tripolitania reached the public with *Kalem*'s metaphoric fictionalization of the situation, in a cartoon that disseminating a critique of the CUP's hands-off policies over these territories. The illustration portrays the defenselessness of the province by comparing it to a block of cheese left to rot, and, with sophistication, it accentuates the approaching loss of the territory to the Italians by exhibiting the cheese—laid on Italy's most popular newspaper, *Corriere della Sera*—as attracting three rats, recognized as Italian statesmen, eager to devour their prize. The issue of *Corriere della Sera*, dated in the near future (a month from the date of the cartoon's publication, 28 December 1910), implicitly announced the inevitable news to the Ottoman public (fig. 54).[8]

The CUP failed to make adequate preparations to meet the Italian threat. For a long time, Tripolitania was seen as the backyard of the Ottoman Empire, a place for exile, especially during the reign of Abdülhamid II. Fezzan in particular had been a major site of suffering and deprivation for those who were sent there. Later, with the CUP, the Turkification policies employed elsewhere in the empire were applied to Tripolitania as well, but language issues and religious reforms stirred opposition and created a power vacuum among the Tripolitanian elite, who wanted reforms aimed at economic development instead of cultural centralization against European integration (Anderson 1991, 226–27). With weak garrisons and a poor financial situation, the insecurity of Ottoman rule was almost an open invitation for the Italian invasion in 1911.

8. The characters represented in the cartoon are: on top, with the moustache and already starting to nibble the cheese, then–prime minister Sidney Sonnino; on the left, with the cigar, foreign minister Antonino di San Giuliano; and, finally, Giovanni Giolitti, the former prime minister, who was succeeded by Sonnino.

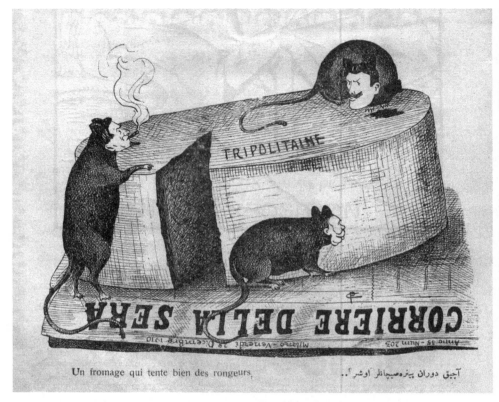

Un fromage qui tente bien des rongeurs,

آجیق دوران پینه صبیحانلر اوشر.

54. C.P., *Kalem*, 22 November 1910, 13. [Ottoman] "Rats tend to pour on the cheese left in the open!"

The Italian threat to Muslim North Africa was perceived as an attack against Muslims in general, unifying the Arabs in the region for a joint resistance effort led by CUP officers, despite their ideological differences. The "enemy of my enemy" approach mobilized Muslim Arabs to support the Ottoman Empire in North Africa. According to Hasan Kayalı's (1997, 108) assessment, based on an article published in the *Revue du Monde Musluman*, "The Arabs were the first ones to forget their hatred of the Turks and . . . the CUP was actually able to profit from the war to maintain its position of power at a time of mounting opposition within parliament and outside." The shifting winds in the Muslim world in the direction of

the Ottoman government were overwhelming. As Kayalı notes, thousands of Ottomans volunteered to actively join the fight.

The cartoon space during this period reflected, to a certain extent, galvanized public opinion among Muslim Ottoman society with regard to state policy in the Arab provinces of Mesopotamia and the Levant to North Africa. Yet the modernist political cartoonists did not completely abandon their critical position. They continued to critique the government for not taking necessary measures to protect the territory. They likely saw the region as similar to Yemen: a liability, not an asset. While the modernists were more concerned with the maladministration of the government, the traditional cartoon press pioneered by *Karagöz* simplified the events as an outcome of the European colonialism and consistently accused the Europeans of being the bad guys. Childishly, they blamed the empire's misdeeds on a single enemy instead of performing a constructive self-assessment in light of the world's changing balance of power.

The imagery of Europeans as colonizers of former Ottoman territories was already a frequent theme in the traditional cartoon press. A *Musavver Papagan* cartoon from 1911 is one example (fig. 55). The drawing offers a visual narrative of the Europeans' power struggle in North Africa, focusing on current events in and around Morocco, and engages landscape symbolism through objects like the palm tree and the arched Islamic architecture characteristic of the region. An orientalist richness of resources is portrayed in the dates hanging from the palm tree and the exotic fruits stacked in the corner of the cartoon's frame. The cartoon is like a parade of various European nationalities where each of them is deliberately positioned according to the present balance of power.

In this intricate equation, Arabs are placed at the far end of the scene, embedded in the symbolic landscape, and intertwined as a single body, with no clear marker of national belonging. Their relatively insignificant position in the given order conveys the Arabs' feeble diplomatic position. The contrast between the European powers' military uniforms and the Arabs' traditional daily garb implies the Arabs' lack of military capacity, suggesting their vulnerability and need for protection. Their impotent status is almost justified by the artist, who fictionalizes the entire scene as

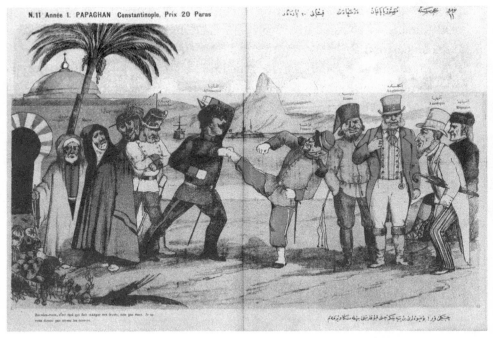

55. *Musavver Papağan*, 30 November 1908, 24. [Ottoman] "Stand back! It is I who must eat the fruits. No, not you! I'm not even giving you the rind."

a struggle for colonization among imperial powers in which the Arab has no voice. The quarrel among the European powers, especially Germany and France, for the protectorate of Morocco very clearly demonstrates the popular awareness of Europe as the exploiter of the resources of the "Orient." This was a topic often used by traditional cartoonists in their exposition of the European powers as a potential threat to the "fruits" of the Orient, not only in this particular case of Morocco but also in the rest of North Africa and the Middle East.

During the late summer of 1911, *Karagöz* published a series of five cartoons concerning Tripolitania and the Tripolitanian Arabs. In its accustomed manner, *Karagöz*'s cartoons took advantage of the increasing currency of political propaganda. They created an imaginary world of oriental richness in Tripolitania—almost a North African oasis—that the Italians were attempting to steal, visually narrated by positioning

56. Halit Naci, *Karagöz*, 13 September 1911, 1; 4 October 1911, 1. [Left] Karagöz: "We won't let you eat even one of the dates, keep moving, and you'll get your lesson!" [Right] Hacıvat: "Go ahead, Karagöz, hit it on the head so it staggers and drops it! Look at the dog! It grabs the best part." [It reads "Tripolitania" on the meat.]

Tripolitania as an object of desire, represented as a bunch of dates hanging from a palm tree (which is typical of the landscape), and a chunk of meat that appears very appealing to the hungry Italian in his feathered military headgear (fig. 56).

The repetitive correlation between Italians and the act of stealing consolidated the negative image of this expansionist European power in the Ottoman public mind. Theft under Islamic shari'a is considered a *hadd* crime, with harsh penalties required by God from which there can be no deviation. The cartoons in this series convey this subliminal message to its audience while inciting laughter by mocking the Italian, sometimes as a clumsy thief, sometimes as a helpless figure trapped on top of a palm tree trying to eat the dates, or sometimes as a hungry dog attempting to get away with a juicy drumstick in its mouth. However, on each occasion the Italian is outsmarted by the two traditional protagonists, Karagöz and Hacıvat (representing the Ottoman public and the government,

respectively), thus confirming the empire's impending victory over Italy and its covetousness of the last Ottoman territories in North Africa.

The CUP viewed the defense of the province as both a political necessity and a moral obligation. Ottoman officers from throughout the empire were appointed to join the local resistance to aid in repulsing European encroachment. The war in Tripolitania and the inland Bedouin tribes' resistance created sympathy among the Ottoman public toward the Arabs, who displayed profound fidelity to the faltering empire during the Ottoman confrontation with major European powers. The Bedouin tribes that controlled the inlands of Trablusgarb and Benghazi under Sanusiya leadership were attached to the empire in the Islamic sense. The North African Muslims' previous experience with the West was a bitter one, and they were intolerant of Europeans (Burke 1972, 100). Many Arab notables saw the war in Trablusgarb and Benghazi as a clear sign of European incursion, calling for a holy war against the infidels (Masters 2013, 214–15).

In the early stages of the war, *Karagöz* commonly engaged in territorial symbolism whenever it referred to European expansionism and Italy's claims over Ottoman provinces (fig. 57). However, as the war progressed and the local tribes of Tripolitania became significant actors in the resistance, the political cartoon space included portrayals of Sanusiya members in their traditional garbs, stressing their heroic stand against the enemy. This overstatedly courageous image of the Arab, at least in contextual terms, was different than what the Ottoman reader had encountered or imagined during the past decades (fig. 58). Even though these cartoons contextualized the Arabs in a rather affirmative setting, their representation still asserted their barbaric and uncivilized nature.

Other cartoon magazines like *Baba Himmet* and *Yeni Geveze* adopted similar portrayals of the Sanusiya fighters as *Karagöz* in publishing their fictional narratives of the events encircling Tripolitania. For example, *Baba Himmet* also praised the local Arab tribes' loyalty to the Ottomans in resisting Italy and supporting the empire, despite their redundant positions (fig. 59). A cartoon from September 1911 centers around a giant Ottoman figure personifying Baba Himmet, the invincible, macho Anatolian woodcutter character from the traditional Karagöz plays. As transferred

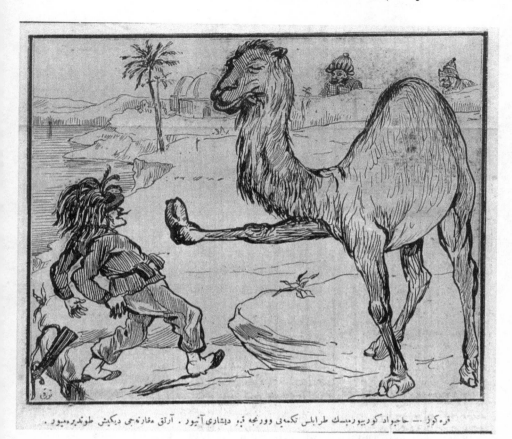

قره‌کوز : ـ حاجیواد کوریو رمیسك طرابلس تكمه‌ی وورنجه قیو دیشاری آ‌یور . آرتق مقارنه‌جی دیكش طوتدیریمیور .

57. *Karagöz*, 1 September 1915, 1. [Ottoman] Karagöz: "You see Hacıvat? When Tripolitania kicks, the prankster cannot survive here anymore."

from the cotton curtain to paper, the fashionably dressed, giant, modern-day *Baba Himmet*'s figure works as a narrator, offering to the reader a bird's-eye view of the current situation. Like all of his commentaries, Baba Himmet raises the ultimate question for the Ottoman public: "Can the Tripolitanians resist against modern guns and arms?" While presenting the problem, he stages the crude reality for the eyes of readers, exhibiting the helplessness of the uncivilized locals, wooden sticks in their hands, resisting the unmatched power of the modern-day cannons that surround them. Yet, given the defenselessness of the situation, Baba Himmet honors these local Arabs' loyalty to the empire by suggesting that they hold their

58. Halit Naci, *Karagöz*, 18 October 1911, 1; 11 November 1911, 1. [Left] Karagöz: "What is it that filthy thing at the tip of your hunting rifle?" Tripolitanian: "Carcass! If it is a carcass, don't you wait and throw away the filthy thing quickly!" [Right] Karagöz: "C'mon, Hacıvat, there is still some litter left down here, let's sweep them away!"

positions so that their wooden sticks might turn into even deadlier weapons than those pointed at them.

On the other hand, *Yeni Geveze*, one of the other short-lived but influential satirical journals, depicted the Sanusiya fighters in a fictionalized peace deal, captioned as "sulh etrafında" (around peace). In the scene, the Arab fighters are depicted watching the power play between Italy and the Ottoman Empire, holding a secondary place behind the major powers. The cartoon refers to the Italo-Turkish negotiations where the major European powers put pressure on Italy to achieve consensus with the Ottoman Empire rather than declare outright sovereignty over Tripolitania. On the other side, the CUP cabinet was unwilling to participate in a deal in which it would have to surrender its position in North Africa. The new head of the cabinet in Istanbul, Ahmet Muhtar Pasha, announced that an agreement with Italy would not occur unless Italy renounced its sovereignty in Tripolitania, ruling out any possible peace solution (Hermann 1989, 345). Most certainly appreciating Ahmet Muhtar Pasha's decision, the artist applauds him in his cartoon, which dramatizes these developments by staging its actors on a symbolic playground seesaw. In the scene, the two

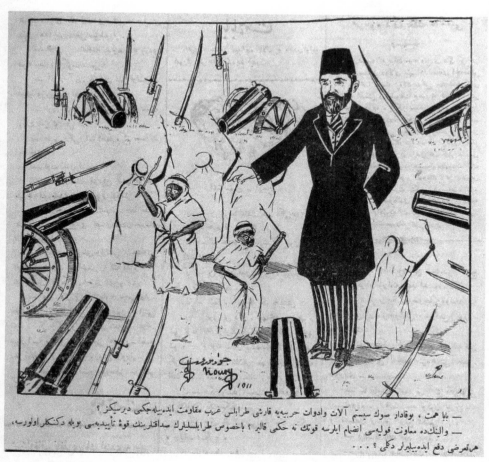

59. Cevat Nuri, *Baba Himmet*, 4 October 1911, 4. [Ottoman] Baba Himmet: "Do you think Tripolitanians could resist against these modern guns and arms? If the local government agrees on supporting and aiding, the modern power won't mean much, would it? And if Tripolitanians take the strength of their loyalty, then they can overcome anything with such sticks!"

sides of the seesaw are occupied by Ahmed Muhtar Pasha and the Italian commander. A third figure, the goddess of peace–personified as a European woman—stands in the middle. The identifiable character of Ahmed Muhtar sits on the lower side of the seesaw, representing his stronger position in the balance of power with the Tripolitanian mujahedeen standing behind him, holding their primitive lances ready to fight as loyal soldiers.

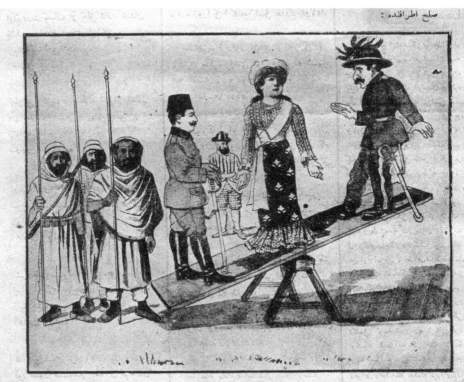

60. *Yeni Geveze*, 29 April 1912, 1. [Ottoman] *Around Peace!* [Caption] Karagöz:
"Hey, senior! You are too light when you are alone. Watch out, You'll roll down . . .
I would recommend you ask help from the one who stands in the middle but
seems like she turned her face away from you as well!"

The goddess of peace (in a secondary register, Europe), both hands open
at her sides, looks as though she is questioning the Italian officer's next
move in such an unbalanced spot. The legend elucidates the unexpected
challenge in Tripolitania resulting from the mujahedeen resistance while
belittling the Italian threat for the Ottoman public's morale. Again, the
Arabs are depicted in their orientalized positions as copies of one another,
creating a single image for the entire Tripolitanian society. Despite their
bravery and fearlessness, two things remain intact in their appearance:
their remoteness from modernity, and their singled-out images (fig. 60).

North Africa: Egyptians in Ottoman Political Cartoons

From 1517 to 1867, Egypt operated as an *eyalet*, an administrative division of the Ottoman Empire. However, from the early 1800s onward, it gradually became a quasi-independent state under its regional administrator, Muhammed Ali. Ethnically Turkish, Muhammed Ali claimed to rule Egypt for the Egyptians, sometimes in correlation with and sometimes set against the Ottoman Empire's political and regional interests. Although his dynasty ruled over what remained a nominally Ottoman province during his and his successors' reigns, the relationship between the two gradually weakened. When Egypt fell under the political and economic domination of the British in 1882, the British presence severely damaged the authority of the khedive—the title given to the ruler of the Egypt by the Ottoman palace—over state matters and that of his overlord, the sultan. Nevertheless, even with its ups and downs, Egypt retained a relationship and a sense of allegiance to the Ottoman Empire, based on many centuries of interaction (Jankowski 1991, 244–46).

The occupation of Egypt brought the British a unique position among the era's competing powers. They did not repudiate the sultan's rights or the international agreements the empire had made with other European powers in Egypt. In effect, this cast them as the acting guarantors of Egypt, and thus of the khedive's interests, which included expanded control over Syria and the Hejaz. Under these circumstances, the sultan's authority over Egypt became an essential point of leverage for France and Russia, who contested Britain's domination in the Levant.

The last Ottoman viceroy was the Khedive Abbas Hilmi II, an ambitious leader who wanted personal autonomy from both Britain and the sultan. The Young Turk revolution gave him ground from which he could challenge the sultan as the caliph in the Arab world by reclaiming the caliphate's rightful seat in Egypt under his protection. Much to the ire of the CUP government, Abbas Hilmi reportedly established secret contacts with various Arab notables and tribes, including Sharif Hussain in the Hejaz, the Sanusiyas in Libya, and the Idrisis in Asir, to support the nationalist factions proclaiming their sovereignty (Hirszowicz 1972, 290; McKale 1997, 21).

Such trends endangered the continuing relationships between Istanbul and Cairo. As was the case with Libya and Yemen, CUP leaders sought national unity within the empire's territorial imagining. The events following their rise to power increased Egypt's and Libya's strategic importance for control over the Mediterranean and, most notably, the Suez Canal. Viewed from Istanbul, this state of affairs appeared as a real danger. The struggle for power between the khedive, the CUP, and European forces eyeing North Africa entailed a fierce battle over imagery, where the Ottoman cartoon press became one of the central front lines.

The projection of Abbas Hilmi II's cocky, arrogant, autocratic personality into Egypt's political affairs became a favorite attack strategy among Ottoman cartoonists (Jankowski 1991, 250–51; McKale 1997, 21). They assumed that to propagate Abbas Hilmi's abusive and mischievous policies that led a non-Muslim power interfere with its politics, and, thus, his failure to rule the Egyptians, was a firm way to rationalize the Ottoman claim on Egypt.

The self-speaking language of symbols employed by the Ottoman cartoonist was remarkably successful in representing the complex internal and external turmoil in the relations between personified actors, providing the audience with simple, predetermined cues and references. Papagalu's *Punch*-style cartoon published in *Hayal-i Cedid* in May 1910, *Mısır siyaset hatırası* (Souvenir of Egypt's Politics), stands as a good demonstration of the layered demonstration of the defamation campaign against the khedive in the larger context of power struggle (fig. 61). Starting with the title, which implicitly foretells what might happen in Egypt, the illustration takes a fictionalized snapshot of Egypt's multifaceted political theater.

The cartoon's first layer sets the scene of an orientalist carnival through the exotic landmarks of colonized Egypt: the pyramid, the sphinx, the palm trees, the alligator, and the desert-like rocky geography. Each symbol in this primary setting constitutes a prereading for the allegories to come. The personified Sphinx, for example, silently watches from the corner with a concerned, gloomy facial expression as the imperial carriage comes into view. It is perhaps appropriate to have concerns, because the carriage is harnessed to two completely different animals in place of the customary horses: an alligator and a turtle. Entirely dissimilar in nature, the two try

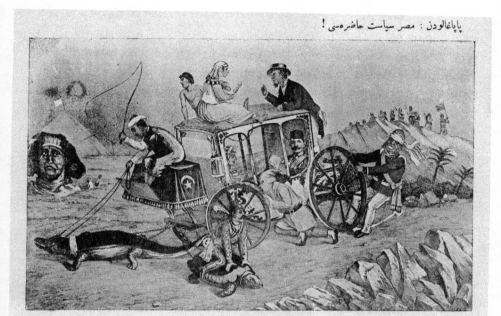

پاپاغالودن : مصر سیاست حاضرهسی !

تماشا ــ مصرلیلر . قاپلومبغه ــ مصر عسکرینك راكب اولنوری حیوان . قاپلومبغهنك سوارپسی ــ مصر نوۀ عسکرپسی .
آرابهجی ــ آنارشیست . آرابه ــ کردونۀ حزب‌الوطنی . اولۀ تکرلك ــ اوروپا پولتیقهسنك عکسنه دونك ایستهیور . آرقه تکرلك ــ
انکلیزلرك قونه مقاومت صددهده . آرابهنك اوستندكی قادین ــ مصر عائلهلرینك تمثالی .
پاپاغالو بو رسمه : مصر تأسیوناللیستارینك حرکات ‌درکشانهزرله امور ادارۀ مصرپهنك مذبذب برحالده بولنديغنی . دوآمی حالنده مصرك انکلیزلر
أنه کهجكئ آکلانهئ ایستهیور .

61. Papagalu, *Hayal-i Cedid*, 18 May 1910, 3. [Ottoman] *Egypt's Political Assembly.*

to pull the carriage, but they seem not to be succeeding. It takes the poorly dressed driver's horsewhip to put the alligator in motion, while the turtle is mounted by an Egyptian man who struggles to prevent it from running away. Both animals in and under different commands are chained to the carriage, risking its balance—political, economic, and cultural—on the rugged road with their wicked actions.

As for the passengers in the carriage, the khedive of Egypt and Sudan, identified as Abbas Hilmi II, is seated beside Cleopatra, thus creating a relationship between the cultural heritage of Egypt and the ethnically Turk khedive, sharing a joint journey. However, the question of who rides with whom is not answered and left to the spectator. Outside, on top of the carriage, sits a woman in ancient, traditional dress with a baby in her

arms. From her dress one can assume she is the mother of Egypt's future, passing on her ancient roots to the next generations. At least she wishes to pass on this heritage: she is chained to the carriage by her foot, as if she and her child's future depends on whatever happens to it next. A fellah in his ancient outfit is next to her, underlining Egyptian farmers' long-standing position as the stronghold of Egyptian society. He is the only one amid the ancient ruins facing the sphinx, looking concerned with the future of Egypt rather than engaging in his ladyship's conversation with a recognizably British figure standing at the back of the carriage. The British man's gestures suggest that he is trying to convince the chained woman of something, probably to force the Egyptian cultural consciousness into conformity with the British position in Egypt. The scene gets even more complicated when a soldier from the British-Indian forces in Egypt grabs the carriage by its back wheel to take it away from the gaze of the passengers and prevent it from continuing its journey.

On the other side of the carriage, another character in a white cloak and hood (perhaps the artist Papagalu) takes the front wheel and tries to press it back onto the road, helping the rider. Meanwhile, a group of Ottoman soldiers' approach from the horizon. Their small, blurry silhouettes create a sense of remoteness in space and distance in time. The cartoon's final touch is a white flag unfurled on the pyramid, announcing to the Ottoman audience Egypt's cultural and political surrender.

Of course, an Ottoman commoner unfamiliar with Egypt's current political and diplomatic struggles might find this cartoon in *Hayal-i Cedid* rather perplexing. Therefore, the artist explains its abundant symbols in the caption. This interpretive text is, in this case, important, because it both functions as a decoder for the symbols and as a blueprint for their reproduction. Therefore, once the visual scramble of the cartoon is unfurled for the reader, this fixes the translation in their mind, sealing these symbolic interpretations for their encounters with future cartoons. For example, the text reveals the alligator as the Egyptian people. The turtle represents the actual animal, which the Egyptian soldiers are competing against. The rider is the anarchist (perhaps the nationalists or the rebels against the British presence) that tries to hack the existing

Egyptian government. The carriage, meanwhile, suggests all the groups that are included in the struggle for the homeland. The front wheel wants to turn against European politics, while the back wheel supports the British powers. The woman on top of the carriage embodies the long-standing elite families of Egypt. *Hayal-i Cedid* concludes the process of definition with a punch line from the daily Ottoman news on how the unorganized maneuverings of the nationalist cause mess up matters of government and make it inevitable so that Egypt will fall under British rule.

Papagalu's imaginary circus of figures offered a critique of Egypt's claim for independence from the empire at the cost of its political order and security. It announced to readers Egypt's approaching end under a non-Muslim imperial power and depicted Egyptian Arabs as incapable of making long-term political decisions that would benefit their nationalistic aims. Perhaps the cartoon also threatened those who sought the help of foreign powers for a prospective change, as the khedive once did.

These cartoons demonstrate the contingent nature of historical developments and invite us to reconsider linear and anachronistic narratives of history. The heroic and fearless representations of Sanusiya Arabs of North Africa who fought against the Great Powers, including the Italians and British that we encountered in previous cartoons, are here depicted as cowardly Egyptians running away from the same threat. Thus, the public image of the Arabs once again deteriorates from the status of loyal citizens of the Muslim periphery to the politically influenced and unreliable subjects of an empire run by ethnically superior Ottoman Turks.

With the war's outbreak, the British declared Egypt a protectorate (which meant formally adding the territory to British sovereignty under a subordinate ruler), deposed Abbas Hilmi as the khedive of Egypt and Sudan, and appointed his uncle Hussein Kamel in his place, adjusting his title as the new sultan of Egypt. Hussein Kamel's first act as sultan was to declare the annulment of Egypt and Sudan's nominal ties to the Ottoman Empire. As soon as the news was out, his act echoed through the Ottoman political cartoon papers. The Ottoman political press was not mistaken concerning Egyptian struggle under the newly appointed, British-influenced khedive. From the beginning, the nationalists, along

with decrowned Abbas Hilmi II, were supporting the German-Ottoman cause in hopes that victory would entail Egyptian liberation from British occupation (Jankowski 1991, 253).

The struggle over Egypt, especially after the British declaration of its protectorate in 1914, was addressed by *Karagöz* in a series that used symbolism similar to Papagalu's. In its cartoons, the longing for Egypt as part of the homeland underlies the imaginary created around the narrative of the Ottoman Empire's campaign against the British for regaining authority over the region. For instance, a *Karagöz* cartoon printed on 4 December 1914, almost right after the British claim, demonstrates this melancholy in the crudest way: the main protagonist, Karagöz, and his son, who represents the coming generations, pole-vaults the Suez Canal to a landscape with its pyramids and palm trees recognizable as Egypt (fig. 62). The act of the vaulting of father and son signifies a simple and sudden movement to the designated location. Of course, to the reader, that does not mean a sudden military campaign to literally take over Egypt; however, it does suggest the Ottoman government's maneuvering in response to British imperial interests. The artist delivers this information, again, through various symbolic representations, as with the pole that made the maneuvering possible. The latter is made from a relatively large Ottoman flag, a metaphor the cartoonist used for the Ottomans' envisioned reclamation of the recently lost Egypt. These symbols of power assure the reader that Egypt is still part of the empire and will remain so for generations to come.

The message, of course, was designed to convince readers that Ottoman policies were superior to those of the British. The dialogue in the cartoon's caption further confirms the territorial assertion by referring to Egypt as "mübarek vatanıma" (my sacred homeland), emphasizing Egypt's religious—not ethnic—unity as part of the empire. This concept of unity becomes even more clear in Karagöz's son's reply to his father, where he refers to himself as "genç Osman" (young Ottoman) and promises that, with the power of his will, he will go all the way to "Cezair" (Algeria). This guarantees the Ottoman public the mightiness of their government, which threatens not only the British who "abduct" Egypt from the empire but also all of the imperial powers that colonized ex-Ottoman North Africa.

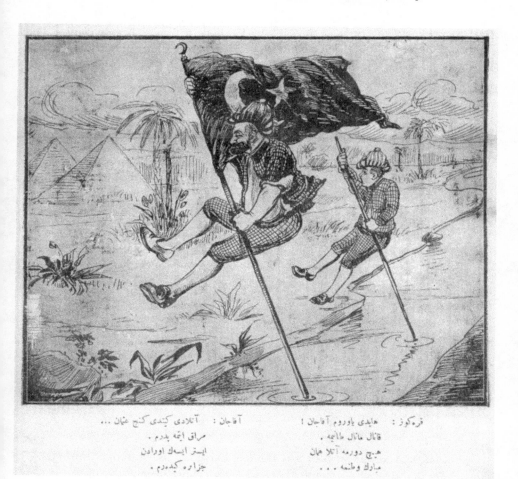

62. *Karagöz*, 4 December 1914, 1. [Ottoman] Karagöz: "C'mon, my son, Afacan! Do not worry about the canal, jump quickly to the other side, to our homeland!" Afacan: "Don't worry, Father, the young Ottoman already jumped! If you wish, I can go all the way to Algeria!"

A second example from *Karagöz*, from May 1915, puts similar effort into imagining Egypt and its people as an abducted colony. A fictionalized bird's-eye-view map identifies Egypt with a Papagula-style illustration of a pyramid, and a sphinx placed under a British military figure. The map is a simple illustration of an imaginary vertical line identified with the Suez Canal that imaginarily connects Egypt to Serbia, with Istanbul located

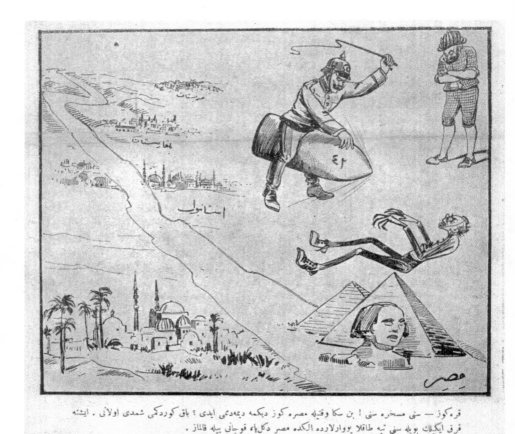

قره‌كوز — سنى مسخره سنى ا بن سكا وقتيله مصره كوز ديكمه ديه‌دمى ايدى ؟ باق كوردكى شمدى اولأى . ايشته
قرق ايكيلك بويله سنى تبه طاقلا يووارلارده الكده مصر دگلياء قوچاق بيله قالماز .

63. *Karagöz*, 3 November 1915, 1. [Ottoman] Karagöz: "You buffoon! Didn't I tell you not to raise eyes for Egypt? Do you see what happens now, 42 will take you down in such a way that you won't see a piece of Egypt!"

between the two (fig. 63). The artist positions Germany as the muscular leader of the central powers, attacking the British with a 42cm projectile, which he sits on.[9] Naturally, the cartoon refers to the latest developments on the front, where intensive air attacks were carried out by the Germans over British headquarters in Egypt, thus raising the hopes for Ottoman readers in an upcoming redemption of the Egyptian people.

9. "42cm," written on the barrel, represents "Big Bertha," the nickname of a super-heavy mortar developed by German arms maker Krupp on the eve of World War I.

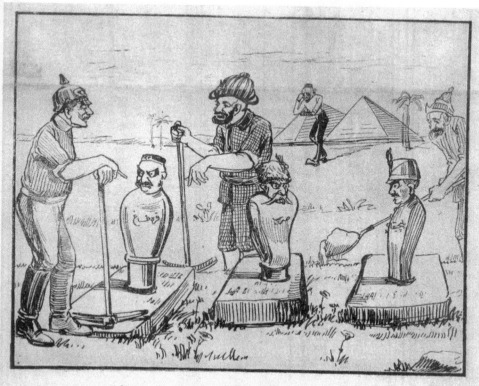

64. *Karagöz*, 4 December 1915, 1. [Ottoman] Karagöz [to German ally]: "These were glorious and we raised their statues! Now let's go and finish that bean pole over there, it is his turn!"

The same Papagalu-style pyramids appear again in two more cartoons published in *Karagöz* in the following months. The first, in December 1915, magnifies the Central Powers' attacks on the allies by depicting enemy powers as gravestones—which read, from left to right, Montenegro, Serbia, and Belgium—and symbolically cheering their defeat (fig. 64). The British officer in the background stands in front of pyramids and palm trees, holding his position in Egypt, while wiping tears from his eyes for losing allies. The caption imposes the imagined reality of an Ottoman-German victory over the Allied forces, declaring that the next to be buried is the British who enslaved Egypt. Of course, being a "hostage" is a

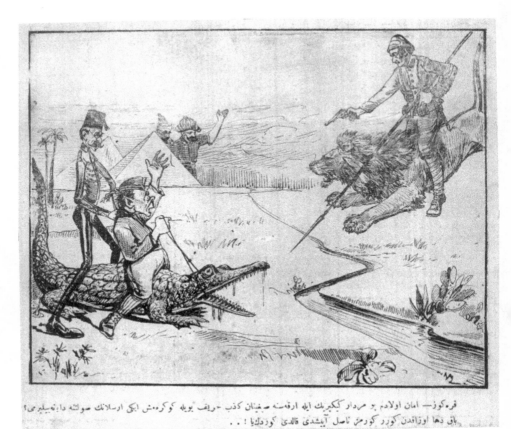

قره‌گوز — امان اولادم بو مردار کیکریك ایله ارقه‌سنه ضنان کذب — ریف یویله کوکره‌ش ایکی ارسلانك صولتنه دایه‌بیلیرمی؟
باق دها اوزاقدن كورر كورمئ ناصل آیشدی قالدی كوزدك‌یا ! . .

65. *Karagöz*, 2 February 1916, 1. [Ottoman] Karagöz: "Look, son, do you think that a filthy scrawny like him and the man hiding behind can resist the attacks of two such roaring lions? Don't you see how they are baffled?"

concept that is repeatedly pinned on Egypt, announcing again and again its state of neediness, and thus its weakness and call for salvation.

The cartoon published in February 1916 in *Karagöz* attacks the new khedive Hussein Kamel, who cooperates with the British (fig. 65). Here, the cartoonist challenges Kamel to a fictional duel where the Ottoman army has the upper hand. Karagöz and Hacıvat watch the scene behind the pyramids to narrate the story for the Ottoman public. As is customary, the symbolic landscape of Egypt is at play with the pyramids in the background, and the Suez Canal forming the virtual division between the

duel's two parties. In the cartoon, the balance of the composition is also noteworthy. The geometric configuration of the cartoon space centering the river creates a subliminal perception of comparison where, in this case, the left side holds a lower position than the right. The right side of the river is occupied by a single image of an Ottoman officer, placed in a higher position to the Egyptian sultan sitting on top of Papagalu's alligator of the Nile, bridled by the British as the aggressor in Ottoman Arabia. The cartoon's imposition of the Ottoman army as the Egyptians' savior from the expansionist ambitions of colonialist Britain is fortified in its presentation of the Young Turks' revolutionary spirit, aimed at opposing the rulers' despotism. The Ottoman officer fearlessly takes aim at the British, while the Egyptian sultan with his gun and spear palpably demonstrates Istanbul's anger over Egypt's cooperation with the British.

Before and during World War I, very few political cartoons personified Egyptian Arabs. All references were mostly made implicitly through landscape and animal symbolism. One rare example was published in *Karagöz* (fig. 66). The Egyptian Arab that Karagöz brought under the Ottoman eye was surprisingly different than what the cartoon press had adopted in illustrating the Tripolitanians or the Moroccan Arabs of ex-Ottoman North Africa.

In a distinct fashion, the Egyptian Arab now resembled the *zenci* (Black) Arab character of traditional Karagöz shadow theater more than the actual Egyptian. His facial features; fleshy lips; small, rounded nose; big, questioning eyes; and dark skin did not reflect reality but instead presented a metaphorical imagining of the Egyptians as still part of the Ottoman household but holding a special status compared to the white Arabs.

Karagöz's Egyptian character in the cartoon published in February 1915 appeared as an uncivilized fellah in shabby, single-piece garb and with bare feet. On that level of remoteness, he is no better than the Yemenis or Tripolitanians for Istanbul's urbanites. Yet his identity as a Muslim is conveyed not with a keffiyeh but with a *takke* (knitted skull cap). The caption of the cartoon acknowledges the Egyptian Arabs as naive—another characteristic of Karagöz's Black Arab—when fellah shows Karagöz and Hacıvat the British he caught in the water (presumably the Nile, due to its surrounding landscape). The cartoon makes a mere reference to the

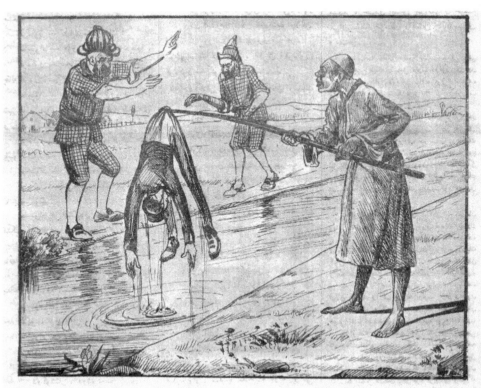

قره‌كوز — یورنه دوغرو نیه اوزاتوب طوریبیورسك ، بی حریف اكری‌یه چك كری‌یه !
مصرلی — مالش یا سیدی !..
قره‌كوز — اوولان بونك ماسی فضله !. بیلدیكدز باس بلاغی مرداو بر لش .. ایشته اورادن چیقارمشسك . ىكا اوزاتهجنگه
كو تو دكزه آت ! ..

66. *Karagöz*, 5 February 1915, 1. [Ottoman] Karagöz: "Why do you keep reaching up my nose, troubled bastard! Move back, way back!" Egyptian: "My friend, this is my carcass!" Karagöz: "Men! This is heavy . . . Nothing special with it, this is a common filthy carcass, that's where you got it out, so take it and throw it to the sea instead of reaching up it to me."

Egyptian people's sense of resistance to the British occupation. The remoteness of the Egyptian character, as a man who just happened to catch by putting his straw in the water, is no different than the turtle of Papagalu that got stuck between taking action or not.

Throughout the first decade of the twentieth century, the Arabs of the empire were fancied either as friends or as foes, according to fluctuating

political circumstances. With no clear definitions of "nation" and "home-land," cartoonists found themselves in a quandary: how to portray those who were outsiders and insiders at the same time—part of the empire, but not quite part of the nation—and how to do so in multilayered cartoons in a manner that crystallized geopolitical signs, highlighting particular politico-administrative boundaries, territories, and geographical visions at a time when ideological experiments such as Westernization, Ottoman-ism, and Islamism, in line with currently emerging ideas of nationalism and Turkism, were in competition with one other.

6

From National to Non-National Other

The Arab in Early Republican Cartoons

The Great War ended in 1918, leaving behind ruined empires and nation-states. Shaped around the Wilsonian principles of self-determination, these new nation-states took their place as modern constructs in the new world order, placing at their core, in Anthony D. Smith's words (2002, 5), "the ideal national type." For Smith, the notion of the other was inherent in this type as a representation of an imagined national identity. Yet the double-edged character of national identity holds the capacity of defining not only who is a member of the community but also who is not—specifically, who is non-national. Within this scope, the once-Arab subjects of the Ottoman empire that were contested against the imperial powers of Europe now were redefined as a unified stereotype for the nascent Turkish Republic's non-national others. The Arab, in its regenerated context, was characterized, identified, and thematized in early republican political cartoons to consolidate Turkish national identity. Such a deployment of nationalism required the manipulation of public opinion through an emphasis on the role of ethnic myths, memories, symbols, and traditions materialized in the mirror images of the non-national.

To trace this fluid processes of otherization from its colonial and continental to a nationalist and ethnic context, this chapter examines Turkish political cartoons from 1923 to 1927. The cartoons of this period are especially significant for contextualizing and demonstrating how the graphical representations of different Muslim ethnicities of the newly

206

formulated ex-Ottoman Arab provinces as the Middle East—the Kurds, Arabs, Yezidis, and Druze—continued to be amalgamated into a single "Arab" stereotype, thus undermining their diversity as people living within this geography. Moreover, the cartoons show how old grievances of the Ottoman Empire regarding its Arab subjects were transmitted to their conventional nationalist context. These visual delineations reflect the way political and diplomatic developments were communicated, whether directly or implicitly, in the cartoon press, where the republic encountered its non-national types. These types can be traced in the five major events that dominated the political satire press during the formative years of the Turkish Republic: the Mosul question (1923–26); the struggle between King Hussein and ibn Saud over Hejaz (1924); the Yazidi rebellion of 1926; the Syrian revolt under the Druze tribesmen against the French mandate (1925–26); and, finally, the Moroccan revolt against Spain and France in North Africa (1921–26).

World War I and the Arab Revolt of 1916

As World War I drew to a close, the Turks found themselves in the midst of a struggle for national independence and a war for their very surviv-al.[1] Ottoman armies were trying to hold their position in the major Arab centers like Baghdad, Damascus, and Jerusalem and their surrounding territories all the way to Hejaz for a final battle. What they did not account for was the secret agreement signed in June 1916 between the British and French governments, with imperial Russia's blessing, that sealed their intent to parcel out the Ottoman Arab lands. Named after their signatories, Mark Sykes of Britain's Arab Bureau (Cairo) and French diplomat François George-Picot, the Sykes-Picot Agreement's long-lasting

1. Rida's (2007, 246) memoir of his travels to Syria, Istanbul, India, and the Hejaz between 1908 and 1916 details both his personal itinerary and the larger, tragic course of Turkish-Arab relations in the late Ottoman period, when the British were trying to undermine the sultan's legitimacy over the caliphate. In his notes, he refers to the CUP's betrayal of Arabs and Islam, and he commends Sharif Hussein for revolting against the CUP, and France and Britain for providing safe routes for the transportation of *hadjis* to Mecca (Riza).

consequences still echo in the political unrest of the Middle East. With this agreement France ceded the coastal areas of Syria (including Lebanon) and an exclusive zone of influence in inland Syria. This region had a strategic significance for the oil-rich Ottoman province of Mosul, as well as a sizable part of eastern Anatolia, which the French had to relinquish after a prolonged campaign against Turkish nationalist forces.

Britain, meanwhile, was given Baghdad and Basra provinces, with an adjacent zone of influence to the west and Mediterranean outlets at Acre and Jaffa. Except for these two ports, Palestine was internationalized, but the issue of how it would be administered was left vague. It was agreed during the negotiations that the inland areas would be assigned to an Arab kingdom (or kingdoms) that would coincide partially with the zones of influence of France and Britain, leaving imperial Russia with eastern Anatolia (Fromkin 2009, 194–96; Shaw and Shaw 1977, 320–22; Zürcher 2010, 143–44). The agreement remained confidential until the Russian Revolution was succeeded in 1917 by a Bolshevik government that had no interest in keeping Czarist secrets. When it became public, it produced the first rift between the Hejaz's Arabs and Britain.

The main reason for the secrecy, it seems, was the agreement's contradiction of promises made earlier by the British (specifically, Sir Henry McMahon, British high commissioner in Cairo) to Arab leaders (mainly Sharif Hussein of Hejaz and Abdul Aziz Ibn Saud). Unaware of these promises and encouraged by the thought of a kingdom of his own, Mecca's Sharif Hussein revolted against Ottoman rule in 1916, with British support. Be that as it may, the Arab Revolt of Sharif Hussein ended up being the major constitutive event in constructing the republican period's Turkish perception of Arabs, affirming its stereotype for decades to come.

Consolidating the Borders, Establishing the State

The downfall of the Central Powers, including the Ottoman Empire, was sealed with the Armistice of Mudros, which was signed in 1918 with Britain. The settlement surrendered remaining Ottoman garrisons outside Anatolia, allowing the Allies the right to control the straits of the

Dardanelles and the Bosporus, and granting these powers the right to occupy "in case of disorder" any Ottoman territory. The Ottoman Army was entirely demobilized, and all ports, railways, and other strategic points were made available to the Allies. Following the defeated powers' disarmament, a peace conference took place at the Paris Peace Conference in 1919 to finalize the terms of defeat for the member states of the Central Powers.

The negotiated terms during the Paris Peace Conference resulted in series of treaties, one of them signed in 1920 with the Ottoman Empire. The Treaty of Sevres, which officially declared the Ottoman Empire a defeated power, stripped it of its Arab provinces, with its territories occupied by British, French, Italian, and Greek armies. The Ottoman sultan was allowed to keep his title and seat in Istanbul, while, in inland Anatolia, a War of Independence raged under Mustafa Kemal and his comrades.

Mustafa Kemal, the leader of the Turkish national movement, proclaimed the borders of a new Turkish state that rejected both the Treaty of Sevres and the government in Istanbul. Establishing Ankara as the seat for the new Turkish government, he declared the National Pact (*Misak-ı Mill î*) as the borders of the new Turkish state on 28 January 1920. From 1919 to 1923, the national struggle succeeded through a War of Independence (*İstiklâl Savaşı*) against an array of Greek and Western occupation forces, including those of the Ottoman government in Istanbul. After a series of military victories against the imperial powers, and the eventual signing of the Treaty of Lausanne that overrode Sevres in 1923, the Turkish parliament announced the establishment of the Turkish Republic, with its capital in Ankara. The new state had limited power and prestige not only domestically but also internationally. The borders declared by the National Pact in 1920 determined the confines of the new nation, which was recognized internationally only by the end of 1923, with only two disputed provinces to be negotiated later: Mosul and Alexandretta.

From the beginning of the national struggle, Mustafa Kemal had two main concerns in determining Turkey's national borders. First, the boundaries had to include the areas fought for and defended by the Ottoman Army at the time of the armistice; the latter enclosed the mainland Anatolia inhabited mostly by Turks and Kurds. Second, parting with the

Arab provinces and the areas to the south of the frontier—except Mosul and Alexandretta—did not seem to be a priority issue for Mustafa Kemal and the national struggle's leading members (Zürcher 2010, 227–28).

Memories of the Arab Revolt in Turkish National Discourse

The emergence of the republic ushered in a period in which the ideal national type began to crystallize. The bitter memories of World War I were put to work to serve the idealization of the new nation, as the agony of the Ottoman soldiers in the harsh geography of Arabistan were still fresh in the minds of many—especially the intellectuals, who were crucial players in the consolidation of the double-sided nature of nations. For example, Falih Rıfkı Atay (1933, 50–51), in his famous story "İştah" (Appetite), drew a demonic and highly sexualized image of the "despised" Arab as "a glossy dark and greasy appetite that drinks water from one morning to the next, sweats from all of his hair; his lust coils up like a snake on his female lizard, and then only relaxes." In a similar vein, Ömer Seyfettin (1884–1920), one of the most significant ideologues in modern Turkish literature, invoked a nationalist discourse in his story "Piç" (Bastard), in which he complained: "I can feel the lazy dependency of the Şark [East] on my shoulders" (Seyfettin 1938, 70). Another paragraph in the same story reveals his deep dislike of Egypt, where the Turks sacrificed their lives to protect the Ottoman Empire's territorial integrity: "Oh, Egypt! Some Turks go there to have fun, to change their mood! I don't know how they tolerate that life, that landscape? How can one have fun at the bedside of a sad and sluggish patient lying with millions of tuberculosis germs in its lungs, drink, get joyful, and not cry over the floods of blood that have flowed and not yet dried? I cannot sit for a week in such a place, it's not possible" (Seyfettin 1938, 71).

Similar references to the barrenness of the land and the "disgusting" habits of its people were echoed in the memoirs of other prominent Turkish nationalists and intellectuals such as Yakup Kadri Karaosmanoğlu, Refik Halit Karay, Reşat Nuri Gültekin, and Kemal Tahir. Their experiences of grief and loss over the ex-Ottoman Arab provinces were reflected in the figure of the hostile and untrustworthy Arab.

On the other hand, the state and its ruling elite was ideologically committed to defining the Turkish Republic within the characterization of Western liberalism, as a secular and pluralistic democracy. A series of reforms was required for social and cultural modernization in order to construct Turkey's "own high culture and state . . . against the pre-existing imperial center" (Ahmad 1993, 53; Gellner 2006, 67). As the president of Turkey, Mustafa Kemal and his associates were aware that the society they had inherited from the Ottoman Empire was, in effect, a multicultural and multiethnic body, which presented a challenge to the process of nation-building. Simultaneously, the society's firm Islamic texture would not easily permit cutting ties with traditions adapted from Arab-Islamic culture, and, accordingly, would not enthusiastically allow a new "modern" perception of statehood to take shape.

During this formative period, the nascent Turkish government tried to redefine the relationship of the Turkish people to ethnicity and religion. This attempt to adapt Turkey to Western nation-states' norms and construct a homogeneous sense of nationhood required excluding non-Turkish elements that had been woven into society over the centuries. This process required constant comparison with the empire's former uncivilized regions and a concomitant effort to redefine their values. Starting in 1923, the new government introduced a series of political, cultural, social, and economic reforms that aspired to solidify the new republic's construction, substituting notions of an inclusive Islamic identity with those of a modern, secular nation-state. The first modification toward this aim was abolishing the caliphate in 1924 by the Grand National Assembly and ratifying, in its place, a secular constitution—the initial move in a grand project of social engineering that aspired to create from scratch a new generation that conceived of itself as a "nation." According to Mustafa Kemal, the concept "nation" meant "the body of people who live together on the same piece of land, with the unity of the same ethics and language and who comply with the same set of laws" (in Nutuk 1981, 589). This formulation of Turkish citizenship left the religious and non-Turkish elements out of "Turkishness," not so much separate from its roots in Islam but, rather, from Arab culture. For example, there were changes made to attire and headwear, conversion to the Gregorian calendar and time

system, acceptance of the civil code, and the closure of Sufi lodges and orders (*tekke ve tarikât*).

The adoption of the Roman alphabet and the process of stripping the language of its Arabic and Farsi components marked the crucial stage of the reforms. Arabic script and language were embedded in every level of Ottoman culture that passed through the sieve of Islam, which had joined the two cultures during the preceding centuries. The new Turkish leadership therefore felt that reforming the language was necessary for a complete social transformation. In 1928, the Grand National Assembly voted to accept the new Roman alphabet and started a mass educational mobilization campaign.

British and French Mandates in the Middle East

While the Turkish republic was busy with its own full-scale reformation, former Ottoman provinces now agitated for their own independence from their European mandate governments within their predesigned boundaries. The ex-Ottoman *vilayet*s of Damascus and Aleppo were merged into Syria under the French mandate government while Mosul, Basra, and Baghdad were integrated into Iraq under a British-controlled Arab kingdom. Both mandate jurisdictions had borders with Turkey, and both indigenous societies revolted against their rulers in the 1920s. The wave of resistance was not limited to Syria and Iraq; the intermittent resistance of Palestinian Arabs against British rule and Jewish settlements continued, while the Hashemite dynasty founded a new kingdom in Transjordan with direct British support.

As a new actor in the region, the Turkish government under the governance of Cumhuriyet Halk Fırkası (Republican People's Party, or RPP) remained neutral, indeed almost oblivious, to these developments in neighboring Arab nations with minimal diplomatic relations except the two unresolved border issues: first, the dispute with Britain over the contested territory of the Kurdish-populated, oil-rich former Ottoman *vilayet* of Mosul; and, second, the status of the *sanjak* of Alexandretta that bordered the French mandate of Syria. These developments were explicitly

represented in republican political cartoons that played around with the image of the white Arab.

Kurds, The Mosul Question, and the National Self: 1923–1926

One of the two disputed territories of the National Pack following the Lausanne Conference and consolidation of the Turkish Republic as a sovereign nation-state in 1923 was Mosul. During the Lausanne Conference, the question of Mosul was addressed by the Turkish and British delegates who claimed the province as part of their future mandate in Mesopotamia. The failure of consensus among the two parties resulted in the conference committee's decision to defer the negotiation and settlement of matters on Mosul.

It took close to three years to achieve accord in the Mosul dispute. During this period, the popular print media propagated the state discourse concerning the events surrounding the political and diplomatic maneuvers of both Turkish and British governments by glorifying one and demeaning the other. *Karagöz* and *Akbaba*, as the most prominent political satire papers under the new republic, covered the dispute with great interest. In representing the aggrandized nation and national self that stood against the great world powers, they often adopted a two-fold approach: first, they kept the negotiations with Britain at the center as a point of comparison, presenting Turkey as one of the victorious countries of the Great War; and, second, they persistently alluded to the Turks' collective memories of the colonial powers as exploiters of former Ottoman lands. Overall, the line of production of cartoons during this period emerged as a smear campaign against the colonizing powers, particularly Britain. Within this contestation of diplomatic warfare, the colonized people of ex-Ottoman provinces would often stand as spear-carriers.

The first appearance of a the colonized Middle Easterner emerged in the political cartoon press in relation to the British Royal Air Force's (RAF) bombing of Sulaymaniyah, a Kurdish-populated town in Northern Iraq that rebelled against the joint Arab-British kingdom of Iraq. The October

1923 issue of *Akbaba* introduced the first cartoon of a series regarding Mosul, illustrated by the popular cartoonist Ramiz. The cartoon magnified two figures, a British officer and a Middle Easterner (whose ethnic identity was not indicated), as they were seen from the sighting device of a camera capturing a photo from a British royal hunting adventure. The relatively small figure of the British officer with a high-and-mighty facial expression appears to be proudly posing for the cameras with the yield of his great hunt: the giant "Middle Easterner" who struggles to free himself from under his boot. The hunting of animals like lions, tigers, or even elephants was associated with Europe's colonial experience in North Africa and the Middle East. This experience was part of a discourse, as Rudyard Kipling put it in 1899, to "take up the White Man's burden" to rule the "wild, new caught, sullen peoples, / Half devil, half child" (Storey 1991, 135; Kipling 2007, 96).

Ramiz's representation of the failed rebellion of the Kurdish tribal leader resonates with Kipling's language regarding the restless or "sullen" natives of ex-Ottoman Arab provinces. The cartoon's visual rhetoric reflects the British colonial experience that served as a primary determinant for colonial cultures of "half devil, half child" people for its readers. The "white man's burden" to exorcise the devil from the soul of the child and educate him in a manner that deprives him of his own cultural values was obviously a major theme in Ramiz's narrative. This theme was underlined in the cartoon's caption, in which the officer delivers a supposedly peaceful message to the oriental East, in a tone completely contradicting the actions of the British: "We announce to the entire world that we are here only for the populace's well-being!" (fig. 67).

The perceptional delusion here is that it is impossible to determine the ethnicity of the native portrayed with his keffiyeh and cotton robe. For a commoner, the man in the illustration can actually be an Arab or a Kurd or any other member of this ethnically and religiously diverse region. For Ramiz—and, therefore, for his audience—he is first and foremost a colonized Middle Easterner in its unified orientalist sense. If the identity was not clarified in the text of the cartoon, it would be almost impossible to differentiate the figure's origin as a Kurd. The title communicates to the audience headlines in the daily news—*British Planes Bombard*

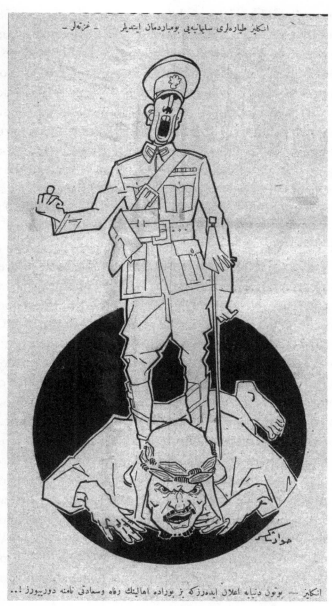

67. Ramiz Gökçe, *Akbaba*, 29 October 1923, 1. [Ottoman]
British Planes Bombarded Suleymaniah! [Caption] British:
"We announce to the entire world that we are here only for
the populace's well-being!"

Sulaymaniyah!—and cues the reader to recognize the character's identity as the Kurdish tribal leader, Sheikh Mahmud, with no further details.

The symbolism employed by Ramiz sends two subliminal messages to the Turkish audience. The first is the obscurity of the prospects of the ex-Ottoman province under mandate power. For example, the Middle Easterner—in this particular case, the Kurd—placed in a dark circle similar to the heart of a target board, works as a reminder of their doomed future, their position of as prey to be hunted down. The second message produces a sensation of satisfaction, even a sense of victory for the national self, a feeling of self-glorification that comes from the cartoon's composition of the relationship between the two dominating figures. The facial expression of Sheikh Mahmud under the British officer's boot suggests his anger, along with his desperation and helplessness. Ramiz portrays him as a wild animal forcefully tamed by his trainer, whose level of violence is far beyond the barbarism of the Middle Easterner, who can never hope to achieve it. This is precisely the moment when the cartoon delivers its message to the audience: the deceived people of the once-Ottoman lands—unlike the self-determined, civilized Turkish nation—cannot look forward to anything better than bombings and boots. The cartoonist glorifies the Turkish people and their overall achievements through comparison with the calamity of the Middle Easterner.

Negotiations over Mosul between Turkey and Great Britain were disputed on the basis of nationality and principles of self-determination. This was mainly constructed upon US president Woodrow Wilson's postwar formulations of the Middle East asserting that ex-Ottoman Middle East should not be divided among the victorious powers. In line with Wilson's doctrine, negotiations over Mosul between Turkey and Great Britain were mostly carried on through Wilson's principles, with each trying to counter the other's argument. While Britain and King Faisal produced their share of public propaganda during this twitchy diplomatic battle, Turkey raised its own public campaign. The Turkish press became the primary propaganda agent to publicly legitimize the ex-Ottoman *vilayet*'s rightful attachment to the mainland. This was intended to stimulate in the mind of the Turkish public the Arab stereotype, with all its symbolic references. For example, *Akbaba*'s 29 May 1924 issue depicts a Turkish

soldier happily hiking in a mountainous landscape. He walks his pet-like sheep, holding it with a string with one hand while carrying a bundle of hay in the other. The sheep, labeled "Mosul," seems to be comfortably following her owner; however, both the sheep and the Turkish soldier are unaware that an overweight British figure wearing a Union Jack hat is stealing the sheep's milk by sucking her teats. To make his point, the artist declares the obvious—"?—Mosul is mine!"—but he does not specify who is asking the question: Is it Turkey or Britain (fig 68)?

Ramiz's *Akbaba* cartoon served as a symbolic battlefield for the two rivals contesting a single territory. His visual metaphor of motherhood reinforces Turkish public belief that Mosul is part of the motherland, thereby declaring that it has legitimate dominion over it, as a mother has over her child. On the other hand, the British figure's infantile hunger demonstrates his position of need and, thus, conveys a sense of inferiority. To feed his primitive craving, he has had to steal Mosul's natural resources, and, while doing so, he demonstrates neither superiority over nor sensitivity to his victim. His daring to take it from its rightful owner works as a reminder of the Britain's colonial reflex.

Ramiz's choice of a sheep to symbolize Mosul is also noteworthy. From Aristotle on, the studies of bodily characteristics related to animal representation anthropomorphizes sheep for those who have a soft, toneless voice (Hett 1955, 133). Of course, one can never know if Ramiz was aware of Aristotle's writings when he decided to personify Mosul as a sheep; still, he was surely aware of its metaphorical meaning as a person who lacks self-determination, as defined by the dictionary of the Turkish Language Association. The choice of a sheep conveys a perception in the Turks' mind of the easily influenced, domesticated nature of Mosul's Kurdish population in serving its rightful owner. For Ramiz and his audience, Middle Easterners were naive to the degree that they were incapable of making decisions for themselves—also a colonial trope emanating from an Ottoman unconscious. It was this simplicity that made them vulnerable to the imperial powers in the first place and that positioned Turks as their protector.

Britain's exploitation of Middle Eastern naivete was, for Ramiz, a crude act cloaked with civilization. Ramiz often caricatured British vulgarity, as embodied in a fat man wearing a suit and a Union Jack hat. His uniquely

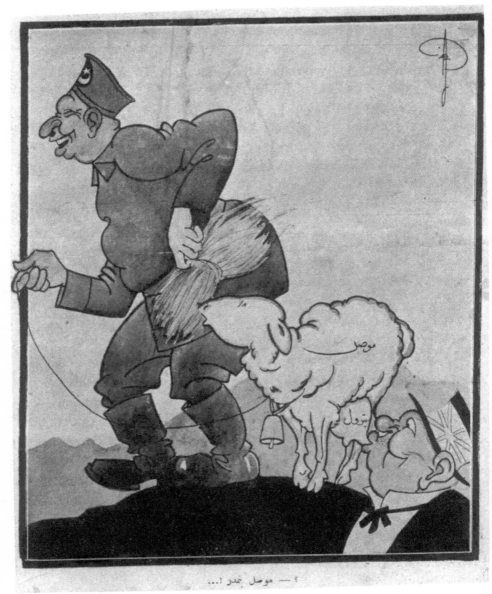

68. Ramiz Gökçe, *Akbaba*, 29 May 1924, 1. [Ottoman] "?—Mosul Is Mine . . ."

shaved beard, which covers his lips, his chubby and sagging cheeks, and his big red nose, emphasized his villainous character, similar to Bill (Bull) Sikes in Charles Dicken's *Oliver Twist*. Ramiz's Brit is chubbier than Bill Sikes because he is relentlessly feeding on his colonies, but, like Bill Sikes, Ramiz's Brit represents the outcome of a brutalized existence; he has lost almost any sign of the human tenderness that is necessary for social harmony, and, lacking in humor, he openly scorns anything resembling ethical or moral principles. In a way, he represents all of the ills brought on by the industrial revolution and the Western individualism it imposed. One cannot help decoding these details in the way Ramiz formulates the contested ideologies of the time, especially socialism and its critique of liberalism, which found its structural expression in the 1917 Russian Revolution. The themes of victimization and oppression dominated Ramiz's characterization of contested Mosul province as he translated the British presence in the region as an unjust and cruel exercise of authority by imposing a burden on its people.

Ramiz's cartoons interwove various symbols and practices to communicate this status of vulnerability in a constant binary opposition with Britain's heartless and ferocious colonizing. One of these was his repetitive portrayal of the British as buffalos. In a cartoon published on 2 June 1924, the caption, "British mandate over Mosul!," puns on the word *manda*, whose literal meaning in Turkish is "buffalo," or "wild cattle." However, with the internationally accepted status of the ex-Ottoman provinces, the word was adopted by the Turkish Language Association to refer to the political order in the Middle East and North Africa established by the League of Nations. The Turkish cartoonist managed to creatively combine these two words, anthropomorphizing a buffalo's heavyset body with its stocky legs and large head, to suggest the massive body of Britain's and France's colonial possessions. Another constructed similarity in Ramiz's cartoons was a reference to mobility: the buffalo's heavy weight signifies a limitation of mobility both for itself and for the person crushed under it. Political cartoons of this period frequently used this imagery, which emerged in the early days of the republic, to imply oppression by the imperial powers.

Finally, the lack of motion caused by the buffalo's mass is used as a metaphor for weakness and helplessness. For instance, a frequent theme engaged by the cartoonists was the condition of nakedness as the conditioned representation of slavery, a phenomenon often embodied in a female body to symbolize the notion of defenselessness against the strength of a greater power—in our case, the Allied powers. Yet, in Turkish culture, as in other Mediterranean cultures, a woman's body cannot be perceived simply as embodying the concept of "honor." In Turkish, the word most frequently used to express this notion is *şeref*, which carries a sense of nobility, dignity, and integrity. In these cultures, rape is one of the cases where the female's honor is shamed. As Beth Baron (2007, 46) eloquently puts it, "The rape of women in the midst of war or political turmoil has historically been seen as a by-product of war and chaos. Yet, rape by an enemy had political as well as personal consequences. The dishonor to the woman and her family became a collective dishonor; her body became a metaphor for a communal or national disgrace." This relational triad between the buffalo, female body, and honor created a symbolic basis in Ramiz's cartoons for demonstrating the nature of the interactions between the mandate powers and their quasi-states.

As exemplified in this cartoon from *Akbaba*, Ramiz represents Mosul as a beautiful, vulnerable, naked woman with her mouth gagged and her hands chained, who conveys the impression of being sexually harassed by her overweight British colonizer. Ramiz mocks the Brit by constructing a binary between the image of his forceful actions over the naked, molested woman and the caption containing his false declaration to international media concerning these actions. In his visual and textual composition, Ramiz challenges these claims, quoting in the caption speeches from the ongoing League of Nations hearings: "She's so content under my mandate," the Brit claims, that "she doesn't even open her mouth to complain!" Ramiz's explicit demonstration of the skepticism and suspicion of the veracity of the rape charge by the British in particular and the modern world in general spotlights not only the power relations between the oppressor and the oppressed but also the ethical numbness of Western civilization. Text and image work together to provoke numerous

conceptual implications, which appear concurrently in the reader's mind, creating a perceptual reality devoid of humane characteristics that could only be represented by unearthly creatures that feed on human dignity (figs. 69–70).

Ramiz was convinced that Britain insisted on keeping Mosul under Iraq's political structure because of its oil. His cartoons contested the rightful owner of these possessions, sidelining its indigenous people in the process. This technique of presumably unintentional exclusion reflected an underestimation of the Middle Easterner's capacity to claim and utilize his own natural resources on Ramiz's part. This incapacity was also related to the lack of "appreciation" of one's resources, or, from the perspective of Turkish national discourse, the comforts offered under the brotherhood of religious unity. For Ramiz, the ex-Ottoman citizens of the Middle East could not evaluate the worth, merit, or quality of the Ottoman rule; they could not comprehend the freedom they had enjoyed until they lost it to Britain and France after they revolted against the Ottoman armies. Again, their lack of appreciation resulted in a loss of honor: their rightful claim over their homelands was no longer relevant, and their bodily integrity was shamed and violated.

The constructed link between the notion of honor, the female body, and colonization in Ramiz's cartoons also demonstrates the exploitation of colonies' natural resources by their colonizers. The symbolic reference is often constructed in relation to sexual harassment of a woman's body by its intruder. These portrayals of Mosul or other provinces under similar conditions as a naked maiden not only suggest these places' lack of civilization, and thus their defenselessness, but also their appeal to the appetites of so-called civilized countries. Depicted with devilish and grotesque features, the British cannibal can only be satisfied with his prey—in this particular case, with Mosul and the oil under "her" tender skin. The chained, naked woman seems to have no choice but to accommodate her oppressor and accept whatever is coming.

Through 1925, Turkey tried eagerly to prove to the international community Mosul's historical and social attachment to the Anatolian homeland. By the time the League of Nations was called in to reveal its decision

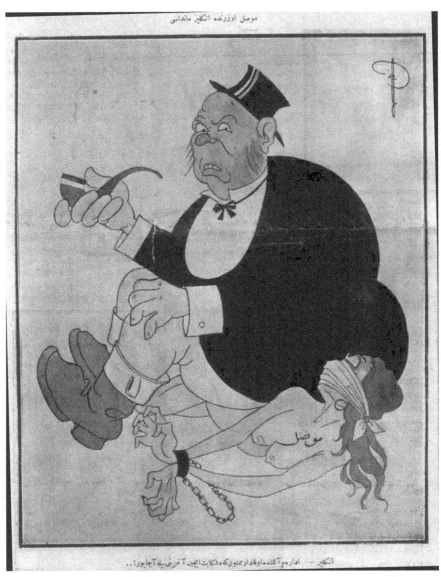

69. Ramiz Gökçe, *Akbaba*, 2 June 1924, 1. [Ottoman] *British Mandate over Mosul!*
[Caption] British: "She is so satisfied under my mandate; she does not even open
her mouth to complain!" [It reads "Mosul" on woman.]

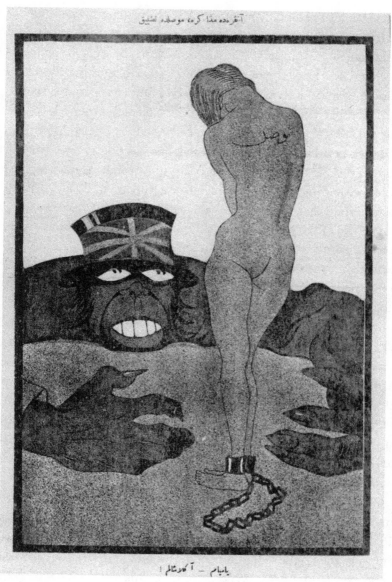

70. Ramiz Gökçe, *Akbaba*, 14 May 1925, 1. [Ottoman] *Proceedings in Ankara, Pressure on Mosul*. [Caption] Cannibal: "Let's get settled!" [It reads "Mosul" on woman.]

on the province's fate in September 1925, British institutions had already begun to transform Mosul and its oil resources (Shields 2009, 217–30). Ramiz's cartoon from July 1925 announced to the Turkish audience the expected outcome of the hearing with a rather disturbing illustration of a Middle Eastern man with half of his cranium cut open, his round eyes closed, and his face expressionless, wearing a chain around his neck that spells out "Mosul." The inner section of his skull is labeled "petrol" (oil).

Ramiz's portrayal of the man's thick lips, big pointy nose, and arched eyebrows reveals his Middle Eastern origin, without ethnic specification (once more it is unclear if he is an Arab or a Kurd). The combination of his features produces a numb expression, reflecting the latency of the colonized people of the Middle East. Although a sense of irritation appears to be concealed behind his expression, it seems like he feels nothing of the cannibalism to which he is currently being subjected. The Brit, depicted as a tiny flea (or mosquito) dressed in a black suit and a brimmed hat, sits on top of Mosul's nose, holding his skull tight from both sides. Although Ramiz draws a parallel between the blood-sucking parasite and the British, he does not draw the Brit as the animal itself. The Brit lacks any natural appendage for extraction; instead, he uses a straw to suck out the oil. What is happening to Mosul is conveyed in the text via a commonly used Turkish idiom, *burnumdan getirmek*, which translates to "exasperation" but literally means "to bring [it] through my nose." By using this expression, Ramiz clearly articulates the general state of mind of the Turkish people concerning the Mosul case, indicating a condition of weariness and disgust (fig. 71).

Mosul province, which Turkey claimed but Britain subjugated, remained part of Iraq, based on the League of Nations' final decision in 1926. After extensive consultations among the province's various ethnic groups, the league's Commission of Inquiry authoritatively concluded its report on 16 July 1925 (Write 1926, 455). This was not a big surprise for the Turkish political elite, who were aware of Britain's stronghold over the League of Nations (Coşar and Demirci 2007, 127). The Turkish government strongly opposed the Mosul *vilayet*'s formal attachment to Iraq, citing both its Turkish and Kurdish inhabitants' right to self-determination

جميعت اقوام ايلوله اجيلاحق وموصل مسئله‌سى قونوشيله‌حق

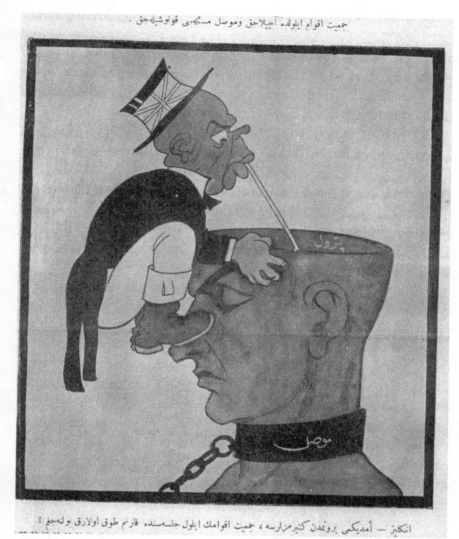

انكليز — أمديكى روبتدن كتبر مزارسه ، جميعت اقوامك ايلول جلسه‌سنده قارنم طوق اولارق بولنه‌جغ !

71. Ramiz Gökçe, *Akbaba*, 27 July 1925, 1. [Ottoman] *League of Nations Will Be Opened in September and the Mosul Question Will Be Discussed.* [Caption] British: "If they don't spoil my pleasure, I will be present at the League of Nations' September hearing with full stomach!" [It reads "Mosul" on the collar.]

as well as historical and conventional rights and pointing out that Turkey had never formally renounced its claims to Mosul, which it considered an integral part of its national territory. Meanwhile, King Faisal sought the support of the province's inhabitants, whom he considered part of the Iraq's population. Any decision in favor of Turkey would overturn what the king and the British assumed to be an existing reality.

King Faisal, as part of British diplomatic plots over the territory, was quickly targeted by the Turkish media for "swindling the naive people of Mosul" to serve his regional, financial, and personal ambitions. King Faisal, as the son of Sharif Hussein and the commander of the Arab armies that fought against the Turks during the Great War, was already detested by the Turkish public, whose memories of the Arab Revolt were still fresh. Thus, King Faisal's reencounter with the Turkish public over Mosul brought fury toward the Arabs back to the surface. Following the outrage expressed in the Turkish daily newspapers, maybe for the first time, Ramiz's cartoon of 27 August 1925 depicted Faisal in a personified form, dressed in his traditional outfit. With this cartoon, Ramiz surprisingly converted the symbolisms he often employed (animal forms or woman body) in representing Mosul—and its people—as a more identifiable type. This shift in style obviously personally targeted Faisal and his drive for strong Arab propaganda against Turkey in the Kurdish-populated Mosul. Ramiz was eager to expose to the Turkish public the mealymouthed nature of King Faisal (fig. 72). With that in mind, in his cartoon he illustrates Faisal as a hybrid creature, half-human, half donkey, something between a centaur and an onocentaur, demonstrating the characteristics of both in himself. Thirteenth-century texts depict the onocentaur as a monstrous animal with only two legs, unlike the centaur, which has four. In mythological texts, the onocentaur has a relatively "horrid face and hands adapted to every activity. It sends forth its voice as if about to speak, but it cannot produce the human voice since its lips are untrained. This creature hurls stones or pieces of wood at any that pursue it" (Zirkle 1941, 488; Pakis 2010, 123–24). This humorous yet demeaning feature brings to mind the early depictions of Arabs in Turkish political cartoons, where their backward nature was suggested by the wooden sticks they used against the heavy armory of the imperial powers.

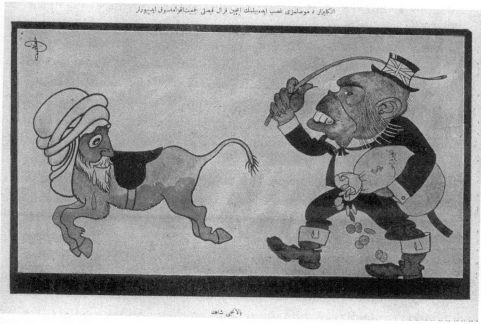

72. Ramiz Gökçe, *Akbaba*, 27 August 1925, 1. [Ottoman] *The British Are Dispatching King Faisal to the League of Nations in Order to Steal Our Mosul!* [Caption] "Perjurer!"

The onocentaur Faisal in Ramiz's cartoon is similarly constructed, using various aspects that recall the traditional attributes of his ethnicity as conveyed in the Karagöz plays. Ramiz exhibits these features in two registers—the first, a physical classification. Besides portraying Faisal as an onocentaur, Ramiz dresses him in a traditional keffiyeh, thereby clarifying his ethnicity as an Arab. The second register is the recognizable aspects of character and behavior. For example, saliva drips from Faisal's mouth as he stares at the moneybag carried by another hybrid creature representing Britain. The fact that Faisal is drooling over a bulging sack of money held by a Brit who herds him with a whip gives an unmistakable impression of the stereotypical immorality of the Arab identified with Faisal in particular and Middle Easterners in general.

The caption reinforces the Arab's image as a "perjurer!," condemning Faisal's propaganda, which serves British interests in order to serve

his own. Ramiz does this by announcing the latest developments in the title: *The British Are Dispatching King Faisal to the League of Nations in Order to Steal Our Mosul!* His emphasis on the action of "stealing" again underlines a characteristic trait of untrustworthiness that would stick to the Arab stereotype in the mind of the Turkish public for decades to come.

The final cartoon of the series concerning Mosul comes with the conclusion of its terms by the League. *Akbaba*, disappointed with the outcome, condemned the final verdict and said its farewell on its 7 June 1926 cover with the title *The Mosul Dispute Is Hushed Up!* In this last episode, Ramiz projects the outcome not as a total loss on Turkey's behalf, but as an achievement. His metaphoric burial ceremony indicates a temporary pause, where the assumed-to-be-dead body of Mosul resurrects and terrifies the British and Arab who are present at the ceremony. Although these stereotypes were difficult to match to players in actual politics, the Brit may have been inspired by Sir Winston Churchill, who at the time was chancellor of the exchequer but had previously been secretary of state for the colonies. Ramiz calls him "John Bull," a nickname often used in Great Britain, a symbolic term created to stand not for the exploited masses but for the satisfied expansionist nation, and a personification of Great Britain or England that dates back to the 1700s (Alba 1967, 123). Interestingly enough, the term entered Turkish slang at the beginning of the twentieth century, and, accordingly, *Con Bul* came to identify the "British," especially in cartoons of this period.

The Arab, on the other hand, is easier to recognize as King Faisal of Iraq. In the cartoon, both men are depicted as desperately trying to bury a corpse that seems to be still alive, yet lies in a coffin labeled "Musul Meselesi" (Mosul Dispute). The body issues his final words: "Mr. John Bull, you can make sure that I will be raised from the dead one day!," thus announcing to the Turkish audience that this will not be the end after all.[2] The body in the coffin personifies Turkish discontent with the league's decision, which is both a defeat and a warning. Ramiz's drawing alerts

2. *Cunbul* in old Turkish slang means "British."

his regional rivals, the Arabs and their British allies, with an omen of the province's future while assuring the Turkish public to maintain faith.

The cartoon also cannot help but satirize the Turkish government's setback by enclosing the insignificant silhouette of the foreign minister, Tevfik Rüştü Aras, leaving the scene silently, with a moneybag loaded on his shoulder. After all, it was not a complete loss case for the Turkish government, which managed to get a share of the Mosul oil for a defined period—a fact of which the cartoon made sure to remind its audience (fig. 73).

Akbaba was not alone in bringing the Mosul case to the attention of the Turkish public. It was covered by *Karagöz* as well, yet from different artistic and political perspectives. Unlike *Akbaba*, *Karagöz*'s propaganda focused on the complex formulations of the rivalry between Turkey and the allied powers centering Great Britain. In the few cases where a Middle Easterner was present in the cartoons, he would be only a minor participant, a pawn, personified with Faisal's physical features. Unlike *Akbaba*, *Karagöz* boldly highlighted the remoteness of Middle Easterners as the reason for their victimization, stereotyping them as a unified figure, with their keffiyeh, particular style of dress, and slippers.

Besides, in the very few cases where *Karagöz* portrayed the Middle Easterner, most of the time symbolic references were preferred to address their presence. Moreover, the Mosul dispute itself was often embodied in symbolic objects—for example, an oil well on top of which the British sit, or a locked chest carried on the shoulders of a British officer. One feature that remained consistent was the setting of all scenes with reference to Mosul against a desert landscape, signified by distant palm trees in a dull, empty expanse.

Despite the nationalist trends of the time, Middle Easterners as an incorporated figures were not featured directly in most political cartoons of the early 1920s. Instead, their presence was indicated through metaphoric images of the disputed territories where they would sometimes appear as a naked damsel in distress, or as a wandering sheep, yet always as far as could be from connotations of Arabness in the collective consciousness (except the case where Faisal was targeted). These cartoons merely conveyed the dilemmas created by international disputes. On the

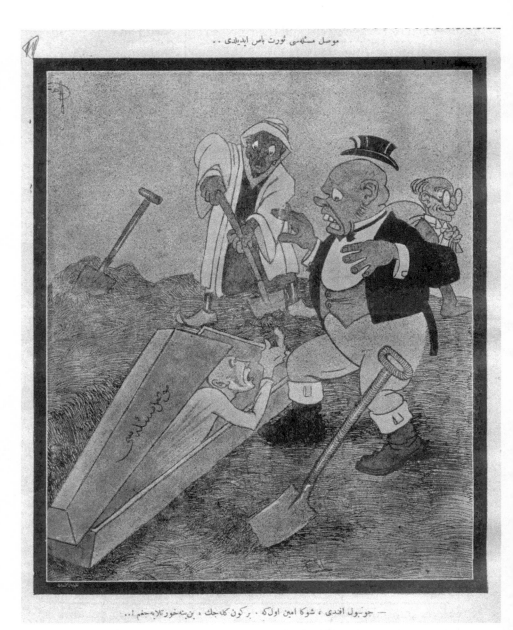

73. Ramiz Gökçe, *Akbaba*, 7 June 1926, 1. [Ottoman] *Mosul Dispute Is Hushed Up!* [Caption] "Mr. John Bull, you can make sure that I will be raised from death one day!" [It reads "Mosul question" on the coffin.]

one hand, these territories included many Arabs/Middle Easterners as the uncivilized, non-national other; on the other, they were claimed by the Turkish state to share a common identity, as "Turks." This conceptual uncertainty about the future forced cartoonists to be cautious with their delineations and to represent the contested lands and their people in metaphors devoid of any ethnic markers—a choice that, in later periods, would leave an opening for depicting the Arabs as evil.

Arabs: Illustrating Betrayal as Part of a National Myth, 1923–1927

The Arab revolt of Sharif Hussein of Mecca against the Ottoman Turkish army in 1916 is probably the most persistent and compelling narrative in Turkish consciousness about its Arab other. By all means, the Arab revolt of 1916 was devastating for the empire, which was already on the verge of collapsing. The sense of treason when support was most needed in fighting the entente powers came as a shock to the Ottomans, who had struggled for their lives on Arabian front lines. The revolt's shock waves were felt most strongly among younger officers and bureaucrats, who would soon become the key actors in the Turkish War of Independence and part of the future republic's political and intellectual elite.

Among many stories, the memoirs of Mahmut Nedim Bey, the last administrator of Ottoman Yemen, provide a detailed account of the empire's final days in the Arab provinces and the affairs that unfolded following the Arab revolt. In his writings, Nedim describes the profound sadness he felt upon learning of Sharif Hussein's revolt against the Ottoman armies in Hejaz. Living next door to Sharif in Istanbul before being sent to Hejaz, Nedim felt a deep affection for him throughout his youth and formative years as an Ottoman bureaucrat. In one section of the memoir, Nedim ponders the reasons behind Sharif's revolt. As if trying to rationalize the act of an old friend, he stresses Sharif's uncivilized, backward nature yet blames this crudeness for his unfortunate decisions about the Ottomans. For Nedim, despite Sharif's privileged position in the palace, he was "an Arab Bedouin chieftain in the desert who knows nothing outside his tent" (Mahmut Nedim Bey 2001, 16). Obviously, Nedim's assessment

of Sharif's revolt was due to Sharif's eclipse of reason as the outcome of his ambitious nature and his sudden reaction to the CUP's upcoming plans to strip him of his title and remove him from power (2001, 16).

Turkish national historiography, especially during the Turkish nation-state's formative years, exposed Sharif Hussein's betrayal to the Ottoman Army in every means of cultural production, from textbooks to popular culture, to further consolidate the bitter Arab experience in the public consciousness as part of a collective memory. Sharif's disloyalty was attributed to Arabs in general, locating these characteristics in their racial and ethnic nature. For example, Turkish history textbooks for high schools, published and distributed by the government press during the formative decade of the republic, discussed the infidelity of non-Turkish Muslims, especially Arabs, to both the empire and Islam in general, in a context where their religious affiliation as Muslims and their supposed attachment to the caliph was publicly condemned: "The Muslim soldiers of India, Algeria, and Tunisia attacked the lands and armies of the caliph [Ottoman sultan] without any religious suffering. Even the Muslims, especially the Arabs, who were directly subordinate to the Ottomans, went to the side of their enemies by betraying the caliphate and joined the war against the Ottomans. Chief among them were the Mecca Sheriff and his sons, who claimed to be from the prophet's family!" (Türk Tarih Cemiyeti 1933, 309). The Arab's weakness was accentuated in these texts, which were keen to construct a sense of Turkish national identity based on ethnicity rather than religion. In Turkish public discourse, Arabs' disloyalty was driven by their reprehensible greed, resulting in their becoming pawns for colonial powers, castrated from self-determination.

Thus, Turkish collective opinion perceived the misdeeds of the Arabs as an outcome of their greed, ambition, and ungratefulness. In the Turkish account, Sharif Hussein's rebellion was merely another example of Arabs' wickedness in their dealings with the Western powers. Sharif's deluded belief in Britain's false promises of an Arab kingdom in the Hejaz and Fertile Crescent, and a crown for himself as the "king of the Arab countries," was nothing but foolish naivete brought on by his ignorant nature.

The concurrently emerging Mosul case placed Sharif Hussein and his younger son King Faisal as the masterminds behind the Arab betrayal

and 1916 Arab Revolt in the Hejaz. King Faisal, in particular, was the one whom the Ottoman Army faced on the front lines of the Arabian desert. King Faisal commanded the Arab tribes against the Ottoman Army to their 1918 capture of Damascus and Aleppo, where he claimed his kingdom. But his expectations of an Arab kingdom alongside his father were short lived. Sharif Hussein was expelled and driven out of Arabia by another Arab tribal leader, Ibn Saud, and forced to flee to Cyprus, while King Faisal was removed from Damascus by the French and pursued his imagined kingdom in Iraq after the British effort to make up for the lost promises (Seale 2010, 152–53). But nothing turned out the way Sharif Hussein had hoped.

From the British standpoint, King Faisal's appointment to Iraq as king was intended to establish a "national government" that would attract genuine Iraqi support and deflect anti-British feelings but would nevertheless be "subservient" to British interests—such that concerned Mosul, for example (Fieldhouse 2006, 90–92). For the Turkish audience, the two Hussein brothers—Faisal and Abdullah— were no less guilty than their father for betraying the Ottoman rule; they were living examples of the Arab disloyalty that endured from the empire's final decades. The cover of *Resimli Gazete* (Gazette Photographic) on 29 September 1923, for example, recalled not-so-distant memories of the Arab revolt when presenting to the Turkish public the whereabouts of Emir Abdullah, the elder son of Sharif Hussein of Hejaz, who was also granted a kingdom by Britain in Transjordan. The story attacked Abdullah and his new kingdom, claiming that these seats were given to Emir Abdullah and Faisal as compensation for their betrayal. The article insisted that their infidelity had failed not only the Ottoman government but also Islam in general. The cover's caption, "Abdullah's crown is shaking," conveys a feeling of satisfaction at the setback of Sharif and his sons by the British, offering an imagined public sentence in the subheading "An emir punished for betraying Islam: Abdullah."

Another important public Arab figure at the time was Ibn Saud of Eastern Arabia. After rather quickly gaining control of the central Arabian desert with British support, he captured the sheikdoms on the Persian Gulf. In Turkish popular discourse, he was another ambitious Arab

character who was willing to take control of the Hejaz's Red Sea region, especially the holy cities of Mecca and Medina.

After the end of the war, the British were concerned with settling their alliance with Sharif Hussein and his Hashemite family, as they needed the Saudi family's strong fighting force in Eastern Arabia (Seale 2010, 278). Sharif Hussein felt deceived by his British allies, who disregarded his aims to rule an Arab kingdom, recognizing him instead only as king of Hejaz and sharif of Mecca and establishing treaties with other Arab chieftains, including Hussein's main rival, Ibn Saud.

On top of this, when Sharif Hussein proclaimed himself the new caliph of the Muslim world following the Turkish government's abolition of the Ottoman caliphate in March 1924, tensions grew even worse with the Saudi ruler, who was willing to take that position himself (Feyzi 1930, 2; Seale 2010, 278). Thus, both sides, boosted by British weaponry, engaged in armed conflict in July 1924. The result was disastrous for Sharif Hussein. Having lost his dominance in Syria to the French, who drove his son out of Damascus, he ended up resigning from his throne as king of Hejaz and was exiled from all the major cities of his short-lived kingdom in Mecca, Medina, and Jeddah. The Hejaz, as a whole, had now been brought under Ibn Saud's rule.

These developments reverberated powerfully in the Turkish popular media. At the same time, it presented an opportunity for the cartoon press to put Sharif Hussein, his son Faisal, and Ibn Saud on imaginary public trial. Unlike *Akbaba*, which engaged more with the Mosul dispute, *Karagöz* was eager to cover the unfolding events. Over the course of a few months, *Karagöz* brought the Arab image to public attention on many occasions, whether as part of the Mosul context, insurgencies against imperial powers, or inter-Arab rivalries.

For the cartoonists of *Karagöz*, Turkish ethnicity was a stronger social bond than religion. An imagined ethnic other would certainly contribute to the maturity of a consolidated national self-consciousness and solidarity within an ideal Turkish type. Thus, the narrative of Arab treachery presented the necessary context whose motifs *Karagöz* adopted in a series of cartoons that relied on the traditionally formulated Arab stereotype. For example, in two consecutive cartoons published in September and

October 1924, *Karagöz* depicted the two rivals, Sharif Hussein and Ibn Saud, in a power struggle, highlighting Arabs' barbaric nature as their most prominent quality. The scenes as designed in the cartoons communicate a chase between the two rival tribes of Hejaz, while a Brit stands still, observing. Sharif's religious affiliation is suggested by his turban, commonly worn by Ottoman *qadi*s, accompanied by the symbolic sword of Islam dangling from his belt (figs. 74–75). However, Ibn Saud appears in his traditional Bedouin costume of robe and sandals, carrying wooden sticks, a symbol of backwardness and deprivation, as his weaponry.

Their mutual hostility can be surmised from their facial features; both figures are illustrated with wide eyes, suggesting their engrossment in the chase, whether pursuing or fleeing. Ibn Saud's wears a savage smile, while Sharif's open mouth conveys shock and surprise. These physical details were bolded to accentuate the primitive drives of human nature that were left untamed within their tribal social and cultural structures as Bedouins. Of course, the aim of these depictions is not to show the reader that Arab tribes fight with one another other but, rather, the constant verification of an internal need of one to demonstrate superiority over the other. In this colonialist perspective of power relations, the cartoonist puts the Arab other in contrast to the sophistication and supremacy of the Turkish self. To propagate Turkey's place among the civilized states, the two Turkish protagonists witnessing the scene from a distance are depicted carrying rifles, referring to Turks' military capacity.

Sharif Hussein's claim to the caliphate was also persistently attacked by *Karagöz*, which put the new republic's principals and its vision for a secular political structure above all. Sharif's claim posed a potential threat to the republic, which was still formulating its relationship with Islam. The political elite was concerned that an Arab entitlement to such a strong seat might add fuel to reactionary insurgencies in Anatolia and Eastern Turkey. *Karagöz*, as one of the most prominent advocates of Turkish state discourse, undertook a propaganda campaign against the Sharif's "irrelevant" self-appointment as the seat of caliphate.

Two cartoons published just a few weeks apart magnify the narrative of Sharif Hussein's escape from Mecca, the city with which he had long held ties and where he maintained his throne. The cartoons were assaults

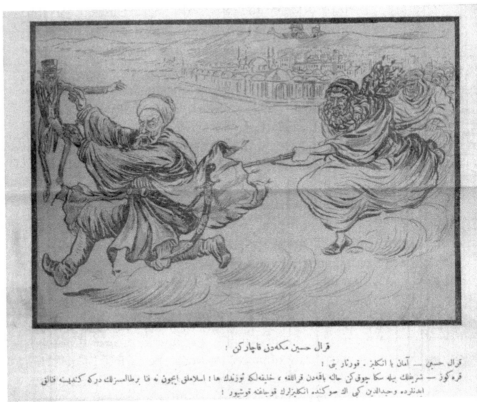

قرال حسين مكهدن قاچاركن !

قرال حسين ... آمان يا انكليز . قورتار بى !
قره‌كوز — شريطلك بيله سكا چوق‌كن حاله باقدن قراللقه ، خليفه‌لك اوزنك ها ! اسلاملق ايچون نه قدر امسزلك درکه کنديسه خيانق
ايدنلرده . وحدالدين کبی الك صوکنده انكليزلك قوچاغنه قوشيور !

74. *Karagöz*, 4 October 1924, 1. [Ottoman] *When King Hussein Runs from Mecca.*
[Caption] King Hussein: "Save me, oh, English!" Karagöz: "You are tempted for
kingdom and caliphate while even being sharif is too much for you, huh? It is so
unfortunate for Islam that he who betrayed it is running to the arms of the Brit-
ish just like Vahdettin once did!"

on the two major titles that Sharif claimed when revolting against the
Ottomans in 1916. One was the title as the king of Arabs, and the other the
title as the caliph of Muslims. Leaving Mecca behind, Sharif gave up on
both, as well as his religious credibility among Muslims. In the cartoons,
the Turkish public imagination was served through the anonymous proc-
lamation in the title *When King of Hejaz Hussein Runs Away!* The level
of Sharif's humiliation was accentuated between the lines—for example,

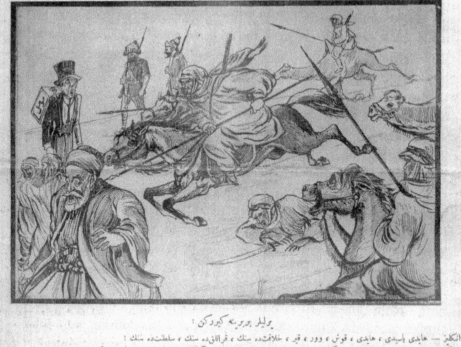

وليلر بربريه كيرزكن !

انكلیز — هايدى يَسيدى ، هايدى ، قوش ، وور ، قير ، خلافتده سنك ، قراللقزده سنك ، سلطنتده سنك !
قره‌كوز — طاورشانه قاچ طازىيه طوت دكى جلى ! اوتارى بربرنه دوشورورسك آما بكا مادبك اوينامازسك ؛ شونكى بوقنه برقورشونه دهر اجنده‌كنى آقيتيرم ها !

75. *Karagöz*, 7 October 1924, 1 [Ottoman] *When Natives (or Barbar) Clash with Each Other!* [Caption] British: "C'mon, Saudi, c'mon! Rush, hit, and bash! All is yours, the caliphate, the kingdom and the sultanate!" Karagöz: "Run to the rabbit, catch the hounds! You can play off of each other but you can't do monkey business to me. Empty that trunk of yours, or I will do it myself with a single shot!"

through verbs like *kaçmak* (run away, escape), which portrayed him and the stereotypical Arab as cowards. Likewise, the text stressed his degradation in the culturally embedded meanings of terms such as *yerli*, the name given to the supposedly primitive peoples of Africa and America, far from civilization (Türk Dil Kurumu 2011, 2581).

The cartoon also visually builds on the term *yerli*, lending it additional meaning by depicting a group of Arab fighters on camels and horses, with

their brutality represented in their slaughtering of their opponents.[3] All of these details work to emphasize the savageness of the Bedouins and to justify their displacement from the civilized world. Sharif's cry for British help merely confirms this isolation, where help is conditioned upon loyalty and obedience to imperial resolutions. The phrase "Save me, oh, English!" in the cartoon underscores the deteriorated, vulnerable position of the Arabs in the Turkish collective perception.

Karagöz, expressing intermittently the Turkish state's and the public's voice, differentiated "true Islam" as practiced by the Turks from the one preached by Sharif. The cartoon condemns him for the false statements he endorsed on behalf of Muslims and places him among the other traitors of the Turkish cause like the fled ex-Sultan Vahdettin: "You are aspiring for a kingdom and a caliphate while even [being] Sharif is over your head, huh? It's so unfortunate for Islam that he who betrayed it is running to the arms of the British, just like Vahdettin [the last sultan and caliph of the empire] once did."

When it came to Turkish public opinion as represented through the two protagonists, Karagöz and Hacıvat, Sharif was nothing more than a thief who shamelessly robbed the pilgrims visiting Kaaba (the prophet's grave). In Islam, theft and robbery and theft are two of the greatest sins. Apparently, the religious hypocrisy of the Arab sheik, being a man of religion himself, is recalled to readers in connection with the white Arab of Karagöz plays who exchanges prayers for money and then, instead of fulfilling his part of the agreement, curses the client. This perceptual feature of the Arab stereotype validates itself in the cartoons when, for example, an enraged Karagöz shakes his fists at Sharif and his British companion, shouting that they "deserve to have [the] chain [his neck]," and when, on behalf of the new Turkish nation, he publicly condemns him "to go to hell" (fig. 76).

3. In the cartoon, the latter group represents the Ikhwan, the Saudi fighters. The people who try to escape the spears of the Ikhwan are the Hashemites, led by King Hussein. What King Hussein called the Ikhwan were also known as the "Wahhabi fighters, [who] were anxious to attain Paradise which, according to their faith, they would enter if killed" (Rogan 2009, 180).

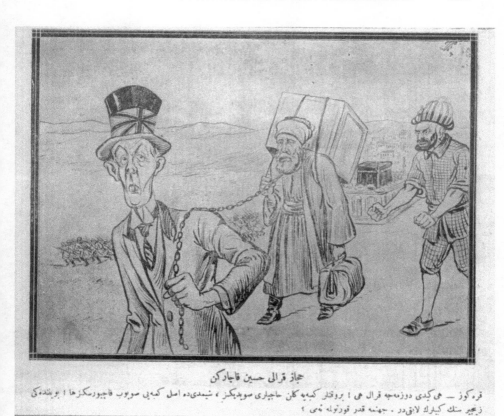

<div dir="rtl">

حجاز قرالى حسين قاچار كن

قره‌كوز — هى كيدى دوزمه‌جه قرال هى ! بوقتلر كعبه‌يه كلن حاجيلرى سويديكز ، شيمديده اصل كعبه‌يى سويوب قاچيبورسكزها ! بويله‌دكى زنجير سنك كيله‌رك لايق‌در . جهنمه قدر قورتوله نمى ؟

</div>

76. *Karagöz*, 29 November 1924, 3 [Ottoman] *When King of Hejaz Hussein Runs Away!* [Caption] Karagöz: "Hey, fake king, hey! Once you used to rob the hadjis who came to visit Kaaba, now you are robbing Kaaba itself while you are running away, huh! You deserve this chain you carry, make sure it stays there till you go to hell!"

These attributions undermined any distinction between the representations of Sharif Hussein and King Faisal and denounced their treachery in cooperation with Britain. The comments delivered by *Karagöz* often pointed out the failed dreams of Sharif and his son as penalty for their betrayal, repeatedly implied them to be "false kings" and expressed a sense of satisfaction in "seeing you both like this in the hands of the British, I breathe a sigh of relief! How is it? Do you miss the old times?" (fig. 77). In these cartoons, Sharif and his sons embody the captivity of the Arabs, a

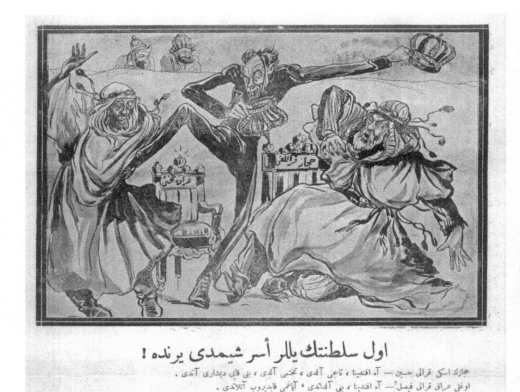

اول سلطنتك يللر أسر شيمدى يرنده !

حاذك اسكى قرالى حسين — آد افندينا ، تاجى آلدى ، تختنى آلدى ، بنى قانى ديشارى آتدى .
اوغلى عراق قرالى فيصل !— آد افندينا ، بنى آلدائدى ، آياغى قايدرروب آتلائدى .
قره كوز — ايكبكيزده مهلدر . شيمدى سزى بويله كبكبرك الده اوبونجاق كوردكجه اووح ديورم . ناصل اسكى زمانلريكزى آرارمبكز؟

77. *Karagöz*, 8 August 1925, 3 [Ottoman] *Your Previous Kingdoms Are Gone with the Wind!* [Caption] "The once king of Hejaz Hussein—ah, sir! He took my crown, he took my throne, and he kicked me out of the door! His son, King Faisal of Iraq—ah, sir! He betrayed me, he replaced me, and he let me down!" Karagöz: "Seeing you both like this in the hands of the British, I give a sigh of relief! How is it? Do you miss the old times?"

position of confinement represented as a human condition in which status and title are conferred by the British in exchange for freedom and agency. These positions of voluntary enslavement—not forcefully imposed, as in America or Africa, but resulting instead from a trade of rights that took place voluntarily—were alternately symbolized by a crown, a bag of money, or a pair of handcuffs. This surrender and its rationalization by Sharif Hussein and King Faisal establishes the undignified nature of the

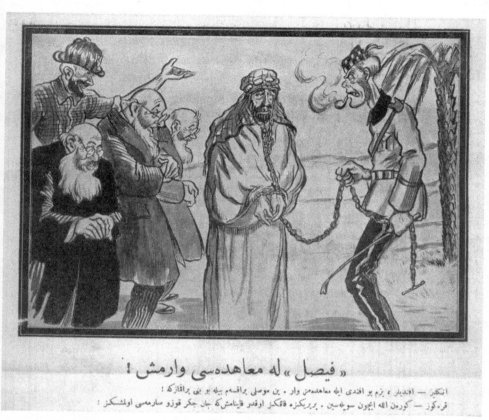

« فيصل » له معاهده‌سی وارمش !

انكليز — افنديز ، بزم بو افندی ايله معاهدمن وار ، بن موصلی براقسم بيله بو بنی براقازكه !
قره‌كوز — كوردن الله ايچون سويله‌سين ، بربريكزه قتقدز اوقدر فينامش‌كه جان جكر قوزو سارمسی اولمشكز :

78. *Karagöz*, 21 October 1925, 3 [Ottoman] *He [British] Has an Agreement with Faisal!* [Caption] British: "Sirs! I have an agreement with this gentleman. Even I leave Mosul, he won't let me." Karagöz: "For God's sake! You benefit so much from each other that you've become inseparable!"

Arab stereotype and the humiliation that comes with it in the popular Turkish sentiment that it deserved a public conviction (fig. 78).

Yezidis: Rebels and Border Disputes

In the cartoons of the 1920s, ethnic differences among the population of the Levant and Mesopotamia do not emerge as one of the major defining features. The post-Ottoman Arab lands were home to all kinds of ethnic and religious groups, most of whom spoke Arabic and dressed in local

attire. The Turkish cartoonists representing their own perceptions of these diverse communities, whom they remembered with bitter feelings, did not see any harm in a monolithic illustration of them as a generic and homogeneous group. Along these lines, upon encountering the cartoon, the reader would be struck first by the image—seeing, for example, that the cartoon is about post-Ottoman Arabia and then, if interested, go on to read the legend for additional information. But this information would be a commentary on the related event rather than an identification of the personae in the cartoon based on their ethnicity or religious affiliation.

As a case in point, an ethnic group with a syncretic religion known in popular Turkish lore as devil worshippers, the Yazidis, are one of the indigenous peoples of Jabal Sinjar, which had been part of the Mosul *vilayet* since the Ottoman conquest in sixteenth century, until the British occupation. The Yazidis of Jabal Sinjar constituted most of the British mandate of Iraq's Yazidis, the second-largest non-Muslim community and the largest heterodox Kurdish group in the Mosul province. Control of this area had become strategically and politically vital for the Iraqi administration under King Faisal to safeguard and guarantee its position in the new regional order created by the victors in World War I (Llyod 1926, 106; Fuccaro 1997, 560). This was also critical for the British-Faisal pact's success in League of Nations over the Mosul case.

For the Turkish media, the Yazidi Kurds of Mosul were part of a larger conspiracy in cooperation with the British to secure Mosul oil. As part of a smear campaign, *Karagöz* published two successive cartoons in March 1926 that involved Yazidis who had been captured along Turkey's border with northern Iraq. The historical context is not entirely clear, as there is no indication of this one specific event in 1926 involving Yazidi tribes. However, as mentioned by Nelida Fuccaro (1997, 568), in the mid-1920s the British tried to recruit Yazidi irregulars from local tribes to strengthen their defense of the northern frontier of Iraq against Turkey, which posed a serious threat to British and Iraqi administrations in terms of the Mosul dispute. It is important to note that, according to Fuccaro, Yazidi tribesmen only occasionally took up arms either against the government, as happened in 1925 during the revolt of Yazidi chief Dawud al-Dawud, or during their frequent intertribal quarrels, in which they

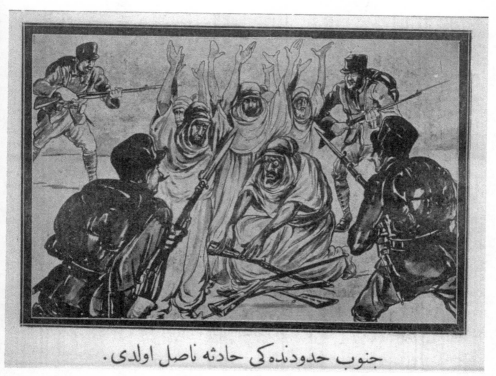

جنوب حدودنده كی حادثه ناصل اولدی.

79. *Karagöz*, 27 March 1926, 3 [Ottoman] *What Is Happening on the Southern Border?* [Caption] Yezidis: "We surrender, of Turk, we surrender!" Turkish soldier: "Impious, faithless buggers, we don't take prisoners! Those who threaten us with British weapons, we take their lives!"

were more invested than in protecting the borders for a governmental cause (figs. 79–80).

In the two cartoons the Yazidis—in this specific case the caption reveals the ethnicity of the antagonists—are presented, from their attire to their facially recognizable characteristics, in a style of compare-and-contrast between their military uniform versus Yazidis' traditional garb. The cartoonist's most probable aim is to demonstrate a position of national superiority, of institutionalized power. The Turkish soldier's uniform suggests affiliation with a contemporary state institution, while the Yazidi's garb, the conventional attire of his daily life, signifies no attachment to any higher form of social order beyond his tribe, which implies

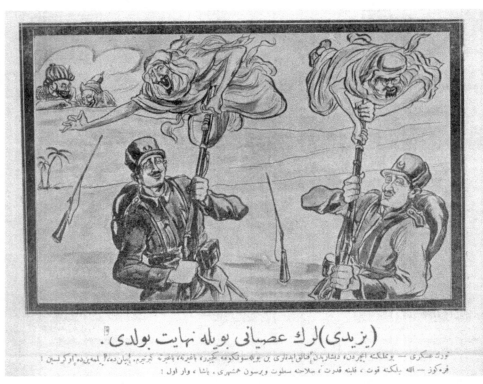

(يزيدى)لرك عصيانى بويله نهايت بولدى.

عورة عسكرى — يوغلكنه اجردن، دیشاردن فالق ایدنارى بن بویله سو نكومه كبیرة باغیره باغیره كترنرم. أيبان دمأ لمین دمأ اوكرلسین !
فره كوز — الله بلكنه قوت، قلبنه قدرت، سلاحنه سطوت ورسون هشیری. باشا، وار اول !

80. *Karagöz*, 3 April 1926, 3 [Ottoman] *This Is How the Rebel of the Yezidis Ended!*
[Caption] Turkish soldier: "From inside or outside, whoever wants to harm this
country, I will make them scream with my bayonets and kill them. Make sure
everyone learns that!" Karagöz: "Let God give power to your wrist, force to your
heart, and power to your weapon! May you live long!"

both a denunciation of the fundamental values of the West, as well as the
Yazidis' potential threat to it. The peril raised by the Yazidis' unreliable
nature—like that of Sharif Hussein and his sons—is threatening not only
to the Turks but also to their existing partners. This paranoid perception
is further illustrated in the "modern" Turkish soldiers mercilessly killing
two Yezidi rebels by hoisting them on bayonets. Of course, this was also a
depiction of physical power symbolically transmitted to the audience in a
binary opposition to the white Arabs' weakness.

This rather disturbing scene portrayed by the *Karagöz* cartoonist delivers the message to Yazidis as well as to the people of the ex-Ottoman Middle East in general and their Western allies. The message was crudely communicated to the Turkish audience by placing the Arab (and, by extension, his landscape) in a demeaning position. The cartoon's caption offers a public legitimization for the "killing" of the Yazidis in a rather ferocious way (swinging from the point of a bayonet, boiling alive in a cauldron) through metaphoric applause in a prayer: "Let God give power to your wrist, force to your heart, and power to your weapon! May you live long!" The prevalent orientalist mode of representation of the Yazidis in the cartoons exhibits their exclusion from modern constructive discursive, extending the commonly presumed features of an alien and uncivilized Arab other.

The Riffians of the Maghreb and the Druze of the Mashriq: The Arab Resistance to the French Mandate

During the War of Independence, Turkey signed the Ankara Agreement with France that put a temporary halt to the border dispute with the French mandate in Syria at Alexandretta. The deal established a special administrative unit where the "Turkish inhabitants of this district enjoy facility for their cultural development and the Turkish language has official recognition" (Khadduri 1945, 407). The Ankara Agreement, which was confirmed by the Treaty of Lausanne, became part of the general peace settlement with Turkey. However, the finalization of the border did not begin until 1925 because of difficulties on both sides. For its part, the Turkish state was challenged by an internal Kurdish revolt, while the French faced a more serious uprising from Druze and Syrian nationalists. The Turks' quick response to the Kurdish uprising (commonly known as the Sheikh Said Rebellion) helped them temporarily bring the unrest in its eastern provinces to a halt; this gave them the upper hand against the French, who were still concerned with the Syrian revolt, which had also induced the Turks to renew their claims regarding the border with Syria and the position of the sanjak of Alexandretta (Mustafa Kemal 1982, 1735).

From 1924 until the end of the 1930s, Turkey waged a diplomatic war while its media led an extensive propaganda campaign against its European rivals. The republican elite was aware that the battle to finalize Turkey's contested borders had to be fought not only behind the closed doors of diplomacy but also on the open ground of public opinion. Therefore, all propaganda channels gave favorable coverage to the diplomatic upheavals with France, Britain, and the League of Nations. During a period of challenged political values, such bias was to be expected, and the political cartoon emerged as an essential medium for such a job, considering its popularity, which probably gave it a more decisive influence than other forms of mass media at the time.

The Turkish cartoon press took a pronounced interest in the Syrian situation, frequently comparing it to the Arab struggle in North Africa, particularly Morocco. In both cases, the Arabs were fighting against the French. *Karagöz*'s cartoonists covered this struggle in a series of cartoons within a flare-up of hatred against European expansionism in post-Ottoman territories. Keeping the Moroccan resistance fresh in the public's mind seemed like a good idea in order to raise the awareness needed to diplomatically pressure France over the Syrian border.

Part of this propaganda campaign attacked the Spanish military operations mounted in the French protectorate of Morocco against the local Riffian rebellions. The message was clear: the uncivilized and backward nations were destined to battle Western imperialism's colonialist ambitions. *Karagöz*'s simultaneous appraisal and belittling of the Riffian stand against European colonialism addressed mainly the lack of civilization and development, which, for *Karagöz*, was the key to independence. As in the case of the Riffians, the great powers could be defeated, but only temporarily, unless the primary condition of development was achieved; nations required economic, social, and cultural development to sustain their sovereignty (fig. 81).

As discussed in the previous chapter, the Ottoman experience in North Africa was remembered in romantic terms of solidarity. According to this narrative, the Ottoman officers who went to Trablusgarb and Benghazi as volunteers (*fedai*) to galvanize Arab resistance with the cooperation of the Sanusiya tribe had successfully harassed the Italians and prevented them

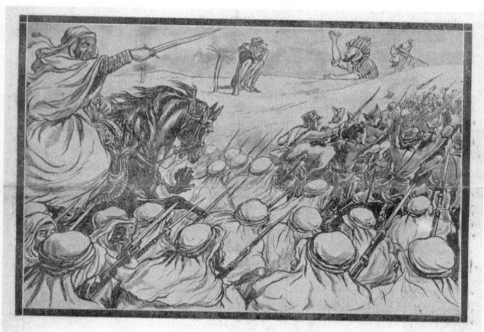

(فاس) ده فرانسزلر جادهیی طوتدیلر !

حاجیواد — قاسلیار یامان صالدیرییور قرهکوز، فرانسزلر بر دون کری ایتدیلرکه آرقارندن صایان طاشی یتشمز !
قره کوز — فقط کیکریکدهک کنیده کورمه ! حریف فرانسزلر أزیلیور دیه سوینجدن هاندیسه کویك آتاجاق .

81. *Karagöz*, 15 July 1925, 1 [Ottoman] *French Captured Jadel in Fas*. [Caption] Hacıvat: "Moroccans are holding strong attacks, Karagöz, the French withdrew so fast that even a slingshot can't catch up with their speed!" Karagöz: "Meanwhile, look how the British enjoys himself! Men are about the start dancing with the joy of France's defeat!

from making much headway inland. This narrative created a crucial difference in attitude toward the Arabs of the Maghrib.

For Turkish readers, the Maghrib represented a story of affectionate cooperation against the common enemy. *Karagöz* often used this nostalgia when criticizing the mandate powers for their expansionism, defined as *büyümek ve taşmak arzusu* (the will to expand and lie beyond). The same thinking contributed to exalt the Turkish patriotism that echoed in the Sanusiya resistance but was missing in the Levant and Hejaz. Yet, even

with this affection for the North Africans, the image of the Arab—dressed in traditional garb and wielding a sword—remained the same (fig. 82).

On top of North African resistance, the assignment of Syria to the French created many conflicts and widespread local resistance among the local Arabs. The Syrian political elite rejected the French government centered in Damascus and appealed for a constitutional monarchy led by King Faisal, as had been promised by the British (Fromkim 2009, 174–80; Rogan 2009, 151–62), favoring a "loose" British mandate over old-school French imperialism. For their part, local notables considered the French presence in the region illegal (Seale 2010, 182, 190).

On the other hand, the French believed that the British were seeking to undermine their position in the Middle East, and that they had already made the necessary concessions by giving up on Mosul. The French had no further intention of handing over more land in Syria (Fromkin 2009, 562–63). Amid the complexities of postwar policies and territorial designs, the French mandate in Syria lurched from one crisis to another, starting with the Druze Rebellion, more commonly known as the Great Syrian Revolt (1925–26).

By the spring of 1925, British officials in the region had already assessed that the French would abandon Morocco along with Syria (Provence 2005, 80). The fact that British officials had received such confidences reinforced public suspicion of a persistent French notion of British and Hashemite intrigue around the mandate in Syria (Provence 2005, 80). For example, in a cartoon published in May 1925, neither the caption nor the illustration itself specify the ethnicity of the group dressed in traditional garb (fig. 82). The reader does not know the identity of the group; whether they are Riffians or Syrians is unclear. The only clue is the relationship between the raiding Arabs and the British watching from afar while sneaking land mines to them. Assuming that the Turks shared similar suspicions about British conspiracies, the cartoon warns the French to watch their back (and front), pointing them to the British regional policies and raising the question "Where is the devil's finger in this?"—"the devil" referring, of course, to the British, the Turks' most powerful adversary.

Karagöz devoted more space than any other political satire paper to the Syrian revolt. Other leading magazines like *Akbaba* had very few

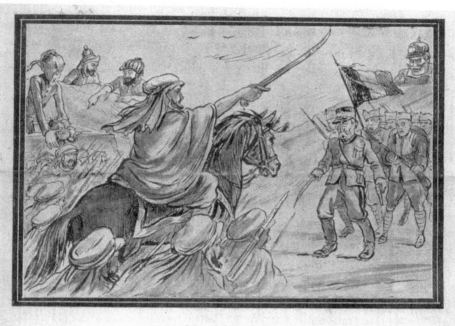

82. *Karagöz*, 30 May 1925, 1 [Ottoman] *Political Puzzle: Where Is the Devil's Finger in This?* [Caption] Karagöz: "My dear Frenchman, watch out for your back and front. There might be a devil's finger in the way you've surrounded!"

depictions of the uprisings in the French mandate, whereas *Karagöz* published a total of twelve. The first of *Karagöz*'s series appeared on the cover of the 25 January 1925 issue, announcing the approach of a Druze rebellion in southern Syria led by Sultan Al-Atrash, a central figure in the revolt.

As a matter of fact, confirming *Karagöz*'s earlier projections, Sultan al-Atrash and a small number of Druze chiefs declared a revolution against the French mandate in August 1925. There was already an established relationship between the Druze and Damascene nationalists, and these networks quickened the spread of the revolution, turning it into the Great Syrian Revolt. Within a couple of months, it had spread to Damascus, where the daring notion that France could be defeated and expelled became a driving force (Provence 2005, 55–59; Seale 2009, 190). Syrian

nationalists also escalated the insurgency, which continued to spread through the Syrian towns and soon engulfed all of the mandate's major cities, calling all Arabs—whether Druze, Sunnis, Alawis, Shias, and Christians who were sons of the Syrian Arab nation—to join the revolt (Provence 2007, 87–88).

The news concerning the Syrian uprising was not narrated as romantic, as was the case with the rebellions in the Maghreb. The Druze were among the Middle Easterners for whom the Turkish audience shared a similar dislike. Having previously rebelled against the Ottomans in Hawran and Jab-al Druze during the Arab Revolt of 1916, al-Atrash did not stand as a popular figure in Turkish collective memory (Seale 2010, 190). He and his companions were also among the sons of Druze and Bedouin sheikhs from Ḥawran who attended the sultan's tribal school (aşiret mektebi) together in Istanbul, where they developed a strong sense of Arab against Ottoman nationalism (Provence 2005, 41).

The Druze identified with al-Atrash and, in doing so, were part of the betrayal narrative still vivid in the Turkish collective memory. For the cartoonist, it was not difficult to revive those memories once his mind was set on manipulating public opinion; an illustration or a photograph plus a few explanatory words would suffice to convey the intended emotion, as long as they conformed to expectations. For example, a single frame could remind the public of the Arabs' barbarism and their untrustworthy nature, capable of slaughtering even their former allies. A cartoon published in *Karagöz* in November 1925 offers one example of such a perceptual mobilization: it reframes the Druze betrayal during the Great War through the symbolic narration of Druzes' barbaric attacks and murders of the officers at the French mandate garrisons in Syria (fig. 83).[4]

4. In the cartoon's original text, the word *Nasrani*, used to identify "Christian," probably derived from Nazareth, the hometown of Jesus. Nasranis, also known as St. Thomas Christians, are a small, ancient Christian community located in eastern Syria. Another note that should be made of the cartoon's caption is "atın-ı mali," a phrase likely known to those who are familiar with the "Arap" in Karagöz plays, where the meaning amounts to "Give me my money."

This act of violence carried out by the Druze against the French provided a narrative of dual advantage to dehumanize the Arabs and belittle the French. To create a strong effect on its readers defined around the values of modernity, *Karagöz*'s cartoonist formulated symbols of things that contravene or violate morality and are thus unendurable; these symbols of inhumanity become the subject that must be destroyed. For example, in the previous illustration, the concept of devilish evil is attributed to the British both verbally and graphically. Another example of such powerful imagery is an attack on some helpless or innocent symbol of identification, as in *Karagöz*'s cartoon titled *French Position Detonates in Damascus!* The cartoon depicts the stereotypical Arab scalping a French officer in cold blood (fig. 83), his facial expression reflecting a sense of pleasure from his action. Apparently, the violent and sensational act of scalping was identified with the Arab stereotype as an attribute of tribal societies. So, while having a reckoning at the French mandate's expense, the cartoon decries the Arabs' uncivilized fighting methods. The extent of cruelty in an unfamiliar geography also makes the French vulnerable to their Arab adversaries. The countermoral of being ferociously victimized by the same uncivilized Arabs formerly allied with the imperial powers resonated in the Turks' collective memory, offering an opportunity for public retribution, as a negative symbol whose destruction was rationalized and justified (Anderson 2013, 470–72). With the resurrection of these historical narratives, the cartoonist vented the public's frustration upon the disliked groups: the Druze as the betrayers, and the French as the colonizers.

A similar position of Arab violence was presented in another *Karagöz* cartoon in December, in which two Arab types were illustrated attacking a French military officer from the left and the right. In the cartoon, it is not possible to exactly identify the ethnicity of the Arabs, but, from the context, the reader can assume that the two figures are the metaphoric personification of the Arabs of Maghreb (Riffians) and the Arabs of the Mashriq (Syrians), both trying to slaughter the French officer in a desert-like landscape (fig. 84).

Barbarism and savagery were the most common negative attributes in representations of a monolithic Arab stereotype during this period. For

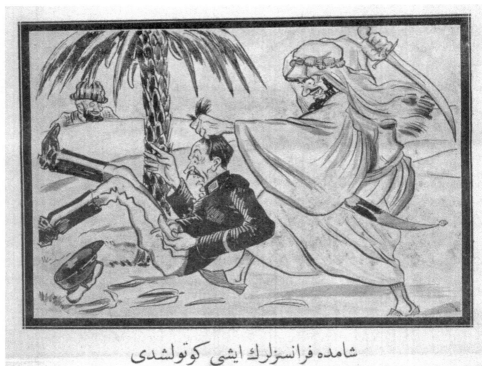

شامده فرانسزلرك ايشی کوتولشدی

درزی — یا خبیث ، یا نصرانی ، اعطینی مالی واللهالاعظم قتل ایدرم بن سنی !
قره‌کوز — یاهو بن شامده ایکن بر بریکزی اوزله‌یوب دوریوردیکز ، شیمدی قاووشور قاووشماز آغاده قایشدیکز ها ! نه ایسه ، هایدی
بر آز بریکزی بیلکده سیر ایدله‌م .

83. *Karagöz*, 7 November 1925, 3 [Ottoman] *French Position Detonates in Damascus!* [Caption] Druze: "Hey, beloved, hey, Christian! Give me my money, or I swear I will slaughter you!" Karagöz: "Gush! When I was in Damascus, you kept longing for each other. Now, as soon as you find each other, you start fighting. Anyhow, let's watch how you fight each other."

example, in the April 1927 issue of the *American Journal of International Law*, a captain in the US Army, Elbridge Colby, writing about his experience in Syria during the Druze revolt, proposed a general moral judgment on fighting methods against the "savage tribes" as interpreted by Quincy Wright in the same journal a year earlier (Colby 1927, 283). In "The Bombardment of Damascus," Wright (1926, 265) had questioned the French's extreme actions against the Syrian insurgents. He asked: "Does

فرانسز چلبی‌نك باشنه كلنلر !

فرانسز — آمانك پورولم، بر باردم ایدن یوقى؟
آمریقالى — سن شو بزم بارارى بابل بافلاده صوكره بكنديكندن امداد ایسترسك!
قره‌كوز — باردم ایستورسك كبكریكه لغنه یاپ !

84. *Karagöz*, 26 December 1925, 3 [Ottoman] *What Happens to Frenchmen?*
[Caption] French: "Oh, God! I'm tired! Is there anyone who can help me?" American: "You first pay me off what you owe, then you can ask for my help." Karagöz: "If you need help, call the British!"

international law require the application of laws of war to people of a different civilization?" The question, in a way, delivered an insight within itself, confirming the Syrians' cultural inferiority to a Westerner.

Similarly, the French had similar concerns around the laws of war with regard to its colonies in Syria and North Africa. This position was mostly apparent in the writings of James Lorimer, a nineteenth-century Scottish philosopher of law who looked upon non-European communities as "outside the system of international law." For Lorimer (1883, 101), humanity

was organized into three "concentric" spheres—"civilized humanity, barbarous humanity, and savage humanity"—and they were entitled to, respectively, "plenary political recognition, partial political recognition and natural or merely human recognition." For the European powers, Syria, as included in the larger Middle East and North Africa, were incorporated into the second sphere of partial political control, where the "positive laws of nations" would not bind them, but where other nations were "bound to ascertain the points at which and the directions in which barbarians and savages come within the scope of partial recognition." For Wright (1926, 265–66), on the other hand, classification of the "barbaric states" in terms of "non-age, imbecility, and criminality" had allowed the European nations to justify their harsh actions in their colonies in North Africa and the Middle East. The conquest of Algeria by France or Egypt by Britain, for example, were among these colonial state-building experiments. However, Colby (1927, 285) argued that punitiveness should be the "real essence" of the matter because "devastation and annihilation is the principal method of warfare that savage tribes know." He reasoned for the necessity of the French methods over the Syrian insurgencies, referring once more to their savage and wild nature and the barbaric practices they employed in warfare. He asserted that "excessive humanitarian ideas should not prevent harshness against those who use harsh methods, for in being overkind to one's enemies, a commander is simply being unkind to his own people" (285).

These discussions of the concept of savagery encircling the "Concert of Europe" was familiar to the Turkish intelligentsia, as the same vicious and brutal warfare carried out by the Arab tribes and supported by their European allies had caused thousands of Turkish soldiers to perish in Hejaz and the Levant. This fundamental sense of grief was accentuated in almost all the *Karagöz* cartoons, keeping its audience in touch with the feeling.

The ultimate graphical representation of this deep anger appeared in *Karagöz*'s portrayal of a Syrian insurgent in an issue in December 1927. The cartoon depicts a monstrous Arab in his traditional robe with no clearly defined ethnicity (i.e., whether he is a Druze, Arab, or a Kurd).

In the depiction, the artist uses all the symbolism necessary to evoke his victim's violent nature: the Arab's gestures in clutching his long dagger tucked into his belt, holding his sword between his teeth, and carrying his rifle on his back make him a fully decorated symbol of barbaric inferiority. The emphasis on his devilish, menacing eyes, dark skin tone, and hairy body adds a racial layer to his savageness. Although the cartoon aimed mainly at illustrating the negotiation between France and Italy for a land exchange in the colonies in light of Italy's claims in Tunisia, the illustrative extent of the monstrous figure (representing Syria) revealed something more than a simple act of visual news-telling (fig. 85).

Although the Great Syrian Revolt that began in the spring of 1925 lasted more than two years and ended with the slow and inevitable reassertion of French control over the region, for *Karagöz* it was already losing ground before the end of 1925. The heavy French bombardment of Damascus was crucial in suppressing the rebellion. In its 18 November 1925 issue, *Karagöz* depicted Arab insurgents taken hostage by French officers and chained to cannons ready to be blown, announcing the *End of the Arab Revolt*, once again calling attention to the savagery and cruelty of the captive Druze, passing on a final reminder to the Turkish public on "how you shot them dead, how you killed the wounded, and dragged them on the ground" (fig. 86).

During the year of the Syrian revolt, *Akbaba* ran a single cartoon by Ramiz in which he presented France's accusations against Turkey for supporting the Druze rebellion. The French believed that the insurgents had collaborated with and received supplies from the Turks and the British (Provence 2007, 66). Ramiz mocked the claims of the French by reflecting the French media's headlines in his illustration's title: *French Newspapers Say That Turks Are Encouraging the Syrian Revolt*. In the cartoon, he draws a French officer strangling a rope-bound Arab insurgent, grasping his throat with one hand while wielding a horsewhip in the other. The cartoon obviously resembles another hunting scene of a colonizing body—a metaphor of which Ramiz was particularly fond of using in his projection of power relations in the Levant. The image offers a concise representation of the French order in Syria: the Syrian insurgent (from a colonial

اك صوك سياسى خبر: فرانسه «سوريه»يى ايتالياته وبريپور!

فرانسه ـــ آل عزيزم، بكا بر قاچ بوز بيك جانه مال اولان (سوريه)يى سكا ويريپورم. كوله كوله قوللان.

قره گوز ـــ ويرده ويره عزيزم ويره، سلاحلى يلا (موصولينى)نك او يومنك، طاشمش آزوبريه مكمل بر كبريت صوق نكسين!

85. *Karagöz*, 24 December 1927, 1. [Ottoman] *Final News: France Is Giving Syria to Italy.* [Caption] France: "Dear friend, I'm giving you Syria that cost me a few thousand lives. Enjoy it happily ever after!" Karagöz: "Give it away, dear friend, so that this bloody and armed trouble will wipe out the expanding and overflowing obsessions of those located by Mosul."

عرب عصيانڭ صوڭى !

قره‌گوز — مى‌كيدى عرب فداﺌيلرى هى ، بوواقت قارشيسنده سزه آجيرم، آجيرم‌آمّا نم محدجكلريه سوريه‌دن چكلرکن يابدقاريكزى، يارالى توركـ
صابطلرينى ووروب صويدكڭزى ، عليل محدجكلرى ﺋولدوروب سورو‌يڭكزى عقلمه كتيردكده‌م آجيمى اونوتورم.

86. *Karagöz*, 18 November 1925, 1. [Ottoman] *End of the Arab Revolt.* [Caption] Karagöz: "Hey, once loyal Arab warriors, hey! I feel sorry for the consequences you are facing today, however, I forget my sorrow, as soon as I remember what have you done to the Turkish soldiers during their withdrawal from Syria; how you shot them dead, how you killed the wounded, and dragged them on the ground."

perspective) in his white robe looks to be breathing his last breath, while the French officer's eyes are turned to the Turkish soldier who is sitting in a distant chair, as if getting ready to attack his next prey (fig. 87).

Ramiz's technique of contrasting a positive symbol with a negative one renders the negative symbol—which, in this case, is the Arab—impotent. When one symbol is represented as inferior to another, it is easy to see the superior symbol in a positive light. However, the brutality of the French

فرانسز غزتەلرى ، سوريە عصیانده تورکلرڭ لشویقی وار، دیورلر.

سوریە — آمان .. آمان
فرانسز — [تورك] هپ سنڭ تشویقڭله باغریپور !

87. Ramiz Gökçe, *Akbaba*, 23 November 1925, 1. [Ottoman] *French Newspapers Say That Turks Are Encouraging the Syrian Revolt.* [Caption] Syrian: "Oh, my God! Oh, my God!" Frenchman: "He yells because he craves your help!"

in oppressing his Arab victim, highlighted by his rabid facial expressions, removes that positive impression from the readers' mind. Ramiz accentuates the French man's rage and defiance in his colonial adventure by portraying him as a wild and irritated animal, exposing a canine tooth on one side of his mouth.

Ramiz's representation of the Arab character as strangled by the Frenchman attaches a cautious positivity to the French, who provided a sense of a "fair end" on the part of the Arabs. The bad memories of the Arab in Turkish collective memory give him an inferior position with respect to the Turk, which makes the latter a mirror image of both Arab and French, showing the intended positivity as part of recognized law and order. The built-up illusion of superiority and victory establishes—or even justifies—for the Turkish reader the Frenchman's attitude toward the Arab while presenting the constant threat from the Arab as a motif for national unity against the foreign menace.

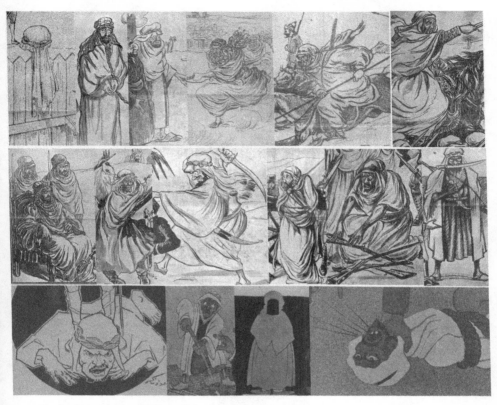

88. Arab image in 1920s political cartoons.

The sense of deep-rooted suspicion, of an atmosphere of conspiracy and betrayal, characterized and dominated the view of the new Turkish elite toward their Arab neighbors. This mistrust can easily be traced in early Turkish republican cartoons. Decades of Western intrusion had nurtured caution regarding the intentions of European states, particularly their influence on the "backward" post-Ottoman Arab provinces. Until the late 1920s, the image of the Middle Easterner in mainstream cartoon magazines was informed mainly by their collaboration with the allied forces and their betrayal of the Ottomans during World War I. The cartoons presented them as primitive nomads with devilish—or even monstrous—looks. There were no identifiable differences in the representation of different ethnic and religious groups. From Kurd to Yazidis, the faces

of the Middle East were depicted in the same manner, creating a unified stereotype of an uncivilized savage (fig. 88).

The cartoonists appropriated the Arab type from the romantic tradition of Karagöz shadow theater and redefined him as a vicious figure deprived of refined human features. His traditional role expanded from that of a mere outsider and placed him in an overtly open political context that transformed him into a negative symbol of betrayal who fully deserved his misfortune under Western mandates. The cartoonists stoked their audience's nationalistic feelings with a binary of stereotypes of Arabs as lacking honor and decency and incapable of standing against expansionist Europe. Predicting this grand finale, the Turkish cartoon press sealed the Middle East in a colonial future, doomed by its primitive nature.

7

Racialization of the Arab as the Turk's Mirror Image

As the republic entered its second decade, the popular stereotype of the marginalized Arab with his keffiyeh and traditional garb slowly gave way to a new form of representation in which Turkish nationalist discourse played a central role. The oversimplified displays of the 1920s morphed into even stronger identifiers of cultural, social, and racial otherness, reflecting something deeper than simple disappointment or bitter wartime memories.

The concept of the Arab as the familiar imperial other had already been redefined as the despised colonized other, whose political and cultural dependence as well resistance to colonization were disavowed due to his betrayal not only of the empire but also of Islam. Thus, by conscious policy from above and popular sentiment from below, in literature and politics, popular culture and the popular media, the Arab paved its way as the Turks' ultimate other.

Starting in the 1930s, the ethnocentric representation of the white Arab took a racist turn. Turkish nationalist discourse at its peak, with publishers and cartoonists as its image builder, worked to fix this new Arab as incapable of self-determination into a joint persona defined within the lines of hybridity and mimicry. The most intense depictions of this altered type occurred between 1936 and 1939, focused mainly on the administrative developments under the mandate governments of France and Britain in the Middle East, especially where the unresolved border issues between France and Turkey continued to present a diplomatic challenge.

Two political developments, one internal and the other external, played a key role at the time of when the Arab stereotype resurfaced in the

daily papers: the Alexandretta dispute that concluded with the region's incorporation into Turkey in 1939, and the Arab Revolt of 1936–39 in Palestine. Turkey's diplomatic effort to include Alexandretta within its boundaries required direct involvement with the French mandate and its Arab counterparts. However, the political satire media was more reluctant concerning the developments in Palestine. As the unofficial spokesmen of the state, cartoonists kept their distance from the Arab Revolt against the British, maintaining a stance as observers and limiting their coverage of the events to a minimum.

The Alexandretta Dispute and Contested Nationalisms

The history of Sanjak of Alexandretta is neither a simple story of the Franco-Turkish rivalry nor a microreflection of the Arab-Turk struggle that dominated international discourse in the region during the first decades of the century. Instead, as Robert Satloff (1986) has neatly observed, it was about a decade-long history of the residents of Alexandretta's success in resisting regional struggles in a highly volatile multiethnic, multilinguistic, and multicultural region. For a short while, between 1923 and 1936, Alexandretta branded itself an interdependent autonomous district characterized by exceptionality, where identity was created in opposition to those who were not from the region. This collective sense was defined in terms of culture, social issues, and local networks, and it found expression in the written works of local intellectuals such as Pierre Bazantay, Avedis Sanjian, and Semih Çelenk, as well as in the cartoons of Tarık Mümtaz's *Karagöz* (Okyar 2020).

As discussed in the previous chapter, the two essential claims over the ex-Ottoman Arab territories were Mosul and Alexandretta. Following the Treaty of Lausanne, the Syrian-Turkish frontier was delimited more precisely with two consecutive agreements in 1929 and 1930 based, respectively, on friendship and good neighborliness. A final delimitation protocol covering the entire boundary east of the Sanjak of Alexandretta was then confirmed with the League of Nations in May 1930, including the province within Syria's borders. However, the position of the *sanjak,*

which had remained autonomous until 1923, was contested by the Turks as international politics began to change with the start of World War II.

An overwrought political atmosphere dominated the international arena as another war came nearer. Fascism under Mussolini's Italy, followed by Hitler's Germany, launched its offensives against the victors of the Great War, challenging them to another round. After Hitler's army moved west of the Rhine in the spring of 1936, and Italy entered Abyssinia, France was forced to reconsider its Mediterranean policy and design new strategies to secure its influence in the Middle East while cutting back on its military presence. After lengthy negotiations, France came to an agreement with Syria on 9 September 1936 to grant independence and cede control to the Syrian national council.

However, this agreement created significant discomfort for the Turkish government, which was looking for a different approach from the French to the border issue with Alexandretta. Turkey argued that transferring the *sanjak*, which held an autonomous position under the Turkish-French Treaty of Ankara (1921), to an independent Arab Syria would undermine the Turkishness of the province. The autonomy of the region was the Ankara treaty's main achievement. Article 7 clearly stated: "A special administrative regime shall be established for the district of Alexandretta. The Turkish inhabitants of this district shall enjoy every facility for their cultural development. The Turkish language shall have official recognition" (Dispatch from His Majesty's ambassador to Paris 1921, 6).

Turkey expressed anxiety about the district's Turkish population. The Turkish government asked the French to make a settlement with its people, similar to the one they had made with the Syrians concerning their self-representation and their privileged status. The French refused Turkey's demand, based on the Syrian Arabs' refusal to give up Alexandretta, due partly to its privileged economy, compared to the rest of the country. The French position, shaped by Arabs' insistence, stoked the conflict even further, igniting disagreements between Turkish and Arab nationalists of the province (Sanjian 1956, 380; Shields 2011, 20–21).

Even widely accepted scholarly narratives for understanding the formation of borders, states, and identities as they become "givens" are not

always equipped to explain the historiographical phenomena that encircled Alexandretta in the early 1930s. Disputes over its contested identities worsened over three years of diplomatic and public confrontation, during which both Turkish and Syrian nationalists hardened their positions and searched for advocates within their local communities. Amid exchanges of diplomatic notes and government vows of the French mandate's policies, Turkish media carried on a broad propaganda campaign both against the Syrian Arabs and the French. However, the real target of the press was the Syrian Arab nationalists, not their French rulers.

The Syrian nationalists perceived the province as an integral part of Syria with certain reserved privileges, due to its uniquely diverse population. From their point of view, the Turks were just another ethnic group with no special rights. The Turkish government felt challenged by the cooptation of local Arab notables into the French administration. In the Turkish narrative that grounded political cartoon rhetoric in the following years, this situation set up the Arab once more as the native subject obedient to his colonial master yet always potentially seditious.

The public and political struggles over Alexandretta's "Turkishness" versus "Arabness" highlighted the role of ethnic, religious, and linguistic communities in fomenting conflict, especially among dominant identities with their assumed partners. Within this "contradictory and ambivalent space of enunciation," statements crafted to demonstrate the inherent originality or purity of cultures became increasingly prominent (Khadduri 1945, 410; Selçuk, 1972, 79). For example, Mustafa Kemal's public messages in the inauguration the Turkish Parliament on November 1, 1936, emphasized the "purest Turkish element" of the region and stressed the importance of Alexandretta's inclusion into Turkey (*Tan*, 2 November 1936; *Cumhuriyet*, 2 November 1936).

It did not take long for the situation to be taken to the League of Nations, where a new arrangement was in play to define the Alexandretta province as a demilitarized independent entity. This decision outraged nationalists in Syria who were already struggling with two main challenges: providing support for the Arab Revolt in Palestine and countering the practices of the mandatory Government of France in Syria to establish a unified Arab nation. A separate entity in Alexandretta would be another

blow to their goals in the region. Feeling deprived, they refused to recognize any special status that might assign the district to Turkey in the future (Seale 2010, 351). To maintain the status quo and prevent the district from becoming attached to Syria, Turkey, in contrast, supported the local Turkish population through intense nationalistic propaganda both inside and outside its borders.

Yet, in 1936, Alexandretta became the code name for Turk-Arab animosity, which manifested in all possible forms of representation. Among all others, cartoons offered the most vivid and colorful examples of the bitterness and hostility between two ethnic groups. Representations of the Arab in particular during this period required an understanding of the process of subjectification that was made possible as much by the ideological discourse of racism as much as by the historical and political context. Understanding this racist discourse of Turkish nationalism as limited to a boundary dispute, of course, only oversimplifies a larger social project. However, the border dispute turned out to be one arena where Turkish racial discourse was displayed most open openly. The rivalry over Alexandretta was a propaganda war carried on by all parties in the nation-state, resulting in forms of discourse that embodied not only cultural but also racial differences.

The League of Nations gave Alexandretta partial independence in November 1937 as the Republic of Hatay, leaving it attached to Syria's French mandate on the diplomatic level but linking it to both France and Turkey in military matters. On 2 September 1938, Turkey managed to ensure the now Republic of Hatay's inclusion within its borders, with its Turkish name "Hatay" assigned to the province. The status of Hatay as a republic lasted one year. Turkey's increased pressure on France to denounce its 1926 friendship treaty, and the economic and diplomatic stress that boiled in the international arena, led the two rivals to undertake an administrative structure favoring a Franco-Turkish protectorate over Hatay. The latter determined the fate of the province in favor of Turkey in an unspoken strategic alliance with France, which needed Turkey's potential support against the growing threat from Germany. When the fate of a Turkish majority was sealed by a popular referendum held in June 1939, and Hatay was ceded to Turkey (Mango 2002, 506–11; Seale 2010, 351).

The Reemergence of the Arab's Image
in Racial and Ethnic Hybridity, 1936–1939

The construction of modes of racial differentiation became particularly evident in the political cartoons of the late 1930s, when Turkey exploited anxiety over the growth of fascism in Europe to coerce France into ceding the Alexandretta province. The features emphasized in the racist depictions of Arabs marked the domination of the Turkish national self over its colonized neighbors, whose supposed impotence in self-representation was a product of colonial discourse. This discourse was reflected in a visual symbolism in which the Arab turned into something more inhuman, a hybrid being, set against the well-defined Turkish self. This hybrid otherness was fixed in the Turkish public perception as a synonym of subversion, a "limited being" that, as Bhabha (1994, 35) describes it, "mimics" his oppressor in his need to survive. The place of this hybridity, Bhabha explains, is "the construction of a political object that is new, neither the one nor the other, properly alienates our political expectations, and changes, as it must, the very forms of our recognition of the moment of politics." In representing the Arab other as political object, the cartoonists of the early republican period often deployed an ornamental pattern consisting of regularly disposed features of foreignness, impurity, and corruption through "circulation and proliferation" of images of racial and cultural otherness. Even "Blackness" became a code for the overlooked Arab other.

The stereotype of the sub-Saharan Black Arab (*Zenci/Kara Arap*) was already a familiar figure from the traditional plots of the Karagöz shadow theater. The Black Arab, cast in the role of a loyal servant in the Ottoman household, had entertained the Ottoman public for centuries. As nineteenth-century colonial discourse emerged in its most exaggerated sense along North Africa's shores, the Black Arab of Karagöz, stripped from its cultural position, became a subordinate object in a racial discourse. The familiar image of the sub-Saharan African slave as loyal but foolish and naive traveled through Tripoli and Cairo to the Ottoman Empire, where it was reembodied as part of a reactionary Ottoman expansionist propaganda that had been similarly adopted from European orientalism. The

Black Arabs emerged in the political cartoons of the nineteenth century as members of savage tribes that needed civilizing.

For Bhabha (1994, 67), "the construction of the colonial subject in the discourse, and the exercise of colonial power through discourse, demands an articulation of forms of difference—racial and sexual." To be sure, political cartoons were one of the platforms for the an articulation of difference, which was crucial for dominating the colonized North Africans both physically and psychologically (Fanon 1970; Said 1994, 11). The colonial narrative exercised its authority through farcical figures, ridiculing the colonized to foreground their inferiority and abjection. These common practices of the imperial cartoon press extended their influence into the époque of nation-states, rapaciously and repetitively aggressing against the colonial other in a predetermined power struggle.

For scholars of nationalism, a nation is a linguistic group, a cultural body, a race, or a collective with a shared history. Between the two world wars, this definition lent momentum to revolutionary nationalist movements in Europe: first to Italian fascism under Mussolini, followed by German fascism under Hitler, and thence to other European countries. In all these cases, the Black Arab was consistently depicted as the emblem of colonial exploitation and racism. He was deprived of basic human dignity along with his difference and presence. This, of course, was not a nationalist project that suddenly appeared; efforts to scientifically prove the superiority of white men had begun to be made in the eighteenth century. The growing interest in the science of anthropology no doubt contributed greatly to this nationalist discourse and its means of reproduction.

Cartoonists were no exception in adjusting to this trend. From the 1930s onward, European political satire, including in Turkey, heavily engaged in altering the physical features of their "others" with racial formulations. For example, the indistinguishable skin tone of the ex-Ottoman Arab would be traded for a darker skin tone. Other distinguishing facial elements, such as the lips, eyes, and even attire carried a similar racial connotation, where the supposedly genealogically superior were defined against the inferior. Such bold yet resentful illustrations of physical qualities provided a considerable stock of material for cartoonists to use, especially with their capacity for developing a grotesque image of

the targeted subject. At the edge of the colonial system, where pluralism clashed with Europe's fascism, these binary signifiers became even more evident: the African in comparison to the European, or the Black man's inferiority to the white man on the ladder of civilization. The distortions that were applied to the concept of Blackness were particularly emphatic in the political cartoons published in French and British papers right up into the twentieth century.

A similar visual racial rhetoric was reflected in Turkish papers in the first years of the republic, although it was not as aggressive as in Europe. For example, the cover of the 14 June 1924 issue of *Resimli Gazete* (Illustrated Newspaper) was devoted to a comprehensive demonstration of the "evolutionary descent" of Black Africans from apes (fig. 89). The photograph on the cover depicted an ape bearing the legend "orman adamı" (jungle man), making a racial connection between Black Africans and humanity's ape ancestors by sharing the page with another heading, "Zenci Kongresi" (Black Congress), which ironically raises the question of whether the ex-Ottoman eunuchs would participate. The front page also featured an image of a monkey (*maymun*) praised for its abilities to smoke a cigar, ride a bicycle, and even a car. In its "jungle man" and human-like monkey, the paper relationally carries the Turkish racial discourse to its audience, introducing a blueprint for future issues of the paper. Turkish cartoonists were not late in adopting a similar visual discourse in their own productions, similar to those of colonial Europe in their depictions of North Africa's Black Arabs. Black skin tone, disordered curly hair, wide nasal structure, and fleshy lips were among the racial identifiers dominating the cartoons that used Blackness as a symbol of the backward and barbaric colonized subject.

These physiognomic features, which aimed to construct a correspondence between moral character and physical appearance, were at times reflected in, for example, the quality of Black Africans' hair, whose significance in the Turkish cultural imagination can easily be traced in longstanding idioms generated through Karagöz plays. From Black Arabs' first appearance in the shadow theater, they were represented with thick black curly hair as a mark of their savage nature, an image that goes back further than French or British scientific configurations.

نومرو : ٤١ — سنه : ١ نسخه‌سی هر يرده ٥ غروشدر جمعه ايرتسی ١٤ حزيران ١٣٤٠

رسملی غزته

آبونه شرائطی

سرمحرری :
سليمان نظيف ، ابراهيم علاء الدين

اداره‌خانه :
...

٭ هر هفته جمعه ايرتسی كونلری نشر اولنور هرشیدن بحث ايدر ، مستقل‌الافكار و رسملی تورك غزته‌سیدر ٭

زكی قونفرنسی

اورمان آدمی !

اسكی مكتب استحاله‌لندن : امجد قوغوشی كديه چكی دوزن وريبور :

In Ottoman and later Turkish popular discourse, the idiom *Arap saçı* (Arab's hair) is used to suggest a complex, tangled situation, even a state of disorder, caused not by external means but instead due to the nature of the existing phenomenon. Such a state can only occur due to the undomesticated status of its owner, a person that is uncivilized and tribal (fig. 90). This metaphor of the Arab's hair was widely used at the time by republican cartoonists. For example, a series of cartoons published in *Karikatür* during Mussolini's invasion of Ethiopia in 1935 included examples typecasting the Black Arab's hair in early Turkish satire. The series narrated the latest developments in European rivalry around the Arab's hair trope to emphasize the complexity of political circumstances in North Africa. These cartoons, by Ramiz Gökçe and Orhan Ural, illustrated a correspondence between the moral character of Black Arabs and their grotesque appearance, with degraded facial signifiers underlining their weakened position caused by their wild nature in a world dominated by civilized Europeans. For example, in Figure 90, the cartoon titled *The State of the World* stresses Ethiopia's complex situation in the European colonial scramble for Africa by depicting a dangerous game played by the two fascist dictators of Europe, Mussolini and Hitler, with flying balloons. The balloons are portrayed as the heads of Black Arabs, in this case Ethiopians, attached to strings made out of their frizzy hair, signifying the various uncertainties of colonization in Africa, where both dictators are trying hard not to get their balloon strings tangled. Mussolini warns Hitler: "Adolf, you'd better watch out. At the end of the day, it is just hair!"

The phrase "it is just hair" is especially significant in deconstructing how the cartoonist envisioned the colonial subjugation of Africans due to their supposed inferior status. Although this statement refers to Ethiopia's colonized population, the subliminal message sent by the cartoonist reflects the general colonialist discourse where, in Bhabha's (1994, 71) words, within that system of representation, as Edward Said has suggested, an "Orientalist power" emerges that defines the Orient as "a unified racial, geographical, political and cultural zone of the world." The emphasis on the adverb "just" in "it is just hair" clearly underscores the oversimplification of representing colonial Africa in general. It positions the region as a geography that is both necessary and dispensable to the

90. Ramiz Gökçe, *Karikatür*, 4 April 1936, 1. *The State of the World.* [Caption]
Mussolini: "Adolf, you'd better watch out, at the end of the day, it is just hair!"

European colonizer while demonstrating Turkish moral superiority over and against Europe.

During the second decade of the republic, the highly marginalized nationalist ideology of a privileged Turkish race became more visible not only in state discourse but also in scientific studies. The aim was ultimately to consolidate Turks' belonging to the land through prehistorical and early historical accounts of their ethnic origins—Turkishness—of the land. Commonly known as the "Turkish historical thesis," this positivism in archaeological and linguistic research demonstrated how the racist tendency of the epoch overtook the 1930s governing elite and a significant share of its intellectuals, almost to the same extent as their European counterparts (Makdusyan 2005). One of the areas of research supporting this argument developed as part of Turkish anthropological studies designed for comparing physical features of religiously, ethnically, and racially different minorities. Scientific journals like the *Turkish Review of Anthropology* published the results of these studies in an effort to affirm the Turkish historical thesis (Maksudyan 2005, 314). Increased racial markings in representations of the nation's others were not, of course, limited to the colonized Black or white Arabs of ex-Ottoman territories; it also included Kurds, Christians, Armenians, Greeks, Jews and others that were considered ethnically and religiously separate from the defined homogeneity of the new nation-state.

No More White Arab: The Hybrid Arab
of the Levant in Turkish Political Cartoons

Following the scientific, literary and visual reemergence of the Black Arab in the early republican Turkey's historical thesis, the racial formulations of the late 1930s were overlaid with the white Arab stereotype of Karagöz plays as the Alexandretta dispute took its place at the center of the Turkish political and diplomatic agenda. The Turkish state launched a strategic propaganda war to mobilize public opinion against the Syrian Arabs' claim over the district, taking every possible occasion, in cartoons, to attack the image of the Middle Easterner as an incapacitated, colonized other with no proper means of ruling a Turkish-populated land.

The Arab Revolt of 1936 in Palestine offered one such opportunity. Although it had arisen independently from the Alexandretta dispute, the two crises were represented simultaneously in Turkish political cartoon weeklies. The Arab as colonial subject became less fashionable as conveyors of racial typologies and stereotypes were reintroduced to the sieve of "Orientalist power" used to assert a form of "indirect dominance" (Bhabha 1994, 70). Ramiz was quick to share his version of the story with an eye-catching demonstration in *Karikatür*, a popular republican satiric newspaper. Ramiz's cartoon was a simple expression of the current political atmosphere that had emerged against the British colonialism and the Arabs simultaneously. In it he sets an imaginary scene from the 1936 Arab revolt, where a raging Arab figure in his white garb and sandals runs with a baton in his hand after a Jewish figure, identified with the star of David (fig. 91). The cartoon makes a twofold implication: first, to emphasize the difference between the West and the East, as symbolized by the outfits of the two figures (a Palestinian Arab and a Jew); and, second, the chaotic situation that had been created by the European mandates over the contested nationalisms (Arab nationalism and Zionism).

This tangled political situation in Palestine discomfited the rest of the region, especially the French mandate that had been challenged by the recent Syrian revolt (Khoury 1985, 327–28). Syrian and Lebanese Arabs' popular support—upon losing their own battle—of the Arab Revolt in Palestine was well known to Turkey's political elite, who sought to gain leverage against the French, concerning the negotiations on the Alexandretta province. The French were worried that the Palestinian revolt might trigger another rebellion in Syria, which was already showing resentment against the French for its engagement with Turkey over Alexandretta.

The Turkish cartoonists were eager to keep Syrian Arabs' support for the revolt rather than the Palestinian cause in the public eye. Ramiz's cartoon *İsyan* (Revolt), published as the first of a series on the cover of *Karikatür* (5 December 1936), personified the Arab Revolt in the bodily form of a giant ape-like creature with dark, hairy skin and swollen red lips, exaggerated to magnify his foolishness, a trope reserved for colonial subjects such as Arabs. This was the first of such an expression of the Middle Easterners in the Turkish cartoon press. In his stereotyping, Ramiz's

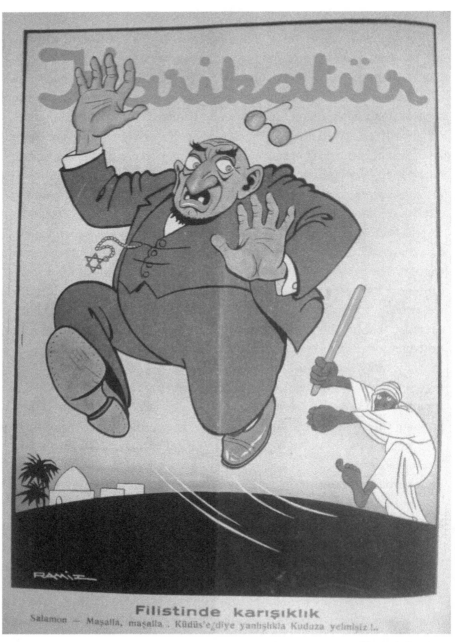

91. Ramiz Gökçe, *Karikatür*, 2 May 1936, 1. *Trouble in Palestine.* [Caption] Solomon: "Mashallah, Mashallah, turns out we landed into the middle of a canine madness instead of Jerusalem."

disavowal of racial and ethnic differences turned the Arab "colonial subject" into a misfit, a "grotesque mimicry that threatens to split the soul and [the] whole, undifferentiated skin of the ego" (Bhabha 1994, 75).

This mimicked presence held the dual character of loyalty and seditiousness in its depiction of the giant monster, the Arab. While he was not to be trusted, at the same time his colonizing master's days were obviously coming to an end. Ramiz's depiction of European colonization as an old, beaten-up gladiator metaphorically announces to the audience its approaching demise. The feeling that Ramiz dredges up from his audience's collective memory of his audience is precisely this sense of Arab betrayal. His cleverly fictionalized metaphors serve not only to reinforce binaries in a rigid representation of the Arab as the Turks' non-national other—its psychological enemy, trapped in the dichotomy of skin and culture—but it also glorifies the Turkish position in excluding Arabness from its national formulation (fig. 92).

The concept of "sedition" was repetitively embodied in other cartoons in the series tailored around the theme of rebellion, passing beyond the simple rhetoric of the Palestinian Arab Revolt to consolidate the agitating character of the Arab as untrustworthy and disloyal. In its title, one of the two following cartoons in the series, published on 17 April 1937, disclosed the news that *The Rebellion in Syria Is Expanding . . .* on the magazine's cover through a portrayal of a Syrian Arab, identified by his keffiyeh.[1] The cord encircling the cloth, called an *aqqal*, is in the form of an open-mouthed snake, symbolizing the wickedness and disloyalty of the Arabs as announced in the *aqqal*'s label, "isyan" (revolt). The Arab's exaggerated facial features show his desperate fear of being bitten by the snake that is coiled around his head. His full, fleshy lips halfway open, showing white teeth that contrast with his darker skin, thereby assigning him a racial identity beyond his actual one (fig. 93).

Ramiz adds one final aspect of inferiority—and hybridity—by pinning an earring on his Arab subject that constructs a presumptive linkage with

1. In the formative decade of the republican period, the fez became a symbol of underdevelopment, associated with Ottoman backwardness, which was contrasted with the republic's secular and Western-facing enlightenment project.

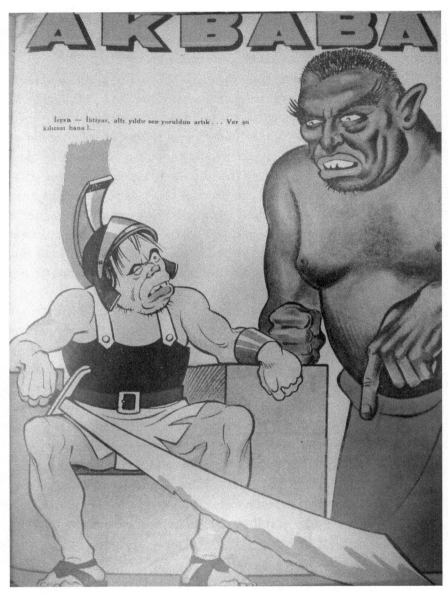

92. Ramiz Gökçe, *Akbaba*, 1936, 1. *Revolt*. [Caption] "Old man, the last six years must exhaust you, give the sword to me."

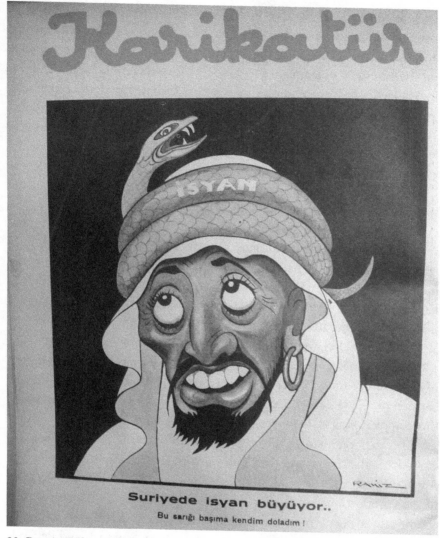

93. Ramiz Gökçe, *Karikatür*, 17 April 1937, 1. *The Rebellion in Syria Is Expanding...* [Caption] "I coiled this rope around my head myself!"

a gypsy or pirate-like nomad. The latter manipulation of the character somehow incorporates the 1930s fascist wave that described Romani living in the Balkans as having physiognomies similar to those of Africans, a common theme at the time. In his article "The 'Gypsy' Stereotype and the Sexualization of Romani Women," Ian Hancock (2008, 184) recounts

various "inaccurate" racial comparisons made between Romani and Black people similar to those Ramiz adopted for his portrayal of the colonial Arab stereotype. He quotes the various renderings of European travelers on the Romanis' resemblance to Black African men: the "Romani slaves in Wallachia had crisp hair and thick lips, with a very dark complexion [and] a strong resemblance to the negro physiognomy and character." Hancock focuses in particular on these numerous references that magnify facial features—"Their lips are of negro heaviness, and their teeth white as pearls; the nose is considerably flattened, and the whole countenance is illuminated, as it were, by lively, rolling eyes"—that seal the Romani inside the subjugated colonial world.

Inevitably, Blackness and racism were connected to one other in these representational forms of targeted groups. The racial cocktail of Romanis, Arabs, and Black Africans manifested in a hyperreality where the imagined Arab became a product of a fabricated system of meanings that barred him from freedom. Within this nationalist hyperreality, the real image of the non-national and its fictional forms blend together in a seamless hybridity. They were now caught up in the simplified definitions of colonial discourse, where all the adjectives for the colonized, in all means of cultural production, were attributed to their presence. Cemal Nadir's cartoon on the October 1936 cover of *Akbaba* was one of such example of this complex, hybrid, hyperreal image of the Arab (fig. 94).

This cartoon features the large face of an overweight French woman, embodying the "French motherland," yawning with her mouth wide open. Apparently, she has slept all night after gorging on her colonies. Meanwhile, a proportionately smaller "Black" Middle Eastern figure desperately attempts to rush out from inside the French woman's mouth. His ethnicity as a Middle Easterner is defined not only by his white garb and keffiyeh but also by his racially significant "Blackness." Nadir, who enjoys playing around with the multiple connotations of words, magnifies the dual meaning of "Arab" in Turkish cultural semiotics—as it was in the Karaköz plays—which implies both the white and Black people of the Middle East and Africa. For him, the 1930s Middle Easterner is nothing but a hybrid product stuck in limbo.

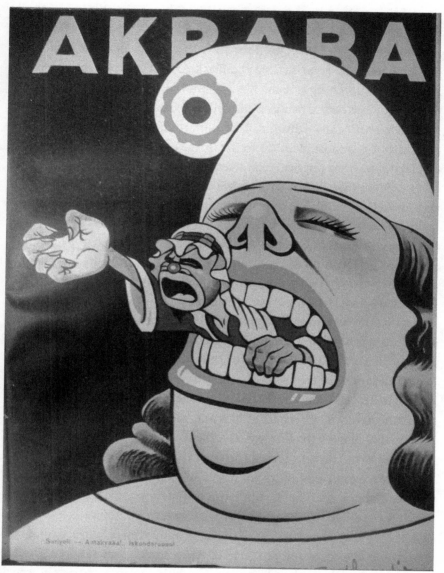

94. Necmi Rıza, *Akbaba*, October 1936 [Syrian] *Antioch!* . . . *Alexandretta!* . . .

Nadir's cartoon does not give any other clue to the ethnic identity of the figure. Is he an Arab or a Kurd? A Muslim or Christian or Jew? Is he Palestinian or Syrian? Not until reaching the caption does the reader find out, perhaps with surprise, that the Black Arab in the picture is a Syrian Arab who is reaching not for his salvation but instead to take Alexandretta with him before being swallowed by the half-asleep French woman. Nadir's Syrian Arab—with his black skin, rounded skull, wide nose, and fleshy lips—is almost identical to the image of the colonized African. He displays almost no physical characteristics that resemble the white Arab of the Middle East; he is not that familiar cunning type with relatively fair skin and a bony skull, hooked nose, and thin lips accompanied by a pointy beard. Nadir's Syrian is no different than Ramiz's and Ural's Ethiopians, the savage subjects of Europe's African colonies mired in barbarity.

Nadir's re-creation of his victim's persona in hyperreality by assigning him a character that incorporated all orientalist signifiers in a single body was noteworthy. His cartoon exhibited the congruent system of representation that introduced a set of binaries (white/Black, civilized/uncivilized, superior/inferior) that worked to amalgamate the various tropes in Turkish state discourse in order to advance it in the minds of his audience—a brilliant example of the hybridity that combined multiple racial configurations in representing the Middle Easterner's alterity. The constant and simultaneous correlation of the Black and white Arab created a perceptual illusion that blurred the line between them.

These racial designs joined the colonized Arabs into a population of degenerate types based on racial origin to vindicate their subjugation by the colonial powers. The Alexandretta dispute provided a platform upon which these almost daily orientalist scenes served to reproduce the Arab stereotype. The central theme of the Turkish narrative in the daily news concerning the contested province of Alexandretta was tailored around the salvation of the enslaved Turkish population from barbaric and cruel Arabs—Syrians—and their French masters.

At this point, the cartoon press assigned the Syrian Arab a new image: as the racially modified slave trader. In series of cartoons, his physical features mixed the racial peculiarities of Blackness as a colonial subject combined with the colonizer's oppressive presence. Some good examples

of this construct can be found in the work of Necmi Rıza, a prominent republican political cartoonist in line with Ramiz Gökçe and Cemal Nadir who published a series for two consecutive issues of *Akbaba* on 3 and 17 October 1936.[2] By this time, the French agreement had granted Syria its independence and placed Antakya (Antioch) and İskenderun (Alexandretta), the two towns within the contested territories, under Syrian administration. Turkish cartoonists were ramping up their propaganda against the Arab nationalists who were still pursuing their claim over the region. Their aim was to publicize the Arabs' incapacity to exert rightful governance over the Turkish population due to their historically colonized status. This rendering of the Arab stereotype differed from Turkish collective memory as seen in the traditional plots of the Karagöz theater. This new Arab dressed differently and looked different. The visually fabricated hybridity of this new Arab was not simply defined around the skin color, but around the cultural and social erosion, caused by their cooperation with their colonizers. The political cartoon space performed as a visual exhibit hall, designed and constructed as a unique two-dimensional national pavilion displaying this "Arab, but not really an Arab" for Turkish spectators.

Necmi Rıza contributed a great extent to this entrapped image of the Arab in a series published in *Akbaba*. In his cartoons, the Arab stereotype surfaces not only as a disliked figure but also as a point of reference for the Turk's mirror image, as its ultimate non-national other. Positioning the Syrian Arab as a swarthy, villainous slave trader lurking at the gates of civilization recalls the ethnic, racial, and sexual images of the Orient as fictionalized through the gaze of Western modernism (figs. 95–96).

Rıza's first cartoon in his series, *Yirminci Asırda Esircilik* (Slavery in the Twentieth Century), depicts a negotiation between an Arab slave trader and his French colonizer over two beautiful white slave girls, evoking Ottoman memories of slavery in a duality of race and gender. Through

2. Necmi Rıza was a prominent Turkish cartoonist of the Republican period. He first started to draw daily in *Cumhuriyet* in 1928, and in the late 1930s he moved to Akbaba. After 1936, he became the paper's head political cartoonist, while Ramiz continued to illustrate mainly for *Karikatür*.

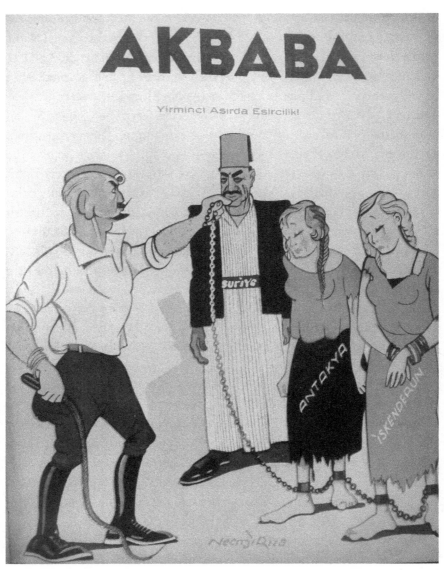

95. Necmi Rıza, *Akbaba*, 3 October 1936, 1. *Slavery in the Twentieth Century!* [It reads "Syria" on the slave-trader's belt, and "Antioch" and "Alexandretta," from left to right, on women's skirts.]

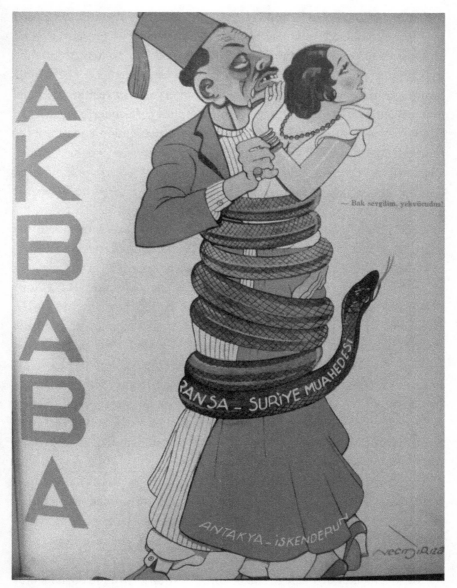

96. Necmi Rıza, *Akbaba*, 17 October 1936, 1. "Look, my darling, we are one body! . . ." [It reads "French-Syrian Concordat" on the snake, and "Antioch-Alexandretta" on the woman's skirt.]

the latter analogy, Rıza fictionalizes the power and exploitation exercised over those colonized Arab communities. The entire series presents a social and historical context that displays different modes of exclusion, inferiority, subordination, and exploitation linked to a racial element. The Middle Eastern man's dark skin implies his racial inferiority in relation to white men while the white woman's femininity implies her gender inferiority in relation to men in general. These elements of subjugation constitute the fundamental message in Rıza's rendering of the scene, where he relationally constructs the sexual signification of women as objects of honor and dominance, recalling Ottoman practices of female slavery and the exotic aura of the harem.

The visions embedded in standard fictional accounts of harem life were described in all forms of European orientalist literature and art, from Montesquieu to Ingres to Daumier. They contain a certain element of truth but often were largely the product of inaccurate travel accounts that tickled the imagination of the European public. Nevertheless, by the nineteenth century, female slavery in the Ottoman harem had already undergone significant changes (Lewis 2004, 61). Under the empire's new reforms, the slave markets were closed and the importation of the Circassian and Georgian women, who at the time were esteemed for their beauty, was terminated (Tolenado 1981). However, female slavery in the harem remained part of Ottoman social practices almost to the end of the nineteenth century and was the center of many orientalist fantasies entwined within the sexual domination of women by men.

From the eighteenth century onward, the oriental man's stereotyped appetite for absolute control over a large number of women was a favorite subject of European political cartoons. However, the European idea of the oriental harem continued to offer not only exotic sexual escapism but also a form of domination, an assertion of cultural superiority, a signifier of social class that safeguarded women's proper, limited social status as defined within the margins of domesticity and sexual pleasure, thus fulfilling every wish of the imagination for modern European man and woman (Lewis 2004, 131). This orientalist image of woman exemplifies Bhabha's (1994, 67) notion of the "construction of the colonial subject in

the discourse, and the exercise of colonial power through [this] discourse" by articulating sexual as well as racial forms and differences.

Rıza was, of course, not aware of the colonial discussions or orientalist discourse on slavery when he was creating his cartoons about ongoing political circumstances. Rather, he was illustrating his political perspective from a national standpoint in which the new Turkish self was being defined against the social and cultural values presented by the Ottoman Empire, particularly those related to Arab heritage. *Resimli Gazete*, for example, published a series in 1931 on Ottoman pashas, criticizing their mistreatment of women in harems. The article features an image of the harem's Black eunuch, who is described as *müstebit ve korkuç* (the most tyrannical and terrible) of all servants. As it resonated within the Turkish collective memory, in Rıza's cartoons the concept of slavery awakened a perceptual border between Turks and Arabs, civilized and uncivilized (fig. 97).

Just as the enslaved woman played an essential symbolic role in Turkish political cartoons in general, and Rıza's in particular, so did the slave merchant. This heartless, malicious character was not limited in the Turkish imagination to the stories in the *Arabian Nights*. As was the case with slave women from Circassia, Black African slaves were also part of Ottoman social practices, mostly as domestic servants in elite houses. But, for centuries, Arabs were the primary suppliers of African slaves to the empire's households. When changing ideological formations redefined social and cultural relations in Europe, as Ehud R. Toledano (2007, 57) has pointed out, Ottoman policies against the slave trade became essential to withstanding European—mainly British—pressure. Especially on the cusp of the twentieth century, these policies developed as part of the mission civilisatrice.

Historically, the slave trade, particularly from sub-Saharan Africa, which supplied most of the Black slaves who served in Ottoman households, was dominated by Muslim-Arab traders who worked the markets of North Africa or the Levant all the way to the Hejaz. John Wright (2007, 6) has asserted that, besides transporting men and women to market via the Mediterranean, these slave dealers also ensured the circumcision

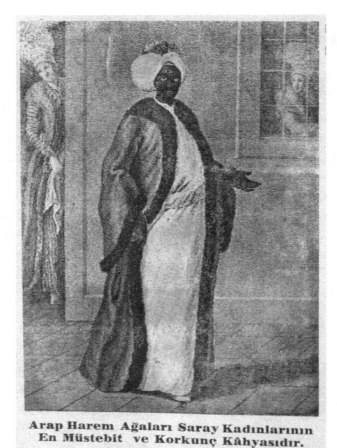

**Arap Harem Ağaları Saray Kadınlarının
En Müstebit ve Korkunç Kâhyasıdır.**

97. *Resimli Gazete*, 26 February 1931, 4. [Turkish] "Arab
eunuchs are the most despicable and terrifying stewards
of the Ottoman harem."

and training in Arabic of their slaves to make sure they would sell to
wealthy elites.

The empire prohibited slave traffic from Africa and, by the end of the
nineteenth century, had managed to suppress it. Still, a clandestine trade
in slaves persisted via alternative routes, concealed from European moral
and civil outrage and abolitionist ideology until the French and Italian
intrusions in the 1930s. According to Wright (2007, 160), the Egyptian
traveler Ahmed Hassanein Bey reported that, in 1923, he could buy a

slave girl for between £30 and £40 sterling in Kufra, the largest district in Libya.

Rıza's fictional slave dealer, with his racial identifiers, was depicted in a manner similar to that of near but distant narratives of North Africa's Arab slave traders. In all of his cartoons, Rıza formulated his Arab type with a monstrous facial expression highlighted by fleshy red lips, a dark skin tone, a comparatively larger head wearing a red fez with a pendulous tassel, a long striped robe, a short coat, and slippers. The slave dealer was no different: he represented the cultural and social hybridity of the colonized subject reassigned to the social imaginary of modernity. The once clear difference between the master and the slave, the oppressor and the oppressed, became blurry, opening up a space of translation and hybridity where a new political object emerged, one that alienated the political expectations of Turkish state discourse and changed the public's recognition of its Arab other at a moment of political conflict.

Rıza's slave dealers, working for their French masters, were the manifestation of the hybridity expressed in a discourse of power. Rıza represented the Arab as something more than a simple colonized subject that mirrored Turkish sovereignty. The Arabs' claim over the Turkish-populated region of Alexandretta and their restlessness over the French mandate called forth a wave of anger from the deeper strata of Turkish collective memory. This memory translated into a revaluation of the assumptions of colonial identity through the repetition of discriminatory identity effects displaying all sites of discrimination and domination in a "negative transparency" (Bhabha 1994, 113) that prevailed for years in the Turkish consciousness, creating not only physical but also perceptual boundaries with respect to its Arab other.

The Arab image offered a mixture of racial and ethnic signifiers joined in the creation of an ultimate non-national other. Whether we take these representations as the products of historical myth or treat them as satirical grotesques, they represent the emergence of a form of social and political temporality that was repetitious and indeterminate. The resentful circulation of the Arab type, and the political uncertainty over the border issues with Syrian Arabs under French mandate by the Turkish political cartoon press contributed, in a complex temporality of social

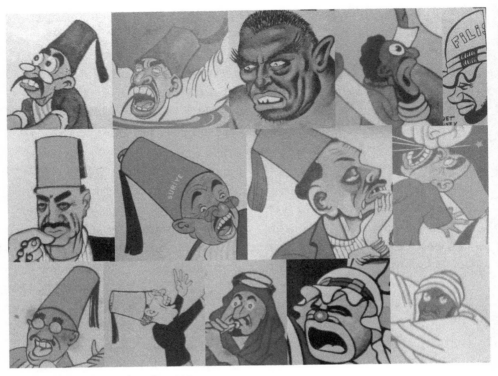

98. Arab image after the 1930s.

contingency, to the creation of the Turkish national self. The chain of communication in the political cartoon press, and its visually semantic content, were transformed in transmission through exaggeration, magnification, and imprecision. Without any significant difference, all Arab nations were eventually represented as nearly identical, bearing the racial marks of colonial discourse as their common denominator (fig. 98).

Conclusion

The Forever Haunted Image of the Arab

None of the national identities discussed here are simple. All contain a great deal of complexity, due to a long history that has left in its wake various self-images, moral contradictions, and, apparently, different identities. In such a long journey, freedom from the cumulative knowledge of the past would be unthinkable. And, in that context, stereotypes are far more important than one might think. They are the product of a nation's cultural unconscious, which, no matter how hard a nation tries, falls back on its national myths, and the images from these narratives as recycled in the routines of daily life.

This book is about the cross-national images and perceptions of the Arab as expressed in the Turkish visual discourse of political cartoons. It tracks the centuries-long journey of the image of the Arab from the coffeehouses of the imperial capital to the early republican print houses in Istanbul's Cağaoğlu quarter. From the first traceable occurrence of this image in the Ottoman Karagöz shadow theater to the Cemal Nadir's multidimensional depiction in popular *Cumhuriyet*, this book rereads and reenvisions the Arab stereotype, layer by layer, through the interpretation of political cartoons in the wake of political and cultural revivals of ethnically and religiously diverse groups, and in the dissolution of imperial states and empires.

With the emergence of the Turkish Republic, the sphere of politics is, then, the sphere of the exercise of formal state power, entailed to the mobilization of not only political and cultural symbols in the creation and development of a modern state but also its stereotypes. The instrumentalization

of these stereotypes by state discourse in order to consolidate national unity represented a challenge to the idea of their authenticity. However, there can be no prior judgment that these stereotypes, whether national or non-national, have no basis in the lived experience and the hearts and minds of the nation's people. Thus, one aim of this book has been to make these traditional images of those who had once been members of a multiethnic empire—particularly the Arab—visible within the larger discussion of the politics of culture in the making of a nation-state.

It is never an easy task to follow the transformation of a stereotype over a long duration, especially when the case is defining precisely whom is meant when referred to as "Arabs." The adventure of the Arab image as it appeared in Turkish historical and cultural memory required the difficult job of comparing cross-national relations. Political cartoons, as historical resources, offer a way to visually decode these identities as they were imagined in Ottoman and Turkish popular culture. Of course, there were limitations in writing this book, in terms of singling out national and non-national identities while working on the Arab stereotype. Certainly, Arabs were not the only ones who were left out of the national unity; religious (Armenians, Jews, Rums) and ethnic minorities (Kurds) that were otherized within the making of the Turkish nation-state were not the focus of this book, yet they offer an excellent opportunity for scholars interested in ethnic studies.

The story begins with the four-hundred-year-old Karagöz shadow theater that produced the first visual illustrations of the Ottoman stereotypes. These stereotypes exhibited powerful images set against familiar and often accustomed backgrounds. Arabs were among these familiar characters. For centuries, with their colorful, humorous portrayals, they served as perception-builders. The Karagöz plots created a set of standard ethnic traits for Arabs that constituted the basis of numerous Turkish idioms and fixed the Arab firmly to its presupposed image. As history moved on to the invention and distribution of print, the Arab stereotype's reproduction also transformed from a leather puppet figurine to lithographic illustrations in daily newspapers.

It is important to keep in mind that images produced in earlier centuries bore the imprint of those times, but also modern cosmologies

reflecting the complexities of a period marked by unprecedented change for a modern audience. We can safely assume that images of Arabs had not remained static in the centuries following the conquest of Arabia, and that they probably changed depending on the nature of local encounters. However, it is also clear that in the pre-republican Ottoman imagination two ethnically and racially separate characters emerged as one "Arab": the white Arab of the Levant and Mesopotamia, and the Black Arab of sub-Sahara, where their faith coincided in the imagination of their audience.

The introduction of political cartoons as a means for popular cultural production helped weld together the archetypes of the Karagöz plays—the white Arab and the Black Arab—in a single, ultimate mental image. I use the term "ultimate" deliberately to describe the final stage of the Arab stereotype as the Turk's non-national other because of the twofold transformation of its popularized visual representation as generated by formal state discourse. The first was the transformation of the traditional Karagöz theater's white Arab as the empire's internal other into a colonial subject toward the end of the nineteenth century. The new image of the Arab in the lithographic representations carried an orientalist touch in the nineteenth-century imperial political cartoon press, uncertain where to place them. Are they one of us—"us" being the imperial unity—or not? And, if so, how are we going to deal with their "uncivilized" nature? These seemed like the main questions for the imperial capital. They could also be traced in the visual portrayals of Arabs in political cartoons, which depicted them always at the edge, neither with complete civility (as defined within the norms of Europe) nor in a state of complete savagery. Interestingly, the visualization of Arabs in nineteenth-century political cartoons often carried an essence of nobility attributed to the fact that the Arab led a life with honesty and generosity designed around the natural laws of the desert—a life that was not a pure representation of Islam but a version of it.

The Ottoman satirical press transposed the Arab's image into a new oriental identity where the boundaries between the Arab self and the Ottoman self received a similar colonial characterization, hijacking the previous position of Arabs in the Ottoman imagination as the pastor of pure Islam with a capacity for civilization. The new orientalist visualization of the Arab imitating the West often preserved a special and superior status

for the notion of the Ottoman West over the non-West. To be certain, as a discourse, it did less to create a better understanding of Arabs as citizens of the imperial capital than it did to extend power over those peoples by "reproducing a particular image of the Orient, by making statements about it, authorizing views on it, describing it and eventually teaching it" (Said 1979, 6).

Two developments contributed to the Ottomans' Arab image during the empire's final epoque. First was the publications of Ottoman artists who fled to Europe; and second was Abdülhamid II's efforts to rebuild his despotic image in Europe. Ottoman lithographic cartoons of the late nineteenth century were instrumental in creating a sense of Ottoman modernity by depicting their Orient—which included the Levant, Mesopotamia, and North Africa—in a manner similar to that of their European contemporaries. The young, educated intelligentsia who fled the empire to Europe to escape Abdülhamid II's despotism found in the European political and cultural centers an inspiring hotbed of visual symbolism, especially for the quickly flourishing cartoon scene. The recurrence in cartoons of creatively designed and formulated illustrations of signs, forms, and figures empowered their artists with an alternative set of political weapons while attracting more spectators to their respected spheres of popular production. For sure the power of nineteenth- and early twentieth-century political cartoons over their audience was indisputable. These satirical and grotesque illustrations—cartoons in particular—told the stories of the era better than most written forms, especially when their durability as images stuck to the mind are considered (Navasky 2013, 41).

The Ottoman intelligentsia in diaspora who used their artistic skills in their political critiques, adopted the European symbolisms of nationalist discourse. Symbols like the goddess of liberty for freedom, the three-headed dragon for evil, and the chains for enslavement were critically applied by the diaspora to Abdülhamid II and his despotic regime. The latter symbolism was formulated mainly around the diplomatic conflicts and power formulations that shifted the eighteenth-century romanticism of the unfamiliar Orient to the barbaric threat of the familiar. The Ottoman Empire and its imagined geography rested at the center of Europe's articulation of its Eastern Question, where the "premodern"

or "backward" rule of Abdülhamid II prevailed in its harshest sense. To rebuild its image both at home and around the world, Abdülhamid II tried to replace the image of the backward Turk with the backward Arab. For their part, Young Turks, caught between stereotypes and their identities as educated, modern members of the empire, seemed to stand in line with the sultan's efforts to rebuild the image of the Turk by placing the Arab as its imperial other. In that sense, the Hamidian period served as an incubation stage for the Arab stereotype to begin to evolve beyond its original stereotype.

The challenge for the Turkish cartoonists, however, was based mostly around the question of how to illustrate the ethnically different other while sharing a common religious identity with them. Whether one thinks of today or the nineteenth century, the identification of Arabs with Islam is immediate. Nevertheless, Muslim identity was not enough to eliminate the long-lasting, deeply embedded ethnic prejudices between Turks and Arabs, despite their both being part of the same religious community; these prejudices existed long before the discussions of nationalism and orientalism emerged in the literary and political fields. Nevertheless, in the nineteenth-century imagination of the Orient as a monolith, Islam was vaguely associated with the borders of the Ottoman Empire, which Europeans first encountered during Napoleon's Egyptian campaign. The word "Turk," then, quickly became the equivalent of "Muslim," although many of those they encountered were not ethnic Turks but, rather, Arab subjects (who were, of course, not exclusively Muslim) of the Ottoman sultan. The Western world's framing of its eastern opponent as the vulgar Turk heightened the Ottoman palace's reaction to self-identify as a modern empire while situating its Arab subjects as its uncivilized others.

With the founding of the Republic, the Arab stereotype took its second transformative turn along the lines of ethnonationalism. In this development from empire to nation-state, the nineteenth-century oriental image of the Arab was defined against the malleable, modern, and, by definition, invented Turkish self. The nation—with its collective baggage of symbols, histories, and traditions—engaged in a task of total social and cultural engineering, separating off all non-Turkish elements to create an imagined political community. It was at this point that the Arab's visual

representation was formulated by republican political cartoonists in its most distorted form, purged of any possible positive trait, including his desert nobility. The relentless otherization of the Arab that contributed to the creation of the modern nation was associated with fairly recent symbols such as national myths of the Arab betrayal. As Eric Hobsbawm (1992, 169) has argued, "The ability of the mass media to make what were in effect national symbols part of the life of every individual, and thus to break down the divisions between the private and local spheres in which most citizens normally lived" is an important aspect of nationalism. In the context of Turkish nationalism, this ability of mass media was enormously impactful and worked even more effectively than state propaganda in constructing the Arab in what I call the "ultimate" step in the classification of non-national otherness.

In this book, the selected series of political cartoons, which are part of a larger collection, documents the gradual transformation of the satiric images of the Arab merchant of Karagöz shadow theater. Their previously mocked but accepted image as part of a multiethnic society was now invaded by a despised, rebellious, treacherous, swarthy Arab stereotype that became an intuitive metaphor for every value against which the new republic wanted to define itself. In the ever-expanding number of mass-produced orientalist representations of Arabs, this stereotype contributed to fortifying a symbolic boundary between Turks as ethnically and racially distinct. As fascism and its serving governments swept the Western world in the 1930s and 1940s, the Arab stereotype quickly developed as part of Turkish political life and Turkish society's conventional hyperreality, both conscious and unconscious.

The emergence of Turkish nationalism paved the way for various ethnic, religious, and cultural stereotypes to link the notion of the other to the concept of national identity. The founding elite took up a massive project of social engineering that now required the amplification of Turkishness as the founding concept of the new nation-state. As in other projects of nation-formation, this concept was shaped by the construction of various others as a backdrop. In many ways, for Turkey, the Arab in his keffiyeh and traditional garb constituted the definitive other, yet, in contrast to Europe's dichotomy of "us and them," for most Turks the Arab did not

start out as an external and exotic entity. He was a familiar, though sometimes ridiculed, member of the imperial family, and his cartoon image conjured up a much more complex set of emotions.

As I have tried to show, this was by no means a singularly performed, top-down enterprise. The spectators and producers of these cultural forms were engaged in an ongoing dialogue as they produced visual symbols recreating a myth through what Partha Chatterjee (1993, 127) terms the "classicization of tradition." Traditional images symbolizing the essence of ethnic cultures, like Karagöz's Arab characters, were redefined to invoke public opinion, making them timeless and indispensable to the new nation's cultural formulations, however in the sense of fortifying the Arab image with charges of barbarism and irrationality. The same dialogue dissociated the nation's nonmodern past from its undesirable values in terms of form and content through the codification of that past, or what Chatterjee (1993, 111) calls the "appropriation of the popular." What the intelligentsia did was to manipulate the popularly recognized traditional Arab stereotype as a comparative element of subordination in the nationalist project. The Ottoman and, later, Turkish public's familiarity with the predefined, ridiculed image of the white Arab worked perfectly for the press as the construction of a nationalist project progressed.

When early republican Turkey's political cartoon sphere transcended the bounds of literacy, it made room for popular culture in the new republic to develop a common, increasingly national forum for comprehensible, universally accessible, and socially relevant public discussions about the political community and the state and the threats to both. As a medium, cartoons have a capacity for iconic forms of abstractions. Working in collaboration with the publisher, the editor, and the artist, Turkish political cartoons of the period entertained, informed, and, in the process, provided new and shared discussions about concepts such as nationhood and identity. The cartoon press was especially beneficial at mediating between the written discourses of the nationalists and the colloquial expressions of the Turkish urban masses; it created a virtual Turkish community that interpreted cultural conventions through a form of literacy that included the ability to understand, at a visual level, the language used by the Turkish intelligentsia.

This book opened with the unveiling of Cemal Nadir's monumental cartoon *What about the Buffalo?* and asked how the Turkish national self-imagined its Arab others. In Nadir's cartoon, Arab stereotypes of the Levant and North Africa demonstrate a perceptual generalization of Arabs that stood in for all ethnic and religious populations of the region, portraying them in a timeless loop constituted within a triangle of myth, land, and people. In *Culture and Imperialism*, Said (1994, 6) addresses this tension when he argues that "just as none of us is outside or beyond geography, none of us is completely free from the struggle over geography." The struggle over geography is not merely about the exertion of the physical power of one over the other, but, in Said's words, is more of "a struggle about ideas, about forms, about images and imaginings."

By shifting the focus of inquiry from the abstract discourses of elite intellectuals to the visual rhetoric of popular culture, this book brings the everyday production of nationalist discourse into the mainstream historical narrative of modern Turkey. It shows how the cartoon press became one of the most important influences in the construction, maintenance, and even mobilization of Turkish identity, reinforcing a perceived image of the Arab forever haunted by its ethnic and religious origins.

Obviously, political cartoons functioned best in their contribution to producing these ethnosymbolic images and stereotypes. In a unique form of conquest and domination of the other, these recycled stereotypes serve as a foundation that connects past and present, ethnic myths and their modern translation, into viable, coherent identities and political programs. Within this relational construction, ethnic stereotyping served as a structuring principle for national process, both in terms of physically and imaginatively defining the boundaries of the nation and the constituents of national identity.

These boundaries are still relevant today, standing as solid barriers within the pluralistic and complex social structures of Turkish society. The influx of Syrian refugees to Turkey following the events of 2011, for example, revived these deeply embedded perceptual boundaries in the mind of the Turkish public and created a negative public reflex against the displaced immigrants. A survey conducted in 2020 by a prominent Turkish university showed that Turks do not welcome the presence of Syrian

refugees and demonize them as scapegoats for Turkey's economic and social problems.[1] Similarly, a critical discourse analysis of the mainstream newspapers for a period of two years disclosed that Syrian refugees are almost always represented with negative connotations on their Arabness regardless of the underlying sources or causes of events (Sert and Danış 2021, 204).

To be sure, these modern manifestations of ethnically and culturally racist prejudices toward Arabs tend to be partially understood as an exclusivist expression of Turkish nationhood within the nationalistic project of the post–World War II Turkish Republic. However, the persistence of long historical antipathies and forms of oppression in Turkey in imagining the Arab other is grounded somewhere deeper than in either a colonial or postcolonial political framework. Therefore, there is no one simple conclusion to the story of Arabs as non-national other. From a mixture of convenience, and perhaps familiarity, the same visual and narrative elements concerning the Arab continues to circulate today, if not in political cartoons, then definitely in other forms of popular media. In a sense, this justifies Franz Fanon's (1970, 93) sad but realistic assessment that a Black is a Black wherever he goes—that, in the twenty-first-century Turkish imagination, an Arab is an Arab wherever he goes. This book, then, is an effort to clarify the meaning and means of reproducing the ethnic other and its closely related discourses of race, racism, and nationalism in the realm of postcolonial studies.

1. A survey titled "Dimensions of Polarization in Turkey 2020" was conducted through face-to-face interviews across twenty-nine cities with a representative sample of four thousand people from Turkey's adult population (Ünlühisarcikli 2021).

References ◆ *Index*

References

Archives

National Library, Turkey
Istanbul Metropolitan Municipality Taksim Atatürk Library
Biblioteque National France

Periodicals

Europe and the Orient in Cartoons:

JOURNAL NAME	YEARS SCANNED/PUBLISHED
Le Charivari	1832–1908/1937
Le Charivari	1832–1908/1937
Le Petit Journal	1886–1908/1944
Le Rire	1894–1908/1971
L'assiette du Beurre	1901–8/1912
Punch	1841–1908/2002

Ottomans and Their Orient in Early Ottoman Cartoons

JOURNAL NAME	YEARS SCANNED/PUBLISHED
Ayin-I Vatan	1867/1867
Istanbul	1867–69/1869
Diyojen	1870–72/1872
Terakki	1870–71/1871
Terakki Eğlencesi	1871–71/1871
Şarivari	1871–71/1871
Çıngıraklı Tatar	1873–73/1873

Hayal	1873–77/1877
Şarivari Medeniyet	1874–74/1874
Kahkaha	1875–75/1875
Çaylak	1876–78/1878
Beberuhi	1898–1908/1898

Young Turks and Arabs in Ottoman Cartoons

JOURNAL NAME	YEARS SCANNED/PUBLISHED
Boşboğaz ile Güllabi	1908/1908
Kalem	1908–11/1911
El-Üfürük	1908/1908
Dalkavuk	1908–9/1909
Musavver Papağan	1908–9/1909
Davul	1908–9/1909
Geveze	1908–9/1909
Alem	1909/1909
Hayal-i Cedid	1910/1910
Djem	1910–12/1912
Şaka	1910–11/1911
Cadaloz	1911/1911
Yeni Geveze	1910–12/1912
Baba Himmet	1911/1911
Karikatür	1914/1914
Diken	1918–20/1920
Güleryüz	1921–23/1923
Ayine	1921–23/1923
Kahkaha	1922–24/1924
Aydede	1922/1922

Early Republican Cartoons and Their Arab Neighbors

JOURNAL NAME	YEARS SCANNED/PUBLISHED
Karagöz	1908–35/1935
Zümrüdü Anka	1923–25/1925
Kelebek	1923–24/1924
Akbaba	1922–39/1977

Papağan	1924/1924
Guguk	1924/1924
Karikatür	1936–39/1948

Newspapers

NEWSPAPER NAME	YEARS SCANNED/PUBLISHED
Resimli Gazete	1881–89/1889
Cumhuriyet	1924–48/Present
Resimli Ay	1924–31/1931
Tan Gazetesi	1926–35/1935
Son Posta	1930–39/1960

Legal Documents

Treaty of Ankara. Dispatch from His Majesty's Ambassador at Paris, enclosing the Franco-Turkish Agreement signed at Angora on 20 October 1921. London: His Majesty's Stationary Office.

League of Nations. C. 400 M. 147 1925 VII. Errata. Geneva, 20 August 1925. "Question of the Frontier between Turkey and Iraq." Report submitted to the Council by the Commission instituted by the Council, Resolution 30 September 1924.

Treaty of Lausanne. "Frontier between Turkey and Iraq." Article 3, paragraph 2. Collection of Advisory Opinions. Publications of the Permanent Court of International Justice Series B-No 12. 21 November 1925.

Dictionaries

Türkiye Halk Ağzından Derleme Sözlüğü. 1975. Ankara: Türk Dil Kurumu.
Türkçe Sözlük. 2011. 11th ed. Ankara: Türk Dil Kurumu.
Turkish and English Lexicon. 2006. 3rd ed. By Sir James W. Redhouse. Istanbul: Çağrı Yayınları.

Books and Articles

Ahmad, Feroz. 1993. *The Making of Modern Turkey*. London: Routledge.
———. 2008. *From Empire to Republic: Essays on the Late Ottoman Empire and Modern Turkey, Vol. 1*. Istanbul: Bilgi Univ.

————. 2014. *The Young Turks and the Ottoman Nationalities: Armenians, Greeks, Albanians, Jews, and Arabs, 1908–1918*. Salt Lake City: Univ. of Utah Press.

Ahmed, Hassan A. 1986. "Recent Contributions to the Geography of Saudi Arabia." *GeoJournal* 13 (2): 188–90.

Akçura, Gökhan. 2012. *Cumhuriyet Döneminde Türkiye Matbacılık Tarihi*. Istanbul: Yapı Kredi Yayınları.

Akçura, Yusuf. 1976. *Üç Tarz-ı Siyaset*. Vol. 7. Ankara: Türk Tarih Kurumu.

Alba, Victor. 1967. "The Mexican Revolution and the Cartoon." *Comparative Studies in Society and History* 9 (2): 121–36.

Altınay, Ahmet Refik. 1931. *Eski Istanbul*. Istanbul: Kanaat Kütüphanesi.

And, Metin. 1963. *A History of Theatre and Popular Entertainment in Turkey*. Ankara: Forum Yayınları.

————. 1975. *Karagöz: Turkish Shadow Theatre*. Ankara: Dost Yayınları.

————. 2004. *Karagöz, Helmut Ritter, and Andreas Tietze: Torn Is the Curtain, Shattered Is the Screen, the Stage Is All in Ruins*. Istanbul: Yapı Kredi Karagöz Collection.

Anderson, Benedict. 2006. *Imagined Communities: Reflections on the Origin and Spread of Nationalism*. New York: Verso.

Anderson, Lisa. 1991. "The Development of Nationalist Sentiment in Libya, 1908–1922." In *The Origins of Arab Nationalism*, edited by Rashid Khalidi, Lisa Anderson, Muhammed Muslih, Reeva S. Simon, 226–40. New York: Columbia Univ. Press.

Anderson, Scott. 2013. *Lawrence in Arabia: War, Deceit, Imperial Folly, and the Making of the Modern Middle East*. London: Atlantic.

André Lagarde Laurent Michard. 1985. *XIXe Siècle*. Paris: Bordas.

Apaydın, Mustafa. 2007. *Türk Mizah Tarihinde Bir Dönüm Noktası: Aydede*. Adana: Karahan Yayınevi.

Armaoğlu, Fahir. 1998. *Lozan Konferansı ve Musul Sorunu: Misak-ı Milli ve Türk Dış Politikasında Musul Sorunu*. Ankara: Atatürk Araştırmaları Merkezi.

Atatürk, Gazi Mustafa Kemal. 1981. *Nutuk (3 Cilt)*. Ankara: Türk Tarih Kurumu.

Atay, Falih Rıfkı. 1933. "İştah." In *Eski Saat*, 50–53. Istanbul: Akşam Matbaası.

————. 1938. *Zeytindağı*. Istanbul: Remzi Kitapevi.

Auchterlonie, Paul. 2001. "From the Eastern Question to the Death of General Gordon: Representations of the Middle East in the Victorian Periodical Press, 1876–1885." *British Journal of the Middle Eastern Studies* 28 (2): 5–24.

Backhaus, Gary. 2009. "The Problematic of Grounding the Significance of Symbolic Landscapes." In *Symbolic Landscapes*, edited by Gary Backhaus and John Murungi, 3–31. New York: Springer.

Barker, Francis, and Homi K. Bhabha. 2003. "The Other Question: Difference, Discrimination, and the Discourse of Colonialism." In *Literature, Politics, and Theory: Papers from the Essex Conference, 1976–1984*, 148–73. London: Routledge.

Baron, Beth. 2005. *Egypt as a Woman: Nationalism, Gender, and Politics*. Berkeley: Univ. of California Press.

Barron, Roderick M. 2008. "Bringing the Map to Life: European Satirical Maps, 1845–1945." *Belgeo* 3–4: 445–64.

Bauman, Zygmunt, and Tim May. 2014. *Thinking Sociologically*. 2nd ed. Oxford: Blackwell.

Beller, Manferd. 2007. "Perception, Image, Imagology." In *Imagology: The Cultural Construction and Literary Representation of National Characters*, edited by Manferd Beller and Leerssen Joep, 1–17. New York: Rodopi.

Berkes, Niyazi. 1999. *The Development of Secularism in Turkey*. London: Routledge.

Bhabha, Homi K. 1994. *The Location of Culture*. New York: Routledge.

———. 2003. "The Other Question: Difference, Discrimination, and the Discourse of Colonialism." In *Literature, Politics and Theory: Papers from the Essex Conference, 1976–1984*, edited by Homi K. Bhabha and Francis Barker, 148–73. London: Routledge.

Boer, Inge E. 2004. *Disorienting Vision: Rereading Stereotypes in French Orientalist Texts and Images*. Vol. 5. New York: Rodopi.

———. 2006. *Uncertain Territories: Boundaries in Cultural Analysis*. 7th ed. Amsterdam, New York: Rodopi.

Braxton, Phyllis Natalie. 1990. "Othello: The Moor and the Metaphor." *South Atlantic Review* 55 (4): 1–17.

Brummett, Palmira. 1995. "Dogs, Women, Cholera, and Other Menaces in the Streets: Cartoon Satire in the Ottoman Revolutionary Press, 1908–1911." *International Journal of Middle East Studies* 27 (4): 433–60.

———. 2000. *Image and Imperialism in the Ottoman Revolutionary Press, 1908–1911*. Albany: State Univ. of New York Press.

Burke, Edmund. 1972. "Pan-Islam and Moroccan Resistance to French Colonial Penetration, 1900–1912." *Journal of African History* 13 (1): 97–118.

Brynth, Ruth M. J. 2007. *The Rational Imagination: How People Create Alternatives to Reality*. Cambridge, MA: MIT Press.

Çeviker, Turgut. 1991a. *Gelişim Sürecinde Türk Karikatürü III: Kurtuluş Savaşı Dönemi, 1918–1923*. Istanbul: Adam Yayınları.

————. 1991b. *Gelişim Sürecinde Türk Karikatürü II: Tanzimat ve İstibdad Dönemi*. Istanbul: Adam Yayınları.

————. 1991c. *İbret Albümü,1908*. Istanbul: Istanbul Büyükşehir Belediyesi Kültür İşleri Daire Başkanlığı Yayınları.

Chatterjee, Partha. 1986. *Nationalist Thought and the Colonial World: A Derivative Discourse*. London: Zed.

————. 1989. "Colonialism, Nationalism, and Colonialized Women: The Contest in India." *American Ethnologist* 16 (4): 622–33.

————. 1993. *The Nation and Its Fragments: Colonial and Postcolonial Histories*. Princeton, NJ: Princeton Univ. Press.

Childs, Elizabeth C. 2004. *Daumier and Exoticism: Satirizing the French and the Foreign*. New York: Peter Lang.

Cemiyeti, T. T. T. 1933. *Tarih III Yeni ve Yakın Zamanlar*. Istanbul: Devlet Matbaası.

Colby, Elbridge. 1927. "How to Fight Savage Tribes." *American Journal of International Law* 21 (2): 279–88.

Conversi, Daniele. 1995. "Reassessing Current Theories of Nationalism: Nationalism as Boundary Maintenance and Creation." *Nationalism and Ethnic Politics* 1 (1): 73–85.

Coşar, Nevin, and Sevtap Demirci. 2006. "'The Mosul Question and the Turkish Republic: Before and After the Frontier Treaty, 1926." *Middle Eastern Studies* 42 (1): 123–32.

Coupe, William A. "Observations on a Theory of Political Caricature." *Comparative Studies in Society and History* 11, no. 1 (1969): 83–84.

Dankoff, Robert, and Kim Sooyong. 2010. *An Ottoman Traveller: Selections from Travels of Evliya Çelebi*. London: Eland.

Daudet, Alphonse. 1872. *Aventures Prodigieuses Du Tartarin de Tarascon*. Paris: Simone Baçon et Comp.

Dawn, C. Ernest. 1991. "The Origins of Arab Nationalism." In *The Origins of Arab Nationalism*, edited by Rashid Khalidi, Lisa Anderson, Muhammad Muslih, and Reeva S. Simon, 3–30. New York: Colombia Univ. Press.

Deringil, Selim. 1999. *The Well-Protected Domains: Ideology and the Legitimation of Power in the Ottoman Empire, 1876–1909*. London: I. B. Tauris.

Deutsch, Karl. 1953. *Nationalism and Social Communication: An Inquiry into the Foundations of Nationality.* Cambridge, MA: MIT Press.

Douglas, Mary. 1999. *Implicit Meanings: Selected Essays in Anthropology.* 2nd ed. New York: Routledge.

Duben, Alan, and Behar Cem. 2002. *Istanbul Households: Marriage, Family and Fertility, 1880–1940.* New York: Cambridge Univ. Press.

Edwards, Mark U., Jr. 1994. *Printing, Propaganda, and Martin Luther.* Berkeley: Univ. of California Press.

Ertop, Konur. 1974. *Cumhuriyet 1923–1974.* Istanbul: Cumhuriyet Matbaacılık ve Gazetecilik A.Ş.

Eskander, Saad. 2001. "Southern Kurdistan under Britain's Mesopotamian Mandate: From Separation to Incorporation, 1920–23." *Middle Eastern Studies* 37 (2): 153–80.

Fanon, Frantz. 1970. *Black Skin, White Masks.* London: Paladin.

Faroqhi, Suraiya, Bruce McGowan, and Sevket Pamuk. 1997. *An Economic and Social History of the Ottoman Empire.* Cambridge: Cambridge Univ. Press.

Feyzi, Muharrem. 1930. "Says İcmal: Arap Çöllerinde Bir Mülakat." *Cumhuriyet,* January 24.

Fitzgerald, Edward Peter. 1994. "France's Middle Eastern Ambitions: The Sykes-Picot Negotiations, and the Oil Fields of Mosul, 1915–1918." *Journal of Modern History* 66 (4): 697–725.

Fortna, Benjamin C. 2002. *Imperial Classroom: Islam, the State, and Education in the Late Ottoman Empire.* Oxford: Oxford Univ. Press.

———. 2011. *Learning to Read in the Late Ottoman Empire and the Early Turkish Republic.* London: Palgrave Macmillan.

Fromkin, David. 2009. *A Peace to End All Peace.* New York: Henry Holt.

Fuccaro, Nelida. 1997. "Ethnicity, State Formation, and Conscription in Postcolonial Iraq: The Case of the Yazidi Kurds of Jabal Sinjar." *International Journal of Middle East Studies* 29 (4): 559–80.

Gautier, Théophile. 1872. *Emaux et Camées.* Paris: Charpentier et Editeurs.

Gellner, Ernest. 2006. *Nations and Nationalism.* Oxford: Wiley Blackwell.

Gelvin, James L. 2011. *The Modern Middle East: A History.* 3rd ed. Oxford: Oxford Univ. Press.

Giddens, Anthony. 1984. *The Constitution of Society Outline of the Theory of Structuration.* Berkeley: Univ. of California Press.

Gilroy, Paul. 2000. *Between Camps: Nations, Culture, and the Allure of Race.* London: Penguin.

Göçek, F. Muge. 1987. *East Encounters West: France and the Ottoman Empire in the Eighteenth Century*. Oxford: Oxford Univ. Press.

Gökalp, Ziya. 1959. *Turkish Nationalism and Western Civilization: Selected Essays*. Edited by Niyazi Berkes. New York: Colombia Univ. Press.

Goldstein, Robert Justin. 2012. "Censorship of Caricature and the Theater in Nineteenth-Century France: An Overview." *Yale French Studies* 122: 14–36.

Gorgas, Jordi Tejel. 2008. "Urban Mobilization in Iraqi Kurdistan during the British Mandate: Sulaimaniya 1918-30." *Middle Eastern Studies* 44 (4): 537–52.

Grove, Laurence. 2012. *Comics in French: The Bande Dessinée in Context*. New York: Berghahn.

Güçlü, Yücel. 2006. "The Controversy over the Delimitation of the Turco-Syrian Frontier in the Period between the Two World Wars." *Middle Eastern Studies* 42 (4): 641–57.

Güleryüz, Naim. 2006. "Osmanlıda Ilk Basımevi: Yahudi Matbacılığı." *Toplumsal Tarih*, no. 156: 46–54.

Güntekin, Reşar Nuri. 1963. *Çalıkuşu*. Istanbul: Inkılap Yayınevi.

Haarmann, Ulrich W. 1988. "Ideology and History, Identity and Alterity: The Arab Image of the Turk from the Abbasids to Modern Egypt." *International Journal of Middle East Studies* 20 (2): 175–96.

Hallam, Elizabeth, and Brian Street. 2000. *Cultural Encounters: Representing Otherness*. New York: Routledge.

Halman, Talat S. 2006. *The Turkish Muse: Views and Reviews, 1960s–1990s*. Syracuse, NY: Syracuse Univ. Press.

Hancock, Ian. 2008. "The 'Gypsy' Stereotype and the Sexualization of Romani Women." In *Gypsies in European Literature and Culture*, edited by Valentina Glajar and Domnica Radulescu, 181–91. New York: Palgrave Macmillan.

Hanioğlu, Şükrü M. 1991. "The Young Turks and the Arabs before the Revolution of 1908." In *The Origins of Arab Nationalism*, edited by and Reeva S. Simon Rashid Khalidi, Lisa Anderson, Muhammad Muslih, 31–49. New York: Columbia Univ. Press.

Haşim, Ahmet. 1921. "Cem'in Gözü." *Dergah Mecmuası* 1 (11): 161.

Hathaway, Both Jane. 2018. *The Arab Lands under Ottoman Rule: 1516-1800*. New York: Routledge.

Haydaroğlu, Ilknur. 1997. "II. Abdülhamid Hafiye Teşkilatı Hakkında Bir Risale." *Ankara Ünv. Dil ve Tarih Coğrafya Fakültesi, Tarih Araştırmaları Dergisi*, no. 28: 109–33.

Herrmann, David. 1989. "The Paralysis of Italian Strategy in the Italian-Turkish War, 1911–1912." *English Historical Review* 104 (411): 345.

Herzog, Christoph, and Raoul Motika. 2000. "Orientalism Alla Turca: Late Nineteenth-/Early Twentieth-Century Ottoman Voyages into the Muslim 'Outback.'" *Die Welt Islams* 40 (2): 139–95.

Aristotle. 1936. *Minor Works.* Translated by Walter S. Hett. Cambridge, MA: Harvard Univ. Press.

Hirszowicz, L. 1972. "The Sultan and the Khedive, 1892–1908." *Middle Eastern Studies* 8 (3): 287–311.

Hobsbawm, Eric J. 1992. *Nations and nationalism since 1780: Programme, Myth, Reality.* Cambridge: Cambridge Univ. Press.

Hourani, Albert. 1981. *The Emergence of the Modern Middle East.* Berkeley: Univ. of California Press.

———. 2005. *A History of the Arab Peoples.* London: Faber & Faber.

Ichikawa, Jonathan, and Benjamin Jarvis. 2012. "Rational Imagination and Modal Knowledge." *Nous* 46 (1): 127–58.

Jacobs, Georg. 1938. *Türklerde Karagöz.* Translated by Orhan Şahin Gökyay. Istanbul: Eminönü Halkevi Neşriyatı.

Jankowski, James. 1991. "Egypt and Early Arab Nationalism, 1908–1922." In *The Origins of Arab Nationalism*, edited by Rashid Khalidi, Lisa Anderson, Muhammad Muslih, and Reeva S. Simon, 243–70. New York: Columbia Univ. Press.

Janowski, Monica, and Tim Ingold. 2012. *Imagining Landscapes: Past, Present, and Future.* Farnham: Ashgate.

Janowski, Monica, and Ingold Tim, eds. 2016. *Imagining Landscapes: Past, Present and Future.* London: Routledge.

Karaosmanoğlu, Yakup Kadri. 1940. *Gurbet Hikayeleri.* Istanbul: Semih Lütfü Kitapevi.

———. 1945. *Bir Sürgün.* Istanbul: Remzi Kitapevi,

Karay, Refik Halit. 1940. *"Teşebbüsü Şahsi Mi? Heyhat!" Kirpinin Dedikleri.* Istanbul: Semih Lütfü Kitapevi.

Karpat, Kemal H. 2001. *The Politization of Islam: Reconstructing Identity, State, Faith, and Community in the Late Ottoman State.* Oxford: Oxford Univ. Press.

———. 2004. *Studies on Turkish Politics and Society: Selected Articles and Essays.* Boston: Brill.

Kaya, Ayşe Elif Emre. 2010. "Cumhuriyet Gazetesi'nin Kuruluşundan Günümüze Kısa Tarihi." *İletişim Fakültesi Dergisi*: 75–91.

Kayalı, Hasan. 1997. *Arabs and Young Turks: Ottomanism, Arabism, and Islamism in the Ottoman Empire, 1908–1918*. Berkeley: Univ. of California Press.

Khadduri, Majid. 1945. "The Alexandretta Dispute." *American Journal of International Law* 39 (3): 406–25.

Khoury, Philip S. 1985. "Divided Loyalties? Syria and the Question of Palestine, 1919–1939." *Middle Eastern Studies* 21 (3): 324–48.

———. 1989. *Syria and French Mandate: The Politics of Arab Nationalism, 1920–1945*. Princeton, NJ: Princeton Univ. Press.

Kipling, Rudyard. 2007. "White Man's Burden." In *Kipling Poems*, 96. New York: Knopf.

Kral Abdullah. 2006. *Biz Osmanlıya Neden İhanet Ettik?* Istanbul: Klasik Yayınları.

Kubicek, Paul. 2011. "Turkey's Engagement with Modernity: Conflict and Change in the Twentieth Century." *Turkish Studies* 12 (1): 165–67.

Kudret, Cevdet. 2005. *Karagöz 3 Cilt*. Istanbul: Yapı Kredi Yayınları.

Kühn, Thomas. 2007. "Shaping and Re-Shaping Colonial Ottomanism: Contesting Boundaries of Difference and Integration in Ottoman Yemen, 1872–1919." *Comparative Studies in South Asia, Africa and the Middle East* 27: 315–31.

Lagarde, André, and Michard Laurent. 1985. *XIXe Siècle*. Paris: Bordas.

Lamont, Michèle, and Molnár Virág. 2002. "The Study of Boundaries in the Social Sciences." *Annual Review of Sociology* 28 (1): 167–95.

Lane, Anthony. 1999. "Waugh in Pieces: Cruelty and Compassion Mingle in the Short Stories of a Master." *New Yorker*, 4 October 1999. http://www.new yorker.com/%0Amagazine/1999/10/04/waugh-in-pieces.

Langer, Susanne K. 1953. *Feeling and Form*. 3rd ed. London: Routledge & Kegan Paul.

Leach, Edmund. 1964. "Anthropological Aspects of Language: Animal Categories and Verbal Abuse." In *New Directions in the Study of Language*, ed. Erik H. Lenneberg, 23–63. Cambridge, MA: MIT Press.

Leerssen, Joep. 2007. "Imagology: History and Method." In *Imagology: The Cultural Construction and Literary Representation of National Characters, a Critical Survey*, edited by Manfred Beller and Joep Leerssen, 17–32. New York: Rodopi.

Lévi-Strauss, Claude. 1966. *The Savage Mind*. London: Weidenfeld & Nicolson.

Lewis, Bernard. 1991. "Watan." *Journal of Contemporary History* 26 (3): 523–33.

———. 2002. *The Emergence of Modern Turkey*. 3rd ed. New York: Oxford Univ. Press.

Lewis, Reina. 2004. *Women, Travel, and Ottoman Harem: Rethinking Orientalism*. New York: I. B. Tauris.

Lippman, Walter. 1998. *Public Opinion*. New Brunswick, NJ: Transaction.

Llyod, H. I. 1926. "The Geography of the Mosul Boundary." *Geographical Journal* 68 (2): 104–13.

Lorimer, J. 1883. *The Institutes of the Law of Nations: A Tretise of the Jural Relations of Separate Political Communities*. Vol. 1. London: William Blackwood & Sons.

Mahmud Nedim Bey. 2001. *Arabistan'da Bir Ömür: Son Yemen Valisinin Anıları Veya Osmanlı İmparatorluğu Arabistanda Nasıl Yıkıldı?* Edited by Ali Birinci. Istanbul: İSİS.

Mainardi, Patricia. 2017. *Another World: Nineteenth-Century Illustrated Print Culture*. New Haven, CT: Yale Univ. Press.

Makdisi, Ussama. 2002. "Ottoman Orientalism." *American Historical Review* 107 (3): 768–96.

Maksudyan, Nazan. 2005. "The Turkish Review of Anthropology and the Racist Face of Turkish Nationalism." *Cultural Dynamics* 17 (3): 291–322.

Mango, Andrew. 2002. *Atatürk*. London: John Murray.

Masters, Bruce. 2013. *The Arabs of the Ottoman Empire, 1516–1918: A Social and Cultural History*. Cambridge: Cambridge Univ. Press.

McKale, Donald M. 1992. "Influence without Power: The Last Khedive of Egypt and the Great Powers, 1914–18." *Middle Eastern Studies* 33 (1): 20–39.

Medhurst, Martin J., and Michael A. DeSousa. 1981. "Political Cartoons as Rhetorical Form: A Taxonomy of Graphic Discourse." *Communications Monographs* 48 (3): 197–236.

Micheletta, Luca, and Andrea Ungari. 2013. *The Libyan War, 1911–1912*. Newcastle: Cambridge Scholars.

Mondal, Anshuman A. 2004. *Nationalism and Post-Colonial Identity: Culture and Ideology in India and Egypt*. London: Routledge.

Moran, Vahid A. 1985. *Büyük İngilizce-Türkçe Sözlük: A Turkish-English Dictionary*. Istanbul: Adam Yayınlar.

Muhtar, Sermet. 1932. "Masal Olanlar: Eski Haremağaları." *Akşam Gazetesi*, June 11, 1932, 8.

Najmabadi, Afsaneh. 2005. *Women with Mustaches and Men without Beards: Gender and Sexual Anxieties of Iranian Modernity.* Berkeley: Univ. of California Press.

Navasky, Victor S. 2013. *The Art of Controversy: Political Cartoons and Their Enduring Power.* New York: Knopf.

Ochsenwald, William. 1991. "Ironic Origins: Arab Nationalism in the Hijaz, 1882–1914." In *The Origins of Arab Nationalism,* edited by Rashid Khalidi, Lisa Anderson, Mahmoud Haddad, and Reeva Simon, 189–203. New York: Colombia Univ. Press.

Okyar, Ilkim Büke. 2020. "Ethnic Stereotyping and the Significant Other: Re-Imagining the Kurd in Early Turkish Political Cartoons." *Middle Eastern Studies* 56, no. 4 (2020): 607–25.

Özdalga, Elisabeth. 2013. *Late Ottoman Society: The Intellectual Legacy.* London: Routledge.

Özdiş, Hamdi. 2012. *Osmanlı Basınında Batılaşma ve Siyaset (1870–1877).* Istanbul: Libra Yayınları.

Özkan, Behlül. 2012. *From the Abode of Islam to the Turkish Vatan: The Making of a National Homeland in Turkey.* New Haven, CT: Yale Univ. Press.

Öztuncay, Bahattin, Sinan Kuneralp, Guillome Doizy, and Mehmet K. Kentel. 2016. *Youssouf Bey, The Charged Portraits of Fin-de-Siècle Pera.* Istanbul: Vehbi Koç Foundation.

Pakalın, Mehmet Zeki. 1993. *Osmanlı Tarih Deyimleri ve Terimleri Sözlüğü I.* Istanbul: Milli Eğitim Bakanlığı.

Pakis, Valentine A. 2010. "Contextual Duplicity and Textual Variation: The Siren and Onocentaur in the Physiologus Tradition." *Mediaevistik* 23: 115–85.

Palmira J. Brummett. 2000. *Image and Imperialism in the Ottoman Revolutionary Press, 1908–1911.* Albany: State Univ. of New York Press.

Pennel, Joseph. 1915. *Lithography and Lithographers.* London: T. Fisher Unwin.

Pennell, C. R. 2017. "How and Why to Remember the Rif War (1921–2021)." *Journal of North African Studies* 22 (5): 798–820.

Pfaff, William. 1994. "Nationalism and Identity." *Way* 34 (1): 6–16.

Provence, Michael. 2005. *The Great Syrian Revolt and the Rise of Arab Nationalism.* Austin: Univ. of Texas Press.

Rajchman, John. 1988. "Foucault's Art of Seeing." *October* 44 (2): 88–117.

Refaie, Elisabeth el. 2009. "Multiliteracies: How Readers Interpret Political Cartoons." *Visual Communication* 8 (2): 181–205.

Refik, Ahmet. 1931. *Eski Istanbul.* Istanbul: Kanaat Kütüphanesi.

Reichling, Mary J. 1993. "Susanne Langer's Theory of Symbolism: An Analysis and Extension." *Philosophy of Music Education Review* 1 (1): 3–17.

Riza, Reşid. 2007. *Ittihad-i Osmani'den Arap İsyanına*. Istanbul: Klasik Yayınları.

Rogan, Eugene. 2009. *The Arabs: A History*. New York: Basic Books.

Ross, Holland J. 1922. "Great Britain and the Eastern Question." *Journal of International Relations* 12 (3): 307–19.

Said, Edward W. 1979. *Orientalism*. New York: Vintage.

———. 1994. *Culture and Imperialism*. New York: Vintage.

Sanjian, Avedis. 1956. "The Sanjak of Alexandretta (Hatay): Its Impact on Turkish-Syrian Relations (1939–1956)." *Middle East Journal* 10 (4): 379–94.

Seale, Patrick. 2010. *The Struggle for Arab Independence: Riad al-Solh and the Makers of the Modern Middle East*. Cambridge: Cambridge Univ. Press.

Selçuk, Hamdi. 1972. *Bütün Yönleri Ile Hatay'ın O Günleri*. Istanbul: Sucuoğlu Matbaası.

Sert, Deniz Ş., and Didem Daniş. 2021. "Framing Syrians in Turkey: State Control and No Crisis Discourse." *International Migration* 59 (1): 197–214.

Seyfeddin, Ömer. 1938. "Piç." In *Tarih Ezeli Bir Tekerrürdür*. Istanbul: n.p.

Shaw, Stanford J., and Ezel Kural Shaw. 1977. *History of the Ottoman Empire and Modern Turkey: Vol. 2, Reform, Revolution, and Republic: The Rise of Modern Turkey, 1808–1975*. Cambridge: Cambridge Univ. Press.

Shaw, Stanford J. Shaw, and Ezel Kural. 2002. *Reform, Revolution, and Republic: The Rise of Modern Turkey, 1808–1975, Vol. 2*. New York: Cambridge Univ. Press.

Shaw, Wendy. 2007. "Museums and Narratives on Display From the Late Ottoman Empire to Turkish Republic." In *Muqarnas*, vol. 24, 253–80. Leiden: Brill.

Shields, Sarah. 2009. "Mosul, the Ottoman Legacy, and the League of Nations." *International Journal of Contemporary Iraqi Studies* 3 (2): 217–30.

Shields, Sarah D. 2011. *Fezzes in the River: Identity Politics and European Diplomacy in the Middle East on the Eve of World War II*. Oxford: Oxford Univ. Press.

Silvera, Alain. 2000. "The Classical Eastern Question." *Middle Eastern Studies* 36 (4): 179–88.

Siyavuşgil, Sabri Esat. 1941. *Karagöz: Psiko-Sosyolojik Bir Deneme*. Istanbul: Maarif Matbaası.

Smith, Anthony D. 1991. *National Identity*. Vol. 11. Reno: Univ. of Nevada Press.

———. 2002. "When Is a Nation?" *Geopolitics* 7 (2): 5–32.

————. 2009. *Ethno-Symbolism and Nationalism: A Cultural Approach.* New York: Routledge.

Somel, Selcuk Akşin. 2001. *The Modernization of Public Education in the Ottoman Empire, 1839–1908: Islamization, Autocracy, and Discipline.* Boston: Brill.

Stenberg, Leif, and Birgit Schaebler. 2004. "Civilizing Others: Global Modernity and the Local Boundaries (French/German, Ottoman, and Arab) of Savagery." In *Globalization and the Muslim World: Culture, Religion, and Modernity,* 3–29. Syracuse, NY: Syracuse Univ. Press.

Storey, William K. 1991. "Big Cats and Imperialism: Lion and Tiger Hunting in Kenya and Northern India, 1898–1930." *Journal of World History* 2 (2): 135–73.

Strauss, Johann. 2003. "Who Read What in the Ottoman Empire (Nineteenth–Twentieth Centuries)?" *Arabic Middle Eastern Literatures* 6 (1): 209–33.

Satloff, Robert B. 1986. "Prelude to Conflict: Communal Interdependence in the Sanjak of Alexandretta 1920–1936." *Middle Eastern Studies* 22 (2): 147–80.

Sufian, Sandy. 2008. "Anatomy of the 1936–1939 Revolt: Images of the Body in Political Cartoons of Mandatory Palestine." *Journal of Palestine Studies* 37 (2): 23–42.

Tahir, Kemal. 1968. *Yorgun Savaşçı.* Ankara: Bilgi yayınevi.

Tauber, Eliezer. 1993a. *The Arab Movements in World War I.* London: Frank Cass.

————. 1993b. *The Emergence of Arab Movements.* London: Frank Cass.

————. 1995. *The Formation of Modern Syria and Iraq.* London: Frank Cass.

Tibebu, Teshale. 1996. "Ethiopia: The 'Anomaly' and 'Paradox' of Africa." *Journal of Black Studies* 26 (4): 414–30.

Toledano, Ehud R. 1981. "Slave Dealers, Women, Pregnancy, and Abortion: The Story of a Circassian Slave Girl in Mid-Nineteenth-Century Cairo." *Slavery & Abolition* 2 (1): 53–68.

————. 1984. "The Imperial Eunuchs of Istanbul: From Africa to the Heart of Islam." *Middle Eastern Studies* 20 (3): 379–90.

————. 1998. *Slavery and Abolition in the Ottoman Middle East.* Seattle: Univ. of Washington Press.

————. 1993. "Late Ottoman Concepts of Slavery." *Poetics Today* 14 (3): 477–506.

Topuz, Hıfzı. 2003. *Mahmut'tan Holdinglere Türk Basın Tarihi.* Istanbul: Remzi Kitapevi.

Uzer, Umut. 2016. *An Intellectual History of Turkish Nationalism: Between Turkish Ethnicity and Islamic Identity.* Salt Lake City: Univ. of Utah Press.

Ünlühisarcıklı, Özgür. 2021. "The Importance of Mitigating Polarization in Turkey." Paper published as part of the project Dimensions of Polarization, German Marshall Fund of the United States, 2020. Accessed October 20, 2022. https://www.turkuazlab.org/en/dimensions-of-polarization-in-turkey-2020/.

Vinogradov, Amal. 1972. "The 1920 Revolt in Iraq Reconsidered: The Role of Tribes in National Politics." *International Journal of Middle East Studies* 3 (2): 123–39.

Wilson, Mary C. 1991. "The Hashemites, the Arab Revolt, and Arab Nationalism: The Origins of Arab Nationalism." In *The Origins of Arab Nationalism*, edited by Rashid Khalidi, Lisa Anderson, Muhammad Muslih, and Reeva S. Simon, 204–24. New York: Colombia Univ. Press.

Wright, Quincy. 1926a. "The Bombardment of Damascus." *American Journal of International Law* 20 (2): 263–80.

———. 1926b. "The Mosul Dispute." *American Journal of International Law* 20 (3): 453–64.

Write, John. 2007. *The Trans-Saharan Slave Trade.* New York: Routledge.

Yılmaz, Hale. 2011. "Learning to Read (Again): The Social Experiences of Turkey's 1928 Alphabet Reform." *Journal of Middle East Studies* 43 (4): 677–97.

———. 2013. *Becoming Turkish: Nationalist Reforms and Cultural Negotiations in Early Republican Turkey, 1923–1945.* Syracuse, NY: Syracuse Univ. Press.

Yosmaoğlu, Ipek. 2003. "Chasing the Printed Word: Press Censorship in the Ottoman Empire, 1876–1913." *Turkish Studies Association Journal* 27 (1–2): 15–49.

Ze'evi, Dror. 2004. "Back to Napoleon? Thoughts on the Beginning of the Modern Era in the Middle East." *Mediterranean Historical Review* 19 (1): 73–94.

———. 2006. *Producing Desire: Changing Sexual Discourse in the Ottoman Middle East, 1500–1900.* Berkeley: Univ. of California Press.

Zeine, Zeine. 1973. *Arab-Turkish Relations and the Emergence of Arab Nationalism.* New York: Caravan.

Zirkle, Conway. 1941. "The Jumar or Cross between the Horse and the Cow." *Isis* 33 (4): 486–506.

Zürcher, Eric J. 1993. *Turkey: A Modern History.* New York: I. B. Tauris.

———. 2010. *The Young Turk Legacy and Nation Building.* New York: I. B. Tauris.

Index

Abbas Hilmi II, 193–95, 198

Abdülhamid II, 18, 29, 67–69, 82–85, 87, 95, 118, *119*, 120–25, 130, 133–35, 138–40, 142, 147, 149–50, 152, 154, 159, 164–65, 169, 183, 292, *293*; and despotism (*istibdat*), 67–69, 84, 87, 95, 117, *123*, *125*, *128*, 130, 164, 292

Abdullah, Emir, 233

Acre, 208

Administration of Press Affairs (*Matbuaat Müdürlüğü*), 85

Africa, 3–5, 10, 11, 18, 29, 37, 43, 51, 62, 94–98, 101, 105, 107, 109, 113, 118, 120, 126, 158–59, 161, 163, 165, 169, 170, 182–86, 188, 190, 193–94, 197–98, 203, 207, 214, 219, 237, 240, 246, 248, 253–54, 266, 268, 270, 278, 285–87, 292, 296; African, 4, 29, 42, 51–52, 107, 148, 186, 188, 248, 266–68, 270, 278, 280, 285

Ahmet Fuat, 74

Ahmet Midhat Efendi, 100

Ahmet Muhtar Pasha, 190

Ahmet Refik, 2, 45

Ahmet Şakir Pasha, 135

ajam, 32, 38, 42–43, 164, 173; in Karagöz plays, 38, 42. *See* Persian

Akbaba, 22, 76, 78–79, 213–18, 220, 222–23, 225, 227–30, 234, 248, 255, 258, 276, 278–79, 281–83

Alawi, 250

Albanian (*Arnavut*), 38, 42, 136, 159, 165, 170, 172–73, 176–78, 181–82; in Karagöz plays, 38, 42; revolution, 159, 165, 172–73, 176, 182

Alem, 155–56, 174–76

Alexandretta, 209–10, 212, 245, 262–66, 272–73, *279*, 279–80, *282*, *283*, 287. *See* Hatay

Algiers, 101

allied powers (allied forces), 18, 89, 201, 220, 229, 251, 259

alligator, 194–96, 203

Alphabet Reform 1928, 19–21

Anatolia, 33, 90, 120, 154, 170, 208, 209, 235

Anderson, Benedict, 13, 66, 174

Andres, L., 69, 155

Ankara, Treaty of (1921), 209, 254, 263

Ankara government, 30, 76, 78, 89, 90, 209, 263; and press battle, 90

anthropology, 267. *See also Turkish Review of Anthropology*

anthropomorphizing, 112, 219

Antioch. *See* Alexandretta

Arab, Black (*zenci*), 5, 10, 12–13, 42–43, 46, 51–58, *53*, *55*, *58*, 101, 105, 107, 139, 203, 224, 266–68, 270, 272, 278, 280, 285, 291, 297; white (*Ak*), 5, 10, 12, 28, 42–48, *47*, *48*, 51, 54, 59, 101,

Ilkim Büke Okyar teaches Middle East politics and society in the Department of Political Science and International Relations at Yeditepe University, Istanbul. Upon completing her undergraduate degree in political science and administrative studies at the University of California, Riverside, Ilkim pursued her graduate studies with a degree in Middle Eastern studies, receiving a doctoral degree from Ben-Gurion University, Israel. Her research area includes various topics such as nationalism and national identities in the Middle East, emphasizing the Levant. She is also interested in early republican Turkish political history.

CPSIA information can be obtained
at www.ICGtesting.com
Printed in the USA
LVHW042351130423
744287LV00002B/148

9 780815 637974